HEINRICH WÖLFFLIN

The art of
ALBRECHT DÜRER

Translated by ALASTAIR & HEIDE GRIEVE

Phaidon

Phaidon Press Limited, 5 Cromwell Place, London SW7

Published in the United States of America by Phaidon Publishers, Inc.
and distributed by Praeger Publishers, Inc.
111 Fourth Avenue, New York, N.Y. 10003

First published 1971

Originally published in 1905 as Die Kunst Albrecht Dürers
New edition, edited and annotated by Kurt Gerstenberg
© 1963 by F. Bruckmann KG, Graphische Kunstanstalten, Munich

Translation © 1971 by Phaidon Press Limited

ISBN 0 7148 1467 9
Library of Congress Catalog Card Number 70-139837

Printed in the Netherlands by de Lange/Van Leer, N.V., Deventer.

Contents

Acknowledgements

The publishers wish to acknowledge the kindness of the museums which gave permission for the paintings and drawings in their possession to be reproduced in this book, and provided photographic material: The British Museum, London; Kunsthalle, Bremen; Prado, Madrid; Alte Pinakothek, Munich; Albertina and Kunsthistorisches Museum, Vienna; Staatliche Museen, Berlin; Germanisches National-museum, Nuremberg; Universitätsbibliothek, Erlangen; Louvre, Paris; Uffizi, Florence; Musée Bonnat, Bayonne; Staatliche Kunst-sammlungen and Sächsische Landesbibliothek, Dresden; Städelsches Kunstinstitut, Frankfurt; National Gallery, Prague; Thyssen Collection, Lugano; Musée Condé, Chantilly.

In addition they would like to thank the following: The British Museum for providing photographs of most of the engravings and woodcuts; John Freeman, London; Walter Steinkopf, Berlin; Photo Braun, Mulhouse; Robert Horner, London; Alinari, Florence; Clichés Musées Nationaux, Paris; Gabriele Busch-Hauck, Frankfurt; Photo Mas, Barcelona; Stickelmann, Bremen.

Heinrich Wölfflin and his book on Dürer

Heinrich Wölfflin is the founder of modern art history as a science. Profoundly artistic by nature, he yet had sufficient love for and understanding of philosophy to open up new areas which enabled art history to be studied systematically and scientifically. He realized that art-historical research proper could only be undertaken after research into historical records and literary sources had been carried out. Thus he became the founder of a methodical, formal approach to works of art which makes it possible to grasp their essence and development by basing them on definite concepts. What was new in Wölfflin's scientific approach was the way in which he evoked the essential creative and spiritual power in works of art. His writing opened his readers' eyes and held them fascinated. Wölfflin gave art history a unique stability and independence among the humanities, and he achieved this by profound analysis and criticism based on the experience of the senses. The compelling power and originality of his language made this apparent to everyone. This is why—as early as 1910—when Wölfflin joined the Berlin Academy of Sciences he was greeted with the words: 'You are called upon to add a new province to the academic field.'

Wölfflin insisted that, to understand any work of art, all the historical and cultural circumstances of its period should be taken fully into account. Yet he thought that the true essence of a work of art lay in its form, which was a direct expression of its spiritual significance. Wölfflin possessed extraordinary powers of visual perception which enabled him to penetrate into the very essence of a work of art. But he was not merely contented with a critical appraisal of individual works. By looking at all the works of art of a chosen period he established a pattern of observation which provided an interpretation of complete styles and their characteristics and based them on clear concepts. Wölfflin has demonstrated this method most fully and vividly in his book on art-historical principles.

Anyone who knows Wölfflin's writings or who has been fortunate enough to hear him lecture will know that his method was not in any way dryly systematic, but rather that he could do justice to individual artists by characterizing them in a most striking fashion. His concern was always twofold: on the one hand he wanted to understand all of an artist's individuality—and this is why he insisted on art history as psychological history; on the other hand he could happily make generalizations about the development of art over a whole period. In this way seemingly isolated artists were still securely anchored in the general style of their time. Even his very personal account of Dürer

was concerned with him as the greatest sixteenth-century artist north of the Alps and his search for the laws of representing the ideal beauty of the human body. It is significant that the book culminates with a final chapter on the problem of beauty.

This book with its rich language is consciously subjective, but this is an expression of a kind of proud modesty. It may also be said that the subjective approach is highly attractive. And it must be noted as well that Wölfflin's Dürer is a product of the age of Impressionism in which the artist's direct perception of the surrounding world and the resulting subjective naturalism are emphatically stressed. It cannot have been easy for Wölfflin to write this book on the art of Dürer. Kindred by choice to his predecessor Jacob Burckhardt, he had grown up with a close emotional relationship to the art of the Italian Renaissance, and in his first books his aesthetic judgements had been completely determined by it. But now he was confronted with Dürer's very different northern art and he had to come to terms with its nature and peculiarities. One may be certain that this involved much inner conflict. Any reader who follows the book chapter by chapter can still feel this: Wölfflin had to experience the singular progress of Dürer step by step; he had to recreate his works mentally. This is what gives the book its unique dramatic force.

Wölfflin did not discover a single unknown painting or drawing by Dürer. All the paintings, drawings, engravings and woodcuts which he examined, and their subject-matter, had long been known. And yet, compared with all earlier biographers of Dürer, Wölfflin established an entirely new image of Dürer the artist and his development and importance. No one before him had penetrated so deeply into that world of lines and shapes and understood so well how these changed with the changing techniques. No one had thought about the true significance of this art with such clarity or talked about it with such force.

The lasting value of Wölfflin's book lies in the fact that it is the first to approach Dürer's art in terms of visual perception. Each word is the result of creative scholarship and penetrates so deeply that it shows up even the hidden roots in the fertile soil. There are few art-historical books which have become so important for general art education over and above the grasp of their specific subject. At the same time Wölfflin's book on Dürer is a work of literature by virtue of its original, vivid writing, and one cannot but be impressed by its dramatic composition. It has become a book which, of its kind, is everlasting.

KURT GERSTENBERG

From the foreword to the first edition (1905)

A 'great Dürer' has not been written since Thausing's fundamental book, which first appeared in 1876 and went into a second edition in 1884. Yet the interest in Dürer has certainly not declined since Thausing's times. Our age in particular searches so avidly for anything that can be called German and Dürer's name is so much a symbol of all national art that any new account would find its reader. It is not that there is a lack of scholars but their work benefits mainly specialized literature, where indeed a steady and almost uncanny increase in production has been apparent for years. Nearly every issue of our art-historical periodicals contains some contribution on Dürer. The outlines of each aspect of his work have become clearer and more precise, and Lippmann, with his monumental publication of all the drawings, has given Dürer studies an entirely new foundation. The present book should not be taken as *the* hoped-for Dürer but only as 'another Dürer'. The author has arranged the material in his own way, tracing Dürer's art rather than his biography and foregoing the completeness of a catalogue in the description of the *œuvre* and a discussion of all critical problems which research has thrown up in the course of the decades.

There is a statement by Buffon which is often quoted but seldom truly understood—'le style c'est l'homme'. The author has often thought of this statement during his work. As Heinrich von Stein has shown it has a general, not an individual, meaning and Buffon wanted to say that the specifically human element lies in the 'stylization' of the *œuvre*, in a rational presentation and not in a mere collection of raw material.[1] To write on Dürer means to give an account of some 1,200 drawings, prints and paintings. An attempt has been made to arrange the mass of material so that it appears clear and articulate, so that the essential points are quickly grasped and the individual parts are correctly related to each other and no detail obtrudes unduly. It is because this has only been achieved in a very limited way that the author's intention shall at least be clearly stated here. Thausing makes a literary mistake in not speaking of the *Apocalypse*, which after all is the signature of Dürer's youth, for 150 pages, by which time the reader has become inattentive and tired with all manner of subjects. It is self-evident that different points of values are stressed and that the concepts with which we try today to understand Dürer's art have changed essentially in a quarter of a century.

With the popularization of art history the feeling for genuine art has declined dangerously. From time to time it is well to draw attention to the fact that a single original print by Dürer may be infinitely more important for the understanding of his art than a complete sequence of

falsified copies. It will only be possible to speak of a subtler understanding of the art of Dürer's graphic work when an awareness of the quality of different impressions has arisen. To engage in such distinctions lies outside the present task.

We like to call Dürer the most German of German artists and we delight in the idea of him sitting in his house at the Tiergärtner Gate in Nuremberg, sedately working away as his fathers had done, content on his native soil and convinced that art needed only to be heartfelt and true but that external beauty was unimportant. This idea was introduced by the Romantics. But it is a mistaken one. If ever anybody looked longingly beyond the borders of his country for a strange, immense vision of beauty, it was Dürer. He was responsible for the great lack of assurance, the break with tradition in German art and the domination by Italian models. Dürer did not go to Italy through chance or caprice. He went because he found what he needed there. But if one looks into someone else's exercise-books and copies one always has to pay the price. Ultimately he found the balance between his own and foreign characteristics, but at what cost to his own strength!

Dürer's life fell in a time of transition. Everything contributed to hold back or upset the development of natural feeling. Representation had first to be raised to the modern standard of physical and spatial perception. The image of a new style appeared on the horizon and cast its foreboding shadows over the land—a style with classical forms which stressed horizontal lines and favoured ample modelling and full volume. The attitude to human affairs was changing too. Those great upheavals from which the Reformation originated were imminent. Italy experienced a similar development in her art as well but there the new style came naturally and gradually, not fitfully and in contrast to previous styles as it did in Germany, which was presented with a completed model. Raphael and Titian could become classical artists because everything was ready when they appeared. In Dürer's case not even the craft had been developed. By an immense effort he won the new mode of representation for art, achieved the transition from the Gothic to the 'Renaissance style' and created the human type of the Reformation. What he did was great, but the struggle by which he attained his ends is perhaps greater. The results of his life are hardly as interesting as the way they were achieved.

He himself modestly thought that he was the pioneer, not the master, of a new art.

HEINRICH WÖLFFLIN

Introduction

Up to now if one wanted to sum up German art in one name one said 'Dürer'. In spite of certain reservations he could be taken as *the* German artist in the same unquestioning way as Rembrandt could for the Dutch or Rubens for the Flemish. It is a pity that we cannot put forward like them a name from the seventeenth century, for if we could we would not be separated by such a large gulf in outlook. But once dependent on the sixteenth century there is really no choice. Holbein was never really popular, not even through his woodcuts, and Grünewald, wonderful though he is, was taken rather as an exception.

Today people think differently. New conceptions of the nature of German art have been formed and Grünewald has moved from the periphery to the centre. He has indeed become the mirror in which the majority of Germans recognize themselves and his isolation has ended. When we think of his art we immediately connect it with that of Altdorfer, the younger Cranach, Hans Baldung Grien and others. Now it is rather Dürer who appears to be the exception. His fame seems to have been made possible only by the coincidence of Grünewald's disappearance for centuries from the nation's view. Beside Grünewald's abundance and elemental force Dürer's artistry appears one-sided, sometimes almost scholarly and academic, and his cult of Italianate form seems to have undermined his inborn German character in a fatal way. We demand living colour. Not the rational but the irrational. Not structure but free rhythm. Not the fabricated object but one that has grown as if by chance.

It is not easy to prevail against such criticism. All the same it will soon be realized that Dürer's position is rooted tenaciously in German soil and the old master still seems to exert a secret royal power, however often and convincingly it has been shown that the power really rests with the other artists mentioned above.

It is true that no one else speaks to us so intimately as he. By far the fullest biographical information we have is on him. Grünewald, even Holbein, are—as people—mere shadows to us. Nor have their external appearances been established, while everyone knows, or at least thinks he knows, what Dürer looked like. Then we have letters, diaries and a large number of other writings in which a most congenial man reveals himself almost entirely. We hear him laugh and we laugh with him, we witness deep emotional upheavals and through these become extraordinarily familiar with him. Moreover, who can deny that he is also most popular as an artist? This is not always the case. Some of his works appear completely alien, but others allow him to take his place amongst us as a living person. In how many German parlours does the

engraving of the *Knight, Death and the Devil* hang on the wall! It is possibly the best known subject in German art and, although its true meaning as *eques Christianus* is not generally understood any more, even today many a good man may gather strength in the troubles of life from this print. Then there is the *Melancholia*, relevant above all for intellectuals. From his own experience Dürer seems to have known the depression caused by an evil star gaining power over the soul. Although many of the individual details have become strange to us, the atmosphere of the whole is entirely accessible and appears so modern that we can forget the four centuries which have passed since its creation. And finally there is *St Jerome in his cell*, the third of the master engravings. It speaks to us more immediately than the others and, in so far as the essential element of expression no longer rests primarily with the figure but with the unity of the space and light, it is the most advanced.

Then take Dürer's woodcuts. Who does not lastingly remember certain details of the *Apocalypse*? The four riders, the angels of the Euphrates, St Michael's hard fight with the dragon. Not only has a new woodcut style been discovered with these but also an entirely new linear language, whose magnificence changes afterwards to gracefulness in the genre scenes of the *Life of the Virgin*. In the former sequence the creative genius is turbulent; in the latter the god speaks in a soft whisper.

It may be remarked that these creations of Dürer are popular just because they are graphic works, but if this is so then he has understood drawing to be the popular German art. And why has no other graphic work become as famous as his?

The portraits are the most impressive of the paintings. Wherever we come across a head by Dürer the effect is the same—an effect of unprecedented concentration of the sensual and spiritual aspects of form. And when we advance from the portrait to the full-length figure, the Munich Apostles for example, we are confronted by something which takes lasting possession of our imagination. It is hardly an exaggeration to say that the *St Paul* in the Munich Pinakothek is part of the German heritage of characters. Once seen he cannot be forgotten. His serious look follows the observer long after he has left the gallery.

Our concept of Dürer's character is perhaps determined more than anything by the depth and thoughtfulness of his mind. We feel with no other artist as we do with him that we could have talked to him about anything. Added to this is the painter's specific ability to show things concretely, and the extraordinary power, distinctness and brilliance of vision which shines from every drawing and has such a stimulating effect on us that our perception becomes fresher and more lively, and we feel we see everything for the first time. The eye is given a feeling of security and joy by the rounding and stretching of shapes, the apparently natural relationships of size and volume, and perfect psychological lucidity; this feeling outlasts the impression of a single picture.

Admittedly, such an effect is not found in Dürer's art alone, but the even clarity and alertness, the even objectivity with which he tries to do justice to every single creation, is something which remains peculiar to him. The philistine admires the labour of absolute perfection, but there is more to it than that, namely reverence for every object of creation and the ambition to use the tools of vision with as much skill as possible. 'The eye is the noblest sense of man.'

Something else must be mentioned which completes the magic of Dürer's drawing: the way all representation is subjected to a very definite sense of order and scale. We recognize Dürer's hand from a distance by a certain powerful grace of line and contour which gives an impression of solidity and coherence. Nothing is unbalanced, extravagant or careless, everything moves in a measured, clear rhythm. It is true, the grass blades of the piece of turf which he painted in the famous watercolour in the Albertina seem to owe their grouping to chance alone, but this is not the case: the shapes are arranged according to a very precise harmony and order. This principle of order—which is sometimes rather severe but more often appears pleasant and charming—pervades the great figure compositions just as much as the shape and sequence of individual lines in a drawing. One may identify it as a feeling for repose and moderation or one may on the other hand get the impression of serenely vigorous vitality: in any case it is immediately clear that there is a connection with Dürer's homely temperament, and this has contributed much to the popularity of his art.

But this is not the whole Dürer. Besides the artist there is the theoretician who wrote the *Treatise on Descriptive Geometry* and the *Treatise on Human Proportion*, both main occupations of his life. It is not surprising that people have professed to find a certain scientific slant in his art, which counteracts the flight of his imagination. But what is worse, Dürer remains the man who, drawn to Italian art at an early stage, brought a foreign element into native tradition. We cannot close our eyes to much that seems cold, derivative and formalistic; once mistrust has been awakened it stays, and the suspicious observer will look everywhere for traces of alienation from the true self to prove that Dürer could and should have become someone entirely different. A comparison with the luscious freshness of Altdorfer or the younger Cranach makes it almost terrifyingly clear into what narrow paths Dürer's drawing style was pushed by the ideal of sculptural, measurable form. And if one looks at a phenomenon like Grünewald one becomes even more painfully aware of the isolation of Dürer's position. Take the unbounded pictorial riches of the Isenheim altarpiece—what does Dürer have to set against this? And when Grünewald has embraced all the marvels of this world he advances to the metaphysical, and Dürer is left behind altogether. Is there any picture of the Resurrection by Dürer comparable to Grünewald's in its power of representing the extraordinary?

Now we shall examine both attitudes and ask how far we can speak respectively of a German character or its contrary.

If anything can be taken as characteristic of German art it is that intermingling of shapes which we usually call, for want of a better term, 'painterly'. This means that objects are not seen in sculptural isolation but that there is a secret movement which links form to form. Objects do not just stand alone in space but the imagination is aware of a pervasive life which binds together concrete and abstract things. The significance of the single object is submerged in the whole.

It is in this way that Baldung and Altdorfer painted the *Holy Family among Ruins*. Dark caverns whisper and rustle, broken walls are silhouetted in lines which relate strangely to their neighbours, an arbitrary segment of sky becomes most important for the atmosphere. Mystery fills all the forms in the picture. There are well-known paintings of this kind in public collections (Munich, Berlin). Who would not be immediately prepared to call such a fairy-tale fantasy essentially German? Strangely, Dürer has nothing similar to offer. The lack of such 'painterly' motifs is surprising. It seems that he exterminated systematically any similar artistic feeling he might have possessed in his youth. In any case it can never have been strong. A picture like the *Holy Family* of the Paumgärtner altarpiece or an engraving of a similar early date such as *Christmas* would not be called 'painterly' by anybody. The impression is rather of a stage which was set first of all and then had figures added. However charming the detail, the crucial mysterious connection between forms is missing.

When we speak of a wood we do not merely mean the sum of the individual trees. The 'interconnections' within the wood are the crucial factor, the relationship (which can only be perceived by the imagination) of the rustling forms, of branch to branch, tree to tree. We get this feeling from Altdorfer's pictures. Although Dürer has often treated the theme of landscape, there are no painted woods in his work. He passed by the single groups of trees with their mossy, bearded and intertwining branches, which attracted the other artists, or rather he made them clear, simple and tangible. But precisely such intertwinings are one of German art's characteristic beauties. There is no need for profusion—Grünewald, in a few branches in the hermit picture of the Isenheim altarpiece, presents a superb vision of infinite movement.

The distinctive qualities of a classic Dürer landscape, by which I mean a landscape done in his mature style, are a strong suggestion of space and an expressive and forceful descriptive line. In painters like Altdorfer or Wolf Huber this quality will be less marked. Instead their whirling streams, precipitous mountains and skies gleaming with light give us the impression that land and sky are filled with a living breath. Dürer's landscapes, with their objects cleanly separated, have their unity too, but the interest lies elsewhere and the experience of nature has obviously been basically different.

It is significant that the problem of landscape occupied Dürer mainly in his youth and later became less and less important. The 'painterly' architectural background disappeared too, as did the 'painterly' crowds of figures. The sculptural tendencies and with them the individual figure became more exclusively important.

At the same time Dürer made greater demands on the clarity of his drawing. He was not satisfied by the merely expressive—effective as the formula might have been. He demanded something different in principle and this again brought him into opposition with German tradition and contemporary practice. He adumbrated a figure with his eyes as well as with the tools of a geometrician. To measure, measure, measure! This does not mean that Dürer was not aware of that dynamic force which is inherent in forms and which confirms for us the impression of life—he was aware of it in the highest degree—but he arrived at a different solution. With the other artists one's first impression is always of a continuous inner movement, of a general unity, and it is only later that one becomes conscious of a structure, as far as it exists. Dürer saw the body as a unity in which every point had first of all to be isolated and each partial member given a clearly defined and measurable shape. This definition may be misleading but the difference cannot be emphasized strongly enough. It is this quality which separates Dürer's *Lucretia* (Munich) from every female nude by Baldung and which makes such a figure so difficult for most people to appreciate. We are not used to this kind of interpretation of the body and everybody knows that in Dürer's case it was determined by Italian models. There are no prototypes in the tradition of his native art for the bodies of Adam and Eve in the engraving of the *Fall of Man* or for the horse in the *Knight, Death and the Devil*.

But the difference is also present in drapery studies where Italian models are not directly present. Here too Dürer's sculptural imagination coupled with his demand for absolute clarity has led to results which contrast with the work of the other artists who are concerned with immediate expression. To give just one example—the sobbing Magdalen at the foot of the cross in the Isenheim altarpiece, enveloped as she is by the waves of a rippling gown. Whether her figure would stand an investigation for absolute sculptural clarity is questionable, but then who would think of judging it for accurate measurement? That the woman's convulsive sobbing is expressed in every fold is sufficient. Compare Dürer's draperies in the Apostles of the Heller altarpiece or in the Apostles in Munich with this. Although the themes are magnificent they are rigid. They are full of expression but hardly conceived from a definite emotion.

It is true that in the case of the Magdalen the aim is completely different from that of the Apostles. With her it is the unrestrained outbreak of passion, with them calmness and composure. In this respect the comparison has to be treated with caution. But then Dürer is

accused of exactly this—that he never became passionate and retained a certain cool reserve in all he did. The happiness of exuberance was unknown to him and there are few cases where one would call his method of expression irresistible. He said that one of painting's principal tasks was to represent the Passion of Our Lord, so it is all the more remarkable how seldom he takes up motifs with strong emotion. The deeply moving interpretation of Golgotha in the Isenheim altarpiece would be alien to his feeling. Neither would he ever have shown the exuberant rejoicing of the host of angels in the air, storming through the church in Altdorfer's picture of the *Birth of the Virgin* (Munich). He kept to a middle range of feeling. We find no great descents into darkness nor great flights towards the light. And the onlooker will be touched much less often by the charm of the 'naïve' in Dürer's works than in those of his contemporaries, however abundant his representation of psychological life. His human beings nearly all live in the clear life of alert consciousness.

If we continue our criticism we can ask suspiciously if there is not a certain coolness in Dürer's whole relationship to the visible world. We can point to the glowing emotion which we find in the pictures of the 'painters' and which—in the case of Wolf Huber for example—has led to such a splendid exaggeration of forms. Mountains surge like huge, steep waves and leaves pour like torrents from the trees. In no other way could the unending flow, the inexhaustible creativity of nature be expressed. Except for a few early works we do not find this kind of drawing in Dürer. He is reticent and remains entirely objective.

But one imagines that even with this objectivity his feeling for colour and the texture of objects should have been richer and more sympathetic. He does have a feeling for certain surface qualities and this finds expression, often very surprisingly, in his drawings, but why is he so reticent in his paintings? How far he remains behind the others in his rendering of the bloom of youthful skin, the shimmering of precious fabrics, the charm of atmospheric life! It cannot be said that he lacked an inherent sense of colour but he lost interest in it more and more. The inner drive, which precisely here might have found a principal means of expressing heightened feelings, died in him over the years.

And as Dürer's world grew poorer, structural rigidity and conciseness became more prominent. This necessarily further chills our feeling. Germanic art is an art of free and immediate expression—'verse is made by emotion and not by counted sounds' (Haller, *The Alps*): the art of the Latins delights in concise form. In the art of sixteenth-century Italy an extremely passionate scene could be fitted into a very rigid composition. To a German this is always only partly comprehensible. The living incident cannot be bound in fetters but should move in free rhythm. We find splendid examples of this used by the painters who were Dürer's contemporaries but he, on the contrary, showed early on his inclination to use rigorous Italian patterns. He built ingenious

pyramids of figures and made the sides of his pictures correspond in certain ways at first sporadically, as if trying them out, until in his middle period his urge to compose large historical scenes within a firm structure, and with stressed axis, rigid symmetries and so on, prevailed.

The term used to describe this kind of composition is 'tectonic' but it can also be applied in a much wider sense. The composition of the *Knight, Death and the Devil*, based on frontality and right angle, is as tectonic as the group of Adam and Eve in the engraving of the Fall of Man, not to mention other examples. This kind of composition may be easily understandable to the Italians but we Northerners dislike it and soon reject it as rigid. To us, pictures of this sort seem, at a certain stage of development, unlively, artificial and unnatural. This contrast cannot of course be fundamental, as even the apparently accidental work of art is governed by an aesthetic law, but the rigour of a composition has different limits for us from those for the Latin peoples. Dürer vacillated, and strangely free works are found beside strictly structural ones. This is why people, in such cases, will always be inclined to accuse him of denying his own nature and of subjecting himself too much to foreign ideals. How seldom does Dürer's work allow one to speak of a 'vision'!

And finally another, purely Italian, concern must be mentioned— the problem of the beauty of proportions. This fascinated Dürer, especially in the main periods of his life. In long, laborious studies he examined the question of how the perfect human figure needs to be constituted. He produced different answers at different times and eventually he stopped seeking for one example of perfection. Only God knows the highest form of beauty and we must be content to understand the pervading harmony in the various types, some slender and some broad, some fat and some thin. The choice is left to individual taste.

We shall only concern ourselves with the fundamental aspect of this problem, without considering how much of such speculation was incorporated into Dürer's artistic work. Dürer may be defended if one says that he only showed a general prejudice of his time, which was to see the essence of the objective world contained in certain proportions. But there is no doubt that proportion was never as important for Germanic as for Italian minds. The idea that art has to search for purity of proportion is Italian. This concept has little attractiveness for us, much as it has been talked about. Our imagination is stimulated by action, not by things that exist as static forms. At all times the character of German architecture has been determined essentially by the impression of movement, specific movement, and not by set proportions. Thus the human figure has always been treated dynamically in German art and no attempt has been made to impress by the beauty of specific proportions.

Dürer obviously thought differently. It is true that his concern with

beautiful proportions was progressively taken out of his artistic practice and transferred to a purely theoretical treatment in his books. But the author of these books on human proportion was nevertheless convinced that he was thereby being of service to life in his turn and that his work would benefit a future German art. History, however, has not so far confirmed this expectation.

After so many basic objections one hardly dares to ask the question: can Dürer be extolled by us as *the* German painter? Rather must it not be finally admitted that a great talent has erred and lost its instincts by imitating foreign characteristics? Without doubt there is much in Dürer's art, and not only in his early art, that is original and delicious. But his work is interspersed with things which are alien to us. Samson has lost his locks in the lap of the Italian seductress.

Yet it is possible to see the situation from a different angle. Dürer may be wrong a hundred times and may lose when compared to the other Germans, yet it is possible that the objectionable features are only on the surface, that we are only criticizing the means he employed, and that his yearning for Italy arose from an entirely sound attitude, even if he erred in the way he satisfied it.

Proportions—yes, it is true that an Italian lit the spark in him, but is it likely that he would have taken up the idea so fervently, if he had not already secretly had the same notion? And what worries us? It is not simply a case of the connoisseur seeking out a possible way of intensifying a stimulus, but a concern of nearly metaphysical significance. All things have their particular proportions; human proportion is only one example, though the most interesting for us. The task is to find again the forms which God intended and which have become spoilt in the world. And Dürer has called out to the artist: 'You have been chosen to regain the original beauty of created things!' What a position he thus gives to art! Truly, it becomes God's representative on earth.

It does not matter how Dürer actually constructed man and woman; the crucial fact is his demand for an *essence*, for a beauty which captivates the onlooker like a mathematical demonstration. At the centre of all these passionate attempts to find the 'true' proportions lies the yearning to get away from the arbitrary, the accidental and the indeterminate and to achieve 'pure' forms. The fact that everyone has his own idea of beauty, that even one's own judgement makes a different decision every day, made Dürer suffer immensely. Anyone who rejects as un-German this demand for a final, secure perfection fails to understand an ever recurring tendency in the history of German ideas. And those who bled themselves to death to attain this idealism were not the worst. Admittedly, beautiful proportion together with the concept of perfection will never have the same importance for us as for the art of the Latin peoples. Nevertheless it is no will-o'-the-wisp when perfect beauty appears to us like a distant, alluring star in the sky.

But to estimate Dürer's idealism correctly, one has to remember his

18

attachment to the world. He did not want to leave the sphere of reality in his speculations on pure form. This form is present in nature. He who can detach it, possesses it. Woe to the dreamer who thinks he can construct beauty as he wishes! He only produces a pseudo-truth which will certainly collapse.

This attempt to find something indispensable helps us to understand the rigidity of Dürer's formal arrangements, which sometimes takes us aback. Here too he sought the one way which would exclude all thought of alternatives. All his German contemporaries possess a sense of structure which transcends that of the older generation. This was not enough for Dürer and he took up the strict rules of the Italians. At times he possibly asked too much of German understanding and we may well prefer the freer compositions of the others. But what is most important is not an individual solution to the problem, but the emergence of a feeling which calls for the absolute. If one calls this a characteristically classical attitude, it means that the north has one too. Of course it will never produce the same results as the southern attitude, and it would be disastrous to believe that it can be attained by direct imitation of the Italians.

But the phenomenon of Dürer's 'order' has other roots as well. Here too it is not merely a matter of taste. Dürer saw the true form of earthly life as ordered and regular. One feels this in the drawing of a single flower as well as in one of a tuft of grass. Here are no openly structural lines, no pure horizontals and verticals, but the whole picture is infused with the same spirit of order which pervades the large structural figure compositions.

And this world of order is also the world of ethics. The horse and rider in the print of the *Knight, Death and the Devil* may appear somewhat rigid, but is not a part of the knight's moral strength perceptible in this constraint? The honourable man is the upright man. This has to be taken with a pinch of salt, but the symbolism continues right up to the monumental figures of the four Apostles. And the opposite, wildness and arbitrariness, stands for evil, for what ought not to exist.

It is almost tempting to speak of a morality of perception in Dürer's work in the way he understood it. It is his achievement to have realized a conception of absolute lucidity of representation, which was entirely new in the tradition. In complaining about Dürer's deficiency as a painter too little account is taken of the positive values which make up for his shortcomings. He is mainly concerned with tangible form, it is true, but within this sphere he is so strong that it is perfectly understandable that anything that is not of a sculptural nature, any texture, painterly light, painterly handling of colour, could wither away. Light and colour are entirely subservient to sculpturally lucid form and do not lead an independent life. To force a strong awareness of sculptural qualities onto the spectator is only the first aim; the higher artistic purpose is to represent things entirely according to their true and

essential nature. This objectivity can be called Dürer's ethic vision. It was surely acquired with sacrifices. It is evident that he recognized an antagonistic spirit above all in the charms of painterly integration, in the incomprehensible emotional content of a completed picture, and yet he was a German and could not possibly entirely deny these effects their right.

But, it may be objected, he was not German enough. And here too Dürer's imitations of Italian models are held responsible for his occasional bleakness and coldness. We do not want to deny that his natural feeling suffered damage here and there, but it was not as an imitator that he took over the essentials. It is true, he found a lucidity and vividness in Italian art which appeared to him like the fulfilment of his own aims, but he would not have found anything had he not searched. He must have found a pleasure, hardly imaginable to anyone not an artist, in dissolving objects entirely into visual values and in representing this visible world—as far as he found it significant—exhaustively.

Rare though this tendency may be in German art—it too is a mark of a classical attitude—it is not unique and must not be dismissed as though brought in from a foreign country. There will always be a difference between German and Italian classicism, and one need only point out how clearly Dürer himself has shown this in his last work, those four Apostles in Munich, who appear so completely un-Italian.

And we have no right in any case to deplore the poverty of the world as he saw it. His feeling towards subjects differed only from that of those painters who represented their impression of the world through an immense intensification of form. Dürer disappears behind the object. He hated all subjectivism. But all the same, people will always object that his art falls just short of great passionate outbursts. They will always point to the great example of Grünewald. They will say that this is the man who moves souls. Is there anything in Dürer's work comparable to the moving face of sorrows of the crucified Christ in the Isenheim altarpiece? Yes, there is. Dürer's very personal version of exactly the same theme, the head of Christ suffering, equals that of Grünewald. But premise and aim are entirely different. Grünewald shows suffering which provokes pity. Dürer shows strength which opposes suffering. The difference is immense and shows up in a single instance Dürer's entirely different spiritual and ethical attitude. Grünewald's Christ may be more moving, but Dürer's ethos has an effect which is probably longer lasting. It exalts the onlooker rather than oppressing him.

Equally, Dürer's *Head of St Paul* could only be created out of such a mood.

The four Apostles have always been held to be the true legacy of the master. He painted them without being commissioned and presented them to the council of his home town of Nuremberg. The inscriptions explain their meaning: an admonition to hold fast to the

Word and not to give in when false prophets preach a social and religious radicalism which threatens to destroy all spiritual and secular order. Dürer believed that the Bible was the solid foundation on which all men should rely. Not one word should be subtracted from it or added to it. This may seem prejudiced to us. But it was in accordance with his times. In another age Dürer would probably have spoken of the right of historical evolution.

But these Apostles also show clearly how as a painter Dürer enters right into the battlefield of his day. Art for him was not only a revelation of beauty, an instrument of devotion, but a weapon in the battle of spirits. He does not convince his audience by the force of logical argument but by the power of his majestic human figures, which are incarnations of the moral law. Everyone may decide for himself whether or not Dürer thus went beyond the natural aims of art. This conception of the artist's calling would have been agreed with by another great German; Schiller believed that 'the dignity of mankind lies in your hand'.

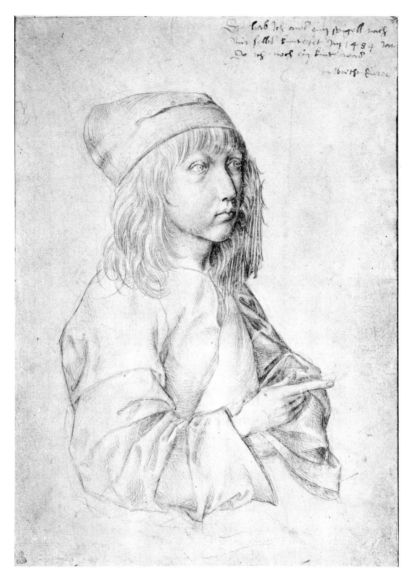

1. *Self-portrait*. 1484. Silver-point, 275 × 196mm. Vienna, Albertina.

Biographical outline

The eye is the noblest sense of man—DÜRER, after a classical source

Dürer's first artistic work to be preserved happens to be a self-portrait as a boy aged thirteen. It is a silver-point drawing with fine, cautious lines. All definite features are already similar to those we know from later portraits, and the individuality of the sitter is already established with strange accuracy. Only the eyes are insincere. But there is a strange tension in the whole of this subtly structured head. One is easily tempted to see more in it than the tension of the model before the mirror, namely something of that wondering expectation with which the genius prepares to meet the impressions of the world (Plate 1).

This boy was born in Nuremberg on 21 May 1471, in the back premises of a house, the child of a poor goldsmith. There were already two children, and fifteen were to follow. His father had immigrated from Hungary and in his forties had married the daughter of his former master, a very young Nuremberg girl.

We know Dürer's father. The young Dürer painted him twice and recorded in the family chronicle that he was a man of few words, rigorously just, and able in his trade, a man who always had to work very hard and who brought up his children under strict Christian discipline. Albrecht was his favourite. We only know the mother, who had once been a charming girl (Dürer calls her a 'pretty, upright maid'), through a drawing of her in her last years, that incomparably great charcoal drawing which the son made shortly before her death in 1514 (Plate 2). He had taken her to live with him after she had become a widow. She practically never left the house except to go to church. She also admonished the others to go and her constant phrase was: 'Go in the name of Jesus Christ'. The drawing shows a woman who has been exhausted by many births and worn out by poverty and work. The shrivelled face, with the protruding, squinting eyes, bears an expression of dumbness and hopelessness which is almost terrifying.

These are the parents. Anton Koberger, the famous printer and publisher, was the godfather.

As a matter of course, the boy became an apprentice of the father after he had learnt to read and write at school, and he had nearly finished his training as a goldsmith when he realized that he had to become a painter. This ambition was not achieved without a struggle —Dürer reports on it in the family chronicle. His father 'was sorry because of the time lost', but eventually he gave in and put him into the workshop of Michael Wolgemut. Dürer was then fifteen and a half. The apprenticeship was to last three years. 'During this time God gave

me diligence, so that I learnt well.' But Dürer adds that he had to suffer much at the hands of the journeymen in the workshop. In the spring of 1490, aged nineteen, he started on his travels—'and when I had finished my apprenticeship, my father sent me away, and I stayed away for four years, until my father called me back again.' He does not tell us where he went, though we know from other reports that Colmar and the workshop of Martin Schongauer was one of his main destinations. But he seems to have made large detours and when he arrived in Colmar he was too late: Master Martin had died unexpectedly in 1491. He stayed with the brothers for a while, then went to Basle, where we find him busy making woodcuts. A stay at Strasbourg in 1494 is indicated in another account.

But, as has already been pointed out, he was back in Nuremberg by Whitsun of that year. Immediately after his return he founded his own homestead, marrying the woman whom his father had chosen in accordance with the custom. Her name was Agnes Frey, she came from a wealthy home and was a dull person with plain features; one can well understand how nasty tongues could call her a cross for the painter to bear. We need not give any account of his marital happiness. It is enough to say that he lived with his wife after a fashion—in a childless marriage—until his death.

Dürer's artistic personality is distinguished from the beginning by an extraordinary sensitivity towards form. It is noticeable how visible things meant more to him than to others and how, early on, he must have evolved a new conception of the value and capacity for the representation of nature.

He cannot be thought of as continuing the local tradition of Nuremberg; rather he confronts us immediately as the heir of the whole of Upper German art, whose most important exponent at that time was Martin Schongauer. The characteristics which can be traced to the instruction of Wolgemut and his associates fade beside the effect made by Schongauer. And Dürer had recently been in Schongauer's native land. In the regions of the Upper Rhine he had become saturated with the subtle, mobile and expressive mode of this art. It is only to be expected that now, back in Nuremberg, he should continue to perfect the art of the master who had died prematurely.

But then the unexpected happened. Dürer came under the impression of Italy. The influence of Schongauer was crossed with the influence of Mantegna. German Late Gothic art met the Italian Renaissance.

One cannot say exactly when Dürer saw his first Italian pictures, but soon after his return to Nuremberg, in the years 1494 and 1495, the signs of contact become so frequent and so strong that we would have to assume a journey across the Alps, even if there were no other indications to force this conclusion upon us. It may be that individual engravings of Italian masters were already copied by Dürer in the north, but in 1495 he certainly stood on Italian soil. Dürer confirms this date

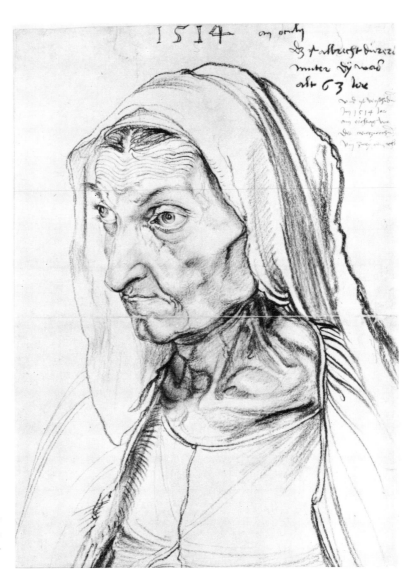

2. *Dürer's mother*. 1514.
Charcoal, 421 × 303mm.
Berlin, Kupferstich-
kabinett.

when he speaks, during his great Italian journey of 1506, of an impression he had received eleven years earlier at the very same place, i.e. Venice.[2]

He must have been strongly agitated by much that he saw: great landscapes, the mountains and valleys of the Tyrol, Venice and her painters. But the main impression upon him seems to have been made by Mantegna. The difference was immense for in all Italy he could hardly have found a stronger contrast to Schongauer than this heroic, stern master in Padua with his mind turned towards antiquity. In bold and accomplished pictures he was shown an entirely different world of beauty with different bodies, different movements and an attitude he must have found equally strange, Mantegna's grandiose pathos. What could northern art put forward of comparable stature?

Of course Dürer did not abandon one art for the other; he could not have become Italian all at once even if he had wanted to. He took a middle course and thus is at a disadvantage in comparison with Schongauer. We find old and new elements side by side and ill assorted, and a stylistic unsteadiness which is the mark of all transition. But this young artist had a fiery soul and we look forward expectantly to the moment when a great task will be infused with the strength of his youth. This happened in the woodcut. Characteristically he committed himself to linear art first. He took up the most topical subject of the time, the Revelation of St John. Here were described what were then expected to be the last omens before the world's decline, and he wanted to represent them in a new graphic manner with an unprecedented force of expression, on very large sheets. He wanted woodcuts so that he could be sure to speak to a large public. The book was published in 1498. This *Apocalypse* (Plates 12–16) opens a new epoch in the history of the woodcut. It has always made an extraordinary impression, particularly on productive minds, by its daring youthful genius which distinguishes it from other works by Dürer.

At the same time Dürer started to represent the theme which occupied him throughout his life, the Passion of Our Lord. Here too he produced woodcuts in a large format. The cycle, known as the *Large Passion* (Plates 17–20; 68), was not finished until later, but, especially in the early sheets, the design is heroic and contrasts markedly with the sentimental attitude of traditional representations of the Passion.

The third woodcut sequence which mainly belongs to the early years is the *Life of the Virgin* (Plates 22–27), which was drawn a few years later than the first cycles and has a different atmosphere. Here Dürer is contemplative and descriptive. The nature of the theme is partly responsible for this but at the same time it shows the general tendency of his development. Observations become more subtle and extensive, the means of representation richer and more precise. Light and shadow play an important role: lines become graceful. The storm and stress is over.

But can this term be applied to Dürer's case at all? Even in the earlier years, where we feel the fast pulse of the young artist, temperament never predominates over artistic reason. Strikingly original features, witty extravaganzas, are not found in his work. A contemporary like the younger Cranach deviated far more from the path of tradition and has probably dazzled some people more for a moment but afterwards he became thoroughly inflexible. Dürer's art has one characteristic quality right from the start, perfect objectivity. What I mean is that he was most concerned with the exhaustive representation of reality. Through him representation as such became for the first time an acknowledged problem of visual art. But the woodcut could never be adequate where exhaustive representation was intended. Dürer is at his most refined in the subtle technique of copper engraving, where he

worked for himself and where he represented form for its own sake. Painting was of little importance for the time being.

The engravings comprise every subject: sacred and secular, landscapes, animals and the human figure. But the main theme is the nude which, he had realized in Italy, was missing from German art. He saw that one had to start with the natural organism of the body and that the human form would at the same time be the ultimate task of art. All draped figures were only clichés as long as the artist had not mastered the body. The few existing representations of the nude, such as a *St Sebastian* by Schongauer, appeared insufficient not only because they lacked strength, but because the sense of the body's structure had not been correctly understood.

But our expectations are dashed. We hope for studies after nature and get imitations of foreign 'ready-made' prototypes. Dürer copied Italian models. The man who could have given German art an entirely new conception of reality was content, in a whole series of works, with a borrowed art. He copied and assembled the elements into learned compositions, and the fact that these bodies all presuppose a nature different from the German caused him no unease.

There is an even odder aspect. Reality alone was not enough for him. He wanted to advance from naturalism, which does not go beyond the depiction of a given reality, to an art which represented the typical, the conclusive. He wanted to show man as he should be according to the design of God. He was confused and alarmed by the infinity of individual appearances and searched for the ultimate image of beauty, which must be contained in definite proportions. How else was it possible to say that one man was more beautiful than another? He found a formula with which he was content for the time being. It was applied to the engraving of *Adam and Eve* (Plate 3), dated 1504, a sheet which is infinitely more important art-historically than his best contemporary paintings, such as the *Adoration of the Kings* in Florence (Plate 52).

Here the perfect representation is at the same time a representation of perfection. Dürer is the first northerner to set the problem in this way. It became important for him that there was in Germany at this time a Venetian painter, Jacopo de' Barbari, with whom he came into close contact. This man had only a third-rate artistic talent and no independent character whatever, but he possessed valuable knowledge because he belonged to the Italian School, and he seems to have succeeded in passing himself off as the custodian of profound secrets. It is true that he initiated the search for regular proportions, but Dürer complained that he was unwilling to give him proper enlightenment. The fact is that the Italian concept of the beauty of motion became clearer to him at the same time as the new problems of proportion. He must have seen drawings of famous classical sculptures. The engraving of *Adam and Eve* of 1504 is a characteristic example of this influence as well.

The following year Dürer crossed the Alps for the second time. Whatever led to his decision, we may say that Italy now fell into his lap like a ripe fruit. And yet his artistic development was not focused calmly and steadily on one point. He was not a Romanist for whom nothing existed but the Italian figure. In the years before 1505 he was absorbed with native, familiar patterns as well as looking out for new and foreign features. How else could the *Life of the Virgin* have been created at that time? And we find side by side with the engraving of *Adam and Eve* the female nude of the *Large Nemesis* (Plate 41), an infinitely individualized northern model, and also that most delicate sheet of the birth of Christ in a yard, known under the title of *Christmas* (Plate 47). This engraving already points to a later stage of Germanic art in its painterly arrangement, where the figures are of secondary importance compared with the charm of the surrounding space. Just

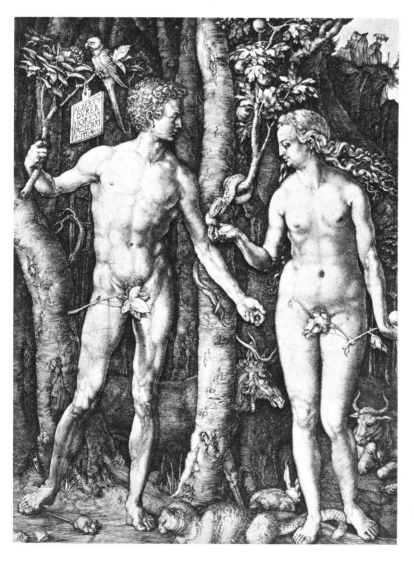

3. *Adam and Eve*. 1504. Engraving, 252 × 194mm.

at this time a feeling for intimacy becomes apparent in Dürer, a feeling for the value of the small German landscape. He considers his subjects in such a contemplative, lingering manner that one expects an entirely different development from what the next years show. This is probably the most interesting moment in his life. Two tendencies struggle with one another. The terms 'painterly' and 'sculptural' only imperfectly describe this contrast; ultimately it is a matter of the Germanic and Latin artistic attitudes.

As a result of his great Italian journey Dürer's national characteristics were not developed further at first. Those who believe in a vernacular art may deplore the fact that the journey was undertaken. Yet not even Dürer could have stopped the ensuing development in Germany. From all directions the Germans pressed south. Before it could develop its own character northern art had to be schooled by the artists of Italy to represent form sculpturally and with a rigorous structure.

Thus Dürer entered Italy for the second time when he was a mature man (autumn 1505). He now knew what he could expect and what he wanted. His own contribution had to be merely completed and developed, and a stay of barely a year and a half was sufficient to give an essentially new stamp to his artistic physiognomy.

It is possible that business considerations drew him to Venice, but it is odd that he did not go further. We hear of an excursion to Bologna, and presumably he also went to Milan, but there is no mention of Florence. And yet he must have known that there were things for him to see there which were much more closely related to his own art than anything in Venice. How one longs to know what effect Leonardo's *Battle of Anghiari* and Michelangelo's *Bathing soldiers* might have had on him!

We get an idea of Dürer's experiences in Venice from his letters to his friend Pirckheimer, which convey the happiness, despite some troubles, of a stay in the sun. He found life with a people who had a natural veneration for artists very comforting, and thinking of his return he sighed, 'How I shall yearn for the sun, here I am a gentleman, at home a parasite.'[3]

On the other hand he said little of what he thought about Italian art. His comment on Giovanni Bellini—that he was old and yet the best— is an exception. In order to get to know his inner development we have to turn to his works. His most important picture was a large painting intended for the church of the German merchants in Venice—the *Rose garland* picture (Plate 56). It was commissioned shortly after his arrival and occupied him until the autumn of 1506. Here he had an opportunity to show how impressed he had been by great Italian painting. The picture has an entirely Italianate form.

We have become extremely suspicious of this assimilation of German art to Italian art, which has been repeated so often since. How could Dürer want to appear Venetian among Venetians, without losing

himself? This is not the place to give a detailed account of those features which remained original and those which were imitated, or of where Dürer was prejudiced in his copying and where not. Generally, one can say, to him Italy meant the perception of more monumental forms, representation of the figure as a distinct organic structure, and abundance of sculptural motifs. He eagerly took up monumental figure paintings and formal aspects gained a frightening preponderance. The danger of superficiality was undeniable but at the same time there was a genuine turn to the heroic, which does not seem to imitate Italian form after all.

It was Venice which made Dürer a painter. Now, however, painting ranked higher than engraving, and while Dürer up to this point had followed the custom of not necessarily applying the *highest* art to an ecclesiastical picture, he seemed to become conscious in Venice that the superiority of the painted panel over the sheet of paper must be preserved under any circumstances. And the kind of monumental effects he sought now were attainable only in this field.

Dürer was a different man after he returned home. He had now reached full maturity. (One outward expression of his new attitude to the world was his purchase of the big house near the Tiergärtner Gate which we know as Dürer's house.) He surveyed his achievements and future tasks. He believed that, while the Italians had already been striving for two centuries to regain the achievements of antiquity, art had still to be won anew for the North. Even the term 'Renaissance' was already familiar to him—he called it 're-growing'. Practice must be founded on theory. One does not get anywhere by mere technical exercises. Just as Leonardo called painting a science, so Dürer demanded that the painter should have a complete understanding of theory. This is the other side of the after-effect of Italy.

He decided to write a manual of painting dealing with perspective, light and shade, colour and composition, but above all with the proportions of human and animal form. The plan was only partly realized, but this scientific work forms an essential part of the character of his post-Italian period.

As far as his art is concerned we now find the epoch of his great paintings beginning. His idea was to produce sculpturally impressive motifs in significant combinations. If the commissions had been given then, a new monumental art of painting could probably have arisen. But Dürer had few opportunities, and he also had a way of getting involved in single works with such pertinacity that the great initiative soon petered out.

He began with the life-size diptych of *Adam and Eve* (1507; Plate 61), presumably done without a commission. It was the necessary sequel to, and correction of, the engraving of 1504.

Then he received an order from the Elector of Wittenberg for *The martyrdom of the ten thousand Christians under King Sapor* (1508;

Plate 62)—a disagreeable subject, but one that contained nude figures and movement. If only it could have been a *large* picture! As it was the composition had to compress a crowd of little figures into a small space; it was a drop in the ocean of Dürer's pictorial aspirations.

He next painted the important picture of *The coronation of Mary with the Apostles at the tomb* (copy, Plate 63), a commission from the merchant Heller for Frankfurt am Main (1509). In this case he was free to lift a momentous subject to imposing heights. The composition is structurally arranged in the Italian sense, and the crowning gesture of Christ as well as the postures of the leading Apostles are endowed with a new feeling for strength and magnificence. But complete harmony of form and subject-matter has not been achieved. The structure is recognizable but the nature of the Apostles is not yet great and vivid enough to give life to it.

The *All Saints* picture (Plate 66), which is the last of the group (1511), is a more modest panel, without individual statuesque figures, but precisely because of this it is more coherent and unified. It is original in the motif of the great apparition in the sky above the earth and ever memorable for its child-like, many-coloured, gay brilliance. This makes it the most popular picture of the group today. Originally it had been commissioned by the coppersmith Landauer for an old men's home in Nuremberg which he had founded.

This is the short sequence of the 'great paintings'. How incomplete and uneven it seems if one remembers what it meant for Dürer! He wanted to demonstrate to the Germans the concept of great art as such in typical examples. He wanted to represent the forms of a new and more sublime human existence. He wanted to free perception from all traditional pettiness and endow feeling and gesture with the grandeur which he had sensed in Italy. Are these really pictures which lodge in the German soul and belong to it as a lasting possession? How little of them has reached the general imagination, how limited the effect of the scattered paintings must have seemed right from the start!

I repeat, the impulse to create great paintings did not lead far. We know Dürer's expressions of despondency, where he blamed circumstances and sighed at himself. He found it more advisable to continue work in the sphere of drawing alone.

The old sequences of the *Large Passion* and the *Life of the Virgin* were taken up and added to, so that in 1511 they could appear as completed books. The additions are easily recognizable. Their design follows the great formal arrangements of the paintings; they are structurally composed and have certain calculated correspondences or divergences in the individual figures. Each part is necessary to the whole. The execution has become broad and tonality is stressed; light and dark are concentrated or contrasted in great masses. The overall effect is much richer, but the drawing has become simplified and the lines which are easiest for the cutter of the wood have been chosen. In this

respect it can be said that Dürer founded the classical style for the woodcut at that time.

Shortly after this he developed the typical form for the engraving too, and economically explored its specific advantages over all other techniques. Engravings and woodcuts became definitely separate, as did the formulation of their aims. This is most obvious in parallel series depicting the same subjects. At the same time as the old woodcut *Passion* was being finished Dürer treated the theme of the Passion with great devotion in two new works—as woodcuts in a series of thirty-seven sheets and as engravings in sixteen sheets. They are called respectively the *Small Passion* (Plates 70, 71, 74, 77, 79, 80, 82) and the *Engraved Passion* (Plates 72, 76, 81, 83). Without exception the higher problems of drawing were reserved for the engravings. While his woodcuts become more and more simple and look for a concise, elemental way of expression, his engravings present the connoisseur with accomplished form, the charm of foreshortenings, textural handling of surfaces and the subtler nuances of light. At the same time there is a corresponding contrast in attitude. The woodcut satisfies popular feeling, it seeks edifying and moving themes, while the engraving, which evidently had a different public, only approaches these effects with reticence.

Dürer's two strangest works are engravings: the *St Jerome in his cell* (Plate 88) and the *Melancholia* (Plate 87), both of 1514. They are entirely unexpected at that stage because they appear so intimate and not at all concerned with form. One does not think of the relation of form to subject-matter. Only now does one realize how much warmth and immediacy Dürer had lost since his journey to Italy. He *had* become too much concerned with form. Formal calculations were everywhere visibly predominant. The period in Italy had been an excellent schooling, but a schooling nevertheless, and this meant lack of freedom. The sheets of the *Life of the Virgin* and the *Large Passion*, which were designed in the Italian manner, are the least interesting ones of the series as far as content is concerned. And none of the other seeds of youth were developed: the feeling for still life, landscape, the 'painterly' attitude in its special sense. Dürer had become impoverished through his concern with great figure compositions.

But suddenly the old feeling returned warmly and strongly. His relationship to nature became more comprehensive and intimate again (this is seen most clearly in the drawings). He concentrated on the truly significant and arrived at a representation of psychological moods in which he was entirely independent of foreign models. Thus the *St Jerome* and the *Melancholia* have become the German people's living possessions more than any other works by Dürer. It is no coincidence that his most soulful portrait, the drawing of his mother already mentioned, is of the same year, 1514. A straight line leads from here to the heads of the Apostles in Florence, which bear the same painfully search-

ing expression. Dürer strives after the great character portrait. He must now have found the Heller altarpiece, the Apostles at the tomb of the Virgin, trivial and insufficient.

Dürer's art was always relatively independent of patrons. He did not get many commissions and he sometimes complained of this. On the other hand it had its advantages, especially during this period of intense feeling when it was better for him to be entirely independent in order to develop the as yet inexpressible concerns of his soul calmly and slowly. When the Emperor Maximilian takes hold of Dürer, it seems like an interference. Dürer was to participate in the great woodcut enterprises through which Maximilian wanted to proclaim his fame. I do not think myself that this was harmful for the artist. It is extremely interesting to hear his opinion on German decorative art at that very moment, but he should have had more independence. With interference from above and the necessity to come to an arrangement with other artists the result was naturally rather stilted. Where he was left alone, as in the marginal drawings for the Emperor's prayerbook (Plate 100), everything is immediately more lively.

Dürer's connection with the Emperor meant that the artist could count on a fixed income from 1515 onwards, as he was allotted a yearly pension of 100 Rhenish gulden, which was enough for a normal subsistence. However the payment was only made irregularly.

The finest monument of the personal relationship between prince and artist is the spirited and amiable portrait drawing which Dürer made in 1518 (Plate VII) during the Diet in Augsburg. It is so accomplished that we have to question the oft-repeated opinion that Dürer tired towards the end of the second decade of the century. True, he now appears dry here and there, the colour becomes cold and discordant, his painstaking detailing sometimes has an archaizing effect. Yet as a decorative artist at exactly the same time he briskly conformed with the broader and fuller taste which looked to the future. And even if his pictorial production did on the whole become more laborious, a secret development went on nevertheless. The comprehensive vision of his last style started to appear and the only question was whether or not his natural feeling would be sufficient to infuse form with life.

Then, like an act of providence, at this moment, the journey to the Netherlands took place (1520/21). It had a definite business purpose, namely to get Dürer's yearly stipend confirmed by the successor of the Emperor Maximilian, the young Charles V. But Dürer must also have felt how beneficial another complete change of scene would be to his senses. And he stayed down there for a long time, even after his business was finished.

He was in his fifties, but still impressionable and capable of change. Looking at Netherlandish art he became a painter again. The multitude of strange sights in a country foreign to him must have had an even more refreshing effect than the impression of single pictures. He seemed

to grow new organs, finer antennae with which he tried to get into touch with—and take possession of—the new world. His pleasure in seeing and reproducing is never so clear and evident as at that time. He seemed to regain a fresh relationship to nature. Every individual, every head interested him and he traced them—not with a specific drawing formula, but now, in his maturity, beginning to revise his style fundamentally and becoming so precise and reverent that it was as though he were confronting the world for the first time.

His pocket sketchbook is partially preserved, and a reasonably communicative diary is also at our disposal, adding to the pleasure with which we accompany Dürer during these years. This contains remarks which are among the most profound statements we know by Dürer. He was not just the eager tourist. In the Netherlands he saw things which excited him much more than the whale which had been washed ashore in Zeeland or the gold objects from America: I refer to the Reformation. Dürer walked on a volcano in the Netherlands. Spiritual tension threatened to explode in violence, and for a moment it seemed that Erasmus would take on the leadership of the movement. Dürer frequented his circle, and the highly charged passage of the diary where Dürer calls out to Erasmus to come forth as the champion of Christ was not merely the effusion of a dreamer ignorant of the world. He followed the developments closely and it has even been suggested that he was compelled to return because he had to flee from the Inquisition.

Dürer came back to Nuremberg a serious man. His style became completely simple, objective and broad. He sometimes told Melanchthon that he regretted that formerly he had been too fascinated by the charm of the merely extraordinary and by colourful variety, and that he realized his weakness only now.

Of this classic period the public at large knows only the *Four Apostles* in Munich (Plate VIII) which, it is true, surpasses everything else. But Dürer's personality would doubtless seem very different if the other pictures which he had fully prepared had also been executed, such as the picture of the Crucifixion or the large *Sacra conversazione* (Plate 105), religious paintings of the most solemn kind which are so rare in the German Renaissance.

Neither was a final cycle of the Passion in large woodcuts completed. This would have been the most beautiful of all Passions because Dürer now abandoned himself entirely to his theme without losing any of the virtuosity of his highly developed art. Only the *Last Supper* (Plate 111) has been cut; the other scenes merely exist as drawings and the whole sequence was obviously never completed.

But now there are many more portraits than in the middle period, as this particular challenge had gained a new significance for him. They are masterpieces showing a majestic vision coupled with a most detailed rendering. When Dürer had returned from his Italian journey, he had taken up the problem of human beauty as his first task and painted the

34

figures of Adam and Eve. This last period is given its signature by the four Apostles. Furthermore Dürer painted them without being commissioned, and later gave them significant inscriptions and dedicated them to the town council. He felt the end of the world to be near and warned against false prophets and scribes who eat up widows' houses. The Word of the Lord is eternal and nothing must be subtracted from it or added to it. Thus the rulers should listen to these men whom he shows as great ethical figures erected like statues.

There is a great deal of evidence to show that in his heart Dürer was on the side of the Reformation. In a letter of 1510 to Spalatin he was already saying of Luther that the momentous word of this Christian man had helped him in great anxieties, and the diary of the Netherlands visit contains a moving expression of grief and despair on receiving the rumour of Luther's disappearance after the Diet at Worms. It is not within our scope to examine his relations to people and objects of the Reformation,[4] but we must know that the older Dürer grew, the more he was occupied by thoughts of the other world. He tended towards melancholy. In the extensive passage in which he reports first the death of his father and then that of his mother one feels the whole dreadful oppression under which he and probably most serious people lived at that time. He records with awe the memory of the miraculous rain of crosses, which he saw in 1503, and his report of a nightmare in the year 1520, in which immense floods poured from the sky, reads like something from the Apocalypse.[5] These confessions reveal the anxieties of the age in a flash.

But such thoughts were balanced by the unending pleasure he took in knowledge and perception, which are after all the main characteristics of our general impression of Dürer.

His main concern during this late period was the completion of his theoretical works. The chapter on human proportions had emerged as the most important part of the general *Instruction of Painting*, which had once been planned as a manual. Eventually it alone was selected for publication. Dürer had abandoned the search for one perfect type. It seemed to him that human limitation was always coupled with vacillations of taste and that the only reasonable aim was to recognize the permanent formal harmony in the changing types. Following this he tabulated the proportions for different human types, which he had established from a great number of actual measurements and extended to the minutest details. This was obviously an immense piece of work which Dürer did not want to lose under any circumstances, since he thought very highly of this method—even if the results were not conclusive. He did not think any progress in German art would be possible without this study of all the measurements of the figure. But to make certain that he would be understood he preceded the work on proportions with a special textbook of descriptive geometry (1525)—an original work in which Dürer satisfied the mathematician in himself. This

mathematical fantasy led him also to the art of fortification, and a treatise on this subject seemed to him of such great contemporary relevance[6] that his work on proportions was once again laid aside, causing the publication of this major work to be held up until the year of his death (1528). Dürer did not see the book in its finished state.

His high estimate of his theoretical works was shared by his contemporaries. Already in the first appreciations of Dürer it was stressed that he had united theory and practice and thus raised German art to a new level. The people who said this, Pirckheimer and Camerarius, were scholars. For us Dürer's importance does not rest in his books, and we may even ask the question whether the theoretician in him did the artist more harm than good. But what is important in the first place is that Dürer had a standard of learning which put him on a level with the most cultivated men of his time. Only through Dürer did the visual artist again become an acknowledged power in the German cultural world. And it must also be said that his speculations on human proportion were not just a personal hobby but were a great preoccupation of the time. They were based on the idea of the natural perfection of man, and this concept was of central significance for the Renaissance.

Dürer died on 6 April 1528, not yet 57 years old. An illness which probably went back to the irregularities of the Netherlandish journey had undermined his strength for years and disfigured him. Now he suddenly collapsed.

We do not have a self-portrait of this last period. No portrait of Dürer in old age balances the great number of youthful self-portraits. The features we remember him by are seen in the highly idealized head in the Munich Pinakothek (Plate 60). It is certainly not a strong likeness but a self-confession which contains all the essential qualities of his nature.[7]

A noble face with the forehead of a thinker, full, sensual lips, which also have significance and intelligence in their movement, eyes more observant than contemplative; ardent and stern—thus Peter Cornelius described Dürer's character.

Background and beginnings

The character of the second half of the fifteenth century is not an elevated one. It lacks a feeling for simplicity and strength. The view of nature suffers from a strangely complicated ideal of beauty, and the feeling for true, profound and great features of human life conflicts disastrously with a certain notion of daintiness and delicacy which swallows up higher ideals. Schongauer is the typical representative of this mannerism. There are single masters, even whole regions, which were able to avoid it, but Schongauer is the most fertile talent of the epoch and gives it its stamp.

Let us try to characterize the spirit of the times more clearly by giving some examples.

There is a series of engravings of Apostles by Schongauer. They are meant to be taken perfectly seriously, but none the less show most disquietingly how for that generation any higher existence was associated with a graceful appearance and how daintiness threatened to become affectation at any moment. Motifs suggesting movement include a discreetly fastidious lifting of garments, an elegant dance-like positioning of the feet, and sometimes an almost coquettish handling of attributes. St James the Less was killed with a kind of club—here he holds the deadly instrument, which rests on the ground, between two fingers and the little finger is delicately raised. A figure like the dragon-slaying St Michael, of whom one expects strength and seriousness, becomes an insignificant, fashionable hero toying with his lance.

The spiritual theme easily becomes playful too: the way the prophets speak, the Baptist points, or the Evangelists make assertions. A shocking example, in a way a caricature of the whole movement, is that of the Apostle Paul 'reading' by the Master W. (Wenzel of Olmütz), which shows St Paul balancing the open book on his arm and trying to attract attention by nimbly stepping forward.

When an Annunciation is represented this art can attain a strange beauty. There is hardly anything more nobly delicate than the Virgin Mary in the small engraving by Schongauer. She draws up her coat a little as she listens to the angel with slightly bent head. In this example this attitude is appropriate but in more imposing situations the atmosphere is not elevated enough.

The great scene of Golgotha becomes weakly tearful. How insignificant is the expression of the suffering compassion of St John in Schongauer's famous three-figure print, with his head to one side and his embarrassed, clasping hands! And how unsatisfactory is the figure of Mary compared with older representations! There are beautiful examples of figures swooning, but whenever an action is intended to be

shown we are disappointed. Is there one Magdalen with a really passionate expression of suffering? We get nothing more than a tender embrace of the cross. The crucified Christ himself is not terrible, not triumphant, but moderately piteous.

All gestures are somewhat diminutive, scanty and miserable, as if strong expression were something to be feared. Such events as the Baptism of Christ, the Ascension of the Virgin, and her Coronation all somehow falter and seem dull in spite of refined gestures. They lack breadth and also that mysterious magnificence which older art had managed to possess without any great show of movement. Whatever one may say for Schongauer his Coronations have none of the ravishing features of Gothic pictures.

In the Ascension there is often just a small doll-like figure kneeling, which is made to rise with effort, and the action of the Baptist is usually insignificant and cramped because of the dense crowding of figures.

We would not deny that some situations are deeply and sincerely felt. Christ's head in Schongauer's large *Christ bearing the Cross* (Plate 4) is very moving, and the crucified Christ bending down to St Bernard in the Augustine altarpiece of 1487 (Nuremberg) is probably the most beautiful rendering of the subject in existence. But it will be admitted that all the beautiful features that can be thought of belong to a confined range of feeling, and the majesty which is still present in the Decker *Entombment* of 1446 in the church of St Aegidius in Nuremberg, for example, can hardly be found. (Any fantastic and extravagantly exaggerated traits of the time found their expression not in painting but in architecture, which was still magnificent. But it was a magnificence beyond life, not a majestic conception of life itself.)

What is also strange is that one finds bare triviality produced unhesitatingly beside the most heartfelt subjects. The artist, wanting to be natural, tries to convey this impression by adding a number of features from everyday life. People eating and drinking are depicted with painstaking precision. There are touching motifs in the pictures of the parting of the Apostles, for instance where they embrace with their averted eyes full of tears in the anonymous picture from Bamberg in the Munich Pinakothek. In the same way no one will take offence at the typical subsidiary motif of one or another disciple quickly filling his cup at the spring, but why does it have to be the principal figure, St Peter, right in the foreground, who feels the need to take a good sip from his flask before setting out to preach the gospel to the peoples? These artists are not concerned with producing a coherent atmosphere. Entirely typical of this period is the incident in the Death of the Virgin when a candle flickers and one of the apostles—who have come from all over the world to assist the Mother of God on her deathbed—circumstantially brings a candle-snuffer into operation (epitaph for Margareta Haller by a Nuremberg master, about 1487, church of the Holy Cross, Nuremberg). Schongauer is more careful in his choice of

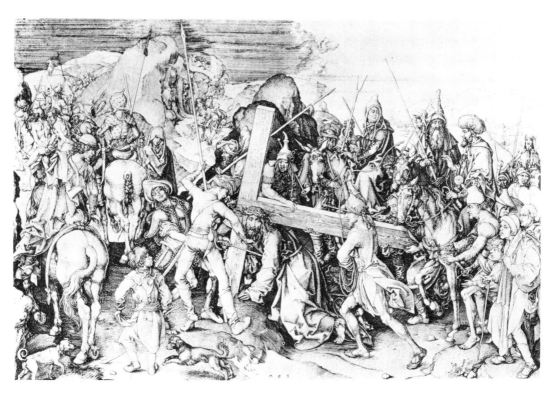

4. Martin Schongauer: *Christ carrying the Cross*. Engraving.

motifs; nevertheless there are incongruous features in his work too. I am thinking of his large engraving of the *Death of the Virgin* and of the apostle who looks into his companion's book and searches along the lines with his pince-nez, which he has taken off. This is a surprisingly life-like motif, but one which a later generation finds distracting and too everyday. It is well known how studded with trivialities the Passion plays were and it is really astonishing that more of this material did not find its way into the visual arts. But one can get one's fill of this taste from a camp-follower, Ratgeb, who in 1517 painted the altarpiece now in the Stuttgart State Gallery. During the Last Supper one of the Disciples blows his nose—with his fingers of course—and Judas throws down the wine-jug, which has to be picked up by the landlord on the instruction of a third Disciple.

The epoch was proud of its naturalism. The painters' search for a head of striking character but convincing realism was their sole aim and we do not progress beyond rather common company. We find multiplicity, but no depth. Human nature is low on the average. Of course there are exceptions. Syrlin for instance created truly imposing heads in the choir-stalls of Ulm Minster. But generally the art of the past provides the best models for types of a higher order, and we will hardly find that the means were available for even an atmosphere which was out of the ordinary. We find no expression of the extraordinary in

39

the features and the general attitude, even in a picture like Schongauer's *St John on Patmos*. And yet this period is not limited to what is merely natural. As already stated, reality borders on refinement, the transcendental. Schongauer, who could grasp a host of everyday characteristics with a firm hand, also transformed reality in the most refined way when drawing idealized figures. This generation had an image of beauty which is hardly of this world at all.

Late Gothic beauty is inconceivable without delicate hands, without long extremities of the body with which to grasp and touch. The fingers spread out like spider's legs. With such hands Mary adores her child, outdoing artificial form by more artificial movement. The fingers must only touch very slightly. The beginnings of this modern delicacy apparently lie in the Netherlands.

Feet are long and narrow and strangely pointed, and to walk beautifully one foot must be set obliquely in front of the other. This step can be found in Schongauer's *Christ in Limbo* as well as in the knightly figures of Syrlin (*Fischkasten* in Ulm, 1483). Its peculiarity is stressed by the bending of both knees which makes the walk appear light and bouncing and almost negates the impression of bodily weight.

The same aim is followed in the shape of the body with its lean limbs. It is hardly to be supposed that thin necks, arms and legs were really a general feature of the people of that time. If that was the case completely different men must suddenly have been born after the year 1500. Before this even a child's body was made to conform to the style with a slender build, no fat above the ankle and a constriction above the knee making the childish figure appear very strange.

The same formal intention has been at work in the pointed shoes, the narrow waist, tight-fitting sleeves, and seamless shoulders. But in addition to this there is a wealth of superfluous, hanging, fluttering, massed materials billowing down to the floor with ruffled many-faceted accumulations of drapery. One must not ask why they are there for they do not represent the imitation of specific materials, but rather the free expression of ornamental fancies. And these fancies have to be taken seriously. The drapery is a part of the ideal nature of the figure. This latest Gothic style tried to emulate what the earlier Gothic wanted—a particular mood evoked by the lines of the draperies.

Its taste is painterly. This does not mean that people were insensitive to line; on the contrary, no generation appreciated more for instance the charm of the branches of leafless trees. But it is also possible to be painterly in the use of lines. The term 'painterly' will always have to be used where the charm of intricate, complicated, seemingly arbitrary effects connected with the impression of unending movement is sought. Artists thought of the human form as having little aesthetic value and believed it gained significance only in conjunction with other forms. In the case of the clothed figures no one asked how the body behind the drapery was to be conceived—in most cases there would have been

no answer anyway; artists concerned themselves with painterly appearances, billowing heights and depths from which appears a head here, a hand or a foot there.

The tabernacle which Adam Krafft made for the church of St Lawrence in Nuremberg can be taken as the quintessence of late Gothic form. Is there another object which continues to stimulate the imagination as this one does? There are no finite shapes, no clear joints: all is transition, each part penetrates the next. The eye is forced to search. Intersecting limbs mask important joints, and the figures hide in deep shadowy caves. This is the least classical product of Germanic soil, horrifying for Italian sensitivity, but a source of unending charm for us.

But it is evident that this painterly imagination is partly responsible for a certain slowness in the development of German art. A feeling for lucidity develops conspicuously late and laboriously. The more artists strove for a rich impression, the more difficult they found it to work out a motif clearly. They became intoxicated with abundance and did not feel vagueness to be any discomfort. Representation was not confined to the plane any more but attempts were made to achieve depth. This is the reason for the abrupt diagonals, entanglements, intersections, and sudden foreshortenings, which make those very pictures disagreeable to us, but which, we still have to acknowledge, express the living throb of the desire for space as something new and important.

The second half of the fifteenth century had lost the comprehensive vision it had had at the beginning. There is much richness of detail but no monumentality. Pleasure is taken in small broken movements of lines, in the fragmentation of planes. It is true that more subtle distinctions are made in drawing now than in the last generation. There are more nuances. Attempts are made to catch even the fleeting moment. One figure may contain two motifs. A draughtsman like the so-called Hausbuch Master develops a true genius for capturing the instantaneous. But the noble ideal which calls for the exercise of restraint has become as rare as strong temperament. I cannot think of anything comparable to the forceful realism of a Konrad Witz. Even those who studied, like he did, the painterly tricks of art of the Netherlands at source fell short of his powerful handling of reality. The eye was distracted all too easily by details and there was a danger of seeing the veins but not the body. There are exceptions but generally the earlier art was the greater. And turning to pictorial lucidity, I think Schongauer was the only one who worked for it consistently. We shall come back to this.

This is the atmosphere in which Dürer grew up. His historic deed was to have broken through to a new attitude and a new perception. No one will be able to say where he got the strength to do so. Even if the whole network were visible and we could see what influences he came under we still would not find an answer because genius cannot be explained

by an addition of influences. He was born a citizen of Nuremberg and served his apprenticeship with Michael Wolgemut.

It has always been said that Nuremberg's leanings are more towards linear than towards painterly art. The most serious attention is given to sculptural, spatial features. In addition to this there is truly a greater tendency to produce characteristic rather than ideal forms. There is a certain objectivity in the Nuremberg mentality which always produces a significant and imposing impression even though it sometimes degenerates into dryness. To pampered Western taste much of it may seem coarse and bourgeois. The graceful plant of Schongauer's art cannot be thought of as being at home in this kind of air. There is a single instance of something which is akin to his mild and subtle spirit—the altarpiece of 1487 from the Augustine church of St Vitus in Nuremberg (Germanisches Nationalmuseum). The frail young Sebastian here is like a brother of Schongauer's *Sebastian* (Plate 34), and the adjoining panels have the same atmosphere. The painting of this time has produced no purer work of art. This altarpiece was done during Dürer's apprenticeship. Thus his attention would have already been drawn towards Schongauer during his first training, though Wolgemut's works really show a very different spirit. However, we must not forget that Dürer still acknowledged Wolgemut as his 'teacher' at a late stage. A personality of a powerful nature is suggested, especially in the portrait of the man when very old which Dürer made in 1516 (Plate 5). Wolgemut's early pictures are surprising in that they aim at a stern and solemn effect, but he seems to have lacked the warmth necessary to bring on a more fruitful development. Robert Vischer calls him 'soberly observant and of almost ill-tempered seriousness'. Maybe it was precisely this element of severity and immediacy which impressed Dürer and which represented a positive value beside even Schongauer. But one should always keep in mind that every attempt to trace Dürer back to the Nuremberg painters' workshops must needs lag behind reality. Think merely of the fact that among Dürer's youthful impressions was the completion of the majestic choir of St Lawrence!

Schongauer has been mentioned from time to time but more as a representative of his generation than with reference to his special qualities. The characteristics of his art which must have been admired were above all the multiplicity and the strength of an individual and also the variety of scenes and the diverse appearance of his figures drawn tightly together. Prints such as the *Death of the Virgin* and the great *Christ bearing the Cross* (Plate 4) have been imitated even by people who had little comprehension of his idealism, and few have understood his pictorial concepts of the necessity to present things in the way the eye most easily perceives them. Schongauer strove towards this aim consistently and from the very beginning. He looked for the simple aspects of a scene, presented straightforward orientations and abandoned foreshortenings to achieve a picture which was as clear as possible. Similar

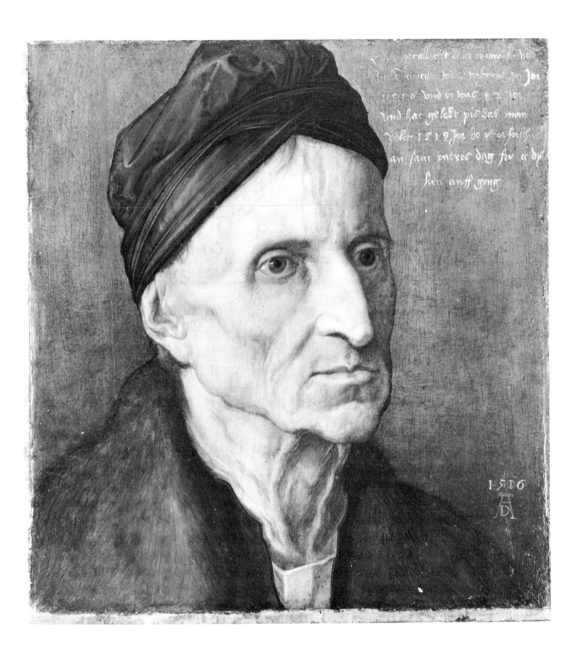

5. *Michael Wolgemut.*
1516. Oil, 29 × 27cm.
Nuremberg,
Germanisches
Nationalmuseum.

works by other artists have to be compared with those by him, like the *St John on Patmos* or the sequence of Apostles by the Master E.S., in order to understand how Schongauer made objects more visible by stressing contours, placing a figure in profile and treating backgrounds as foils.

His scale of highlight and shadow is already very wide and his sheets become clear as well as subtle through the economical use of contrasts of light and dark, dark and light.

His great importance as a draughtsman is also noteworthy. He possessed an astonishing feel for the expressive power of line. How much

43

life there is in his ornamental engravings! Gothic crabs, small chain-serpents, even simple scrolls—they almost move, and creep and coil wonderfully. How well form is worked out in organic growth—the back of a lion, the grasping claw of an eagle! All lines are exaggerated but show a full understanding of essential features. At unstressed points silhouettes are contracted, so that the main accents at points which need emphasis stand out all the more.

But the most important factor is the modelling. In the traditional way a figure is modelled with many short straight strokes which—though not expressive in themselves—taken together make up a shadow and round out the form. Schongauer is the first to draw shadow with long modelling strokes and to try to use these strokes as aids to expression. This is especially important in his drawing of nudes, where he follows the form with his lines and succeeds in giving an indication of the movement of muscles or a greater or lesser surface tension.

The whole art of Dürer is based on this principle of indicating the form with shading lines. In spite of all this the example of Schongauer also had many dangers for an imitator. His taste inclined towards sophistication. His strong feeling for nature was governed by a very one-sided ideal and his perception moved in those extreme regions where refinement touches upon artificiality. In a certain sense it can be said that there was no future for this kind of art. Any continuation was found to become decline, and an example of this is provided by the so-called St Bartholomew Master, who in all probability started off from Schongauer.

For Dürer the great corrective—if he was in need of a great corrective—lay in the lesson of Italian art. He would probably have broken through to a great and powerful art by his own strength, but Mantegna provided a short cut. Mantegna set free the monumental perception and powerful feeling that were inherent in Dürer's nature. But it was not an entirely organic development. What always happens in such cases happened now: the finished model also contained elements which were not understood or intelligible and which could never be entirely resolved in German art.

We have always been so used to art of all kinds that it takes a special effort to imagine the impression Mantegna and Italian art as a whole must have made on an unprepared northerner with a Late Gothic kind of perception. Late in his life Dürer still praised, as the true superiority of the Italians over the Germans, the Italians' knowledge of the nude and of perspective. These are presumably the characteristics which seemed to him the most valuable and desirable from the very beginning. He must have been moved by the 'secure presence' of Mantegna's figures (Goethe). The perfect clarity of the spatial relations was as new to him as the organic, coherent representation of the human body. How these figures stood in space! How their feet rested on the ground and their body's weight made itself felt! And what kind of bodies they were

and how they moved! The human figure was not only differently pro-
portioned, but was also conceived on different lines, with horizontal
divisions which were unknown to the Gothic eye. And movements had
an entirely different rhythm; legs which were free or weight-carrying
were coupled with contrasting shiftings of the upper limbs and ener-
getic turnings of the head. And all this was presented in a monumentally
simple style based on a feeling for magnificence and rising to the
strongest expression of passion, but also heroically transfiguring plain
existence.

If the distinguishing characteristic of artistic sensibility is taken to be
an early awareness of the inexhaustible depth and abundance of objects
in the world, then Dürer's urge to see and represent what he saw can-
not be underestimated. Very soon he must have evolved his own new
concepts of the value of nature and the possibility of rendering it.
Objects in space appealed to him so strongly that he could not be in any
way content with traditional formulae of expression, and he had an in-
sight into individual life which made all previous attempts seem merely
like vague indications.

Of course many of the early works especially have been lost. But
though everything cannot be elucidated in detail we still have enough
evidence to show generally how Dürer's manner developed, how he
responded to the impressions of art and nature, and how he guided his
boat through the whirlpools and cataracts of youth.

With the aid of the self-portraits the whole period can easily be sur-
veyed biographically.

I have already talked of the first one, the boy's drawing of 1484
(Albertina; Plate 1). The next is an undated portrait (Erlangen;
Plate 6), quickly scribbled on to the paper with the pen, and full of
meaning. It shows the youth with his head supported on his hand,
looking into the mirror with a burning eye, an expression of complete
concentration and a mental tension for which prototypes hardly exist.
I would date this most remarkable sheet in the middle of his journeying
years. This is what the young painter must have been like when he
went out into the world and asked himself: 'What do I want?' Com-
pared with this the painting of 1493 (Paris, Louvre; Plate 7) is more
solemn and quiet. The pouting lips and the line of the nose show pert-
ness, but the overall appearance is restrained and almost shy, with a
sideways glance and slightly bent head which recall Raphael's—more
sentimental—youthful portrait. He holds a flower in his hands known
as 'husband's fidelity', and near the upper edge there is the inscription:
My Sach die gat, als es oben schtaht ('My life is determined by what is
written in the stars'). He may have sent the small picture home from
abroad: it is suggested that it was done during his courtship. Finally
there is a portrait in Madrid dated 1498 (Plate II), where the luxury of
his dress and the display of his artfully curled cascading hair show that

the effect of splendour is consciously sought. He is maturely self-assured rather than provocative. The folded hands with their firm grip are significant too. Although this picture is obviously already formed under the influence of Italian portraiture, it must still be taken as a more reliable historical document than the later portraits. The eyes, in contrast to the big godlike eyes of the idealized Munich portrait, are very small. This is how the artist looked when he published the *Apocalypse*.[8]

Dürer obviously took pleasure in his own history. He carefully preserved the documents of his development and later he always put a date

6. *Self-portrait*. About 1491. Pen drawing, 204 × 208mm. Erlangen, Universitätsbibliothek.

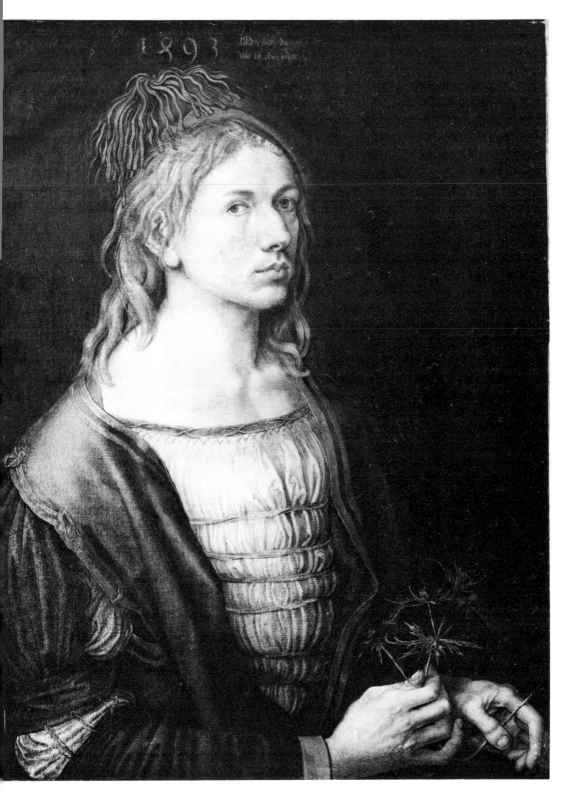

7. *Self-portrait*. 1493. Oil, 56.4 × 44.5cm. Paris, Louvre.

on even minor works. A picture of *The Virgin with angels* (Berlin) bears the date 1485 and thus immediately follows the Albertina self-portrait. Though presumably not entirely original in its invention, the small sheet is nevertheless noteworthy because of its decorative coherence. Then there are pictures of subjects which attract every boy—soldiers, horses, riding cavaliers. Here too there was no lack of prototypes. Contemporary graphic artists liked such subiects. Dürer's are painstaking pen drawings, without the direct utilization of nature. A strongly developed sculptural perception can already be felt.

Before leaving his parents' home in 1490, he painted a portrait of his father (Florence, Uffizi; Plate 8). He wanted to show what he had learnt. Though the mood of the sitter is somewhat self-conscious and the form is still small and somewhat incoherent, the work has yet a strangely radiant effect. A human existence is traced with such precision that Dürer comes to mind immediately, and as the performance of a nineteen-year-old the picture must have astonished the people of Nuremberg. It is of special value for the historian because Dürer himself criticized it later with his second portrait of his father of 1497.[9] It is remarkable how the eyes have not yet been drawn in a precise linear style but retain the more painterly vagueness of the earlier pen drawings.

Dürer's journey took him to the Upper Rhine. We find his track first in a cut woodblock of St Jerome, which has been preserved in Basle and which bears on the back an inscription in Dürer's own hand —Albrecht Dürer from Nuremberg. It was first printed in a book of 1492. Though the cutter of the block has not quite done justice to the original, the considerable quality of the drawing is nevertheless visible. The figure is expressive and the rich, sculptural handling of space and multiplicity of lines modelling the form point to Dürer's hand, even though there is no signature. It seems reasonable to look for similarities in the contemporary production of Basle. Earlier connoisseurs have already suspected that Dürer was the illustrator of the moral tales of the *Knight of Turn* (1493) and Sebastian Brant's *Ship of Fools* (1494). In the same way attention has been drawn to a collection of about 150 partly uncut drawings on wood destined for an edition of Terence which show a similar style. Opinions have varied as to whether a single hand or several members of a workshop can be recognized but on the whole this work seems to have been the responsibility of *one* artist. Compared with the older prints in Basle the difference in style is considerable. Was Dürer this artist? The whole group of drawings does indeed have certain motifs in common with Dürer's work, so that there can be no doubt of some connection, but I think that such isolated parallels should not be taken as proof of his authorship.

However the large drawing of the *Holy Family* in Berlin (Plate 9) is at once convincing. It must have been done about 1492–3. It shows Mary with her child sitting on a grassy bank with Joseph at her side sleeping, his head supported on his hand. She holds a carnation with

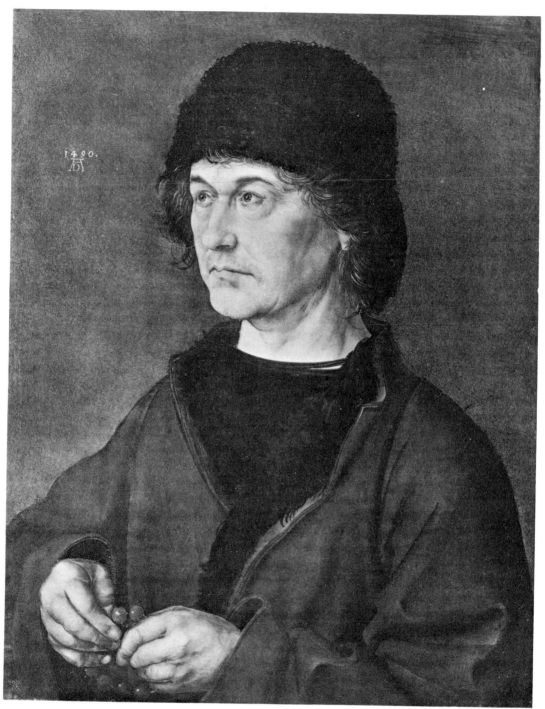

8. *Dürer's father*. 1490. Oil, 123 × 89cm. Florence, Uffizi.

9. *Holy Family*. About 1492/3. Pen drawing, 290 × 214mm. Berlin, Kupferstichkabinett.

a pointed, Gothic gesture. The draperies are rich, though thematically not very interesting. The figure can be compared to Schongauer's picture of the Virgin in Vienna, for it originates from a very similar mood. But Dürer is already clearly different and the mere landscape in its spatial depth and richness goes beyond all of Schongauer's possibilities.

But now we would like to see Dürer taking up more than mere variations of traditional patterns. We would like youthful genius effectively expressed, the utterance of things never said before, so that the most ordinary things give the impression of a new experience.

The Erlangen self-portrait was an utterance of this kind, a momentary expression unexpectedly lit up. Related to this is a standing female nude from the Bonnat collection in Bayonne, dated 1493 and probably done in Basle (Plate 10). It is a drawing from life, quickly set down with

10. *Female nude.* 1493. Pen drawing, 272 × 147mm. Bayonne, Musée Bonnat.

the pen. The drawing shows no calligraphic timidity; it traces the form with many different strokes and in spite of all its imperfections the effect of the motif as a whole is compelling. Also belonging to this context is the drawing of two young riders in Munich. The foremost rider was drawn first, then the one behind him. The happy rendering of instantaneous movement is surprising.

Why are there not more studies after nature of this kind? Even when everything is considered—the landscapes will be dealt with later—the list still remains short. Of course the present number of drawings does not represent what once existed, but we do know that around 1494 Dürer underwent a change. Strange notes were suddenly heard. One after the other a whole sequence of copies after Italian originals was done, making a new world of subjects, and above all a new style. Dürer pounced on these things as if his own salvation was at stake. He copied, not to do something different for once in a while, but because he was convinced that Italy meant a state of grace for him. Figures from nearly all of these copies have been used in Dürer's work.

First of all there is *Orpheus clubbed to death by the Thracian women*. The source is an engraving which, although not preserved in the original, is obviously by Mantegna (there is an old copy after it in Hamburg). Mantegna himself took his model from antiquity.[10] We shall not discuss whether Dürer had any personal interest in the subject but in any case the boldly gesturing women in their distinctive garments and the fallen nude man were motifs which could well kindle a vivid, sculptural imagination. The engraving is not simply copied, but transposed form by form into the language of modelling lines developed by Schongauer, and this is no small achievement. The drawing still appears spiky, the contours are broken into sharp corners, the limbs lack sufficient volume, but the care taken in the execution shows Dürer's pleasure in imitating when he had felt the sculptural qualities of the original.

In the background some bushes have been freely added to the composition, with the leaves drawn in full detail, as they were never done again later. The sheet is dated 1494.

Two copies after Mantegna in the Albertina date from the same year: the Bacchanal and the *Battle of the sea-gods*.

The first is a dry composition, a Bacchanal without drunkenness, but like every Mantegna it contains valuable examples of the rendering of joints and of foreshortening, and Dürer must have been amazed at the naturalism of the fat bodies of old gluttons and low women. How could any characterization of thieves and hangmen by German artists stand up to the abundance of nature in Mantegna? The same applies to the other sheet (Plate 11) with its strong movement and fury of bestial passion, a wild scuffle into which the melodious calm of beautiful female bodies chimes wondrously.

In this copy too Dürer has transposed the simple diagonal hatching

of the original into his own modelling line. And more than that, he has searched everywhere, in vegetable and animal forms, for a more precise and subtle expression. Most characteristic is his elaboration, always with increased linear movement, of the fish-tails, and his rendering of hair, woodwork, and vine branches. He let his feeling for form run free with these things but when drawing the human body he submitted to the Italian model. He took over Mantegna's system of making the shapes within the contours clear, the classical system which meant a complete change in perception for Northern eyes.

The nude was hardly known in the North at all. As far as the figure in motion was concerned people had become accustomed to look for the expression of movement mainly in the lines of the drapery. Dürer literally had to come to grips with the human figure.

Antonio Pollaiuolo seems to have provided another picture of immense importance with his *Rape of the women*. We do not know the original. Without doubt it paraphrases a type of classical sculpture. There are two nude men of Herculean stature, striding out vigorously, each with a young woman on his shoulders. What strength there is in their legs! A similar motif can be found in Schongauer's large *Christ bearing the Cross* (Plate 4), where again someone strides out—one of the executioners, urging Christ on with a rope. Here too there are

11. *Battle of the sea-gods*. 1494. Pen drawing, 292 × 382mm. Vienna, Albertina.

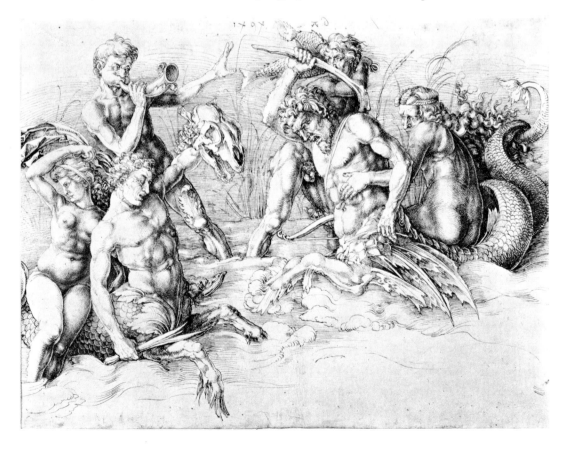

naked legs, but what contrast there is in the drawing! Dürer, not Pollaiuolo, must be held responsible for the exaggerated lumpiness of the muscles.

The problem of the child's figure was tackled in a copy after Lorenzo di Credi of 1495 (Paris). The Italians conceived the child in an entirely different way from the northern Late Gothic artists—as fat and bulging with bloated ankles. We, with our historically trained eyes, may not view such a representation as a particular accomplishment, but for Dürer the matter was less self-evident. The fact that he could observe the foreign form in such an objective manner presupposes a strong command over the eye. In less important features, for example the ears, he let the pen have its accustomed way.

We do not know whether these drawings were made in Germany or Italy. There is nothing to contradict their origin in the north. But there are Italianate subjects of 1495 which could only have been taken up on the spot in the south. Possibly the Lorenzo di Credi already belongs to this group. More important are the Venetian costume studies in the Albertina. Another early sheet, also in the Albertina, showing the *Rape of Europa*, points equally decisively to a stay in Venice. It contains, among other subjects, a drawing of a figure of Apollo copied from antiquity in the Quattrocento, the figure of an oriental, lions' heads, all things which could be seen side by side in Venice. The Rape of Europa has been represented particularly often in woodcuts.

In this field much must have been lost too. The later works still contain a number of Italian motifs for which the intermediate drawing stage cannot be traced any more.

The treasure Dürer brought home was dangerous. We are aware of this most strongly today, when everyone is anxious to preserve the eye's innocence and the sense of intrinsic characteristics. When Dürer starts to incorporate these studies in laborious engravings, taking one figure from here, another from there, one involuntarily asks oneself if this is still a healthy development or if in fact anything worse than this trafficking with foreign prototypes could have happened. The product was of course impure and it is not excused by the fact that Dürer was borne along and protected by a strong general prejudice in favour of Italy. But in fairness it must be said that it was not simply a case of the importation of single Italian figures and specific suggestions of movement but of a basically new feeling towards the human body. This was experienced with an unprecedented strength and comprehensiveness. And not only was an entirely new significance given to the body but the attitude to the whole world had to change too. This development was so radically new that it is easily understandable that Dürer at first stuck to already established form. Through the Italian models his dormant vitality was changed to waking consciousness.

The same holds true for the Italian treatment of perspective. What is important is not the use of geometric principles, nor a single fore-

shortening, be it as difficult as it may. Fundamentally it is a new experience of space, of the meaningful relationship of front to back. Dürer had a natural bent for this too, but the sight of Italian art was decisive. From now on the north shows a new feeling for three-dimensionality, even when the laws of linear perspective were not fully understood.

This is most strongly felt in the few large landscapes which Dürer did at that time along the Brenner route. The main interest for him did not lie in the fantastic silhouette of this mountain landscape, but in the relationships of the large masses and in the spaces they enclosed. The extraordinary quality of these drawings lies in their suggestion of volume. They are not mere instructions as to how the sequence of objects in a landscape should be seen, but immediately convey to the imagination a complete picture of space.

How vast Trent seems! Dürer himself would later have certainly balanced the separate houses and similar objects with the whole, but is a new feeling not produced by the sheer volume of air in this picture? Which German painter would one believe capable of such a commanding vision? And strangely, the region is also seen completely objectively. Gothic draughtsmen normally show an inclination to stylize the mountains by making them higher. But Dürer definitely maintained the just horizontality of this landscape, as anyone can still test on the spot.

Another surprising feature emerges from the original painting (formerly in Bremen)—its astonishing beauty of colour, which seems quite modern in its freshness and abundance. The blue-green shadows of the mountains change on the left into reddish-purple. There is a coloured reflection on the water where it is dark. The trees are blue-green and yellowish, the moving sky whitish-blue (Plate I).

If I am not mistaken the 'nineties show the beginning of a general intensification of a sense of humanity in Germany. Those features which we thought necessary to stress above as characteristic of the second half of the century are not relevant any more for the Nuremberg which Dürer entered on his return. One man, Veit Stoss, was already responsible for that. He returned from the East in 1496 after a long absence and soon pulled wider circles into the whirlwind of his stormy genius. The deliberate Adam Krafft rose to the vitality of his Pergenstorffer tomb (Church of Our Lady) and sought to surpass himself again in the *Landauer coronation* (Church of St Aegidius). And Peter Vischer's restrained monumentality is seen in the early and characteristic examples of the tombs in Magdeburg (1495) and Breslau (1496) cathedrals. This is no philistine and sentimental society. The concept of a higher human dignity is already emerging here and there and the horizon widens to infinity if the intellectuals of learned Nuremberg are taken into account.

Dürer developed very lively and varied activities in this circle from 1495. Actual painting was of secondary importance compared with his

graphic work. He designed the great woodcut sequences of the *Apocalypse* and the *Passion*, altogether new in technique and of astonishing originality in conception. They were popular publications, though he did not conceal that he had seen Italian art. He treated the nude, as the Italians did, in carefully elaborated engravings. He took up the classical histories of the Humanists and joined Italianate figures with romantic landscapes of his own invention into curious combinations. He wanted to be entirely modern and with this in mind he created his monogram, which he kept all his life, in these years—presumably 1496 —out of the Latin letters A and D.

12. *Apocalypse: St John's Vision of Christ and the Seven Candlesticks.* 1498. Woodcut, 395 × 284mm.

The Apocalypse

One has to be sensitive to line to understand the young Dürer. He could confine himself to the mere linear expression of the woodcut, because it could convey perfectly all the essentials of his sensitivity to form. For him the whole visible world transposed itself into linear movement. There is nothing static and indifferently calm. The tree stem winds upwards, the bark encloses it like the arms of an octopus, the grass shoots up from the ground, the juicy leaf curls up and the mound of earth arches visibly in ever renewed motion. Even in the dead stone the forces which were once active and creative seem to become visible. What then must the human form be like? Bodies need not necessarily be in motion, for this new art will always seem to possess a heightened activity and even resting forms will seem to be functional. But understandably real movement is preferable. Men fighting, Samson as lion-killer, the frantic gallop of horses—these are welcome subjects.

Sometimes one would like to describe a drawing as 'boiling', for all the lines undulate so much that nothing at all remains calm and everything, down to the leaves of a book, bends and curls. This is a characteristic which is only to be found in the woodcuts. It does not mean that Dürer's feeling for form is different elsewhere but he only permitted himself strong exaggerations in the woodcut. He thought that the coarse line of the wooden block needed this stylization. This of course immediately ensures great decorative impact but it is not of essential significance. His linearity would not have appeared had it not been preceded by a new and very intensive experience of form. Just as with the young Goethe the sound of every word seems more sensual, so with Dürer line attains a new sensuality, because to his eye form immediately and everywhere gained a more lively significance.

With Schongauer we have the beginnings; here is the fulfilment. Schongauer drew only with the burin: Dürer made even the uncouth line of the woodblock serve his purpose and he is at his most magnificent where he has to express himself in a completely primitive way.

The primary characteristic of Dürer's woodcuts, compared with earlier Nuremberg ones, is their simplicity, for he reduced all appearances to a purely linear expression. In the woodcuts of the *Schatzbehalter* and the chronicle of the world, a fire, an undergrowth or a cloud-bank are shown in a way which is not strictly graphic. Though this technique is restricted, it is still intended to convey the subject in a seemingly painterly way. The individual stroke has little or no importance and only the overall effect of the massed strokes is meant to present the approximate image of the object. But in Dürer's case individual lines already have their own characteristic shape, each has been tested

for its expressive value. The brilliant discovery of his youth was that he could represent by linear means even transitory subjects and evasive form: blown flame, for example, or glittering stars and billowing clouds, those proud clouds with which the young generation sallies forth so splendidly.

The woodcut had always derived its strength from the contour line. Then (probably already under Schongauer's influence) the drawing within these contours was taken up on a larger scale so that forms could be made clear. This meant that the shadows did not just represent darkness but revealed the form by their course and direction. But when it was done, this was in an undecided and uneconomical fashion and the artists hardly ever went beyond shading in short layers. Only with Dürer did modelling by internal drawing emerge in its full significance. His broad streaks and long lines of shadow give emphasis and energy to the figure. The layers now become coherent. Dürer did not constantly and unreasonably change direction but kept natural connections together. He tried to attain a pure harmony in the general movement and his lines have an effect of decorative cohesion. He even took the decorative value of each individual line into account.

This is the basis of that new kind of drawing style in which all linear elements denote form but can at the same time be appreciated as arabesques.

The woodcut originally counted on colour as its obligatory accompaniment. But colour presupposes empty planes. The more the contours were filled with lines, the less appropriate did colour become. Its power had already been shaken before Dürer but he was the first to attain an explicitly painterly and completely satisfying effect in his use of black and white. And yet from the very beginning he renounced the extended areas of black which the older artists liked to incorporate as an enriching motif in their compositions. They used to leave, for example, the shapes of foliage, or ornamental patterns, or most frequently shoes, all black. Dürer saw the woodcut as pure drawing, necessarily homogeneous in all its parts, and because of this he dissolved the mass of black into areas of line, so that even the densest darkness is still transparent.

His scale of light and dark was very much richer and he replaced the archaic, even light effects of the earlier woodcuts with powerful tonal contrasts. For example clouds stand brightly in front of a dark background, a dark sky hangs above a light landscape. These are painterly effects which Schongauer had modestly initiated.

But some people complain of the difficulty of taking in these woodcuts by Dürer. They say that the figures do not stand out clearly enough and that one only finds one's bearings very gradually. This is true, and Dürer himself strove in later years for greater clarity, but on the other hand the modern spectator should realize that in these drawings one should not start with individual figures. Their essential characteristic

lies in the linear and tonal coherence of the whole and not in a single motif. These sheets take their atmosphere from the general linear movement and the rhythmic distribution of light and dark. They must be seen as decorative entities. Just as a relief by Adam Krafft takes its beauty not from this or that figure but from the way the whole plane is dissolved in movement, so a sheet of the *Apocalypse* is always significant as linear decoration besides all the interest of its subject. In this respect it is fundamental that all parts of the plane are evenly filled. Our eyes may well sometimes find their task too difficult. In earlier times complicated things were taken in more easily. This Late Gothic generation already possessed in its architecture a school for vision which we lack.

And there is something else. Dürer divided his planes in an entirely new way. Remembering older books, like the *Schatzbehalter*, one is surprised how much the sheets vary, how the general character changes again and again. This is especially apparent in the contrast of Dürer's freely composed pictures with those which have a prominent structural basis. I am thinking of the great symmetrical arrangements which we find in the *Falling stars* or the *Seven trumpets* and the *Four exterminating angels*. This does not mean that symmetry was unknown before but it appears here with an entirely new force. Dürer had first seen these effects in Italy.

> *I live, for how long I do not know,*
> *I die I know not when,*
> *I travel I know not where,*
> *I am astonished that I am gay.*
>
> SAYING OF 1498

The book of the *Apocalypse*, dark and depressing as it is, was the first important subject on which Dürer tried his strength. The book had an immense significance at that time. There was a general feeling that the end of the world was near. Everyone was prepared to see mysterious omens in natural occurrences and there was a general nervous watchfulness for portents and miracles. We know Dürer himself believed in something of this kind. It is also well known that even Luther believed right to the end that the years of the world had run their course.

And now, people possessed, in the *Apocalypse*, a description of the terrible things which were awaiting mankind. There was an almost insatiable need to make the difficult text visible in pictures.

'Blessed is he that readeth, and they that hear the words of this prophecy, and keep those things which are written therein: for the time is at hand' (Revelation 1: 3). The subject often occurred in illustrated manuscripts. It had been represented in a block-book. The illustration of this paragraph in the German bible which was published in Cologne around 1480 is especially detailed and later, in Luther's first edition of the bible of September 1522, it is in fact the only part illustrated.

Dürer thus started from a tradition. He had known the woodcuts of the Cologne bible since his youth. The publisher Koberger, Dürer's godfather, had edited a Nuremberg illustrated bible in 1493, using the same blocks. But Dürer left his predecessors far behind. Though there are instances in the 'nineties of attempts to concentrate on serious and significant subjects, such a majestic conception is suddenly shown here that it is easy to believe that these drawings of the Apocalypse took hold of people's minds like a storm. Dürer knew he possessed fresh means of expression, but he also had new things to say. And he wanted to speak with an urgency never heard before. Even the format was extraordinary. It was to be the same size as the largest of the blocks made for the magnificent edition of Schedel's *Chronicle of the World*.

Thus fourteen folio sheets were printed and appeared in book form in the first edition of 1498 and in the second of 1511. The text is always printed on the back, at first in German, later (in 1511) also in Latin. For the second edition Dürer drew a title-page with a figure, in which the lettering (*Apocalypsis cum figuris*) is more interesting than the picture of St John writing.

The spectator coming to the illustrations immediately after reading the biblical text will perhaps find that Dürer does not fulfil his expectations, and it is understandable that the written word should have a greater effect on the imagination than the pictures. The text is impressive in a number of ways which cannot be reproduced. It surges and roars, fumes and flames. What is said, is said 'with a voice of thunder' and 'as the lion roars', or we find that 'his voice was like the sound of many waters'; the picture is mute in these cases. In the text, colours play an important part but in the woodcuts even they are absent. The immense and inconceivable products of the Jewish imagination defy all illustration. Even apart from this, many modern spectators will think Dürer too dry, too linear, not visionary enough, believing that the subject demands a different style. It is true that painterly fantasies should not be expected. If one wants to judge the power of the imagination in Dürer's *Apocalypse*, one has to decide to submit to *his* means of expression. And perhaps, to get any idea of how the majestic style of Dürer's line must have once shone like a writing of fire, the original old book should actually be looked at in an old, low parlour.

THE FIRST VISION: a mighty voice speaks and John turns to see who speaks to him, 'and being turned, I saw seven golden candlesticks; and in the midst of the seven candlesticks one ... clothed with a garment down to the foot, and girt about the paps with a golden girdle ... his eyes were as a flame of fire ... and he had in his right hand seven stars; and out of his mouth went a sharp two-edged sword: and his countenance was as the sun shineth in his strength. And when I saw him, I fell at his feet as dead' (Revelation 1: 12–17).

This text is illustrated after a fashion in the woodcut of the Cologne-

Nuremberg picture bible. It shows a seated man (Christ) in the traditional dress, one hand (because of the reversal in printing it has become the left hand) lifted in the gesture of speech and surrounded by stars, with a sword poised in a downward direction from the mouth. The book in the other hand, which is not mentioned in the text, has been taken over from the usual arrangement of the seated Christ in Majesty. The candlesticks form a symmetrical frame, with the seventh behind the head, and the whole is surrounded by frills which in the old art indicated clouds. John is kneeling at the feet of the apparition: he is not shown like one dead.

What has Dürer made out of this subject? Everyone is struck by the force of his new representation (Plate 12)—clouds steaming upwards; seven colossal candlesticks (they can be colossal justifiably, for John sees them first of all), not just distributed on the plane as an ornament, but in real spatial succession; the man seated on the connecting arch with the book and the stars. But how much more imposing is this starred hand! All the fingers, the whole arm, are extended with a sudden thrust, a movement which seems so strong that the flashing up of the stars has to be accepted as a necessary accompaniment. The verticals of the drapery of the sleeves convey a powerful message, which is taken up in the centre by another great linear motif. Every detail is pervaded by a swirling movement: the belt, the curling leaves of the book, show up the extent of this movement. The folds of the upturned sleeves are a splendid example. Dürer represents the monstrous much more literally: the sword really issues from the mouth, the eyes shine like flames of fire, but the overall force is so immense that one is not astonished at what is unbelievable. The head itself seems to go back to a Schongauer type, and also the candlesticks seem to be connected in part with Schongauer's art, though they intermingle fashionable Italian motifs with Late Gothic ones.[11]

Here too John is only a kneeling, praying figure and there is no expression of his having been thrown to the ground by terror. It was not in the spirit of the fifteenth century to represent momentary emotions. Later, a man like Holbein of course did not miss the more vehement representation, just as Christ for example is not shown seated any more but walking towards the Evangelist.

ST JOHN AND THE ELDERS: the second sheet shows the vision of how a door opens in heaven and a man becomes visible, seated inside in the centre, surrounded by the twenty-four elders in white garments on twenty-four chairs. Dürer spreads out a wide, calm landscape at the foot of this heavenly scene. This is a premonition of what he has to do later in the All Saints picture, though the solemnity in this has an entirely different character. The heavenly company sits close together and is not very clearly arranged; the landscape on the other hand already has noteworthy characteristics which give an impression of spatial depth.

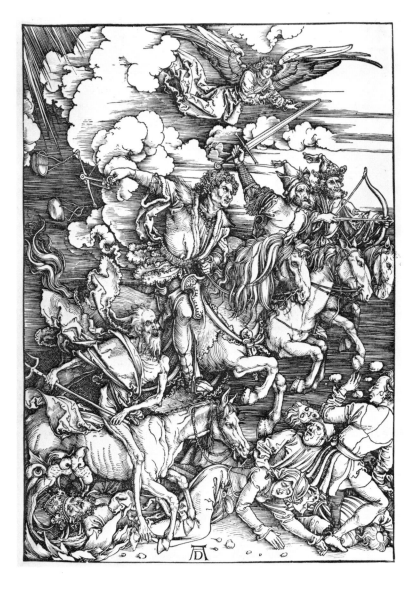

13. *Apocalypse: The
Four Horsemen.*
1498. Woodcut,
394 × 281mm.

THE FOUR HORSEMEN: Dürer used the subject of the four horsemen—
who are given the power to kill a fourth of mankind with sword, with
hunger, with death, and with the beasts of the earth—to make the
famous representation of destruction passing over the earth like a storm
(Plate 13). German art up to then has nothing that can be compared to
this effect of movement. Dürer brought the four figures, who appear
in the text one after the other and had never before been shown as one
group, closely together. He lifted them up in the air and thus gained
a number of corresponding, fantastic movements. At that time he was
not yet entirely capable of representing a horse, let alone a horse in
movement, but he worked with suggestive effects of lines which made
more perfect drawing superfluous. These horses do not gallop equally

well, and in the case of the panting, scrawny horse of Death the laboured movement is even intentional; but the main motif, the rider who leans forward in the saddle and swings the scales in his lifted hand like a hunting whip, has a fine, powerful movement. The animals make big strides; their hind legs are not visible and this greatly adds to the effect.

All four horsemen look into the distance, none at the nearest object. They form a chain which goes through the whole picture and completely crushes everything on the ground. This too is new. In older representations usually only a small heap of people were shown in front of Death.[12] On the lower left is the mouth of Hell, and rays of light are seen in the top left corner. An angel with mighty wings accompanies the group (it is the angel, carrying a crown, who is poised originally over the first horseman); a white cloud rises steeply like a column of dust raised by the strong beat of hooves. But the atmosphere of the sheet is determined above all by the vehement collision of light and shade and the general linear commotion at the edges of the clouds, the fluttering saddle-cloths, garments, manes and tails. There is a trembling and roaring in the air.

THE FALLING STARS: following this is the moment when the earth trembles and the stars fall from the sky, and men hide in the dens and rocks and say to the mountains: 'Fall on us, and hide us . . . for the great day of his wrath is come.' The text provides a gruesome prelude as an introduction, telling how the souls of the martyrs cry for revenge from underneath the altar and how they are given white robes and instructed to wait a while until all are gathered together.

Dürer has taken these two scenes together. If for us the sheet does not have the expected character of elemental catastrophe, this is not due to Dürer's adoption of stark symmetry, but to the fact that we do not now find this symmetry as moving as it was when it was new, new in this kind of application.

At the bottom near the corners there are two groups of people. On one side are emperor, pope and cardinal frightened and sighing, on top of each other; on the other the main figure is a squatting, stooping woman holding her child in front of her and piercing the air with a shrill scream, a desperate forlorn cry of distress. This is the best part of the picture.

The falling stars are darting objects with flaming tails, which appear now on light, now on dark backgrounds and thus really convey the impression of movement.[13]

THE FOUR ANGELS: then comes a contrasting picture of utmost calm, the four angels, who have to hold back the winds from blowing, while the 144,000 chosen ones receive the seal.

Both the guardians and the sealed are shown. In older representations the angels are placed at the outer corners around the congregation of the sealed. Dürer puts them all together and juxtaposes them

boldly and harshly as *one* mass against the others. In this way the picture is split up, and the two parts are so different that the picture is nearly put out of joint. The subject is hardly distinct either: the two main figures lack completely any intelligible relation to the winds or to the angel who brings the commandment. How does this lack of clarity in motifs and arrangement arise? The young Dürer has obviously taken a pleasure in breaking with the old principle of even distribution on the plane and in placing his stresses, intensified to accumulative accents, in an asymmetrical way. But this explanation is not quite sufficient. This sheet shows only too clearly a composition into which finished motifs, taken from different contexts, have been incorporated. At least I would like to maintain positively that the drawing for the principal angel was already finished before Dürer thought of this Apocalyptic scene. He wanted to use it at all costs, and it was a matter of little importance whether it provided what was needed for the story. One knows of analogous cases. This principal figure, a youthful angel with large features and mighty wings, looks like a reminiscence of Mantegna. What is most eloquent is not the mighty head nor the powerful shaggy wings, but the wonderful slow rhythm of the movement as it pervades the body, the immense though restrained pathos of look and gesture. Such a figure shows an entirely new humanity. The same motif has been used for the apostle Paul at the Sebaldus tomb.

The long idealized garment contributes to the free, solemn effect and contrasts strangely with the entirely different handling of the ecclesiastical costume of the companion figure with its warped movement.

Only general suggestions can be made as to how Dürer came upon this Italian figure. At least I have not yet found a precise model, but the Mantegnesque character is obvious. There are female figures in particular by Mantegna which are extremely similar to Dürer's figure —the Magdalen of the altarpiece in the National Gallery, London, for example—and there are even earlier examples. It is possible that the London picture was finished just at the time of Dürer's journey. The long thin pipe-like draperies also have analogies in Mantegna's work; thus there is no need to draw on Venetian examples. One can point to the youth receiving a wreath in Mantegna's *Bacchanal with the vat* for the upward glance and the foreshortening of the head.

THE SEVEN ANGELS RECEIVE THE TRUMPETS: the text now becomes very tense. There was a silence in heaven and then the seven angels standing before God were given seven trumpets and another angel came and filled the censer with fire from the altar and threw it on the earth and there were peals of thunder and flashes of lightning and an earthquake. But this only heralds the terrible devastations which will come when the trumpets give the sign. 'And the seven angels which had the seven trumpets prepared themselves to sound.' They appear like a choir of revenging spirits. And the first blew his trumpet and there followed hail and fire which fell on the earth and a third of the

I. *View of Trent*. About 1495. Watercolour, 237 × 358mm. Formerly Bremen, Kunsthalle.

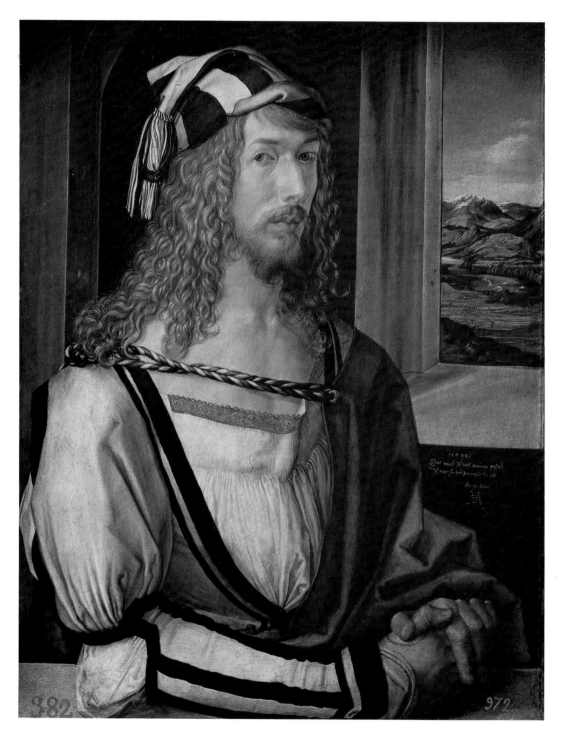

II. *Self-portrait*. 1498. Oil, 52 × 41cm. Madrid, Prado.

trees was burnt up and all green grass. And the second blew his trumpet and a great mountain—burning with fire—was thrown into the sea, and so it continues. And when the fourth angel has blown his trumpet and the measure of terrors seems full, a voice is heard calling 'woe' through the heavens three times over those doomed to experience what the last three trumpets will call forth.

Dürer's sheet does not render the tension of the narrative, because among other things it lacks the ability to represent the sequence of time. The devastations in themselves have no real effect; the angels are not daemonic; they do not appear as one coherent mass, but are scattered in loose symmetry. Moreover Dürer has taken care, when drawing the wings and garments, that each is slightly different, a

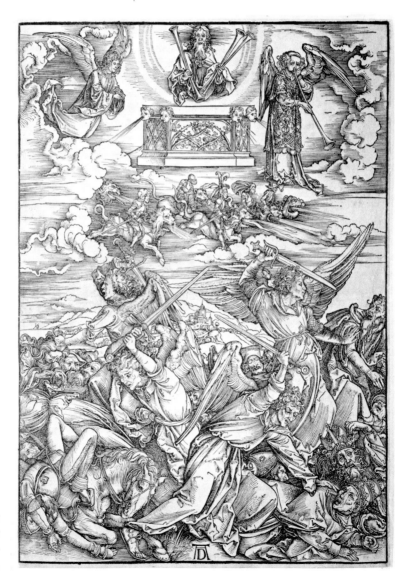

14. *Apocalypse: The Angels from the Euphrates.* 1498. Woodcut, 394 × 284mm.

variety one could have done without. On the other hand, the fluttering garments, a theme which Dürer later treated often and wonderfully, are already a remarkable achievement. And if one looks at the large, powerfully curved wings and the clouds strangely beckoning to each other and surveys the whole picture with its crowded lights and darks and strong, intermingling thrusts of lines, one is moved all the same and has to admit to a feeling of immensity. It is simply that it is not present where one looks first—in the single figure—but only in the combination of all the forms. Smaller reproductions cannot convey the same impression.

A big bird of prey cries 'woe' three times, where Luther's text (less correctly) demands an angel. It is a fine example of the movement of flight.

THE ANGELS FROM THE EUPHRATES: this subject is more to the artist's liking as the destruction is effected by creatures of human form and he does not have to represent mere non-figurative natural occurrences. These are the angels from the Euphrates (Plate 14), who have been ordered to kill a third of mankind. They have been called by the sixth trumpet. (In the clouds is seen the train of the troops of horses with lions' heads and tails like serpents.) The atmosphere of Mantegna's *Battle of the sea-gods* appears intensified in the mighty blows dealt by the four figures. They fill the space (not in one straight line, but diverging towards right and left), their movements are piercingly harsh and they spread ruin around them. Only one of them is visible in full length, but this main figure—who pounces on his victims with the avidity of a beast of prey—surpasses anything known in earlier art in the energy of his action. The intensification of this dynamic element can be measured by comparing it with a figure conceived in a very similar way in the corresponding woodcut of the Cologne bible; this figure with its leg pushed forward straight, however, seeks to give the impression of quick, light movement rather than strength. The mouth, wide open and shouting, is Mantegnesque, as is the general expression of painful seriousness.[14]

The heavenly scene above is somewhat disappointing. The angel blowing the trumpet looks rather too much like an innocent little page-boy.

THE MAN WITH LEGS LIKE PILLARS: here Dürer grapples with the impossible. A strong angel is meant to come down from heaven, wrapped in a cloud and with legs like pillars of fire, and give John a small book to eat. And, it is said, he cried out with a loud voice, like a lion roaring; when he cried, seven thunders sounded. Dürer goes to the extreme: not only does he give the heavenly apparition a garment of cloud frills (in the manner of traditional representations), but he lets him dissolve into the immaterial clouds in the sky. John reaches out for the book with passionate excitement. But however seriously Dürer has treated the subject, however freely he has used the line to represent

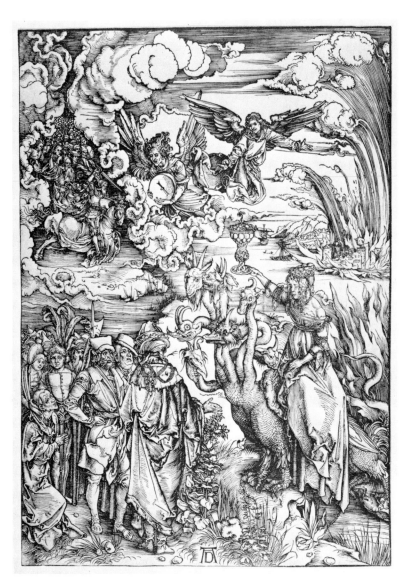

15. *Apocalypse: The Whore of Babylon*. 1497. Woodcut, 394 × 281mm.

the extraordinary, he has not been able to overcome the enormity of the theme, which is virtually impossible to depict.

THE APOCALYPTIC WOMAN: now the story becomes more and more monstrous and tangled. Satan appears in the guise of an animal, as the dragon with seven heads. His tail sweeps down a third of the stars and casts them to the earth. He is confronted with a woman who has the crescent moon under her feet, a crown of stars on her head and is surrounded by shining light. She has given birth to a male child who is caught up to God by the angels, and she is none other than the figure of the Virgin Mary. Earlier and later events are combined in the illustration. The dragon turns against the Virgin and pours water out of his mouth after her to sweep her away with the flood, but the earth

swallows up the water and the Virgin is given wings so that she can fly away.

This is one of Dürer's most splendid fantasies—the unruly animal with its manifold movement which yet gives the effect of unity, the heads, all shaped differently, none of them realistic, but every one convincing and all of them infused with the common character of evil.[15] The dragon appears on three sheets, but it is most imposing here. The pictures have to be taken together in order to understand the development of Dürer's creative power.

THE WHORE OF BABYLON: this is obviously the earliest sheet of the sequence and perhaps even of the whole work (Plate 15). That would probably mean that this particular theme especially attracted the artist. The dragon is still tame, less expressive and on the whole more uniform, though the heads are already differentiated. It is well known that Dürer used a drawing after a Venetian woman done on the spot for the courtesan, the beautiful, alluring woman. His imagination could not have provided him with a more tempting type. The wondering, embarrassed crowd at whom the temptation is directed, is shown in individual characters. One thinks of Signorelli's contemporary representation of the appearance of the Anti-Christ in Orvieto. A monk is the only one who has straightway piously sunk to his knees before the courtesan. But generally the sheet suffers from too many diversions as first works often do: at the top are the angel who announces the fall of Babylon, the burning town, the angel with the millstone, and beside him the horseman 'Faithful and True' with his followers.

THE BEAST WITH HORNS LIKE A LAMB: the middle sheet with the dragon, where the beast appears from behind the mountain and the Lord sits above holding the crescent, is arranged more clearly, though it is also more indifferent.

ST MICHAEL FIGHTING AGAINST THE DRAGON: we have left the historical sequence. There is a battle in heaven (Plate 16) immediately after the first appearance of the dragon: 'Michael and his angels fought against the dragon; and the dragon fought and his angels, and prevailed not; neither was their place found any more in heaven' (Revelation 12: 7). It is a battle in the air: at the bottom a calm sunlit landscape, at the top lights moving to and fro restlessly, writhing, snake-like clouds, terrifying serpents emerging here and there, and right amongst this— effectively placed towards the side—simply the white figure of St Michael in his long gown. With his mighty wings spread wide he has grasped the lance at its upper end with both hands and now, knees bent, thrusts it into the throat of the adversary. This St Michael possesses an immense earnestness. One can feel how he has to concentrate. His movement is not at all vehement but it is extremely intense and quite obliterates the action of his helping companions. The type which was used in the Cologne picture bible is quite similar but Dürer has again dynamically intensified the motif as he did with the angels from

68

the Euphrates. But if on the other hand one thinks of Italian representations of St Michael, as painted by Raphael and Guido Reni—the conqueror lightly speeding along—another aspect emerges which makes Dürer's sheet significant for us: the fight with the Evil One, even if undertaken by an archangel, is felt to be a difficult one.

THE MARTYRS WITH PALMS: this is one of the less effective sheets. The procession which advances from the depth of the picture has no real fluidity and the succession of the twenty-four elders shows a spatial confusion which seems archaic.

THE NEW JERUSALEM: and now comes the end. The Evil One is captured, bound and thrown into the abyss for a thousand years. An angel does this with deliberate speed. There is something fine and light in

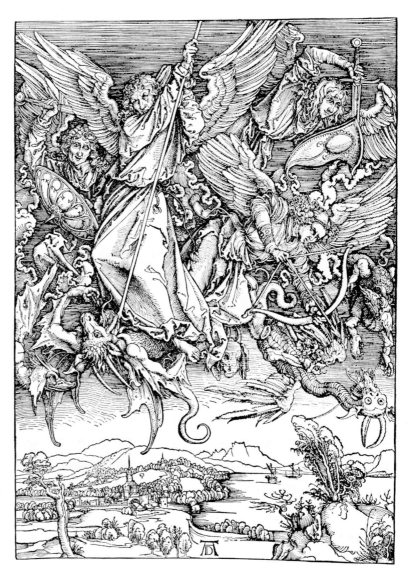

16. *Apocalypse: St Michael fighting against the Dragon.* 1498. Woodcut, 394 × 283mm.

his step as he takes the dragon to the gorge in which he now disappears hissing angrily. The abyss is but a round hole in the ground to be closed off by a lid, just as on the stage.

John stands on the hill-top and an angel shows him the new Jerusalem. This too is done without pathos. It was precisely this kind of simple, strong movement that was new at the time. The arm's horizontal is set off by the three straight, unbroken folds of the gown. The figure of John has been added in a very charming manner, bending forward and moving with gliding Gothic steps.

Following tradition Dürer has added the *Martyrdom of the Apostle* in the cauldron of oil to these scenes of the Apocalypse. It is the first sheet of the sequence and one of the most magnificent. The nude figure of the suffering worshipper with his long locks possesses a Mantegnesque impressiveness. The despot on the throne displays a magnificent splendour and the possibilities of graphic technique are exploited to the full in beard and turban, gown and jewellery.

Though this piece stands at the beginning it must have been one of the very last to be executed. It can be contrasted directly with the *Babylonian Whore* at the other end and the two encompass such a large development that the earlier sheets must go back to more than one year before that of publication, 1498. But even so, a definite connection with the first known woodcut, the *St Jerome* in Basle, cannot be established.

Besides the *Apocalypse* there are a few single sheets of the same large format where Dürer works very freely without being hampered at all by any obstinate subject-matter. They are stylistically related to the more developed drawings of the *Apocalypse*. Some of them deal with great physical movement, others (and they are more numerous) merely represent calm existence which this fluid linear style transfigures into a strange splendour.[16]

None is more splendid than the *Madonna with the hares* (B.102), only one has to see the engraving in its original size and the juicy blackness of a good impression. The Madonna is sitting happily and calmly in the open air, the Child standing in her lap is playing with a book, and behind them Joseph appears deferentially with his hat in his hand. There is nothing at all special in the motif but everything is radiant in this sheet. All the satiated splendour of Dürer's youthful drawing is there. It is true, the body as sculptural form is still immature, but what does this matter? The eye is overcome by the wealth of drapery which is dammed up on the ground in rippling exuberance. The plants with their curled leaves continue this movement, everything breathes the abundance of life, and what a delightful *allegro* concludes the composition at the top in that pair of flying *putti*!

Another sheet, of *Samson* putting his foot on the lion's neck and forcing his mouth open (B.2), is comparable to the exterminating angels of the Euphrates in its nervous energy. It is a subject which had

often been treated earlier but the expression of strength had to be discovered anew. Here too Dürer started with a linear composition (not just the contours), which possesses a certain suggestive power, without making the main motif sculpturally distinct. The pictorial clarity is spoilt because the foot which holds the lion down is not visible: the leg is almost entirely obliterated.

The *Hercules*, with the two men in armour on the ground (B.127), is more satisfactory in this respect although the sheet is certainly earlier. There can no longer be any doubt as to which Hercules story is meant. Hercules executes a frightful punishment on Cacus for the stealing of the cows of Geryon, which he had captured. Caca, who betrayed her brother, is persecuted and slain by a Fury.[17] It looks as if Dürer has used an Italian model for the main figure (the woman with the jaw-bone in the background can surely be traced back to Mantegna) but in the new context the connection with the prostrate man has remained unsatisfactory.

The *Men's bath-house* (B.128) illustrates Dürer's drawing of the nude perfectly. Michelangelo drew his cartoon of bathing soldiers at the same age, with life-size nudes foreshortened and moving in a great variety of ways. Of course nothing like it must be expected here. Men are seen standing, leaning, and sitting, all in simple views. Two figures in the foreground are half-length, one seen from the back, the other from the front. But this very simplicity is astonishing. The bodies are represented with entire clarity, one form calmly balanced against another. One notices how the central figures form a triangle and how the rest softens the rigidity of its structure to give an impression of freedom. This is the result of a conscious intention.

Then there is the strangely energetic conception of the forms. Take the way in which the nude figure with its back to the spectator is shown! Contours and modelling are exaggerated, planes fluctuate—yet this exaggeration was necessary for the drawing to express the whole force of sensuous perception, of the experience of form.

This type was not continued. Dürer considered that the nude was to be reserved for engraving.

The Large Passion

Representations of the Passion are extremely numerous and important in the North. When Dürer wanted to describe the purpose of art, he would speak of two things: the retention of the image of man beyond his death—the very ancient glory of visual art—and the capacity to represent the Passion of Our Lord.[18] How inconceivable such an opinion would have been in Venice or Florence! But it is true; even today one meets the monuments of the Passion everywhere in Nuremberg, in the churches and the streets, here the Man of Sorrows, there Christ crucified, the Agony in the Garden or Christ carrying the Cross. People felt a need to experience the sequence of these situations, to visualize every hour of the great drama of suffering. The mind of the people yearned for subjects which moved them. The torturers could not be portrayed too cruel, nor Christ and his mother too pitiable. The Passion plays went even further than the visual arts in this respect. Leaving the biblical text, they tried to exhaust all the depths of compassion and on the other hand to sharpen the hatred against the Jewish executioners by long and cruel descriptions of Christ's suffering. If burlesque elements entered in too, they could almost be experienced as relief, as an act of self-preservation demanded by the sound instinct of the people.

The visual arts, as I have already said, have an atmosphere different from the tone of the Passion plays, but an inclination towards the sentimental, an exaggeration of cruelty, will nevertheless be noticed throughout the fifteenth century. The task of graphic art was to provide pictorial books of devotion for the home, and this is the basis from which the most beautiful cycle of the Passion before Dürer arose, namely the sequence of engravings by Martin Schongauer. He is not always profound but he clearly intended to supersede low and trivial elements by more noble representations and he excelled in his composition of the scenes—the particular concern of the artist. In order to judge Dürer's *Passion*, a comparison with Schongauer is absolutely necessary.

The beginnings of Dürer's *Large Woodcut Passion* go back far into the time of his work on the *Apocalypse*. None the less the series remained incomplete; it was supplemented with four compositions only long after the second Italian journey of 1510 and published in the following year. The title-page was added then too.

The difference in style between the earlier and later sheets is very marked and applies both to design and execution, so that it is impossible to maintain that the sheets were left and merely cut later in a new manner.

As a young man Dürer chose the most emotional scenes: the *Agony in the Garden*, the *Ecce Homo*, *Christ carrying the Cross*, the *Crucifixion*, the *Lamentation* and *Entombment*. The agitated *Flagellation* is early too. On the other hand the *Last Supper*, *Christ taken by the Jews*, the *Resurrection* and the *Descent into Limbo* were done later. They are episodes which are rendered rather superficially, and in which Dürer relied on the effect of his Italian compositional systems and general painterly approach. We shall come back to this elsewhere.

The seven older sheets, with which I shall deal exclusively for the moment, do not differ from the *Apocalypse* so far as drawing is concerned, but because of the theme the surprising compositions of the Apocalyptic visions are absent. Though of the same format, the whole

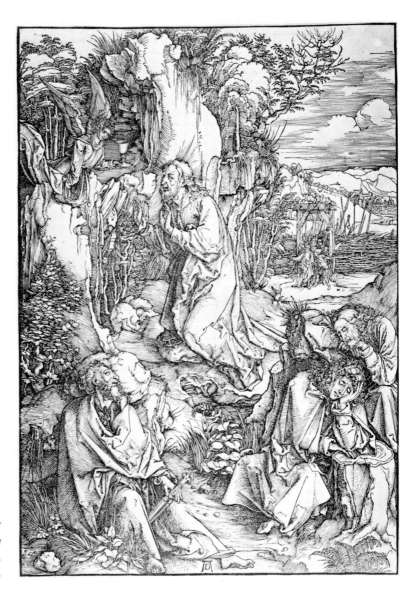

17. *Large Woodcut Passion: The Agony in the Garden.* 1497. 387 × 277mm.

series is uniformly dominated by large-scale figures. This produces a different impression from the start, and it can also be clearly seen how the figures try to free themselves from the painterly entanglement of lines to attain sculptural distinctness and independent sculptural value.

THE AGONY IN THE GARDEN: Dürer has treated this subject extraordinarily often and has successfully conveyed its most widely varying moods (Plate 17). There are two basic possibilities inherent in the subject: Christ's fear, which can rise to a loud cry, can be represented, or his submission: 'yet not what I will but what thou wilt.' In this picture fear is still prominent. As plainly as words the gesture of the hands says: 'All things are possible to thee; remove this cup from me. . . .' The block-cutter's coarse knife has not left much of the expression of the head, but none the less the figure is urgent and moving. Schongauer hardly went beyond an indication of mere praying.

On the whole Dürer has kept the traditional pattern: the rock on the left against which Christ kneels, the vista on the right where Judas and the soldiers are seen approaching in the distance, the three Disciples in the foreground. The difficulty of the Gethsemane composition lies in this last feature, and let us say straight away that Dürer and all artists tend to make the Disciples more and more insignificant. They are not meant to attract the eye too much. They are seen together more or less as one mass, or they conform to the movement of the terrain, or their three faces are not all shown, or they are placed in the shade, so that our minds are not distracted from the main event. Dürer is still archaic in his composition, in that all three of his Disciples, though shown in awkward views, are completely visible and of equal importance. They merely sit and rest their heads on their hands; the onlooker is meant to notice that they have been *surprised* by sleep. They are not grossly asleep on their stomachs as had sometimes been shown in earlier art, but neither do their gestures show the relaxed attitudes of sleep. And that moving expression of grief which was later achieved by Dürer does not even seem to have been attempted.

Another archaic element is the wealth of natural detail. Even the face of the rock with its brushwood shows an infinite abundance of forms: rock splitting into small plateaus, heavily weathered and frayed. These are characteristics which also appear in Dürer's early engravings and they are even more appropriate there, for Dürer's rocks all have a metallic ring.

THE FLAGELLATION: this is a scene with great physical movement and as such has always been valued by artists. The men beating are usually more interesting than those being beaten. Unfortunately Dürer's sheet has none of Schongauer's visual distinctness; it is very difficult to look at as everything is interlocked. (Who notices the two steps which cross the space behind the pillar?) But the individual motifs are simple and in parts go far beyond Schongauer in strength. There is a man who sits on the floor, plants his feet firmly against the pillar and with both hands

holds on to the rope with which Christ has been bound—arms like this had not been drawn in Germany before. He may well be picked out as the best figure in the picture. The man opposite, who binds the birch, seems more contrived simply because he is shown as a purely two-dimensional figure in *one* plane. But it is important that Dürer's archaic style can be identified here, the healthy archaism that first of all reduces difficult things to their most simple expression. Further examples of this are the two figures flagellating Christ. Christ himself is like an Italian nude—no more a graceful Late Gothic figure, but a strong, muscular body, shaped according to Italian tradition in its movement and details. The head is badly spoilt. The motif of the man tearing Christ's hair would have been left out had it been a later work.

ECCE HOMO: the one suffering man and the pitiless crowd are juxtaposed. Schongauer had clearly contrasted the two parties, profile against profile so to say. Dürer wanted to be more interesting in his perspective, more striking in his spatial arrangement, and therefore he set the line of the court-house with the steps on which Christ stands at an oblique angle to the spectator. This introduced an element of unrest into the scene which is dangerous to the main effect, even if the perspective is 'correct'.[19]

The figure of Christ is distinct and expressive, 'pitiable', as the situation demands, though compared with Schongauer's it is more restrained and dignified. His step still has a Late Gothic gracefulness. Secondary figures, decoration and dark background combine in a rich unity. This is not matched by the crowd at the bottom. It has no will. It was still a long time before the mood of a crowd could be portrayed by art. Holbein, in his *Ecce Homo*, has given the impression of the crowd with very few elements in such a masterly way that one seems to hear the roar of voices. And Schongauer had already gone further than Dürer. In Dürer's print the few people seem to be distinctly isolated and they are feeble spokesmen (the strange Late Gothic gait of the foremost figure is characteristically confusing). The most telling is the soldier looking on with his lance by his side, a representation which was advanced for the time. It was used in a similar way in an engraving—the early sheet of the so-called Six Soldiers.

CHRIST CARRYING THE CROSS: Dürer here (Plate 18) competes with Schongauer's most famous engraving, the master's great individual work, a clear, fluent composition of astonishing wealth (Plate 4). The new art's advantages and disadvantages are particularly obvious here. Dürer does not have Schongauer's fluency. His procession is standing still. It seems to be made up of single figures. The menials who pushed and shoved in Schongauer's engraving are replaced here by the standing figure of a soldier turning round with the beautiful pose of an extra in a play.[20] But it is true that Schongauer could not have created such a figure, standing so firmly on the earth, with straight knee and taut calf muscles. This is a manifestation of the new style. New styles have

always a disintegrating effect at first; they are understood only par-
tially, interest is concentrated on details and the sense of the whole
becomes weaker. As far as his main figure was concerned Dürer felt the
need to stress the expression of suffering more strongly and to explain
the body more fully in terms of its mechanical function. Schongauer's
Christ does not carry a weight; only Dürer shows the fully stretched
supporting arm. The second hand seems to have been entirely lost in
Schongauer's picture; it is only after a long search that one finds a few
fingers somewhere below. Dürer makes the arm reach up and visibly
clasp the cross-bar. But this solution is not yet perfect, for the motif
is not suggested in the figure and thus is easily overlooked. The treat-
ment of the head is the most effective. It is important for the expression

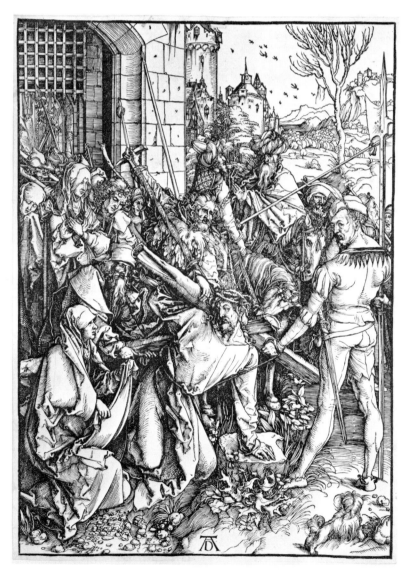

18. *Large Woodcut
Passion: Christ
carrying the Cross.*
1498. 389 × 282mm.

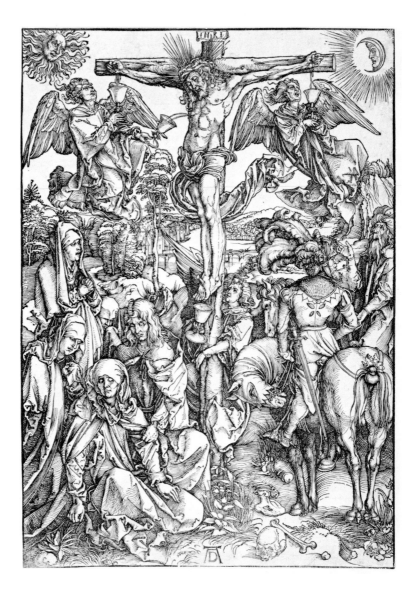

that its turning does not seem easy and momentary but painful and difficult. In Schongauer's case one can only guess that the neck joints move, but Dürer's representation starts at this very point and so makes it possible to tell what is happening. But this too is only a beginning. Only later does he find a final solution, making Christ look over his supporting arm's hunched-up shoulder. He is shown in this way in the *Small Woodcut Passion.*

THE CRUCIFIXION: this is a piece with a feeling of majesty about it (Plate 19). The eye is attracted first to the Madonna. One remembers how she is shown in older representations, collapsing in a swoon with her friends coming to help her. Here she has already collapsed; but only physically, not spiritually. It can be seen how she has slipped to

the ground but still wants to keep up her self-control. She cannot look any more, her eyes are closed, but the way she holds her head and moves her hands shows that she resists her weakness to the utmost. With one step the sentimentality of the fifteenth century has been left far behind. The accompanying figures show the disparity of ordinary mankind. John shows the usual helplessness. Neither does the Magdalen, the only standing figure, raise her eyes to the face of the crucified Christ.

Christ's body is stretched in a way which was occasionally represented earlier, in contrast to another version which aimed more at compassion, showing a broken body, bent especially at the knees. It would be wrong to interpret this by referring to the motif in the Passion plays of the cruel stretching of Our Lord's limbs to reach the ready-bored nail-holes with his arms and feet. On the contrary, the treatment has something triumphant about it. Arms and legs are stretched tautly but this stretching seems to be a manifestation of strength. Even the splendidly fluttering banner of the loin-cloth is appropriate to the mood.

The suffering only reappears as pity in the angels, who fly around the cross with beating wings and gather up the blood from the wounds. They are more developed versions of the angels of the *Apocalypse* who did not yet have this powerful motion. How dainty and insignificant are the same angels in Schongauer! Two horsemen balance the family of Christ on the other side of the cross. The captain sits in the saddle with his leg stiffly stretched out. His overflowing plume is characteristic of Dürer's feeling for form at the time, as is the full-blooded, sweeping drawing of the horse tossing its head restlessly.

THE LAMENTATION: the corpse has been taken down from the cross and has been put on the ground: John supports it so that the head does not fall back, and Mary and the women are allowed to keep Christ near them like this for a short time (Plate 20). This is a theme which only became really popular in Germany in the sixteenth century (it is remarkable that Dürer never took up the more widely known type of the Madonna with her dead Son in her lap); in Italy it had always been common, and the arrangement of the group, nuances and contrasts of expression were developed early. Dürer's intention to order the figures in a structural, regular way in the Italian manner is distinct and is meant to be noticed as something out of the ordinary. The beautiful standing figure of the Magdalen with her hands in prayer, who is taken over from the Crucifixion, forms the crowning termination: it is restrained in mood as in contour. Beside her can be seen loud lamentation, arms thrown up (reminiscent of Mantegna), and also forcibly suppressed grief in the woman who sits at the side and grasps her raised knee with her hands, a popular gesture which is absent in later works but which is already present in Schongauer; only the lively turning of the head is new. The Italians first showed German art how to make use of the joints of the human body. The Madonna herself raises the hand of the corpse so that it rests securely and tenderly on its support. She

78

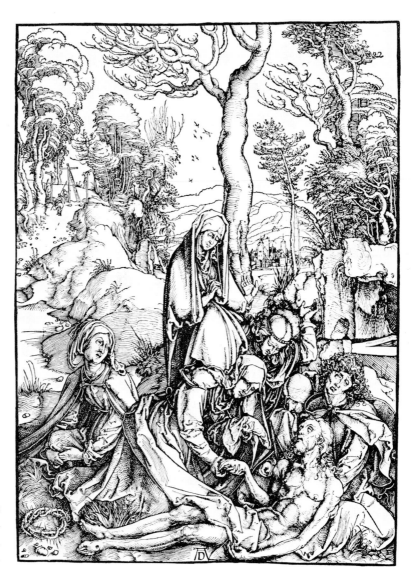

seems about to dry the wound (or her eyes?) with her shawl.[21] Christ's
other hand lies on the ground with fingers cramped. Dürer must have
afterwards found this motif crude and it is not repeated in any of the
later versions of the Lamentation. The drawing is truly heartfelt, as is
noticeable even in the partly-cut very unsatisfactory woodcut. But the
classic indicators of suffering, such as the pushed-up shoulder and the
head fallen back, are still missing. This is more the picture of a man
who is tired and sick than one who has died under immense suffering.

 The painting of the *Lamentation* in Munich, which is best men-
tioned in this context, already uses sharpened means of expression in
the lines of head and shoulders, but the crossed legs are somewhat
coarse and the intersection of the chest by the raised arm would also

have been avoided by Dürer at a later stage as it destroys the calm and solemn appearance of the body. The group's triangular structure is the same as in the composition of the woodcut.[22] The position of Christ is stabilized by the groups of donors in the lower corners, and the harsh, dry colouring strongly accents the corners. The picture must have been painted soon after 1500.

THE ENTOMBMENT: the North preferred the subject of the Entombment to that of the Lamentation, meaning literally the laying of the corpse in the sarcophagus, the farewell to the beloved dead at the tomb, a scene daily paralleled in real life.

Nuremberg possessed a very recent and excellent representation of this kind in the large relief by Adam Krafft on the outside of the church of St Sebald. It shows the unforgettable episode of Mary Magdalen throwing herself down to snatch a last kiss from the corpse, which is being lowered into the tomb. Dürer does not show the entombment proper, but the lifting or rather the carrying of the corpse, namely the very moment that Mantegna had illustrated in a famous woodcut. Three men do the carrying and the procession starts to move. It is astonishing how badly the undertaking is represented: the body is split up and the mechanical operation is hardly intelligible. It is a very early work, as is clear also from the drawing technique.

The figure of the Madonna gives the sheet its life. She is magnificently conceived and is probably even superior to the Madonna of the Crucifixion. She sits on the ground completely paralysed, incapable even of turning her head towards what is going on. She looks dimly in front of her, her hands completely lifeless, and yet her bearing has retained a certain majesty.

It is understandable that these large sheets showing the Passion did not become really popular. There *are* popular figures in them, like the Christ in the *Ecce Homo*. Also the severity of the *Agony in the Garden* or the moving upward glance of *Christ carrying the Cross* must have made a strong impression generally, but it is questionable whether the heroic element in the figure of the Madonna was immediately understood. On the whole it may be said that the work is somewhat uneven, it moves in different directions and the formal and thematic interests are not always at one. In any case it did not originate from an equable feeling for the Passion. And Dürer did not linger over details, which is another drawback as far as popularity is concerned. A series of situations are missing which must have been especially dear to the feeling of the time and which were treated at length in the Passion plays—the nailing to the cross, the soldiers throwing dice at the foot of the cross, the crowning with thorns, the questionings after the arrest, and suchlike. The young Dürer was obviously not interested in narrative; his imagination rather took hold of large single figures or ingeniously composed groups.

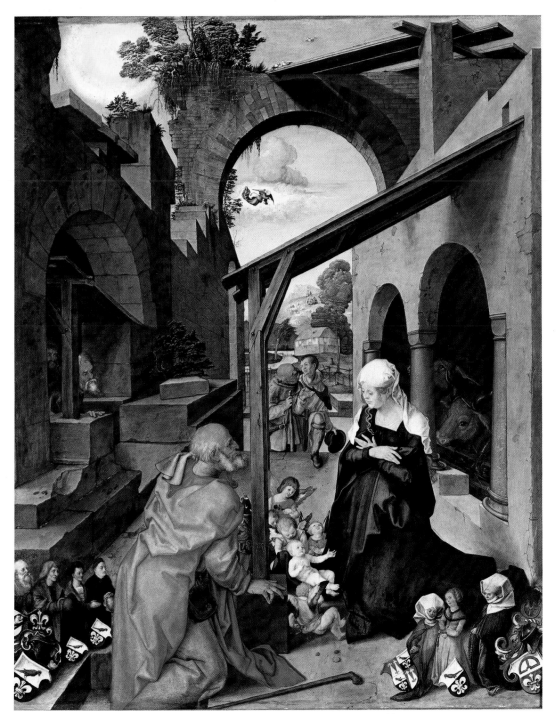

III. *Paumgärtner Altarpiece: The Nativity* (centre panel). About 1500. Oil, 157 × 126cm. Munich, Alte Pinakothek.

IV. *(overleaf) Pond in the woods.* About 1495/7. Watercolour and body-colour, 262 × 374mm. London, British Museum.

This was to change. Around the year 1504 he drew a new sequence of the Passion, which is different in style and attitude. It is the series which we know under the name of the *Green Passion*, twelve pen drawings on green paper, heightened with white, with a definite tendency towards a painterly effect (Plates 21, 75). *Christ taken by the Jews* already gives something of the impression of a night scene (Albertina).

Dürer became more communicative now. He produced exactly those scenes which were claimed above to be the ones liked by the public. And his treatment was detailed, showing not only a lot of architecture,

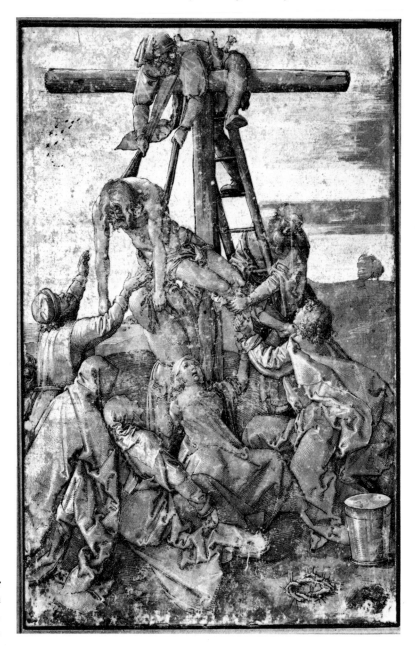

21. *Green Passion: The Deposition.* 1504. Pen drawing, 282 × 180mm. Vienna, Albertina.

halls, portals and stairs, but also many people. In the *Ecce Homo* scene he drew the medley of Jews and soldiers in the lane, and Christ only appears as a small figure high above. In the scene of the *Crucifixion* the angels disappear but the rabble of soldiers can be seen. The scene of Christ carrying the Cross now shows energy and surging movement, and the standing soldier holding a lance has been replaced by a character figure in the old sense. (The transition from the old to this new Passion can be observed very well in the *Flagellation* of '1502' in the Veste Coburg.)

But the fact that the conception is less elevated must not be overlooked. One need only follow the figure of the Madonna through the stories. The tone is nowhere pitched in a lofty key, so that the traditional fame of this series (which it has had since Sandrart) could well diminish. What is a real advance is the growing clarity of the drawing and the richer rendering of single figures, as well as the whole picture. In spite of the multitude of figures the composition can be grasped more easily, space has been made more visible. Dürer has become calmer, he avoids the crowded abundance of lines of the older compositions, he separates the figures, gives them breathing space and draws contours with smoother strokes. The motifs are more clearly developed, yet the older figures are surpassed in richness; the figure of Christ carrying the Cross is an example of the first case, the man who binds the birch in the Flagellation of the second.

The way the situations are generally treated will be more easily assessed elsewhere, in connection with the later Passions. Finally I should only like to mention one woodcut, the *Calvary* (B.59), which belongs to the time of the *Green Passion* and shows very clearly the tendency towards the representation of an event with many participants.[23] This is the same pictorial atmosphere as that which saw the emergence of the *Life of the Virgin*.

The Life of the Virgin

We enter the ordinary world. The monstrous apparitions of the Apocalypse are left behind, the great tension of the Passion disappears. The *Life of the Virgin* (Plates 22–27) is a friendly, graceful story, even though it does not by-pass tragedy entirely. It is a story which is narrated at length, it lingers comfortably, and it takes an obvious pleasure in description for its own sake. Reality asserted itself; for once Dürer wanted to explore the diffuseness of the world. A multitude of the different types of people appear on the stage rather than single heroes, and there is a great variety of buildings: foreign-looking halls, the forecourt of the temple, huts and castle courts, vaults like ruins and strange interiors. Landscapes as well, with a wealth of objects close by and serene distances: fantastic, foreign elements side by side with local ones. The same mixture is found again in the costumes.

This is the same kind of inconsistent realism which rules in the Italian Quattrocento. People do not want to see everyday reality but something which transcends it in splendour and strangeness. The famous lying-in room is correct in all details and yet as a whole it does not correspond to reality. It would be very wrong to think that Dürer wanted to tell the life of the Virgin in a German way. On the contrary, he had a far greater foreign bias than any of his predecessors. The Annunciation takes place in a hall which consciously forestalls any thought of familiar rooms. The angel is an Italian angel, not the long-familiar chorister. The town in *Christ taking leave of his Mother* (Plate 27) is a curious structure designed to take the imagination far, far away. And yet, when Dürer drew the marriage of the Virgin, and Mary's bridesmaids, he fell back again on things most familiar to him and showed the latest Nuremberg fashions.

His formal taste had developed towards the refined and the graceful. If one wants to see the difference between this and earlier works clearly, one has to compare the trees here with those of the Passion, seeing how he now perfects the silhouettes, follows every line of the twigs and even takes pleasure in the broken branch hanging down shrivelled. The same is true of the way in which costume and drapery, architectural and ornamental motifs, angels' wings, trellis-work, wickerwork baskets and so on are drawn.

The old, generous woodcut becomes refined. The lines become more delicate, the intervals shorter, the hatchings end in dots towards the light patches.

The technique keeps close to pen-drawing, which at the same time becomes crystal clear and sparkling, and ripples over the planes with most dainty lines.[24] It is normally pejorative to call a drawing

calligraphic but in this case the term must be used in the positive sense. The strokes are full of feeling for form and yet retain their decorative beauty.

Intention and execution are, however, still far from being united; one still has to add much of the intended effect oneself, but one senses the change nevertheless—all at once the German woodcut has become rich and subtle and graceful.

And this goes together with a new stress on tonality; a feeling for the gradations of light is born. When the background opens out into depth and reveals a second space, it is now done with a painterly consciousness. One knows that a fascinating world lies hidden in the relationships of light and dark. The view into a dark church interior, into a dusky wood, are problems which Dürer is already dealing with here. And all the compositions, when compared with the older sequences, have a new character in that light and shade are exploited consciously.

Another characteristic is a more varied way of combining figures and spaces. The middle-ground is developed. Large figures are seen together with others made small by perspective. The way in which a picture starts off with an intersection in the foreground is new. The views of the single figure are richer, though the Passion drawn in 1504 has more foreshortenings.

The high spirits with which Dürer applied himself to such experiments may have originated in the sense of security which he gained from his new knowledge of linear perspective. He had already known in about 1496 that there was one vanishing point: the interior of the *Women's bath-house* must surely be constructed in accordance with this knowledge.[25] But the result was still unsatisfactory. Did he recognize that the fault lay in the lack of connection between figures and space? He does not seem to have trusted the message, but gave himself up again and again to irrational guesswork. Only after 1500 did his perspective vision with a fixed vanishing point become consolidated. We do not know whether Jacopo de' Barbari was a help. The perspective drawings of the Frenchman Viator (Jean Pélerin) of 1505, from which the interior of the *Presentation in the Temple* was once thought to have been derived, cannot be considered a source for the *Life of the Virgin*; on the contrary Viator was influenced by Dürer.

In the *Life of the Virgin* too the interests of subject-matter and form meet without always integrating. To me it does not seem appropriate to praise the incomparable, sincere quality of this creation: some sheets are really very indifferent (the *Presentation of the Virgin in the Temple*, for example, the *Circumcision*, and the *Presentation of Christ in the Temple*). And Dürer takes the opportunity everywhere to go beyond the framework of the story with minor figures and other ingredients. But the whole makes a friendly impression and glistens with pictorial delights; and in one instance—in the scene of *Christ taking leave of his*

Mother—the emotional tone is as elevated as in the most magnificent scenes of the early works.

The date 1504 which is found on the sheet of *Joachim and Anne meeting at the Golden Gate* must really be taken to mark a date in the middle rather than the beginning or end. It is certain that a number of sheets were only done in 1505, although the beginnings may well go back to the first years of the century. The scene of *Christ taking leave of his Mother*, which stands out, was presumably drawn shortly before the great Italian journey around 1505,[26] and the essentially different pictures of the *Death of the Virgin* and the *Coronation in Heaven* were added very late, in 1510. The completed cycle of the Life of the Virgin, which was given a frontispiece also, was published in book form in 1511, as was the Passion.[27] An Augustinian monk, Schwalbe (Chelidonius), made dull Latin verses to accompany the individual pictures and also provided the poetical text for the Passion.

THE REJECTION OF JOACHIM'S SACRIFICE: the first sheet is already characteristic of the spirit of the whole narrative. The event is embedded in varied surroundings; besides the main characters there is a many-headed crowd and the setting attracts the eye nearly as much as the action itself. The spectator is meant to look at the subject for a long time. The figures possess such an abundance of individual, characteristic life that the whole cannot be fully effective. The childless Joachim, whose lamb is pushed back to him by the priest and who moves forward hastily with the peculiar Late Gothic step, looks very miserable. The other man who offers a sacrifice is strong and dull like a bull and provides a marked contrast to Joachim. The woman who presses her hands together at this embarrassing scene and the reflex of pity in the neighbour are truly Düreresque motifs. The wall in the background has a high arched opening, providing views into darker interiors, and the intersecting and partially obliterating elements—the hanging lamp and the curtains—are made use of in a decidedly painterly sense. The masonry too is shown in a picturesque, weatherworn state.

JOACHIM RECEIVES THE PROMISE: Joachim has sadly gone out into the lonely country to his shepherds and there the angel brings him the good tidings that a child shall be born to him.

The lively contrasts of light and shade give this sheet a particularly animated atmosphere. The angel who comes flying down with his scroll is a light figure set against the dark edge of a wood, and as Joachim advances towards him a lively interaction of light and dark comes into play. His eyes and hands are raised and he is about to sink to his knees. A bright, shining middle-ground has been added and the perspective suddenly jumps, putting the small figures of the astonished shepherds side by side with the large ones. The lines of garments and trees also show particular grace and serenity.

THE MEETING OF JOACHIM AND ANNE: this sheet, dated 1504, shows the embrace at the gate of husband and wife, who have both received

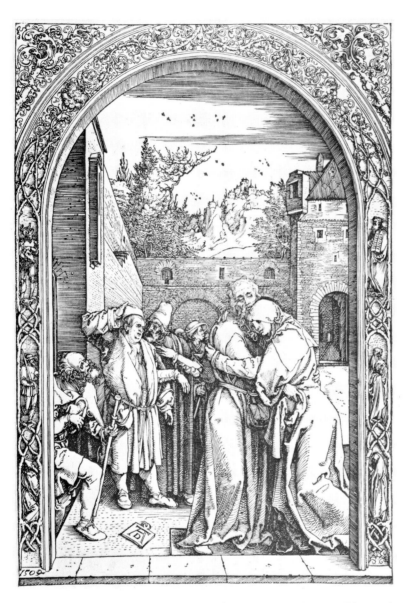

22. *Life of the Virgin:*
The Meeting of
Joachim and Anne.
1504. Woodcut,
298 × 210mm.

the same promise, and it has a truly great, restrained beauty (Plate 22).
(Carpaccio has repeated the motif on a large scale: Venice, Academy.)
She lays her head on his chest, and their hurried approach is still
evident in the embrace. The group stands at the very edge of the picture.
A farmer who, hat in hand, is following his master speedily, indicates
the direction in which Joachim's movement is to be completed. Here
too is a crowd commenting on the proceedings. The small figures bind
the large ones together and the chain has such coherence that one takes
the framing arch almost as an artistic consequence, as a final summing
up.[28] The relatively dark frame also strengthens the brightness of the
picture and makes it somehow sunny. The fine tonal effect of the
masonry of the background should be noted especially.

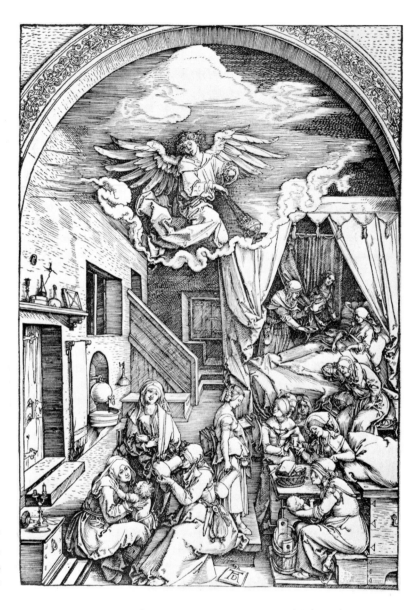

23. *Life of the Virgin:*
The Birth of the Virgin.
1504/5. Woodcut,
297 × 210mm.

THE LYING-IN ROOM (THE BIRTH OF THE VIRGIN): the original motif
of the woman in childbed, with the child beside her being given its first
bath, has been developed into a rich composition with three groups of
figures (Plate 23). It shows a most lively variety of views in the many
projections and recesses of the room, in the chests, benches, steps, and
small windows, and this is made even more attractive to the eye by the
upward and downward movement of the light. It has to be compared
with older examples to see how many different directions have been
concentrated here and how the spatial conception has developed. The
details which are not sculpturally interesting, such as the bed with the
woman in childbed, are pushed into the background. And instead the
whole foreground is filled with sitting, standing, drinking, talking

women, the variety of whose inclining heads and turning bodies conveys a cheerful noise to the onlooker, an optical equivalent to the chattering which fills the room. First there is the charming figure of the woman who has taken the child in her arms to give it a bath. The distinguished visitor behind her follows this movement with her eyes, and a relative at her side offers her refreshments, at the same time giving new orders to the maid who is carrying a jug and the cradle. Next to them there is another group of three women with a child, who sit together in a clump. They have done their work, their time of relaxation has come. One of them lifts her little one, who will not wait any longer, on to her lap, while the woman opposite lifts a mighty beer-jug to her mouth with both hands and a third woman, on a high seat, cheerfully contemplates the scene. The group is constructed as a pure triangle and the three essentially different motifs are bound together very closely. Andrea del Sarto—who, as a sixteenth-century Florentine, after all also knew something of sculptural variety—has taken over one of them (the woman with the child) as a big figure in one of his frescoes.

Above is an angel with wings outspread, swinging a censer—a strange introduction of the celestial into a scene which is so very ordinary. Attention can be called to the new way in which the clouds have been drawn to show the progress of Dürer's painterly style, which contrasts with the linear rendering of the clouds in the *Apocalypse*.

THE PRESENTATION IN THE TEMPLE: everyone can see that the event has been told with great indifference. It is the same indifference with which an Italian Quattrocento artist like Ghirlandaio treats such a story. The child runs up the stairs without being made clearly visible, the parents stand below without really being involved, an exaggerated importance is given to minor figures, and architectural features are presented for their own sake. The minor figures here are a merchant and his wife, excellent character studies, examples of the kind of representation of manners which Dürer had incorporated in his early engravings too, though with less artlessness. In any case the architecture was more important for him here—a piece of Italian classical architecture, arches on pillars and gates with horizontal cornices. It is almost impossible to estimate the imaginative impression of such things on Gothic eyes. We see only the lack of understanding of some of the structures and we are shocked to the core to see Dürer piercing the shaft of the pillar with the stair-rail as one pierces a sausage. But when he drew them, these forms which had come from the other side of the mountains told of the charm of a far-away land and a great past.

To appreciate the sheet as a whole one has to look at the analogous problem tackled in the *Ecce Homo* in the *Passion* (see page 75).[29] We see that Dürer now knows how to construct space, how he starts off with a raised foreground and pushes the main bulk into the depth of the stage, how calmly our eyes are led along the foreshortened walls into the distance.

The perspective of the steps seems wrong, but theoretically it is correct. Dürer did not yet know that there are cases in which the rigid application of the rules leads to results which are optically wrong.

THE MARRIAGE: our conception of the marriage is more than fairly governed by Raphael's early picture, which every traveller to Italy has seen in Milan and which hangs on the wall in innumerable houses as an engraving. It was done at the same time as Dürer's woodcut. Beside it Dürer's version (Plate 24) seems domestic and insignificant in its gestures and types, and compared with the elegant work of a line engraving in the old sense the woodcut perhaps looks coarse and uneven. But how genuinely the event has been experienced, how subtly the bride has been characterized in her shyness and contrasted to Joseph,

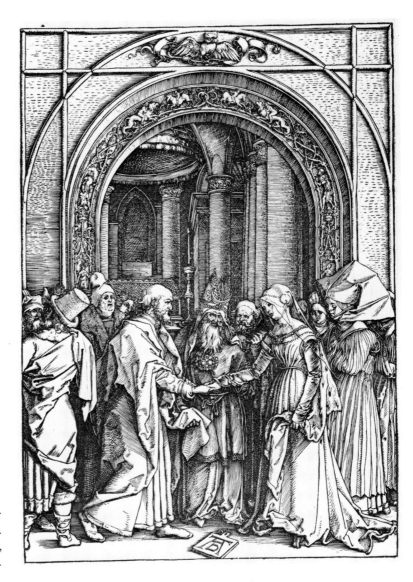

24. *Life of the Virgin: The Marriage.* 1504/5. Woodcut, 293 × 208mm.

and how filled with the sacrament's significance is the priest looking down in front of him and joining the hands of the betrothed! In Raphael's picture he is thinking of the ceremony. How beautiful the original drawing must have been! We can only confirm this in the case of one single figure, the bridesmaid with the large coif, who has been taken from a series of drawings of Nuremberg costumes dating from a few years earlier, which were done independently of the *Life of the Virgin* and are now kept in the Albertina. The sheet (w.224) with its light pen strokes and delicate watercolour tints has a charm which the woodcut cannot even hint at.

The crowd surrounds the pair in a close circle. There is no trace of sculptural isolation; in fact Dürer has tried as far as possible to give the impression that the picture presents merely a random sample of real life. This explains the partly cut-off figures at the sides and the strange motif of the man behind Joseph conspicuously looking away from the ceremony.

The background shows a Late Gothic arched doorway, with a view into the interior of the church, where pillars and vaults, all shown in a dim light, have a picturesque effect. But the orientation is not clear. THE ANNUNCIATION: it cannot be a coincidence that Dürer has recalled the memory of the serene, festive impression made by the large colonnades of Italian architecture. Around this time the Italians themselves liked to set the greeting of the angel in pillared halls. True, Dürer's room has become somewhat chilly and uncomfortable and the complication of the ceiling, the oculi and the boards on the abaci have made things worse rather than better.[30] Nevertheless the majestic width of these arches must have appeared very solemn beside the narrow settings of older Annunciations. The figures here are particularly small in relation to the space.

According to an older tradition—Schongauer produced the most subtly felt *Annunciation* of this type—the angel gently lifts the curtain where Mary is praying and bends his knee and, without coming near, he says his verse while Mary turns her head and listens with downcast eyes. Customarily the angel approaches from behind. Dürer makes his angel run in hurriedly as the Italians presented him; he comes from the side, he is given classical garments and his legs are indicated beneath the light cloth. It is only the colossal, upward-pointing wings that are German. Mary rises towards the angel with crossed arms. Here too she sits behind a curtain, but the subtle atmosphere of devotion of Schongauer's representation has vanished completely.

Only later (in the *Small Woodcut Passion*) did Dürer give the story its calm and air of consecration, and very late, in a drawing of 1526 (Chantilly), he searched for a *majestic* expression of it (Plate 109). THE VISITATION: Mary went into the hill country, it is said. So we are presented with a really mountainous landscape with a surprising effect of sunlight (Plate 25). The hillside opposite can be seen glittering in

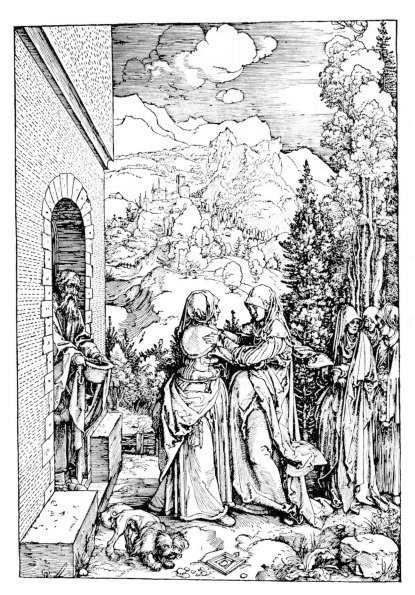

25. *Life of the Virgin:*
The Visitation. 1503.
Woodcut,
297 × 210mm.

full light, framed by dark views at the sides. Even its shadows are
lighter than the sky and the contrast with the vigorous drawing of the
foreground makes it seem as though the midday sun really shines on
the distant ground. The same intention was present in the *Apocalypse*
in the scene where Michael fights in dark storm-clouds above the bright
earth but there one had to guess at what is clearly visible here.[31]

Both women are very pregnant, a naturalistic feature which the
Italians avoided. Their embrace is not entirely clear, it is only notice-
able that Dürer wanted to give special significance to the figure of Mary.
While Elizabeth remains stiffly upright (contrary to tradition) Mary's
body is given a strong flowing movement, as though expressing the
song of praise, *magnificat anima mea dominum*, by its rhythm.

THE NATIVITY AND ADORATION OF THE SHEPHERDS: a hut which can be seen in full length, and in it the Child adored by its mother and gazed at by angels (Plate 26). Doors left and right: on the left the shepherds crowd in, on the right Joseph approaches with a stick and lantern. This great conception of Mary's adoration is unfortunately impaired by the perspective which Dürer has given to the composition. The vanishing point is right at the side, in front of and outside the hut, so that the scene with the mother and child, which should give an impression of seclusion and calm, is drawn into an uncomfortable current, as though exposed to a strong draught. Joseph however seems disconnected.

Such contradictions between form and subject-matter occur in

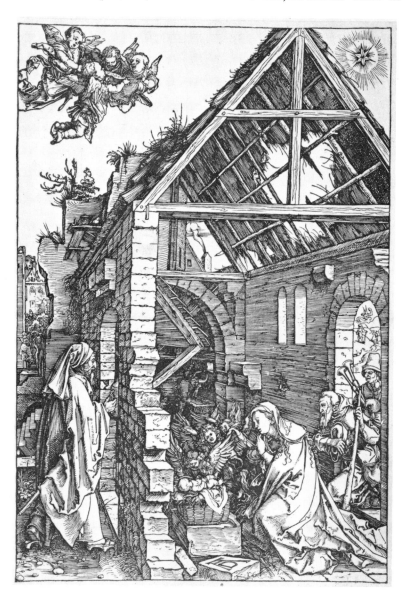

26. *Life of the Virgin:
The Nativity.* 1502.
Woodcut,
296 × 210mm.

every epoch which has yet to discover its means of representation. Italy offered the most seductive models. To give an example: Crivelli has broken up the scene in just the same way in a picture of the *Annunciation* (London) by putting the vanishing point far away and setting up a wall between the angel and Mary, thus disrupting their natural relationship (in spite of the door). The treatment of the hut, which is intended to give the impression of painterly richness, is typical of this early style. A motif like the foreshortened dilapidated wall, with its unevenly projecting blocks of stone, is equally common in the North and in the South around this time. The only characteristics that are confined to the northern artist are the richer tonal relationships.

THE CIRCUMCISION: this is a confused scene. It will be as well to call to mind the facts of a circumcision.

One person must hold the child, one has to carry out the operation; and if this is to be made clear the figures will have to be set in a line parallel to the onlooker. Here they move into the depth of the picture and the scene is further complicated by the fact that they are sitting. Furthermore Dürer takes an obvious pleasure in displaying his virtuosity in the rendering of drapery, which would be quite enough to stimulate the eye, but no!—there are all the minor figures to come. The main group has to be disentangled from amongst a dense crowd of people.

The space is not filled evenly any more. The main mass lies to the right, and the balance is held on the left by a single standing figure. Of course this character attracts the eye strongly, but it is entirely insignificant. The parents whom one looks for, Mary suffering one of her seven sorrows, remain unnoticed in the crowd.

One may imagine the sort of impression such a heap of figures made in Italy. There too there was a demand for rich groupings, but an artist like Filippino always seems sparse in comparison and Carpaccio positively empty. Of course it is not only the sculptural motifs which produce this effect with Dürer but also the ornamental life of the lines —the Gothic interwoven branches above the door in the background are an entirely appropriate ornamental flourish at the end of this chapter.

THE ADORATION OF THE KINGS: this woodcut is not among the more brilliant, but the drawing is one of the best. What seems most natural is the main achievement. There is no earlier Adoration where everything is made so lucid—the sitting, kneeling and approaching postures —and where every motif connects up with the next without effort.

Even Schongauer (B.6) still showed a congealed crowd of figures, and single motifs were rarely completely distinct. It is one of his most often repeated compositions, but the kneeling figure still lacks the lines which would reveal the movement at first sight. Of the standing figures one is very unsteady and even if the other one can be allowed to pass, one detail still presents an obstacle: the hand which lifts the lid

seems meagre and has not been properly studied. In comparison Dürer's work possesses a most successful general coherence as well as an almost perfect clarity in the single figures. And how much new life there is! The way Mary bends forward is sweetly feminine and tender. The old king, the ritual praying figure, is noble and stern; Joseph makes a good contrast and the remaining kings are again strongly differentiated. The Moor is beckoned to advance, a favourite motif, treated here very slightly comically. He comes running with his hat in his hand and the dog follows him. Imaginary ruins make up the background. Although the architecture is not actually used to set off the figures, it is yet noticeable how every head has been given a foil and this secures the visual distinctness at which Dürer seems to have aimed in this sheet especially.

THE PRESENTATION IN THE TEMPLE: our first impression is determined by the architectural element, by those colonnades with open architraves above, which are so colossal and senseless that they seem monstrous. Presumably Dürer wanted to produce a picturesquely fanciful impression by breaking through the ceiling but elsewhere the effect seems impure and painful.[32] It is interesting how Viator, who repeats the *veduta* in his book on perspective (see p. 84), makes his version calmer and more assured.

But more noteworthy is the way in which Dürer again tries to tell his story like a painter who sees the scene from afar, who does not just pull his principal actors into the foreground but strives to give the whole image of reality, who does not present the heroes of the story immediately in the foreground but begins straight away with entirely indifferent people[33] and shows the main event only in the middle of the room. But he nevertheless always connects people and place, producing the impression of the crowd disappearing into the temple's dim interior. This is a painterly conception and leads straight to Rembrandt.

THE FLIGHT TO EGYPT: after the subject of the interior of a temple comes one of the interior of a wood. This is an even more painterly task. It is customary to quote Schongauer's engraving of the Flight as the model, but the similarity hardly goes beyond the superficial resemblance of subject-matter. Above all Schongauer only shows single trees which stand well apart, while Dürer makes a serious attempt to create the impression of the enclosure of a real wood. He begins with strong intersections; the sky is not visible at all, the trunks disappear into the darkness of the background and only in the centre is there once more one young tree shining brightly. A white cloud rests on the tree-tops with a host of small angels (shown in a new way here!), who are accompanying the travellers. In accordance with the painterly way in which the cloud is drawn, the foliage too has an explicitly painterly character already.

The procession is shown sideways on, without foreshortenings. The

94

silhouette of the rider with the sun-hat on her back is charming. Hardly a trace of the child can be seen. This too marks a new style.

THE STAY IN EGYPT:[34] the mother is rocking the cradle with her foot and spinning, and three angels stand around her in admiration. Beside her Joseph is working as a carpenter with his axe and little winged *putti* are brushing the chips together and emptying them into the big pannier. Others are playing. And all this is taking place under the bright sun, the well is splashing and God the Father gives his blessing from above.

This sounds so idyllic that the unprepared spectator may well be disappointed at first with Dürer's picture. The group around Mary has been pushed boldly as far as possible into the corner, and as Joseph alone would not be capable of holding the balance, a high row of houses and ruins has been built up behind him which runs into the depth of the picture in startling foreshortening. They are uninviting ruins with big black holes, the opposite of what we expect; and on top of that there is the obtrusive perspective! The more intimate motifs are to be found only beyond the desolate yard. And yet the sheet has the atmosphere it should have, if only one is prepared to take the ensemble of lines and tones as the essential element, not the single objects. The plane gets its particular life from the way it is covered with a network of the most varied lines, interrupted by gaily rumbling depths of shadow, and to those who looked at it of old it was a matter of course to follow up such effects. It may none the less be admitted that the architectural perspective presents itself somewhat complacently. It was the variety of the painterly qualities, given with such great assurance, which provoked the admiration of Dürer's contemporaries, and from which other artists picked out details and used them in different contexts. In any case, a close look at the figures will console everyone for any impurities in this composition. It must be said above all that Dürer never again portrayed scenes of children with such immediacy. How much less significant are the motifs in the large woodcut of the Madonna of 1518!

CHRIST AMONG THE DOCTORS: this sheet suffers from an unfortunate dispersal of the figures. It is an attempt to show a crowded interior, but only in the (later) sheet of the *Birth of the Virgin* is this attempt really successful. There are many original gestures in the doctors who lounge about, but the disputation itself is nearly lost. Christ is an insignificant doll on the rostrum. Of course contemporaries were not used to anything better. Only in Italy did Dürer approach the theme from the psychological angle. The ugly room in the 'modern' style gives the final touch to the uncomfortable effect of this sheet.

CHRIST TAKING LEAVE OF HIS MOTHER: Christ starts on his last journey to Jerusalem (Plate 27). The women have accompanied him beyond the big garden gate and here his mother makes one more desperate attempt to persuade him to stay—she falls down on her knees in front of him wringing her hands. This is the moment that is represented. In

expressive force it surpasses all earlier art. The mother looks up at her son, her companion wants to lift her from the ground and yet does not do so, and the gesture is thus infused with a double movement, as if the lowered arm means that she resists her impulse, renouncing her plea under the impression of the earnest glance with which Christ looks down on the kneeling figure. He blesses her but still turns to go.

THE MADONNA WITH THE SAINTS: this scene is insignificant for us after this. We could discard the sheet altogether, if it were not necessary to remark on its style in order to slot it into its proper place. For some people still think it is a later addition, yet it seems impossible to over-look the characteristic features of Dürer's early style in the composition which is insufferably crowded and confusing with its entirely dis-jointed background.

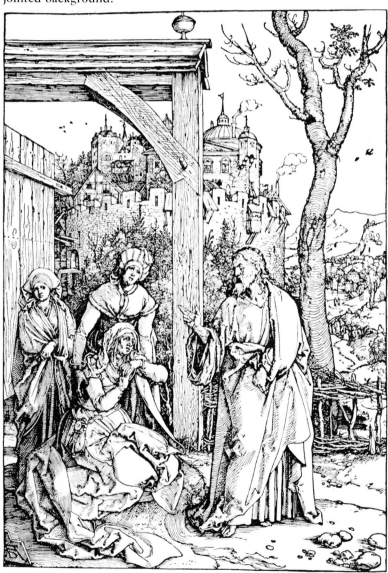

27. *Life of the Virgin: Christ taking leave of his Mother*. About 1505. Woodcut, 297 × 210mm.

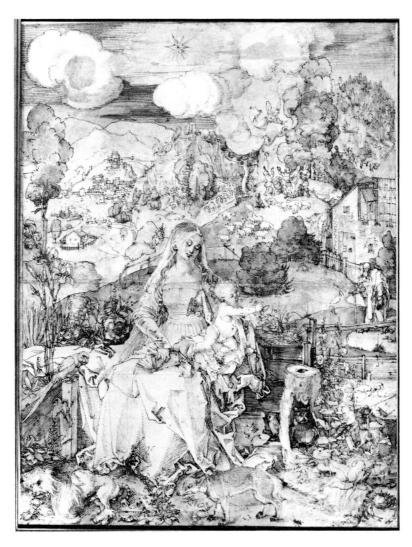

28. *Madonna with
animals*. About 1505.
Watercolour,
321 × 243mm.
Vienna, Albertina.

The coloured drawing of the *Madonna with animals* (w.296) in the
Albertina (Plate 28; a study for this is in Berlin, formerly Blasius Col-
lection), seems to us the epitome of the friendly, benevolent and sunny
features contained in the *Life of the Virgin*.[35] Mary's old, enclosed,
little garden has become a wide open space with mountains and sea-
shores and big clouds above. The main tone is a light yellow-green, in
which the figure sits in a shimmering brightness, completely white. A
festive impression is not intended—as was the case in the *Madonna with
the hares*—but one of smiling gracefulness. Lively folds ripple down
the gown (in a very similar way to the subsequent small engraving of
1503), the irises and peonies are still more dainty, and small life moves
everywhere. The terrier suns himself on the ground, staring at a stag-
beetle who advances towards him; this interests the fox, who approaches
on his lead; in a dark hole sit a screech-owl and a brown owl; a parrot

97

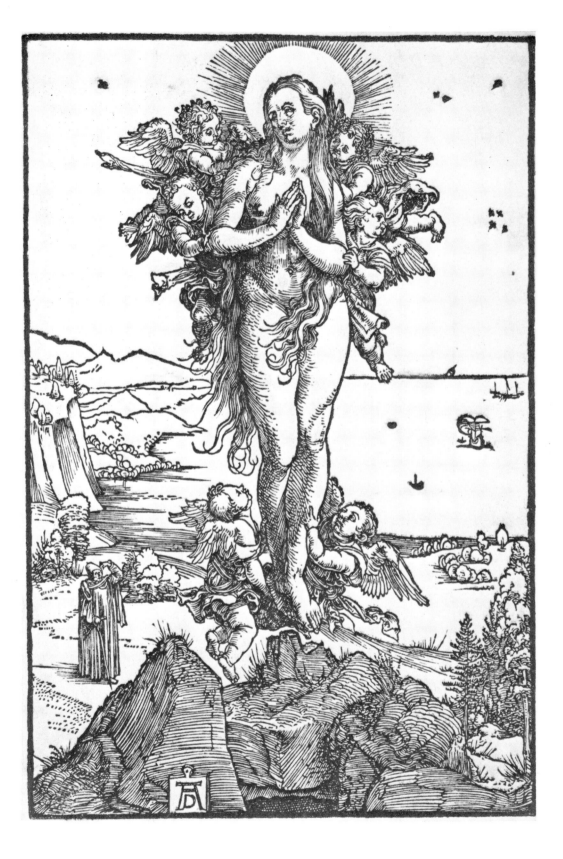

perches on a pole in the grassy bank, and a robin and a woodpecker can be seen: the summer air is filled with loud singing and humming.

But the *Life of the Virgin* does not exhaust the woodcut production of this time. There are quite a number of sheets in the same style. If one were to pick out a characteristic example, one would choose the *Visit of St Anthony to St Paul* (P.107), a story about monks: the two old hermits are sitting together at the edge of the wood and are miraculously brought a double loaf by the raven, because of the visit. Very stimulating is the juxtaposition of the two figures and the even flow of quick short wavy lines. (The preliminary study in the Blasius Collection, L.141, W.183, is still essentially different.) In contrast, the *Magdalen* (B.121; Plate 29), placed before a wide background of the sea, is all beauty and complete weightlessness. Dürer has drawn nothing more perfect than the figure of this woman, floating above the earth in the company of angels. She is meant to have heard heavenly melodies, and this is believable as the movement dissolves entirely into rhythmical harmony. The dating of this important sheet around 1504/5 is not at all certain. There are a number of reasons for placing it in the period after the great Italian journey (cf. Heidrich, *Geschichte des Dürerschen Marienbildes*, p. 190). The way in which the lower pair of angels goes together with the form of the hill already presupposes a markedly developed, large-scale vision.

Mary Magdalen.
1504/5? Woodcut,
213 × 144mm.

The early engravings

The beginnings of Dürer's engravings presumably go back as far as those of the woodcuts. In the goldsmith's workshop he became familiar with metal at an early stage but the precision of his attitude virtually pushed him towards this technique: and when the investigation of the human body became of primary importance it was a foregone conclusion that the problem could only be solved on the copperplate, with the abundance, subtlety and decisiveness of its metallic lines. Thus it can be said that it is engraving which leaves the deepest trace in the development of Dürer's youth.

The first engravings have a rough and piercing effect. Dürer treats the burin just like the pen, demands many painterly effects, and superimposes strokes in a disorderly fashion. A characteristic early work like the *Madonna with the grasshopper* looks as if Dürer wanted to combine the effect of Schongauer with that of the Housebook Master. After this the confusion gradually becomes less, the lines, chosen more carefully, become more distinct and the painterly effects are based on stronger contrasts of light and shade. Examples of this type are the *Madonna with the monkey* or the large sheet of *Hercules* (B.73). And then, shortly after 1500, the greater subtlety of drawing and treatment of light, which we also recognize in the woodcuts and which leads to the inimitable technique of the *Large Nemesis* (Plate 41), the *Coat of arms of Death*, and the *Adam and Eve* print (Plate 3), gradually appears. The surfaces of objects with their textural differences are treated with a subtlety which has no analogy in the paintings of these years.

It is advisable to deal with the short sequence of the engravings of the Madonna first of all. The three-stage development is perfectly apparent in them. The *Madonna with the grasshopper* (B.44; Plate 30) represents the style at the beginning. It shows the old motif of the mother who sits on a grassy bank in the open with the sleeping Joseph at her side. The format is conspicuously large and the richest possible effects are obviously intended—spreading draperies with concentrated masses of shade which have no parallels in the woodcuts. The figures are laboriously and sometimes unsatisfactorily drawn, but in comparison with earlier drawings the overcoming of purely frontal viewpoints is important. The foreshortening of Joseph's head is probably influenced by Pollaiuolo. As the strokes are harsh and clumsy a real effect of roundness and abundance is not achieved. The view into the distance too retains an element of the effects of a March frost in spite of all the display of individual motifs. The engraving will have to be dated 1494/5.

The *Madonna with the monkey* (B.42; Plate 31) was done about five

years later. It already has strokes which are firm and clear and energetically deep. Again there is a woman sitting in the open but this time following Italian precedent. Dürer must have used a model from the circle of the young Leonardo (probably Lorenzo di Credi). The child belongs to this movement entirely and the mother too shows an unmistakably Leonardesque feeling in the mild inclination of her head and the contrasting positioning of the knees.[36] It makes me think of the type of Leonardo's Madonna in the Uffizi *Adoration of the Kings*. This motif has now perfect sculptural lucidity; one knows exactly what is beneath the garments. The drapery does not drown the figure any more but expresses it and is successful in spite of all its Düreresque frills. The picture is completed with a landscape, which is already arranged asymmetrically in accordance with the demands of the figure.[37]

Finally the *Madonna* of 1503 (B.34; Plate 32), the smallest of the three but the most heartfelt, is done entirely in the rich, subtle style and

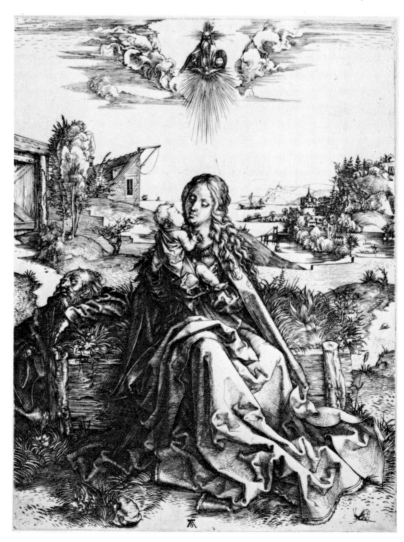

30. *Madonna with the grasshopper*. 1494/5. Engraving, 240 × 186mm.

has the tranquil atmosphere of the woodcuts of the *Life of the Virgin*. The overall situation is the same as before but now the scene is set in a secluded nook. The mother bends forward to give the child the breast; there is a play of hands, more charmingly natural than anything Dürer invented later. The poetry of the drapery is also immediately understandable. As the rippling of a small fountain can give a friendly atmosphere to a whole garden, so this little picture gains its liveliness from the movements of the drapery. And how gracefully the mood dies away in the small bush with the coiling tendrils near the fence!

The most important evidence of Dürer's estimation of engraving as the noblest art is the fact that he confined the problem of the nude to it.

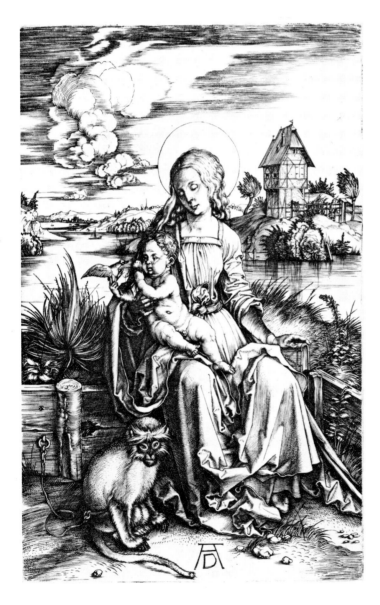

31. *Madonna with the monkey*. About 1497/9. Engraving, 191 × 122mm.

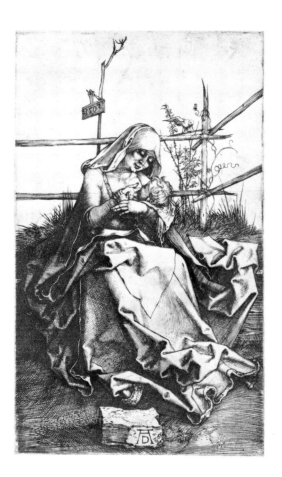

32. *Madonna.* 1503.
Engraving,
113 × 70mm.

The discoveries which the new art made concerning the structure and movement of organic form were published as engravings; and the great question which arose, the question of the beauty of the human figure, was answered on the copperplate. The works of this group were doubtless the most interesting ones for Dürer.

As a small introduction one can take the sheet with the so-called *Six soldiers* (B.88), a collection of motifs showing the standing figure which already presupposes a knowledge of Italy, modern movements and modern fashions. The walking lance-bearer goes back to Dürer's drawing of the *Rape of the women* after Pollaiuolo. The technique of the engraving is still the primitive one.

St Sebastian at the column (Plate 33) is advanced and important, as it is the first nude male figure; his large heavy head recalls features of the Apocalypse. The *contrapposto* is Italian. The model may well have been provided by Cima da Conegliano who was, however, himself influenced by Perugino.[38] This is a subtler version of the original than the engraved copies we know; this is very natural. It makes Dürer's real aesthetic attitude the more explicit, his belief that he could give the figure a higher beauty with a gnarled drawing style. The significance of the motif itself is demonstrated by a comparison with Schongauer,

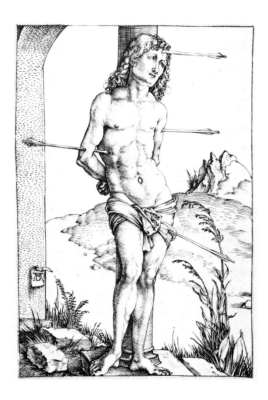 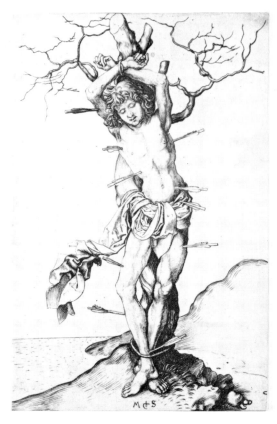

whose graceful and boyishly delicate Sebastian (B.56) had met the
taste of his generation perfectly (Plate 34). Schongauer has constructed
his figure on a pointed base; the feet are crossed and do not stand firmly
on the ground. The knees are separated and both are bent, and the
middle of the body sways strongly, echoing the contrasting twisting of
the tree trunk. His arms are bound above his head, the movement of
the fingers shows great subtlety, and the pointed shape of the elbow-
joint is intentionally stressed. The overall contour is angular and full
of movement. The loin-cloth has to flutter jaggedly and the tree spread
out its fine, withered branches.[39]

The Italian style on the other hand demanded great flowing lines
and coherent movement; the body is not broken but structurally
defined, with clear contrasts like *contrapposto*, for example. This style
presupposed an entirely different conception of the body: the body's
weight was judged and there was a feeling for the pleasurable effect of
certain relations of balance, which gives the impression that the burden
is carried lightly. The view of beauty decided in favour of stronger and
fuller bodies; different categories were applied to them; if northern
Gothic interpreted the figure in an essentially vertical way, the Italian
Renaissance on the other hand (based on the classical conception) did
so in a horizontal way. The area of the pelvis is of decisive importance.

33. (*left*) St Sebastian.
About 1497/8.
Engraving,
106 × 75mm.

34. (*right*) Martin
Schongauer: *St
Sebastian.*
Engraving.

The Italians combined stomach and loin muscles and thus gained a definite lower termination for the torso, a very explicit horizontal partition. The northerners did not know this kind of structuring before the sixteenth century; on the contrary, they combined the parts in a vertical way and only took in the silhouette sharply beneath the chest so that it often looks constricted. Similarly the Italians showed the plane of the stomach muscles as a large wide shield, wide because of the arch of the lower ribs, while in the north this arch is shown only as a narrow fork. Dürer took up this new pattern at the same time as the new ideal of beauty of movement, blindly trusting in the excellence of Italian classical drawing. One can find similarities to the Sebastian in the early woodcuts. The new form has such potent charm that it eclipses nature. Schongauer's Sebastian is decidedly more original and more subtly naturalistic in spite of all its Late Gothic characteristics.

Dürer's engraving must be roughly dated to the year 1497. The same year is to be found on the first dated engraving by Dürer, the *Four witches* (B.75; Plate 35), where he takes up the subject of the female nude.

It shows a group of standing naked women, obviously represented for their own sake. Only gradually does one discover the devilish face which looks in through a door crack and, with his accompaniment of flames, makes it clear to the onlooker that what is represented is not a gathering of Graces but rather one of rakes.[40] There is nothing at all witch-like in these women though. The onlooker wanting to see an evocation of Walpurgis-night has to turn to Baldung Grien, who can revel in the vulgarity of the flesh. Basically Dürer does not want to show anything but a few beautiful female nudes. They really seem to have been called Graces once, for Sandrart saw fit to protest against this name. Yet he was probably wrong. The composition can be associated with Italian groups of the Graces, where a figure seen in back view usually forms the centre too. It is not significant that there are four figures here, for the fourth is only an insertion necessary for Dürer, whose eyes did not demand a relief composition with clear lines but a rich painterly group with intersections. He did not yet have a feeling for the worth or worthlessness of greater or lesser clarity. The women stand on different levels; this too is an arrangement for the sake of richness, though it is hardly fully exploited. The background is dark.

The bodies stand out brightly from this foil, and what bodies they are! The central figure seen from the back has a truly monumental appearance though the lines are still uncouth and stubborn. The rendering of this woman's wide hips shows a feeling, a sensuality new in German art. This part is the best drawn, demonstrating, moreover, a grand vision and an ability to model with an accomplished linear flow; but in the feet the strength ebbs and in the parts around the shoulders too the effect becomes less assured as the strokes are neither clear nor decisive. Dürer did not yet know the significance of lines. The shaded

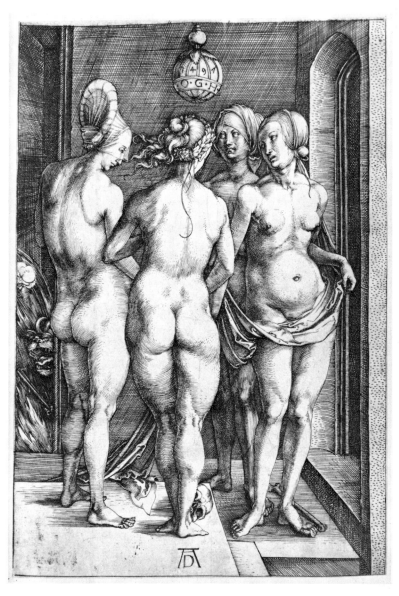

35. *Four witches*. 1497.
Engraving,
194 × 136mm.

upper arm should not have been drawn in vertical lines which follow
the longitudinal axis: the arm thereby receives a tension which is in-
appropriate. The drawing of the second figure seen from the back in
foreshortening is completely spoilt but neither does that seen from the
front give the natural impression of the centre figure. Her stance and
the position of the head are conceived in the Italian manner, but the
details are northern. This is the remarkable feature of this print and
the following one—the oscillation between Italian form and German
Late Gothic tradition. One can guess how much strength must have
been lost through this split character. Dürer also treated juxtaposed
female nudes immediately before the engraving of the witches, in a
detailed drawing of 1496, the *Women's bath-house* (formerly Bremen;

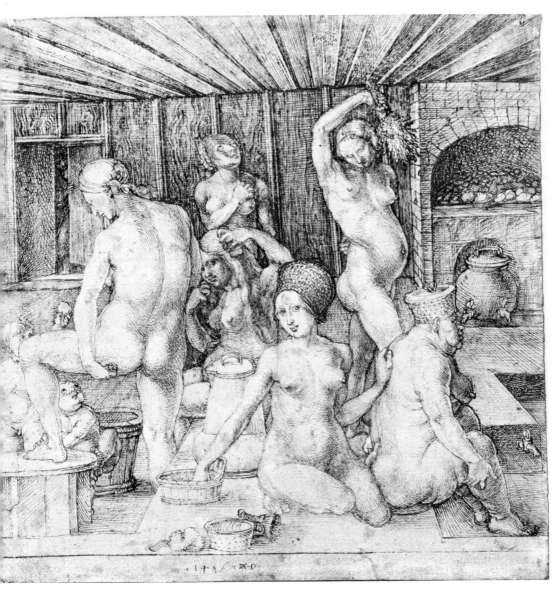

36. *Women's bath-house*. 1496. Drawing, 231 × 226mm. Formerly Bremen, Kunsthalle.

Plate 36) which—like the woodcut of the *Men's bath-house*—was designed completely under the impact of the Italian conception of monumental form and movement. When one sees with what freedom the motifs have been invented and how sweeping are the broad layers of planes of one of the large backs, the drawing of the witches could be regarded as a regression, though this must be mainly because of the intricate work of the burin.[41]

The Italian characteristics in the nudes of the witches are further developed in the engraving of the *Temptation* (B.76), also called the *Doctor's dream* (Plate 37). The impression that finds its resonance here must have been a particularly beautiful one: a nude woman with one arm stretched forward, beckoning, her negligent pose, the slight turn

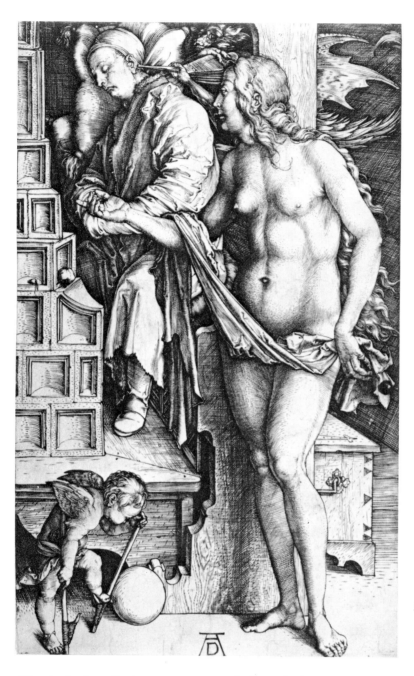

37. *Doctor's dream.*
About 1497/9.
Engraving,
188 × 119mm.

of her body, her alluring gesture—even in Dürer's drawing the effect
is sweet and caressing. Where he got the figure from, whether it was
his own vision—I do not know. The addition to the composition is in
any case original, the well-fed man sitting on the bench by the stove
having a nap, his head resting on pillows, his hands hidden in his
sleeves. A devil with bellows is at his ear. The sheet is known under the
title of the *Doctor's dream*, which is not an old one but its meaning can
hardly be otherwise. Precise literary parallels have not been found, but

the motifs of the lewd doctor and his temptation by the dream image of a beautiful woman are quite well known. Dürer has repeated the gesture of the woman in an unmistakable sense in the later *Temptation of St Anthony* of 1521 (W.884). The putto on the floor who tries to walk on stilts can be interpreted as an Amor. The contrast between the slim nude woman with her graceful movement and the fat sleeping man is most effective, though the woman is not at all sensual in conception. It is the model Italian figure par excellence and it is possible that there might even be an inclination to use the composition for an entirely different purpose—showing not the seduction of the flesh but the poison of Italian beauty.

It is strange that Dürer cannot tear himself away from erotic subjects now. The next is a rape. He himself called the piece the *Sea-monster* (B.71; Plate 38). Such stories were told of the Adriatic, of monsters who

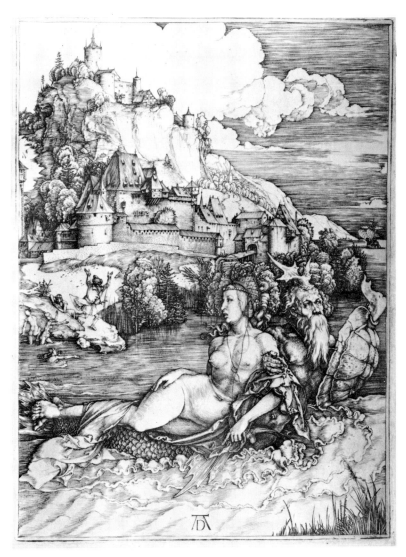

38. *Sea-monster*. About 1500. Engraving, 246 × 187mm.

were said to emerge from the depths from time to time and carry off humans at the shores. It is possible that Dürer already knew classical fables with similar subject-matter. The usual name of *The rape of Amymone* has in any case the backing of the legend on a sixteenth-century piece of a draughts game with this Düreresque composition on it. It must be admitted that the composition is hardly frightening; there are a few little figures running along the bank wailing, but the abducted beauty lies nearly as quietly as if she were stretched out on a couch, and even her mouth opened in pain cannot alter the impression. She fills the whole width of the space and is decidedly the main figure to which the abductor has been unsatisfactorily added. This means that the centre and starting point remains the motif of a recumbent female figure and the whole 'story' has presumably been made up afterwards to suit her. The sea-side abduction was designed to make the nudity legitimate: the monster has snatched his victim from the circle of bathing companions.

Dürer has thus progressed from the standing to the recumbent figure. One is hard put to find earlier examples in German art; this demonstrates how much Dürer attempted to do something extra-ordinary here. So the inadequacies of the solution should not immediately be pointed out but rather the positive achievement acknowledged first of all. The body shows an entirely new character in its heavy repose; the angular meeting of chest and lower torso, the dropping shoulder, the turning of the head, the whole upper silhouette, are somewhat uncouth but very impressive.[42] The left arm has a rather lame effect in the context; originally it must surely have been the weight-carrying arm, but its function was abandoned in favour of the combination with the second figure. I am convinced that here too Dürer had a foreign, Italian model in mind which he incorporated in his own way.

The sea-monster, then, is not much more than a stop-gap. The gripping arm is not developed, one does not quite understand what the woman lies on. But the monster's head, the head of an old forester, is interesting in its own right. And this is precisely what gives all these things their strange effect: copied and original elements, natural and acquired things stand side by side and the painful struggle with the main problem, the figure, still leaves a comforting reserve of strength which manifests itself as explicitly in the gay rippling of the waves as in the rich, mountainous shore which rises high up and fills the background.

The sheet has a painterly character which surpasses all earlier examples. In good impressions the tone of the dark water with the white body above it, or the light and dark of the shaded thigh, have a very subtle effect. The early Dürer will immediately be recognized in the highly original and dashing distribution of patches of light and dark; and it was incomparably daring to run the line of the mountain slope obliquely through the whole picture. After the *Sea-monster* Dürer

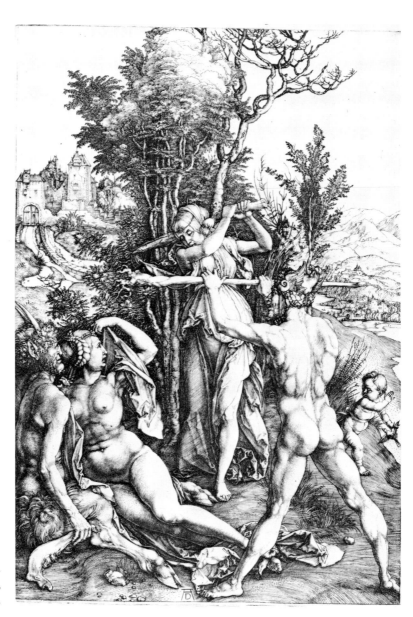

39. *Hercules (Jealousy)*.
About 1500. Engraving,
318 × 227mm.

attempted something even more significant—he refined his drawing,
enlarged the scale, took up the problem of movement as well and tried
to combine four or five figures into a structured group. Thus the so-
called *Large Hercules* (Plate 39) emerged. But again there was no natural,
no original creation; he worked with already existing forms which were
taken from Italian art.

The subject-matter is strange and finds its explanation only in
humanist mythology. But it is certain that Dürer coupled the name of
Hercules with this engraving. It is popularly called *Jealousy*. This much
is clear: the lovers, the satyr with the naked woman in his lap, are being
attacked. A woman in a long gown towers above them and lifts up her

arms to strike them. A strong naked man approaches and holds up a tree trunk with both hands—does he too want to strike the lovers or does he want to protect them? Even at this stage the meaning is not clear. The way in which he grips the tree trunk—with relaxed fingers— looks as if the weapon is used to ward off the blow, but the direction of his glance contradicts this. Is he an attacker after all? And if he was called Hercules by Dürer, must not the caught-out couple be Deianira and her abductor, the centaur Nessus? The print has been interpreted like this. The fact that Nessus appears as a satyr and not as a centaur would not invalidate this explanation, for the confusion of satyr and centaur is known in other cases too. But why does Hercules not have the arrow on which the story hinges? And even if a name for the child could possibly be found, what does the woman have to do in this con- text? One has to embark on tortuous routes of interpretation to come to a conclusion. Jupiter and Antiope have been mentioned too, in which case the woman could be recognized as the affronted Juno—but again the group cannot be explained without difficulty. In any case the fact that there was a public in Germany around 1500 which could be presented with such stories remains remarkable. A satisfactory explana- tion has been put forward only recently, based on the humanist revival of the Prodicus fable of Hercules with the personifications of Virtue and Vice. Unquestionably the attacking woman is Virtus who has hur- ried down from the fortress of Virtue to fight her adversary vigorously. The woman in the arms of the satyr is Voluptas. Her nudity forms a classic contrast to the draped figure. The standing man is Hercules, as yet without the lion's skin, who as the champion of virtue waits with raised weapon, ready to intervene.[43]

The whole question is seen in a new light, however, if one analyses the individual elements of the sheet. The formal sources for the picture are as clear as the subject-matter is confused. One can trace the models of the three main figures to three different sources. The lying woman has been copied from Mantegna—she is to be found in the *Battle of the sea-gods* which Dürer copied (Plate 11); the standing woman with the cudgel originates from the Orpheus engraving (cf. p. 52) and the nude man is based—as is now generally known—on an original by Pollaiuolo, the *Rape of the women* which has been mentioned above (p. 53). Ele- ments which had nothing in common originally have been combined as in a kaleidoscope to form a picture; different combinations could be thought of but whatever was chosen it is improbable that the story to be represented would have related precisely to these figures. Dürer pursued his artistic interests even if it damaged the coherence of the narrative. If one also remembers that earlier engravings were thought of essentially as prototypes to work from, Dürer's procedure can be seen to be less incomprehensible.

The figure taken from Pollaiuolo is the most important one. It is a representation of force, through a nude body in strong movement, full

of new pictorial stresses. It pays to take a close look at Dürer's attitude to his model. Features such as the set-back leg, the back and the raised arm are identical, but he substitutes a sturdy stance with straddled legs for Pollaiuolo's 'lunge'. As far as the arms are concerned Dürer only adds the right hand—one would like to see more—while he takes over the left hand and arm and copies them down to the position of the fingers, although their function is entirely different, for in the original the hand clasps a struggling leg of a woman. This dependence is all the more remarkable as Dürer has remodelled the body entirely in other respects. The pen copy had already been a transcription into a different linear language; here again he tested with every stroke his ability to render muscles as he saw them and he achieved a characteristic tension at the hollows of the knees and in the buttock muscles by the greater detail he gave to the forms. He kept his model's harsh contours of the back muscles on the highlighted side and the sharp contrast to the dark chest which is repeated on the thigh.

The lying woman is the best example of the increasing overall subtlety of his line—in comparison to the *Sea-monster* the female body has gained considerably in softness. But the shapes are those of the Italian prototype. As soon as this prototype is absent, Dürer becomes unpleasant. This can be seen in the feet, for example. He did not regard it as an advantage that Mantegna's clear delineation also makes it possible to follow the lowered arm distinctly. Thus the onlooker is not told anything about this limb's position. And it becomes obvious in other places too how undeveloped Dürer's sculptural conception was as yet: in the way the left hoof of the satyr is separated from his body, and the footless leg of the standing woman looks as though it were made of wood. His model provided clear shapes but he had no feeling for them yet.

However, he did make a significant attempt to take up Italian monumentality in his composition by locking his different motifs together to form a rigid pyramid. We meet the same intention in a number of early works, in the *Men's bath-house* and the *Lamentation* from the *Large Passion*, but it is in the *Hercules* that the structure is most prominent. The question as to what was the decisive model can hardly be answered otherwise than with an allusion to Leonardo.[44]

Dark foliage forms the background. Here Dürer uses what were the original elements of his Orpheus drawing. There he had already shown the most astonishingly painstaking commitment in his pen technique, but this kind of brushwood of young oaks is of course an even greater miracle of industry when done with the burin. Leaf is set next to leaf in a completely unpainterly manner. Dürer did not bother about such things in his later graphic work. Only objects which are sculptural, solid and measurable triumph in the end.

A straight line leads from the Hercules of the engraving to the hero shooting his arrow in the tempera painting of the *Fight with the birds*

of Stymphalos (Germanisches Nationalmuseum, Nuremberg). It shows the figure in a kind of hurried stepping stance with one bent knee pushed forward and the back turned towards the viewer. This might be thought another version of the Pollaiuolo drawing already mentioned, but there is another, more direct model for it in Pollaiuolo's work—in fact, a figure of Hercules shooting an arrow. As a whole the Nuremberg figure is superior to the engraving. It has much greater smoothness; the movement—from the sole of the back foot to the fist of the outstretched arm—has a truly coherent flow. And the preliminary study for it in Darmstadt possibly gives an even better impression of urgency than the picture.[45]

How simple the man shooting looks! The view is so distinct and the contours are so clearly developed in the plane that he stands out in any collection of contemporary pictures. We are really confronted by something new. The importance of the profile view in Italian art had made a lasting impression on Dürer. He deliberately went back now to the simplest viewpoints. He wanted to be entirely objective, to show objects as distinctly as possible and therefore he renounced all features which might complicate the picture. For a while even the problems of movement receded in the engravings: the whole aim is concentrated on an exhaustive representation of the objects in their essential shape.

A characteristic example for this change is the large engraving of *St Eustace* (B.57; Plate 40).

A heathen hunter experienced the following adventure in a wood: suddenly the crucified Christ appeared between the antlers of the stag he was hunting and said to him in a clear voice: 'Eustace, why do you hunt me? Believe me, I am Christ and I have hunted for you for a long time'—whereupon the heathen fell down and believed. It is really quite grotesque to see how Dürer neglects this simple story as a story. The event's specific character is entirely lacking in the representation. Instead there is a host of model figures side by side: a large horse in pure side view, a stag (whose connection with the hunter can hardly be guessed) and the dogs, all shown individually, like a series of working drawings. The kneeling hunter is also shown in profile.[46] In the story the stag is of chief importance, for the artist it was the horse. The characteristic formal features have not yet been completely mastered but it is the attitude in principle and not the 'more or less accomplished' execution which is important. It is at this time that those attempts which later led up to the more precise, well proportioned type of horse in the *Knight, Death and the Devil* began. (The engraving of a horse of 1505 (B.96) marks an intermediate stage.[47]) The dogs of St Eustace are the best drawn animals of this period. There is a brush drawing in Windsor for the biggest dog, which shows admirable assurance and graceful suppleness of line, but how much more subtle does the form become under the precision of the burin!

The detailed drawing of the figures, which even surpasses the style

of the *Jealousy*, is reflected in the treatment of the landscape. Dürer was never so extravagant again with trees where every branch is a world of shapes, never did he go further in the characterization of the textures of different barks, of exposed wood. Thus, the background shows an almost inexhaustible abundance of motifs—the secret pond in the shade of the brushwood, the gurgling streamlet under the bridge, the paths leading up to the high castle, the rocky crags and the buildings clinging to the mountain; all this is significant and captivates the imagination. In the upper right corner the surface of a lake is cut by the tree-trunks in the foreground.

The scene is enlivened by the use of the painterly device of light and

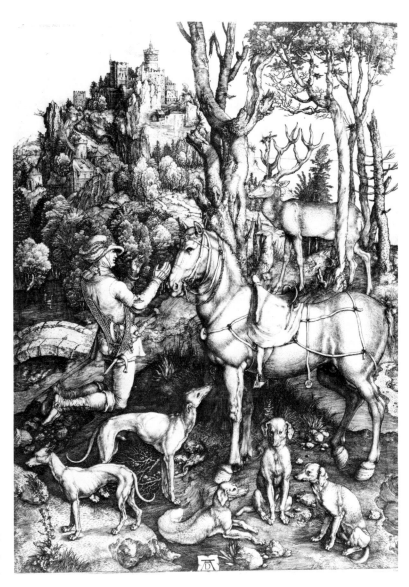

40. *St Eustace*. About 1501. Engraving, 357 × 260mm.

dark grounds, sun and shadow gaily alternating. The whole is of course more a combination of details than a unity in a higher sense, and yet in comparison with the preceding works it is remarkable how large areas such as the mountain are united by one tone. We have entered the period of Dürer's painterly style, not merely that of his delicate precise style.[48]

A new attitude to the nude was also developed on this basis. Dürer renounced foreign gestures and the imitation of Italian form and tried for once to admit the nature of his own land. This he did without restraint and without leaving anything out, so that all the abundance of forms found expression. He took a Nuremberg woman and made her undress. She was stood in profile against a wall, she was given something to hold in her hand and then Dürer—without concealing that she was just a model—tried to give an account of her appearance as comprehensively as possible. The result is a drawing which makes all preceding ones appear empty (Plate 41). Its true significance does not lie in the abundance of detail but in the way it originates from an understanding of the miracle of life. The *Large Nemesis*—for this is the picture I mean—is the first of Dürer's figures which makes us experience the warm breath of reality (B.77).

A nude woman, then, is depicted standing on a sphere above clouds, set off by an entirely white background which forms a contrast to the dark landscape below. This woman is called the *Large Nemesis* in contrast to another, much earlier, engraving of small format which also represents a woman on a sphere (B.78). Dürer used the name Nemesis and by this he meant the goddess who distributes fates, holding both reins and cup—the reins for the wanton, the cup for the victor in life. The conception is a learned one, and recently a few verses by Politian have been quoted which, even if they do not turn out to be Dürer's source, are still worth knowing as a literary parallel.[49]

This kind of reality in this setting is almost terrifying. The woman is not beautiful and young but mature and strong, with a heavy body whose lower parts are more accentuated than the upper: the breasts rather flat, a large belly, powerful thighs. This appearance must have seemed like a slap in the face to Gothic taste. Did Dürer want to characterize Fate as an indifferent advancing power 'hardly concerned with us' who does not need to be charming since she does not want to please anyone? I think this interpretation is wrong. For us to believe that this was intended by Dürer the gesture would have to be more expressive. But the woman stands there self-consciously with her attributes, just as a model stands who does not know what to do with the objects. The way the cup is held is not even completely comprehensible as a grasp. And the fatal way the feet are balanced on the sphere!

Much as this figure breaks with tradition, Dürer must have taken the greatest pleasure in this northern model. She is strong and richly

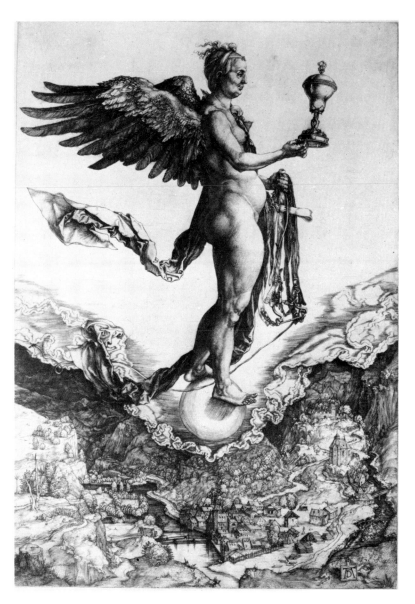

41. *Large Nemesis.*
About 1500/3.
Engraving,
329 × 224mm.

moulded, muscular rather than fat. He did not try to make the body
and its movement conform to Italian patterns at all; but the figure is
not meant to show an ugly exception, it is extremely seriously worked
out as a type and is a normal figure of its own kind. It need not have
been constructed on some specific proportional basis, though this
opinion has also been put forward, but the form shows an even clarity
which makes the onlooker think that a real figure has been 'adapted'.
And here Dürer's drawing technique takes over with very fine burin
lines and he models the powerful curves of this torso, following the
form everywhere, stressing a tighter part of the flesh here, a softer pad
there. He goes around the smallest joints of the fingers with his sharp-
edged burin to establish their shape; the joints of feet and knees are

revealed as rich accumulations of forms whose living relation his drawing seeks to lay bare.

But what do words mean? A visual comparison is infinitely more expressive. One has to measure the change by looking at the general and uncertain appearance of an earlier engraving such as the *Four witches*. And yet the interval is not much longer than five years. Here if anywhere even the layman can experience the pictorial pleasure, the desire for concrete expression of the born artist.

Nothing is shunned by his eye. The monstrous bundle of leather straps, those horse's reins which Nemesis holds in her hand, are traced with a kind of voluptuousness. It seems to be the most thankless task in the world, but the eye bores into the tangle and the burin follows and does not rest until the obstinate material is made simple and clear. How unthinkable such a drawing would be in Italy! And it is the same with the fluttering strip of indeterminable cloth in which another facet of Germanic imagination enjoys itself to the full, as in the flourishes and coiling tendrils of the drawings for the prayerbook of the Emperor Maximilian (Plate 100). The wings of the Nemesis were already admired as something incomparable by Vasari, giving recognition to a national talent of a different kind. For the first time not only the form of the plumage is rendered but also its surface texture. And Dürer later reverts again and again to materials of this kind—feathers, hair, fur— as favourite subjects for his sensuous perception.

The wings and the other accessories provide depth and thus stress the painterly features of the figure, the subtle shadings of the back are vigorously framed. Dürer took care that the side turned towards the light hardly touches the white background.

Dürer also added an earthly scene which seems dark beside the white plane, and its tiny houses make the Goddess of Fate appear colossal. But a spatial effect has not been achieved. Nemesis does not stride across the earth high up in the clouds; and as it is impossible to establish a realistic connection between the upper and lower parts, we are merely left with contrasting planes.

The long-standing question of the name of this locality, which looks like a real place, has now been answered by a happy discovery: it is Klausen in the South Tyrol,[50] a free interpretation but unmistakable once it has been named. Dürer must have brought home a careful study from his journey, such as several others we know. This discovery establishes once and for all that the picture does not allude to a particular event.

Historians who like to construct rational graphs of an artist's development would take this engraving of Nemesis to be a declaration of a programme, meaning that Dürer wanted to turn his back on a less naturalistic past and announce his decision to champion native subjects willingly and exclusively in future. But the facts do not allow such an interpretation. The *Nemesis* is immediately succeeded by the engraving

of *Adam and Eve* of 1504 (B.1) where the poses are entirely Italian and the bodies—*horribile dictu*—follow a strict set of rules of proportion in all their main measurements (Plate 3).

This engraving is not popular. It cannot be popular, for it cannot be approached through its subject-matter at all. Indeed there is hardly another representation of the Fall which is conceived more superficially. The two people are standing coldly side by side, both have the appearance of statues, neither shows particular concern. Why does Adam raise his arm? That this gesture originated somewhere entirely different is only too obvious.

In fact the formal motifs in this engraving were ready long before they were made into the specific subject of 'Adam and Eve'. Should its true significance thus lie in its form? But even our enjoyment of this form becomes questionable when we learn that the bodies have been constructed according to certain proportions. The drawing showing the actual method of construction still exists (w.422), if only as a tracing after the engraving.[51] It provided the point of departure when Dürer began to develop a slimmer proportional system for Eve in Italy. The later origin of the drawing of Eve (w.424) had already been recognized by Justi. The fact that there are 'constructed proportions' has a disenchanting effect on the majority of art lovers, whose interest vanishes as quickly as that of children who are told that a story is untrue. The public only sees the establishment of laws of proportion as a whim of artists who lack a deeper feeling for nature (would they not be content otherwise with the simple appearance of reality?), and they are not at all inclined to pay attention to a demonstration of this kind, for it is well known that one such scheme leads to another.

In Dürer's time things were different. The proportions of the human body were a great and exciting contemporary problem. And when Dürer heard of it for the first time he would gladly have given 'a new kingdom' just to obtain more precise information of how an image of man could be made 'according to measure'. To understand this one has to remember that the natural perfection of man was an entirely new concept. When Jan van Eyck painted a figure of Adam he did not ask if it was the figure of a handsome or not so handsome man, he just painted a man. The representation of characteristic features which the new realism introduced entirely suppressed the question of beauty. When it was taken up there was still the old answer: beauty is not of this world. An ideal beauty for the nude figure did not exist at all. This changed gradually towards the end of the Quattrocento. Memling already thought differently from Jan van Eyck, and at the turn of the century the old concept of a beauty which is inherent in man's natural state rose up gloriously. Not only is the nude re-established at the centre of art, but the eye begins to see beauty in the natural body again and not in a body which has been changed this way and that; though it is true that only a few men's bodies retain their natural beauty, and

human judgement is weak and cannot grasp visible beauty evenly and securely. One person likes this man, another a different one. We may find two entirely different individuals both equally beautiful, and yet, how is this possible? One of them must be the more beautiful! It only means that our idea of beauty is not distinct enough to judge decidedly.

By reproducing trains of thoughts of an obvious platonic bias I do not go beyond what could have occupied Dürer's circle, though he only commented in this way at a later stage. But similar worries may have occupied him early on—this is in the nature of the problem. If only he could leave behind the confusing variety of individual, natural features and reach stable, secure ground—the image of man as he ought to be! And how moving is his belief in the books of the ancients; that the Greeks and Romans knew the secret and wrote it down, but that the books had been lost. The Italians had been working for several generations to rediscover the ancients' art and a messenger of these Italians, Jacopo de' Barbari, was on the track of the secret. He showed Dürer a few things but not enough, so that Dürer had to go on without assistance. He turned to Vitruvius. But even this was not quite sufficient and he started his own speculations, which must have been very exciting as the aim of these researches was nothing less than the discovery of man, an account of how God made man and woman.

Dürer's search for rules of proportion does not begin in 1504 but goes back to about 1500. The first certain piece of evidence is a drawing in reverse of the woman in the print of the *Sea-monster* dated 1501. Jacopo de' Barbari, who was the first person Dürer heard treat this subject, had been in Nuremberg the previous year. Neither does it seem strange to me that Dürer let several years pass before he dared to design a 'construction' on copperplate; and the confidently constructed figures of Adam and Eve, seen in strictly frontal view with all the main planes clearly discernible, show quite explicitly that they have been 'constructed'.[52] But new proportions are not the only subject of the engraving. With a different body we get a different movement. We can hardly imagine what it meant to throw out the whole inventory of traditional ways of showing movement, to see completely new conceptions of standing, walking, bending and poise of the body. I have already hinted at this above. A number of sheets of the *Apocalypse* and the *Large Passion* show how old and new characteristics are not at first organically united. Nowhere has Dürer dealt more thoroughly with these problems than in the engravings. Adam and Eve mark a temporary conclusion. Adam's stance was something entirely new at the time, and in Eve, with her weightless leg trailing negligently, the ancient melody of the body was again heard in its pure form for the first time in centuries. Here too Italy and classical antiquity were Dürer's aim and model. Barbari may have provided some information but Dürer must have had other, richer sources as well.[53]

But the significance of the engraving is not confined merely to form

or movement. These are only transitory values; the really important characteristic, which makes the work a focal point in the history of German art, is the new concept of an underlying pictorial clarity. For the first time we find human bodies which are developed from an understanding of their joints; a representation which seeks to be comprehensive, not in the sense that a chance view has been taken up more carefully than had been done formerly, but in the sense that the body is made to display its form completely. And the joints are the factors which determine the form.

The motif of Adam's movement is composed of the leg which carries no weight stretched to the side, one arm lowered and the other raised and the head seen in profile (facing the opposite direction to that leg). One feels immediately that this motif did not originate here; it was taken over from a different context and once belonged to a figure of Apollo who carried a sun in his raised hand and a staff in his lowered one (London; Plate 42). In a tracing after it, the so-called Apollo Poynter, he carried a bow. A later variant (Plate 43) shows a Polycletan type as Aesculapius, accordingly with different attributes (Berlin) and presumably inspired by a classical sculpture. The Zurich drawing of a figure of Apollo with the sun, a bow and quiver was developed from this. It must have been the last in the series, as it shows how the sharp light from the left causes to fall on the weight-bearing leg the shadow cast by the leg which does not carry the weight and is bent forward, in the same way as it does in the engraving, though only in the engraving are the layers of hatching developed to the full. When Dürer decided to use this sculpturally valuable motif for a figure of Adam he retained the pose of both arms, although he could only explain it in one case with difficulty and in the other not at all. For why does Adam have to hold on to the branch at precisely this moment and what is the meaning of this hand which demands something so energetically? (In the preliminary design it held an apple.) On the other hand, a loftier beauty was unexpectedly found in the way the head turns towards Eve; only with this is a coherent flow of movement attained in the figure. The initial motif of the leg which carries no weight seems to find its continuation in the direction of the head. This was always to be the case in later works.

Formerly it was an accepted certainty that Dürer must have had access to a copy of the Apollo Belvedere. But if one compares the engraving with the statue one finds that the similarity is only a very approximate one. The differentiation between the arms, one horizontal and one lowered, is similar, and so is the profile position of the head, but in the statue Apollo looks towards the raised arm and one leg is set behind the other. If the preliminary drawings are taken into account one finds that the source for Dürer was once again an engraving by Mantegna, the *Bacchanal with the vat*, though it is true that this in turn was based on classical sculpture.[54] Whether one has necessarily to

presuppose a knowledge of a classical type of Venus for the Eve figure seems rather more questionable to me. In any case the Venus in the *Doctor's dream* (Plate 37) looks forward to the figure here, only now it has been put into the obligatory frontal position.

The bodies and heads (for the heads are constructed too) somehow lack individuality, which is only natural; but the arms are drawn purely from models. The original drawing of the lowered arm used for Adam has been preserved by chance, and the left arm of Eve which looks like one of the wind-warped tree-trunks in the engraving of St Eustace also suggests a literal transcription from a model (with scrawny upper parts), looking strange enough beside the 'regularized' torso. Dürer may have been thinking of himself when he later warned artists against combining limbs from different types of body.

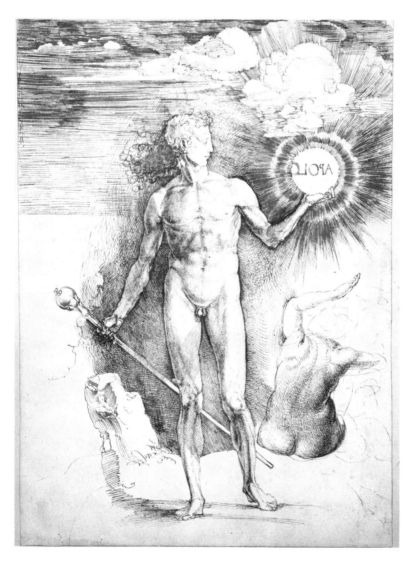

42. *Apollo*. 1501/2. Drawing, 285 × 202mm. London, British Museum.

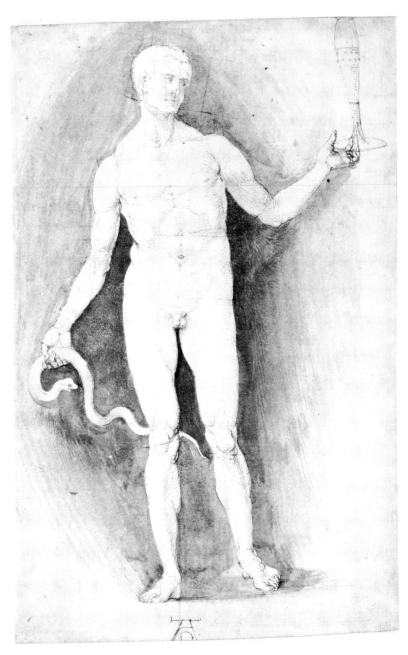

43. *Apollo*.
About 1501. Drawing,
325 × 205mm. Berlin,
Kupferstichkabinett.

He would have called Eve 'gentle' but Adam, 'a hard kind of figure
of strong character'. He differentiated the downy female skin from the
tougher skin of the man and forced his burin to show subtleties which
surpass even those of the *Nemesis*. But the main triumph of his drawing
lies in its clear delineation of sculptural form. Here the principle of the
line designating form has been exploited in all its consequences. The
verticality of the thighs can still be compared to Schongauer's style but

123

the circular lines enclosing the torso are essentially modern. The compression of the muscles of the raised arm is expressed in transverse lines; the shadow of the stretched lower leg is represented mainly by longitudinal lines. (The way the shin bone becomes visible is reminiscent of Mantegna as well as Pollaiuolo.) There is a sharp distinction between the dark parts of the modelling and the cast shadows; the lines of the modelling shading are the only ones which need to follow the form, the lines of the cast shadows pass over it.

A few studies of animals have found their place in the wood of Paradise. Cat and mouse lie peacefully at the feet of the first human couple; there is also a cow, a stalking elk, and so on. The cat with its soft furry coat goes together with Eve. Baldung too sometimes shows this combination in his pictures. As F. Th. Vischer said, the skin of the higher mammals invites us to stroke it.

In contrast to the *Nemesis* the figures are here set off by a dark foil, for the background of tree-trunks has been formed into a carpet of complex tones. Two splendid specimens with beautiful bark provide two light patches beside the figures, though they are not really used in the sense of a contrasting linear accompaniment.

44. (*left*) *Ensign-bearer*. About 1502/3. Engraving, 116×71mm.

45. (*right*) *Apollo shooting an arrow*. 1502/3. Engraving, 116×73mm.

It now remains to mention a few variations of the Adam motif. The *Ensign-bearer* (B.87) is a direct continuation of the theme, though in reverse. The head again is turned towards the lowered shoulder. This subtly balanced figure with its enriched contrasts possesses great vitality (Plate 44).[55]

Of even greater importance is the *Apollo shooting an arrow* (B.68; Plate 45), which is only related to the figure of Adam in so far as Adam had his origins in a drawing of Apollo holding a sun and staff. And in that drawing Apollo was already accompanied by a seated figure, his sister Diana, seen from the back. This is the carefully executed drawing in London mentioned above which was obviously meant to be engraved. The contrast of male and female bodies, heightened by a contrast of movement, has here been retained.[56] But our archer is essentially a figure in profile. The first moment of drawing the bow is shown, not the last, as was more usual; the energy of its upward movement is ravishing. The arms are completely horizontal, almost cover each other, and show an immense concentration of restrained strength. This motif is a painterly and not a sculptural one. A related engraving by Barbari exists (B.16); in this, sculptural clarity has been achieved in the Italian manner by showing one arm drawn back. The beautiful figure from the Apollo fountain in Nuremberg (1532?), made in Vischer's foundry, is similarly conceived. If it is really dependent on Barbari, it could indeed be said that German art lived on the crumbs which fell from Italian tables.[57]

There are still a lot of places in Nuremberg which look the same today as they did four hundred years ago, and people's daily occupations may not have changed all that much either. How strange it is to imagine in the midst of Gothic churches, steep gabled houses, and the throng of the market, Dürer's Adam and Eve, that powerful, idealized couple for whom corresponding images could not be found in life. But Dürer also had an eye for life; the early engravings contain a number of contemporary figures, and one may ask why there were not many more spheres of life portrayed in his art, why he did not develop any comprehensive scheme for showing the manners of the time. In answer to this it may be said first of all that not a trace of concern in *modern* manners must be imagined in Dürer. He was not at all interested in grasping the atmosphere of life of particular classes, to describe for example a poor man's joys and sufferings. The *Ensign-bearer* is not a representation of one aspect of a soldier's life, but a composition in movement; and when Dürer shows peasants they are not workers in the fields who plough, sow and harvest, but comical figures who make the city dweller laugh.[58] And there was another factor which made impossible a broad depiction of social life as we would like to see it—Dürer demanded too much from the execution of single figures to engage in representations of the activities in a public house or in the street. One looks in vain in his work for

animated scenes of contemporary life with many figures such as were drawn by the Housebook Master. Dürer is somewhat more communicative in his woodcuts—the crowded scenes of the *Life of the Virgin* have a real feeling for the manners of the time—but he esteemed the engraving too highly to include it there. The drawings are even more explicit. The Albertina possesses a series of coloured figures (w.226ff.), showing the Nuremberg woman as she goes to a dance, to church, and so on, and an armoured horseman of 1498 with the inscription: 'This is what the armour was like in Germany at that time';—they are all single figures taken up as much for scientific interests as for artistic ones, for the same scientific interest which at other times made Dürer record the exact analysis of a piece of armour, a shoe, the cloak of a Beguine. He preferred to show a single woman going to church rather than the procession, a costume for dancing rather than a dance.

This is a very characteristic feature of Dürer's art. I do not say that the other interest was entirely lacking, but his attempts to capture the flow of rich, momentary events with a fleeting stylus are as rare as his preoccupation with movement as such. All the drawings which can be cited as evidence here are of a relatively early date. And Dürer exploited landscape much more fully than genre motifs. In some cases the accompanying landscape is developed to such an extent that one could almost speak of an independent landscape engraving. Probably the *Prodigal son* (B.28) is most surprising for the modern onlooker because here we find most clearly what we call the 'atmosphere' of a village setting (Plate 46). The farm with its uncomfortable and desolate appearance seems as wretched as the poor sinner himself who kneels at the pigs' trough. But Dürer did not intend to produce a landscape conveying a particular mood. He gave it the greatest painterly richness possible; and it is only the primitive treatment which produced this cold effect. But what is new is the way the landscape is connected with the figure. Houses and farms, towns and palaces had always been painted, but these always appear to be separate, existing independently beside the figures. Here the setting is positively clapped on to the figure which has been set into the space (though the middle ground is not yet entirely clear). The design in London does not yet have this relation, although all the architectural details are there. There is a strong vitality in the pushing pigs, and the praying figure does not lack a feeling of urgency, but the impression is nevertheless impaired by the strange confusion of the legs. Left cannot be told from right. In date the engraving must be put before the completion of the *Apocalypse*.

After a short interval there follows a second penitent, kneeling figure in an open landscape, the *St Jerome* (B.61). The execution shows much greater tonal richness. The saint, rough and resembling a forester, looks like an amiable colleague of the kidnapper in the *Sea-monster*. He is kneeling in a barren hollow which is drawn with splendid flowing

46. *Prodigal son*. About
1497/8. Engraving,
246 × 190mm.

lines. In the background there is an opening in the rocks. The
weathered and corroded parts of the stone must have given the
draughtsman intense pleasure. He has used motifs from Nuremberg.[59]
But under his burin the rocks have taken on a metallic, hard appear-
ance. There is no intention yet of connecting the figure with the
shapes of the landscape; even the effective, energetic darkness of the
wall of rock has not been made use of as a foil. A characteristic indis-
tinctness of this undeveloped style is produced by the combination of
the ground's contour with that of the head and shoulder of the figure.
As yet there was no feeling that such connections were objectionable.

A further step in the development of the independent landscape is
made in the large engraving of *St Eustace* (Plate 40) which already
belongs to the stylistic period of the *Life of the Virgin* in its subtle draw-
ing style. I have already tried above to give an indication of the nearly

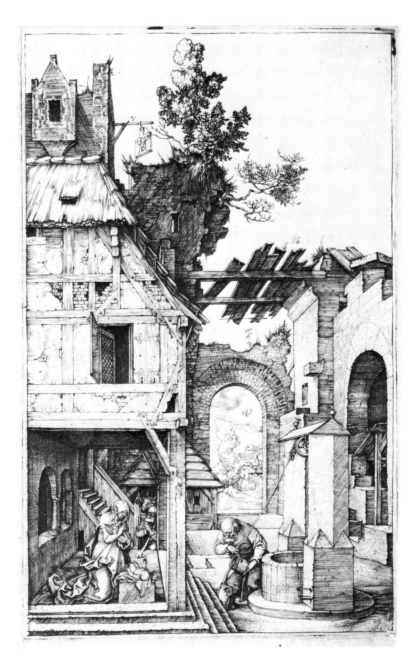

47. *Nativity* ('*Christmas*'). 1504. Engraving, 183 × 120mm.

inexhaustible subject-matter of this print. However, it can also be seen that this conception tends to produce single details rather than co-herent compositions. The greater the detail shown of a single branch, a single plant on the ground, the more they tend to be viewed in isola-tion. In this respect too it can be said that Dürer shows trees but not a wood, a tuft of grass but not a meadow; and there are the same differences between engravings and woodcuts as those we discussed in the case of human figures.

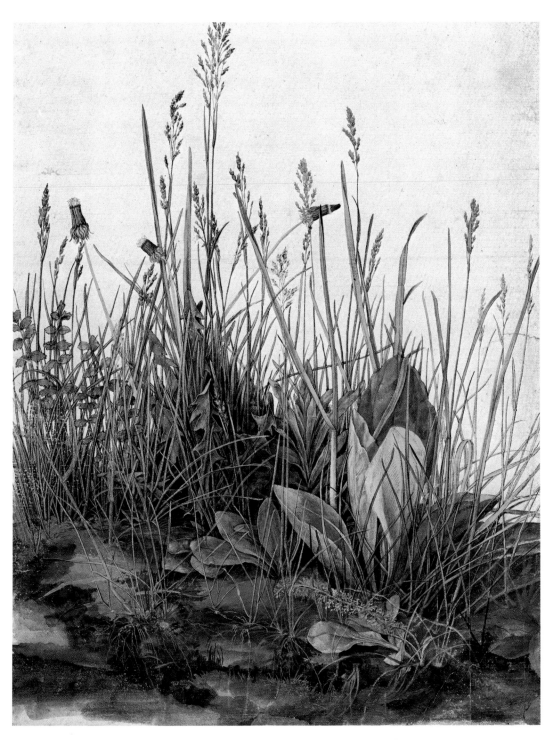

V. *Large piece of turf.* 1503. Watercolour and body-colour, 410 × 315mm. Vienna, Albertina.

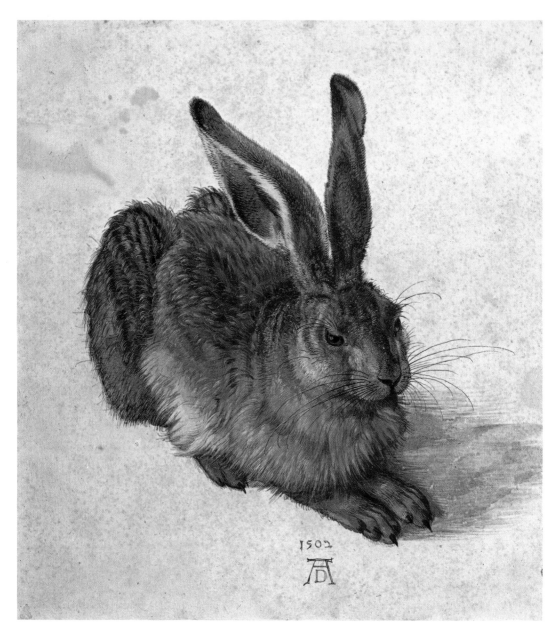

VI. *Young hare*. 1502. Watercolour and body-colour, 251 × 226mm. Vienna, Albertina.

The *Nativity* of 1504 (B.2), called *Christmas* by Dürer himself, is an engraving of the highest perfection of detail, and yet it is more coherent than the previous ones (Plate 47). It is really an architectural view, the buildings making the figures seem quite insignificant. A farmstead is shown with many corners and nooks, with strong patches of darkness and delicious floating shadows, with crumbling half-timbered walls and delicate, gaily spreading brushwood on the towering ruin. And this is not just observed with the eye of a naturalist who likes to show up the accidental and the appearance of decay as trump-cards of his realistic art; the atmospheric values of form and light have been appreciated and used to give the setting the charm of a snug enclosure and a friendly liveliness. Of course one must not expect more than a decorative harmony of black and white—the window openings, for instance, are too black. Ten years later Dürer would have treated them differently, but in comparison with earlier works the gradation of light in this print is already very advanced. In the first impressions the shadow around the well is exquisitely soft, and how pleasing is the dark tone of the gate through which the eye goes out into the sunny landscape. Some romantic element always had to be present. A locality of this kind could not have been found anywhere in Germany. The imagination wants to express its fancies, here, as well as in the open landscape with its towering mountains.

The early paintings and watercolours

It is not true that colour had no significance for Dürer. In his youth
especially he had a strong feeling for it, and I do not know of anything
that has a more unexpected effect than the landscape watercolours of
this time. They contain colour observations which promise a com-
pletely different development in his painting from what we know.
From the beginning there is a gap between the large paintings and the
colouring of the drawings; and in his paintings Dürer distinguished
between two entirely different styles according to whether he painted
with oils on wood, or with coloured washes on canvas. The first kind
was the popular one and it is here that he came nearest to his woodcut
style; the second was the refined style which he had acquired in Italy.
Here he sometimes showed such remarkable restraint in his treatment
of linear movement that one almost loses sight of its connection with
the rest of his work.

 Right at the beginning there is an enigma. This is how I think of
the *Dresden Altarpiece* (Plate 48) as it does not really fit in anywhere—
it embodies contradictory features and has always been embarrassing
to the biographers of Dürer—whether they admitted it or not. It is a
triptych: in the centre the Madonna is adoring the sleeping child; St
Anthony and St Sebastian are shown in the wings which could

48. *Dresden Altarpiece:
Madonna and Child
with St Anthony
and St Sebastian.*
About 1496.
Tempera,
121 × 188cm.
Dresden, Staatliche
Kunstsammlungen.

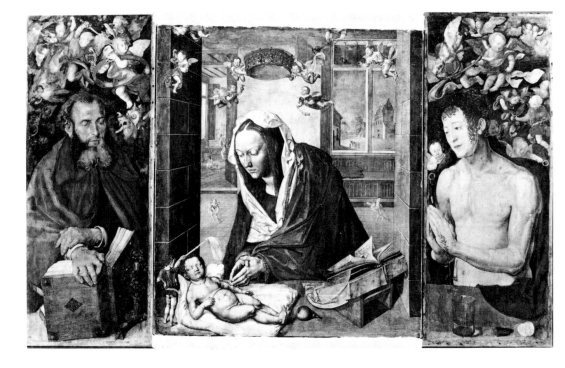

originally be folded. They are half-length figures of life-size. The medium is watercolour or distemper on canvas.

It is a picture which is not easily forgotten: it is harsh and lacks charm, but it is impressive and of moving visual solemnity. One notices immediately that centre and wings are not in the same style. The saintly men have a friendly look and recall other Dürer figures, but the Madonna has such a stony chilliness and everything around her is so bare and inert that the onlooker is taken aback. Is it possible that the draughtsman of the *Apocalypse* painted this? Can the young Dürer, for whom everything was transposed into linear movement, who gave life to the very smallest corners of his pictures, suddenly show such an entirely different face? And it is no less surprising to find a kind of pettiness in the way the important foreshortening is carried out and weaknesses in the drawing of the child's body which do not seem compatible with Dürer, or with any great artist for that matter.

Critical examinations at the beginning of this century showed that we are confronted with a picture which has been much spoilt. The pilasters with the visible courses (in conspicuous perspective) are additions, so are the reading desk with the cover, the floor and ceiling, and the background furnishings; and a foreign and pedantic hand has retraced the lines of the figures in the places where they are petty and lack energy.

Dürer wanted to record the powerful effect of life-size foreshortening. Volume and space were important rather than filling a plane decoratively. The effect was gained by purely linear means. The way the Madonna bends her head towards us is striking even today; in the context of contemporary German art the picture was unprecedented. Furthermore, it is isolated from Dürer's other paintings. The type of the Madonna has its nearest equivalent in the standing woman in the engraving of *Jealousy* (Plate 39), and at most it can also be related to the *Madonna with the monkey* (Plate 31). The overall effect is, however, still rather traditional, so there should be no objection to dating it 1496.

The Italianate character lies more in the simplicity of the lines and the vividness of the foreshortening than in the subject-matter. The sleeping Christ-child occurs in Italy, it is true, but this child is a northern one and is particularly reminiscent of Flemish types. The motif of the parapet is known in the north as well as in the south and this broad type is not southern. Costume and hairstyle of the Madonna are altogether un-Italian. The downward pointing hand (often with the thumb crossed) is typical of Flemish Adorations. In any case an Adoration like the one by Geertgen of Haarlem (London) is nearer to the Dresden Madonna than any north Italian work. Even Bramantino's adoring Madonna in the Ambrosiana could not have been conceived without Flemish inspiration; but this picture has an importance which goes beyond single motifs: it provides the most striking parallel yet known for Dürer's figure of the Madonna.

The figures of the wings appear of later date, which may be explained by Dürer's fast development as a painter. They must have been begun only after the completion of the centre panel. After the great Italian journey Dürer would have demanded more spiritual expressiveness of the saints. These figures have suffered less, although they are not in perfect condition either. Presumably the throng of angels was originally somewhat clearer and brighter. St Anthony (with monsters which are overpainted) has a beautiful old man's head, marked by care and worry—the figures of Joseph in the woodcuts are his forerunners. St Sebastian, a sympathetic, trustingly praying youth, is most important as an example of a life-size nude figure in the new style. The structure of the chest and shoulders has been marvellously understood and is rendered perfectly clearly. The hands (unfortunately quite ruined) must have been a masterpiece. An almost identical drawing of them was made later in connection with the studies for the Apostles of the Heller altarpiece (1508). A glass with a flower in it stands on the parapet, a motif which is easily explained by the painterly tendencies of this time particularly, but the effect has been modernized. Dürer never painted as broadly and in such an iridescent way.

Dürer must have liked the technique of tempera painting on fine canvas with very restrained colours. He used it later on as well, when he wanted to express something out of the ordinary and when he worked for discriminating clients. The self-portrait which Dürer presented to Raphael was done in this medium. It satisfied his inclination for very precise drawing and was by no means unknown in northern art (see van der Goes), though the impression of a metallic, hard style in such paintings was undoubtedly derived from Mantegna.

A portrait in Berlin (Plate 49) immediately precedes the Dresden Madonna. It is a strangely gloomy, wide-eyed portrait which is thought to represent the Elector of Saxony, Frederick (the Wise), the same man who afterwards commissioned the Dresden altarpiece. The format of the portrait alone shows that Dürer was attempting something important here: it is a life-size bust with hands. But again it has a conspicuous rigidity which is not recognizable in Dürer's other works; all his other portraits are treated differently. Dürer here renounces the help of linear movement without which, in the other cases, there would have been no life. The diagonal fall of the cloak even has a cumbersome and laboured effect. And the temperament of the whole picture seems to be like this; the hands (one of which is damaged) are crossed feebly and lack the functional energy which Dürer normally imparts even to motionless forms. Did he want to follow some Italian pattern? For me the head is not convincing either. The great scheme did not fully come to life. Some feeling of emptiness remained. But at the same time the picture is an attempt to give expression to human greatness, which does Dürer honour and which is quite unequalled in German art at the end of the fifteenth century.

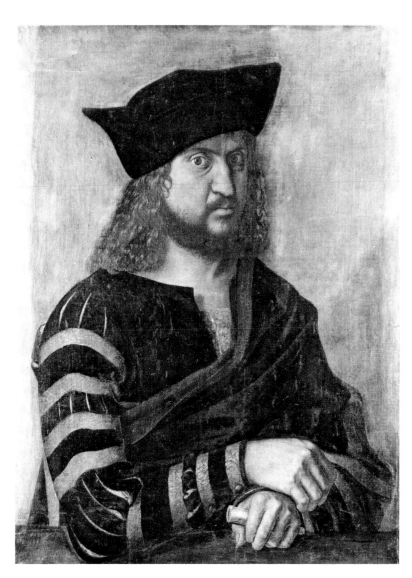

49. *Elector Frederick the Wise of Saxony.* About 1496. Oil, 76 × 57cm. Berlin, Staatliche Museen.

The most telling indication of Dürer's interpretation of individuals at this time is the *Portrait of his father* of 1497, that is, seven years after the first portrait. The picture must have been famous, and there are several versions (Erlangen, Frankfurt, two in England). The version in London—although not the original itself—has the advantage of being the most trustworthy portrayal; this is really the same man as in the picture which Dürer painted before setting out on his apprentice-journey. But how he has imposed his concept of nature's grandeur on the old master goldsmith; the shy and weak figure has grown into an old man whose appearance is almost majestic. This new effect is not only based on the changed relation of the figure to the space, on the inclusion of more of the figure, nor can it be explained by the more imposing drawing of the gown and cap. The motif of the head turned

133

to one side with eyes looking directly at the spectator is also only of secondary importance, effective though it is. The decisive characteristic is the way in which the head is now seen in its full and essential form and the onlooker is not attracted by details but by the whole. New aspects are stressed in this way. Now a wide chin responds to the wide cheek bones. Dürer has realized the importance of the jaw-bone in the structure of the head. The forehead is laid bare. Nose and eyes have become very important. And of course it is true that Dürer now confronted his model with a different attitude, seeing what was magnificent in the features of this old man battling with life. The line of the mouth is full of seriousness and the movement of the raised brows has surely been stressed beyond what is natural, with a definite view to effect. This is a truly linear work of art such as one would expect from the artist of the *Apocalypse*. It is very similar in appearance to the *Elector* and yet entirely different in its means of expression. The original was evidently painted on wood.

There is another portrait, also done in 1497, whose character is immediately convincing although only copies seem to have survived— the so-called *Fürlegerin with hair bound up*. It is a girl's carefree head with strongly curved lines and an almost vehement movement of planes. It is bust length with joined hands. The surrounding space has a vertical division at the side with a view out of a window.

I mention the picture because there is a second, more famous portrait of the *Fürlegerin with hair unbound* (Plate 50; well-known versions in Augsburg and Frankfurt), which is also dated 1497. But it is dubious in every way, in date, name and monogram. Of the two versions the one in Frankfurt is the better by far but it is not the original. It may have been a very beautiful picture with the slightly lowered head framed by waves of abundant hair, the broad, even distribution of light taking up most of the plane—one is reminded of Leonardo. It is difficult to relate it to Dürer's early works. Parallels in the atmosphere could more easily be detected in the circle of the Venetian works of 1506. The Christ-child of the Barberini picture had a similar Leonardesque inspiration. A possible explanation might be the suggestion that the original was a picture on canvas in the style of the paintings mentioned above, if one also recalls the Leonardesque elements of the *Madonna with the monkey* (Plate 31). The study on canvas of a woman's head with lowered eyes (Paris, Bibliothèque Nationale)—with which it has been compared and in which Pauli would recognize Dürer's wife Agnes—has remarkably broad lighting for the suggested date of 1497.

The development goes on to the well-known self-portrait of 1498 in Madrid (Plate II), the *Oswald Krell* (Munich; Plate 51) and the small Tucher portraits (Kassel and Weimar) with the addition of the so-called *Hans Dürer* (Munich), dated 1500. All these paintings are on wood and have a uniform style which is only varied in the degree of detail in the treatment. The more abridged the expression, the more

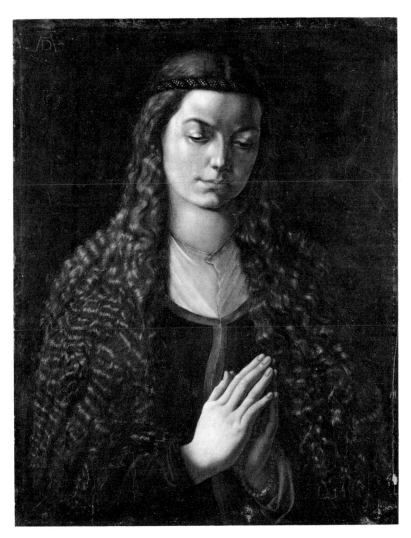

50. *Fürlegerin with hair unbound*. 1497 or 1506. Oil, 56×73cm. Frankfurt, Städelsches Kunstinstitut.

Dürer seems to be inclined to try to achieve the effect he wants by using the stylized drawing of the woodcuts. Thus the stormy, impulsive, vivaciously exaggerated line in the portrait of the hot-head Oswald Krell has an almost aggressive character.

The next years were calmer and produced an accomplished subtle style. The small womanly head of the Madonna in Vienna (1503) is a characteristic example of this serenity. As far as portraits are concerned we are almost wholly dependent on drawings. If a broad judgement can be reached on this basis it can be said that Dürer tried increasingly to capture the momentary expression, even the surprising viewpoint. He tried to render different smiles and make use of the most expressive features, and developed an astonishing ease in quick charcoal drawings and lightly executed pen-drawings; but his psychological insight appears somewhat superficial in comparison with the masterly analyses of the later years. The drawing of the body found in the *Large*

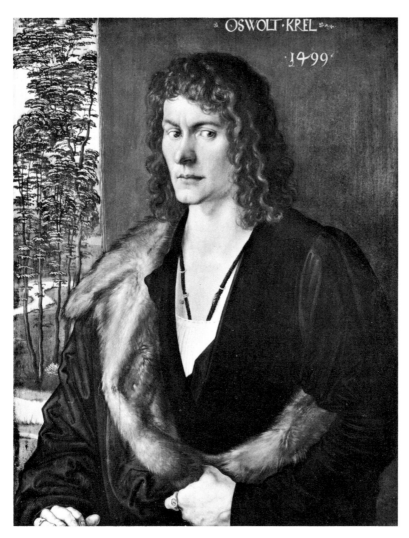

51. *Oswald Krell.* 1499. Oil on wood, 49.6 × 39cm. Munich, Alte Pinakothek.

Nemesis has no corresponding delineation of the soul of equal per-
fection.

On the other hand, two of the most lovely religious pictures were
done at this time, the *Paumgärtner altarpiece* (Plate III) in Munich
showing the Nativity, and the *Adoration of the Kings* in Florence,
which have the full charm of youth. The latter is dated 1504, the first
precedes it by one or two years.

The picture of the Nativity reveals a treatment of space similar to
the more mature engraving of *Christmas* (1504). A yard is shown with
a view through a large arch in the background, only of course in this
case the figures are not merely adjuncts but predominate. Joseph and
Mary, placed diagonally, are kneeling, a small crowd of children
(Christ and administering angels) are between them, and this friendly
gathering fades away in the rows of small donor figures towards the
front corners. The picture has gained very much from the recent

136

restoration, as the discovery of these donor figures has re-established the old rhythm of movement and the original piquancy of detail covering the plane. Much new, colourful life in the sky has also been revealed.

It is well known that the helmets from the large figures of the knights were removed during this restoration as well; instead of the shield the vanquished dragon appeared in the hand of St George, the horses disappeared and instead of the landscape background we now look at a simple black foil (much narrower than before) on which the men with their fluttering white banners appear in unimagined monumentality. A new outlook was expressed when the old wings, divided into panels, were conceived of as *one* plane and this plane was filled with near life-size figures; and we can hardly believe that such figures could be portraits, figures of donors in the guise of saints. The self-esteem inherent in this demanded the most impressive style in the representation of the person concerned. And it is interesting to learn from this Paumgärtner altarpiece what was thought of as an impressive style of living in Nuremberg at the beginning of the new century. The pose of both men is modern. One of them (with the same stance as the Adam in the engraving) poses in a markedly Italian manner, the other one seems to be more German: both his feet are firmly planted on the ground, he bends slightly forward, one knee is straight; but this is a motif also used frequently in Italian art.

The wonderful *Adoration of the Kings* (Plate 52) in the Uffizi shines like a jewel on the wall with especial brightness as it has two paintings with dark grounds at each side. This picture, which comes from the palace chapel in Wittenberg, must have been painted with the greatest care. The motif of mother and child is happy and light-hearted in invention, the flesh is radiant, the garments dark and splendid and everything, including the background, suffused with gaiety.

The *Adoration of the Kings* was not a single panel of the kind Dürer introduced after his second stay in Italy, but a folding altarpiece, as was normal at the time. Recently the panels of the so-called Jabach altarpiece, whose central section was thought to be missing, have been identified as the wings of the *Adoration*. Two standing saints on gold grounds are shown on each wing, as if present at the Adoration: on the left St Joseph and St Joachim, on the right St Simon and St Lazarus (Munich). On the back of the wings of the altarpiece is a representation of the suffering Job (Frankfurt and Cologne) who feels his bodily and mental pain relieved by water and music, and this is to be taken as a counterpart to the Adoration. Consolation in hardship and sorrow is followed by the gift of a preventive against leprosy and plague by the three Kings. Dürer painted the altarpiece in 1504 for the palace chapel in Wittenberg as a commission from Frederick the Wise who saw himself and his land threatened by a 'swift plague'.[60]

Am I saying too much if I state that this *Adoration* is the first picture

in German art to show perfect clarity? It only has to be viewed in conjunction with other contemporary works of art, for it to be recognized how the subject is presented with an even perfection, how the motifs develop from each other as a matter of course and how each is spread out before the eye without the least difficulty. This considerably surpasses the corresponding scene in the *Life of the Virgin*. The background, entertaining though it is in its own right, is already firmly connected with the figures; it follows the direction of movement of the group and provides an effective foil for every single figure.[61]

As in the draughtsmanship, a new economy in the colour, based on simplification and assertion of contrasts, can also be found. Only three colours are 'eloquent': the blue of the Madonna, the red of the kneeling King and the green of the standing King—the Moor only has a slate-grey coat and his trousers are of a cold red. The harmony of the three key colours is set off by a unified, neutral background: ground and walls are of the same light brown.

There are black contour lines everywhere. No attempt has been

52. *Adoration of the Kings*. 1504. Oil on wood, 98 × 112cm. Florence, Uffizi.

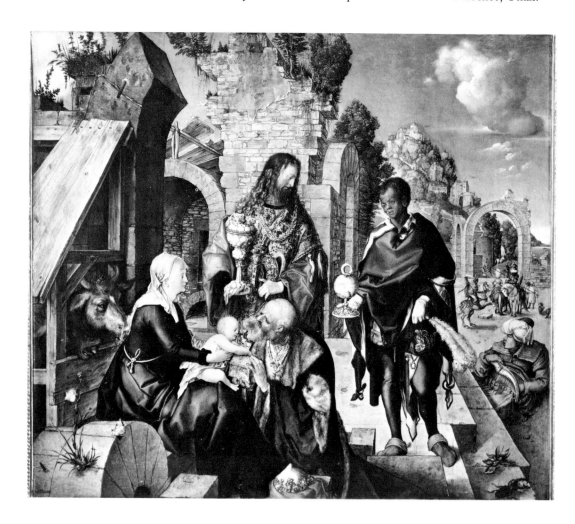

53. *Wire-drawing mill.* About 1494. Watercolour, 286 × 426mm. Berlin, Kupferstichkabinett.

made to produce a naturalistic colouring. There may seem no special need to mention this, but it is not at all self-evident. Dürer has kept within these boundaries to produce a decorative effect, although his sketches from nature prove that he had already gained quite a different kind of experience of the colouring of the world, and that he could not have been unaware of the possibility of a more natural colouring.

Of these 'nature' subjects the landscapes are the most characteristic. We have quite a number of them, executed in watercolour and gouache. As these sheets are very important and as through them Dürer is the true founder of a whole category of art, we shall discuss them here as a group.

Among the earliest works are a few views of the surroundings of Nuremberg which the young Dürer had probably already made before his long travels. Such is the *Wire-drawing mill* (Berlin; Plate 53); the individual details still play a dominant part but the sheet has great charm in its comprehensive and lingering vision. How much life emerges all at once! One might contend that it would have been better if the interest were not so much confined to the details and the scene had been presented more coherently. Dürer did this later on, but—and I know it is 'unartistic' to make this judgement—these primitive drawings surpass all others in the charm of their descriptive power.

In comparison to the *Wire-drawing mill* the view of Nuremberg from

the west does not only show the abandonment of linearity but above all it gives an impression of progress because of the strong effect produced by spatial unity. The relative distances are more explicit, the receding planes follow smoothly one after the other in contrast to the staggered effect which resulted from the high focus point in the other sheet. Dürer had arrived at this kind of horizontal composition in Italy. It already determines the appearance of the view of Trent which must be regarded as immediately preliminary to the view of Nuremberg. The admirable richness of the colouring is no prejudice against such a classification. We know this from similar cases. The landscape with the little house by a pond (Plate 54) which was used in the engraving of the *Madonna with the monkey*, and is thus certainly not much later than 1500, is one such painterly study from nature which we would have to reject as impossible if we merely took the paintings which were contemporary with it as a guide for comparison.

Look at the surface of the water between the sandy banks with the reflection of the evening sky. The red roof of the small house rises among green willows, there are violet clouds in the corner above, which are complemented by a dark boat in the opposite corner at the bottom. The bank is a dark ochre with light blue mountains above; there is a yellowy red glimmer on the horizon. The sunrise in the *Pond in the woods* (London; Plate IV) is even more remarkable. Dürer presumably tried to reproduce the spectacle of the sun's rays flashing through the clouds from memory. A vivid orange-yellow strikes against bluish purple banks of clouds. The sky is red at the rim. The pond, which is surrounded by trees, radiates an intense blue in the centre; at the front it lies in deep shade. Is it the sun breaking through once again after the thunderstorm? One cannot say; the painting remains unfinished. Unfortunately Dürer never did return to this kind of painterly fantasy. It was Altdorfer who developed the theme—who is not familiar with the fabulous sunset in the *Battle of Alexander* in Munich?

Then comes the period of detailed observation of the kind we have met with already in the landscape of the St Eustace engraving (Plate 40; cf. pp. 114–15). A sheet like that of the castle Prunn on the river Altmühl[62] is closely connected with the mountain and castle in the St Eustace, in its detailed forms and painterly blending of trees into a small wood. Even the flight of birds is there. The *Wehlsch Pirg* is unequalled as far as variations in the form of the land are concerned with the crooked valley between the hunched mountains whose final purple ridge reaches towards the evening sky above the blue-green lower range. Dürer's eye was focused so sharply that even the trees on the slope far in the distance are shown in detail (the foreground is unfinished). If they can be called Tyrolean landscapes they were probably done in 1505 on the second journey to Italy. But it is not necessary to go so far geographically for all of them. The *Mill by the willows* in any case is surely a local subject and it is executed in the same style. There are

54. *House on the pond*. About 1495/7. Watercolour, 213 × 222mm. London, British Museum.

intricate wooden huts close to the water with prominent reflections. The evening sky is a glowing yellow.

At this time Dürer was infinitely contemplative and affectionate. He bent down to the unassuming meadow plants and the poor life of a piece of turf became a whole world for him. He reproduced grasses, cow-parsley, plantain and dandelion in their natural size and in the chance confusion of their growth, doing so with a devotion which shrank from the least omission or alteration. Everything is green, and he had to make distinctions by extremely subtle nuances; nowhere is there a large, comprehensive form, only small individual existences which demand to be represented—and yet the whole is clear and comprehensible. The so-called *Large piece of turf* in the Albertina (Plate V) is dated 1503. Looking at this strange subject one is reminded of the bundle of leather straps in the *Large Nemesis*.

Better known, the *pièce de résistance* of the same collection is the *Young hare* of 1502 (Plate VI). One could swear that there is not a single hair missing, but the real wonder is not the industry but the artistic sense which is capable of incorporating a thousand details into one coherent impression. And how well the textural qualities have been expressed! Although Dürer used colours he saw the subject mainly in terms of linearity; thus, the engravings give a stronger reflection of the atmosphere of such studies from nature than the panel paintings. The cat in *Adam and Eve* (Plate 3) is unique and Dürer never attempted a similar rendering of human skin in his painting as in this engraving. One speaks of a 'textural handling' with regard to the graphic work but not the paintings. I cannot think of a painting corresponding to the *Coat-of-arms of Death* (engraving of 1503, B.101), where the brittleness of the skull and the ringing hardness of the metal helmet form such a wonderful contrast.

One of the characteristics of German art is that it has a strong feeling for texture, that it seems to know the feelings of material things. No kind of existence is unknown to it and everything has its peculiar atmosphere, the drop of water in the jar or the stone on the path. The still life is a product of the north, the southerner regards it more as a mere trick of illusion. There is no great northern painter who did not possess this capacity to be a painter of still lifes.

The Van Eyck brothers had opened the eyes of the world to the richness of surfaces, but it took a long time before they were properly understood in Germany. Painters did paint rich dress materials and reflections on glass and water, they characterized wood and types of bark, they made grasses sprout from cracks and beetles run around on stones, but on the whole it was a sparse wealth because the feeling was not strong enough. There were German painters before Dürer who were more talented colourists than he, but he possessed the greater love. Dürer's world was never again as rich and varied as during those years of the *Life of the Virgin*. His great Italian journey meant impoverishment for him, and he only recovered his old self after 1512. His feeling for still life awoke once again and this mood made possible a work of art like the *St Jerome in his cell*.

Italy and the great paintings

Dürer was in his thirty-fifth year when he went to Italy for the second time. He knew now what to expect and he did not look for surprises but for confirmations. Why he went to Venice is understandable, but why did he not go further? Why did he not go to Florence? He was a draughtsman, and Florence was the city of drawing. He had produced his engraving of the first man and woman, of Adam and Eve: this was his representation of the human figure. In Florence he would have had to compare himself with Michelangelo, and how important Michelangelo would have been for him just because of the cartoon of the bathing soldiers which was already finished at this time! We will not consider the quality of the drawing—Michelangelo was in any case already confronting much more difficult tasks. He presented the body in the most varied movement, he showed it foreshortened in ways which had been thought impossible to represent up to that time, and he did not just produce single figures but showed a great many richly interwoven. How little had Dürer to set against such monumental undertakings, what did his woodcut of the bathing men signify and how simply he had approached the problem even in his *Apollo shooting an arrow*! But of course, where would there have been room for such art in Germany? Later on similar attempts converge in the small copperplates of artists like Barthel Beham.

And besides Michelangelo Dürer would have been able to see a great work by Leonardo, who had started to paint his battle of the horsemen as a counterpart to the *Bathing soldiers* and recorded in it the results of decades of his preoccupation with horses. Did not Dürer have precisely the same interests? Though in this case too he would have found that the concerns of the Italian had gone far beyond the calm representation of perfection and demanded movement and foreshortening and crowded profusion of his own drawings. Dürer was not to remain untouched by Leonardo's genius—we shall come back to this—but for him Italy was essentially only Venice.

And at this time Venice is simply the home of the most tranquil art. The first impression of the town with its waterways, the great calm, also represents the character of her art. Nowhere has the peaceful gathering of figures in beautifully enclosed halls been more enjoyed, bringing complete satisfaction to the senses. The space spreads out calmly, the lines glide along peacefully. At the same time the Venetians possess a remarkable feeling for tonal qualities, for the way in which every shadow is softly implanted and the effect of light is mild and calm. Added to this are the saturated colours with their tender glow—an ultimate, solemn transfiguration of the world.

These are really all characteristics which are opposed to Dürer's manner. What did he want here with his gnarled line? How little capable he would be of following the soft harmonies of the Venetians. One would have thought that he would have felt more at home anywhere else. Yet this is not the case and when he assessed Venetian art, it was the most Venetian painter whom he liked best, Giovanni Bellini. 'Bellini is very old, but still the best.'[63] And we know exactly what he meant by this. There is a large altarpiece by Bellini of 1505 in S. Zaccaria, one of the master's principal works, which Dürer must certainly have seen. Bellini was indeed still entirely fresh, although he was a very old man. He did not repeat older forms, but lifted his style once again to new heights of beauty. What would such a picture have meant to Dürer?

I do not doubt that he was particularly moved by the charming fusion of Mother and Child. He had tried to imitate Italian rhythms for long enough. He may also have already possessed a feeling for the confluence of the contours of figures and surroundings. But what about the Venetian spaciousness of the hall? Bellini had here become entirely simple; he gained his effect with the single motif of the wide niche and the shade of its vault, and he renounced all ornamental details. It is hardly conceivable that Dürer, with his idea of space, could follow this, that he did not feel that the setting seemed empty. The draperies are more richly treated, but they are not merely designed in the traditional linear way as a complex of assorted drapery lines; their charm lies essentially in the refractions of the planes which have no linear interest but add exclusively to the richness of the tonality. This was for the time being far removed from Dürer's own usual treatment of draperies. Furthermore, this is only a single case. Basically we are concerned with the general contrast of a perception in terms of lines and a perception in terms of planes. Dürer the draughtsman was confronted with a fully developed painterly style where the contour disappears and the mass effects of light and dark are predominant, where the form is modelled very broadly, light and shade are soft and the ultimate beauty is sought in the harmony of tonal gradations. This art is sheer harmony and poetry, in comparison with which Dürer's seems like hard prose. He must have felt enveloped by a soft, caressing element but incapable of abandoning himself to it.

This much is clear—the breadth of the Venetian treatment made a strong impression on him. With his innate capacity for taking up foreign elements, he changed his drawing style to follow the Venetian model. The soft watercolour brush which had only been used in a few instances before now took the place of the pen, and coloured paper, on which he stressed the highlights with white gouache, became the norm. The most important characteristic, however, is that the strokes are broader. The lines are calm and the eye begins to see objects in broader masses. Nor do the paintings lag behind the drawings; in the

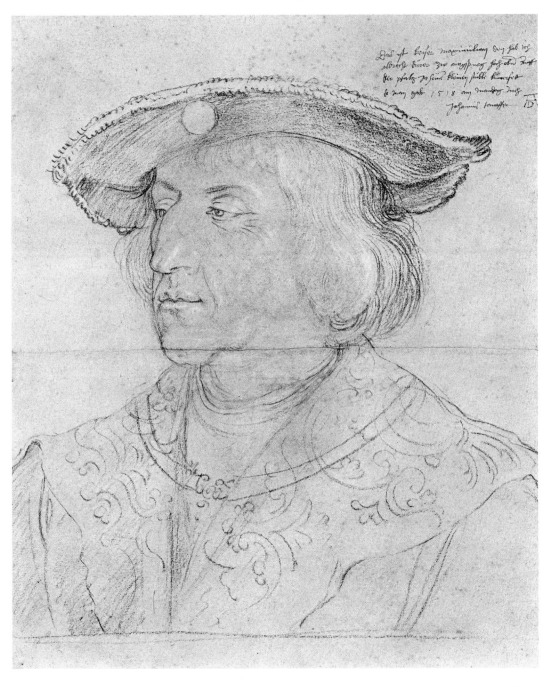

VII. *Emperor Maximilian.* 1518. Charcoal, with colour added later. 381 × 319mm. Vienna, Albertina.

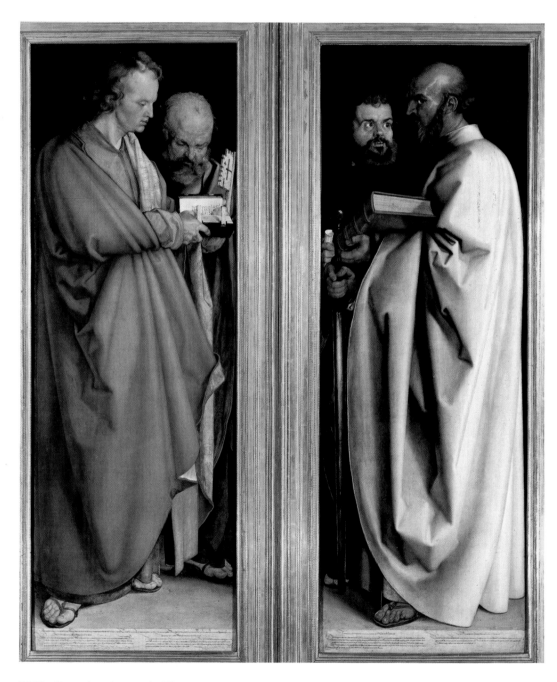

VIII. *Four Apostles*. 1526. Oil, 204 × 74cm. Munich, Alte Pinakothek.

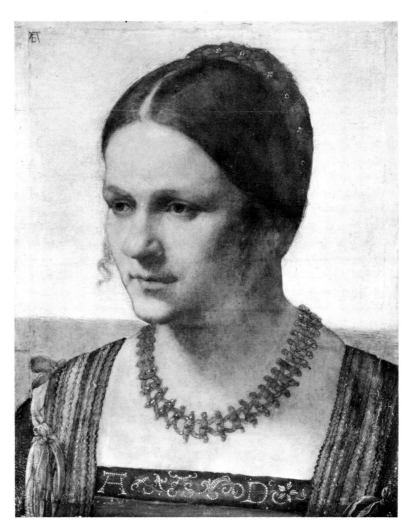

55. *Head of a woman.*
About 1507. Oil,
28.5 × 21.5cm. Berlin,
Staatliche Museen.

wonderful *Head of a woman* in the Berlin Gallery (Plate 55) the highest achievement of a broad vision was reached. Dürer was after all very well prepared for anything concerned with the treatment of light, and if his colouring possibly seems dull beside the subtlety of the Venetians, his graphic works show us how developed was his feeling for light—I use this term in analogy to 'feeling for colour'. But Dürer used light primarily for the sake of modelling form. From now on there are almost always reflected lights on the dark sides of the forms, and the deep shadow has disappeared, except for a narrow strip which is set between the lighted area and the area away from the light like a fleck of foam left behind on the shore by a wave.

And what an effect the even clarity of the way the figures were drawn must have had on Dürer at this time, after his own self-taught and painful efforts which had led up to the engraving of *Adam and Eve.* Even if the Venetians did not show the same sculptural tendencies as the Florentines, as Italians they had so much to offer to a German that

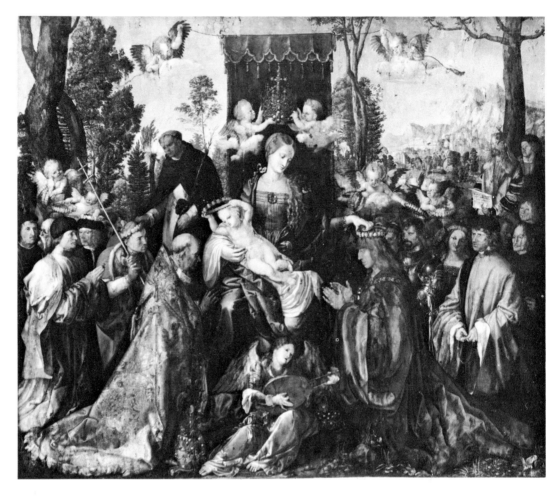

it would be easily understandable if he did not get as far as to dis-
tinguish a greater or lesser degree of sculptural content. How clear and
explicit the form was everywhere and how much sculptural richness
such a picture contained! A calm Bellini, such as the altarpiece of 1505
mentioned above, shows a kind of movement in the figures and a wealth
of spatial relationships that make it infinitely superior to Dürer's
picture of *The three Kings* of 1504. The convincing ease of the bending
and turning movements, the way the directions diverge, the feeling for
the figures' positions in space—these are characteristics which Dürer
did not yet possess. Added to this were the monumental groupings of
the figures and the large scale in general. He must have felt that
pictures could have a higher vocation than to be dispersed in a church
like haphazard ornaments; here they were part of the architecture and
the figures had been combined in such a way that they had a powerful,
almost architectural effect themselves.

Dürer must have experienced a great heightening of his feeling for
life at this time. He gained a conception of a mankind which possessed
a higher dignity, acted with larger gestures, and seemed to lead a more

56. *Feast of the rose
garlands*. 1506. Oil,
162 × 194.5cm.
Prague, National
Gallery.

vivid life. Dürer lost the heaviness and constraint of his northern existence. His eyes were opened more widely and became more radiant. A world of new movement, and unknown regions of the soul opened up.

Expectantly one asks into which works this new feeling flowed. They are few in number and a modern onlooker will hardly acknowledge any of them as a really personal statement. The *Rose garland* picture, the Berlin *Madonna*, a few heads, possibly also the large figures of Adam and Eve, for which the studies at least go back to Venice—that is all. How restricted Dürer's artistic imagination appears with this list of titles; there is nothing here which could be taken as a direct transposition into a picture of his Italian impressions, as happens with modern painters. And yet Dürer found full satisfaction in this utterance and gave everything that he wanted to give. The only one who will be disappointed is the onlooker who thinks that Italian atmosphere necessarily demands that kind of elegiac tone which has become almost indispensable for the German public through Feuerbach and the young Böcklin.

The main work of Dürer's second stay in Italy is a religious picture which he was allowed to put up on a side altar of the small church, San Bartolommeo, near the house of the German merchants (Plate 56).[64] It was commissioned by his compatriots, and it might be thought that they turned to him because they wanted the familiar and beloved kind of woman of their home country alongside all the Italian madonnas. But it is evident that Dürer was concerned to produce 'high art' in the Italian sense much rather than to meet possible moods of homesickness.

The subject was provided by the newly kindled cult of the Rosary. What the picture was meant to show was the solemn ceremonial in which the Madonna and her Child distribute garlands of roses to the leaders of the ecclesiastical and the secular worlds. St Dominic, the traditional founder of the cult, is also active, and with the help of angels the crowning with garlands is extended to the hosts of worshippers. Dürer followed a traditional type in his work. In the volumes of the Confraternity of the Rosary published by Jacob Sprenger in the 'seventies the woodcut of the subject is found repeatedly (Schreiber v. 5293). It shows the same composition, which also appears elsewhere on individual sheets, with the Madonna in the centre and at her left and right the representatives of ecclesiastical and secular government; the Boy gives his garland to the cardinal, the Mother hers to the emperor; two angels hold a crown above.

Dürer repeated this arrangement. But he wanted to elevate the scene to the solemn and splendid, and thus he joined the main figures into a group which governs the whole picture as a powerful motif. Mary and the kneeling figures of emperor and pope are combined to form a closed triangle; the lines of the sides come down at a wide angle from the

vertex, the heavily trailing coats go right down to the corners. With a new feeling for monumentality the two corresponding kneeling figures are set opposite each other in pure profile. Between them is an angel playing a lute, whose strong diagonal movement is all the more effective as it is in contrast to that of the Child.

Behind the Madonna is hung a coloured rug; the congregation, with symmetrically placed accents, continues to the sides. There is still a crowded, Gothic effect without any definite economy in the poses, but a feeling for a balance of directions already exists. The dominating horizontal is answered at the sides by the verticals of the tree trunks. Here too, as elsewhere, the arrangement is distinctly—even if not always strictly—symmetrical.

Of all German Quattrocentists Stephan Lochner, in the Cologne cathedral altarpiece, comes nearest to Dürer in his intention of achieving a monumental effect based on symmetrical order. Lochner had to force his subject, the *Adoration of the three Kings*, into a symmetrical design (it is only approximately symmetrical!) and the solemn impression of the composition was never quite forgotten in Cologne. But Dürer produced much more than mere symmetry. Here, for the first time, the idea of basing the construction of a picture on a coherent figurative theme was introduced into German high art.

And what marvellous figures Dürer used for his construction! Both the fall of the drapery and the gestures are heightened beyond the hitherto accepted norm. The splendour of the pope's broadly and heavily trailing pluvial is a magnificent attempt to make the drapery monumental in the Italian sense; and if analogies for the emperor's gesture are looked for in older art, it will soon be found that this is also the result of an essentially new kind of feeling. The head of the emperor —it is the Emperor Maximilian—whose vividness was once one of the main reasons for the picture's fame, is presumably based on one of the large Halle coins of 1505 showing the sovereign's profile. As a portrait of Julius II was presumably unobtainable the drawing of an old monk (W.380) served as a model for the pope's head.[65] The Madonna is somewhat constrained (the head is entirely over-painted in the original), her draperies are awkwardly congested and restorations have made matters worse. The feeble white linen underneath the Child is a coarse disfiguration of what was originally there. In the Child itself the intention was to show richly differentiated movement and to clarify the various structures of the body at the same time. Dürer is almost more Italian than the Italians. The way in which he dissects the body anatomically as it were, verges on the pedantic, and the impression of naturalness is necessarily somewhat impaired.[66] The lute-playing angel at the feet of the Madonna is more coherent and immediate in effect. In this figure Dürer arrives at a kind of rapturous ecstasy unknown in the north. I need not stress that he is a specifically Venetian type, but he resembles less the angels of Giovanni Bellini than those of Palma. At that time

148

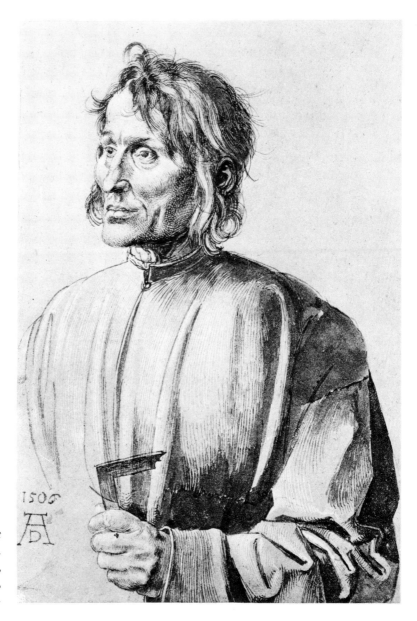

57. *The architect Hieronymus of Augsburg.* 1506. Drawing, 386 × 263mm. Berlin, Kupferstichkabinett.

artists did not usually present their own moods in specific pictures as they do nowadays but this angel, calmly rapturous amongst earnest men, had surely been entrusted by Dürer with a confession of his own secret feeling of happiness. The heads of the angels who are in the sky also follow Venetian types. The foreshortening of these rotund images, whose axial positions are continually changing, may well have constituted the most interesting aspect of the picture. Some of them have an oddly constructed, mask-like, empty appearance.[67]

But we are compensated for this by a rich variety of portraits in the rows of the devout congregation.[68] The cardinal crowned by St

Dominic is thought to be Domenico Grimani and, in the figure of St Dominic himself, a nameless but earnest and fervent Venetian (or is it a German?) priest has been immortalized. But the main part of the congregation is of course made up of the members of the German colony in Venice—with the clever, positivist heads of merchants— beside which the head of an artist at the right margin stands out strangely; he is the architect of the house of the German merchants, Hieronymus of Augsburg (Plate 57). He is the idealist in this society, somewhat unkempt in his external appearance but with extremely ex- pressive features and the kind of visionary eyes that perceive invisible things. The preliminary drawing for him is also fortunately still in existence.[69] Near him, Dürer has put himself in a splendid garment and with festively curled hair. His hands hold a piece of paper with the inscription: *Exegit quinquemestri spatio Albertus Dürer germanus 1506*.

He was satisfied with his own work, and of that of his Italian col- leagues, who had been hostile to him up to then, he said that he had 'quietened them and they must admit that they have never seen more beautiful colours'.[70] It might be thought that Dürer had overestimated Venetian politeness, but the picture's fame, based on its especially resplendent colours, continues up to Sansovino's time.[71] And indivi- dual parts which have been preserved, like the coat of the pope, do indeed support the belief that the picture was once very brilliant in appearance, though this does not exclude the possibility that its bril- liance may have seemed slightly barbaric to Venetian eyes. The gold brocade of the pope, the red of the emperor and the blue of the Madonna are spread out and interact in broad masses.

On the whole Dürer's work is best compared with the panel by the great Bellini of 1488 in Murano where the Doge Barbarigo kneels at the feet of the Madonna. But any comparison will make it painfully clear that a sense of calm festivity has not been achieved either in the colours or in the arrangement of the figures. Everywhere the striving after too much effect stands in the way, and only fifteen years later in the designs for a large picture with many figures, which unfortunately was never executed, can it be said that Venetian impressions were transposed into a congenial work of art.

Closely related to the *Madonna of the rose garlands* is the Berlin *Madonna with the goldfinch* (1506; Plate 58). This picture is radiant with strong colour, the exultant colour of the Venetian Dürer.[72] It is strange that this exultation hardly seems contagious, but this can surely not be the fault of the motif itself. It is a very pretty scene which shows how the Boy sitting on his Mother's lap lets the little bird walk on his arm, withholding his dummy which the bird peckingly demands. The way the small St John, accompanied by an angel, brings a posy of lilies of the valley which the Madonna takes from him is most charming— but has a theme ever been treated more frigidly and academically? Is

this by the same man who three years earlier did the glorious small engraving of the *Madonna suckling her Child*? In the painting all sense of immediacy has disappeared and all the movement's natural coherence has congealed. Mary displays her face and puts one hand over the upright book and takes the flowers, but she does all this mechanically as if made to do so by a photographer. The Child sits on her lap but is not connected with her, and his movement is determined by the wish to convey a sense of richness and at the same time to make a display of all the joints. This is the same attempt to *rationalize* nature from which the Christ-child of the *Rose garland* picture suffered before; and it is something for which Venice is not responsible—the principle is already completely exemplified in the engraving of *Adam and Eve*.

It was very important for the development of German art that such exercises were done, but the immediate result is displeasing. There is a small Altdorfer in the Berlin gallery, not far from this Dürer, a *Madonna and Child at the well* (1510). A comparison of the two shows very clearly that Altdorfer surpasses Dürer where fresh and natural

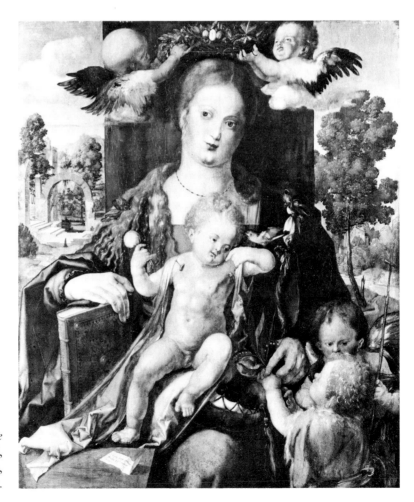

58. *Madonna with the goldfinch*. 1506. Oil, 91 × 76cm. Berlin, Staatliche Museen.

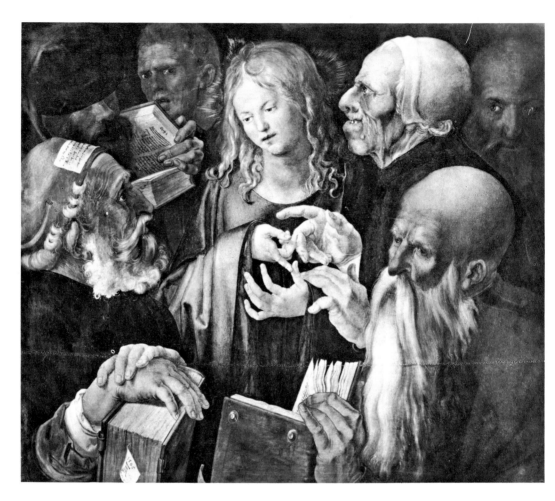

movement is concerned as much as Dürer surpasses him in the distinctness of individual motifs and in structural perfection.

Beside this the *Disputation of Christ with the elders* (Plate 59; 1506, Lugano, Thyssen Collection) is little more than a curiosity. Dürer has in any case expressed the opinion that it need not be taken seriously by his comment that it was done in five days (*Opus quinque dierum*).

The form is North Italian. Mantegna for example has used half-length figures of this kind on a black ground in his *Presentation in the Temple* (Berlin), and it seems to me that even the heads in the very background of Dürer's painting are a direct reminiscence of Mantegna's picture. But its calm, relief-like character has not been understood at all. Dürer has put figure behind figure, as many heads as will fit into this plane. Added to this is the complete arbitrariness in the directions of the heads. But it is significant that the theme is interpreted psychologically. These figures could really participate in a disputation and it is noticeable how the characterizations have attained independent value. One may recall in this context how much trouble Leonardo took to establish the types of human physiognomy and expression. Dürer

59. *Disputation of Christ with the elders.* 1506. Oil, 65 × 80cm. Lugano, Thyssen Collection.

got to know fragments of these studies at this time. I would not have assessed these stimuli very highly, but however remarkable it may be, it was only in Italy that the great northern delineator of the individual found for himself the conception of the completely self-contained head to indicate character. Herein lie the beginnings of the physiognomic studies he made for the Heller altarpiece. Sometimes one discovers one's own innermost characteristics in a foreign land. Thus the old man in the front right-hand corner with his bald head and long beard can be seen to anticipate the type of St Paul in the *Four Apostles*.

Christ's delicate, slightly lowered head with its curly hair obviously goes back to a drawing by Leonardo, though the bloom has been lost in Dürer's harder style. The study (Albertina, w.404) looks better than the painting. But the most beautiful study for this picture is that for the hands of the Boy (Berlin): it shows the delicate hands of an Italian boy which have become more knobbly and gnarled in the actual picture. As they meet the similarly conceived hands belonging to the old man, who touches them and interrupts Christ, a strange junction of twenty fingers results, which can be likened to the kind of Late Gothic intertwining of branches found on the base of chalices or on church portals.

But there are also more serious moods at this period. A remarkably solemn feeling for the Passion could be found in the small *Crucifix* in Dresden, dated 1506 (if it really turned out to be by Dürer).

Christ is shown as light against the black ground of the sky. Only at the sea's horizon is there one yellow streak, set very low in the picture. In front of it are a few small, intersecting, spring-green birches. The mountains are deep blue and there is a reddish-brown strip at the lower front margin of the picture. The long ends of the loin-cloth are very prominent. They move in the wind like frightened, fluttering birds. They had always been important in northern art: the playful quality of Late Gothic art had made use of them. The cloth beats around the cross like a rushing torrent in the *Large Passion*; trivially decorative, like the chirpings of a canary, the ruffled ends rise in the drawing of *Christ on the Cross* of 1505 (Albertina, w.325), but in the painting the line is used more to express an atmosphere of tragedy. The sharp decline on one side determines this impression and the way in which both ends are bent back towards the body resembles a lament. Christ himself looks upward with painfully opened mouth; the inscription says: *pater in manus tuas commendo spiritum meum*. This appears here for the first time and it would be very interesting if Dürer had created a type which was to become generally used in the seventeenth century, but the attribution of the picture to him cannot be upheld. It is a Dürer-imitation of around 1600 and seems to go back to a type of composition which appears in the Cranach workshop only after Dürer's death.

In any case, the few pictures from Venice which we know remain an uneven and incoherent series. And little is gained if we include two or

three portrait heads which were done for commissions at that time, as they do not add anything to the heads of the *Rose garland* picture. One of them looks almost like a repetition from the altarpiece; it is the head with fair hair on the left between the cardinal and the praying priest in the picture in Hampton Court (1506). Apart from this the young man in Vienna (1507) and the very damaged portrait of a man in Genoa (1506) may be taken into consideration. Besides the perfection of the portrait of a woman, of 1507, in Berlin, which reflects more purely the subtleties of colour of Venetian painting, there is the charming, friendly, graceful portrait of a girl in Vienna which must be granted an exceptional position. It was done in the autumn of 1505, at the very beginning of the stay in Venice, and was painted with such heart-felt sympathy that it gives the impression of an immediate reflex of heightened vitality and seems suddenly to reveal to us Dürer as a human being.

But I think that at this time there were ideas active in Dürer's mind which were not yet properly reflected in his pictures. I do not know how he himself formulated them but they must have been similar to what Goethe meant when he wrote from Italy: 'Henceforth I want to occupy myself only with permanent values . . . in this lies necessity, here is God.' Only in the pictures which follow is it shown how much Dürer's preoccupation with the laws which are the basis of all natural forms was consolidated in Italy. This explains his indifference to any effects that move through the emotions or by spontaneity of expression. Dürer wanted to be lucid above all and to reveal the laws inherent in finished form. He continued his speculations on the proportions of the human head and body. The physiognomic variations of nature were examined for their basic relations—one can feel the immediate proximity of Leonardo. I find the most perfect expression of this mood, which always wants to relate what has happened by chance to what is permanent, in the Munich *Self-portrait* (Plate 60). It is wrongly signed and wrongly dated '1500', but without doubt it belongs to the Italian period of idealization, no matter whether it was painted in Venice itself or later in Nuremberg. The appearance of the man represented, who must at any rate be around thirty-six years of age, confirms this opinion.

Our image of Dürer is completely governed by this picture, the noble face with its long, undulating locks, the immense seriousness of the wide open, calm eyes, the intellectual forehead and the abundance of sensuous feeling in the vigorous, full curves of the mouth. Yet it has always been felt that the conclusive stamp of individuality was lacking in this head. One need only compare it with the earlier self-portraits to recognize that here Dürer hardly intended to reproduce what he really looked like. He did not paint himself as he was but as he wanted to be. He did not have those big eyes; his were small and narrow and lay flat, with the brows arching high above them. The characteristic form of his vigorously hooked nose is not given any significance in the

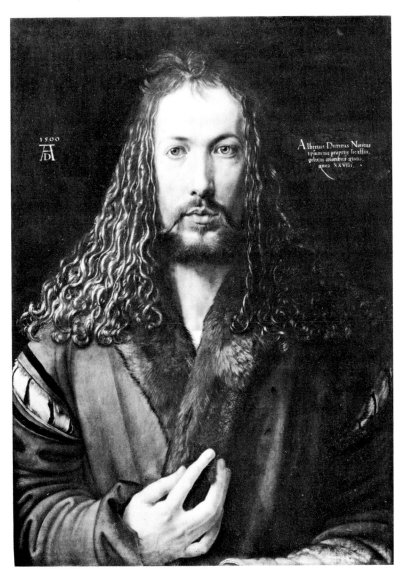

60. *Self-portrait*. After
1500. Oil on wood,
67 × 49cm. Munich,
Alte Pinakothek.

picture. All the features are imbued with a sense of solemn calm,
though without any distortion of their essential proportions.

The purely vertical and purely frontal position of the head is strongly
effective. The hair cascading down in long, finely curled strands
strengthens the impression of great solemnity—it too is a product of
art, not nature. The contours correspond strictly on both sides, but the
head gains its real force from the fact that, together with the accom-
panying locks of hair, it fills the whole width of the picture. This is the
same principle of composition as that applied in the *Rose garland*
picture.

The direction of the light seems to have been such that one cheek
was entirely in the half-light. Again an effect of calm was intended. This
cannot be judged from what one sees today.

155

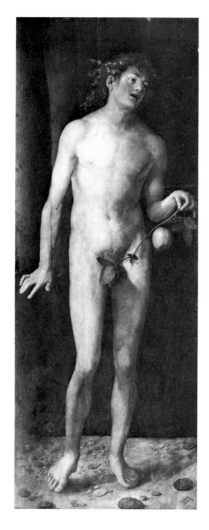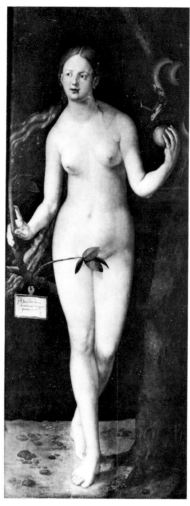

61. *Adam and Eve.*
1507. Oil,
209 × 83cm.
Madrid, Prado.

Only one of the hands is visible (the right hand in the picture, but really the left hand as it is a mirror image). Negligently it grasps the fur, an Italian gesture which, however, has here become somewhat rigid, almost spasmodic. It must be remembered that the fame of the beauty of Dürer's hand, to which contemporaries testify, is a Late Gothic fame. The costume corresponds to that in the *Rose garland* picture.

Self-esteem has been called a basic trait of the Renaissance. But there is more than that here, namely the intensification of individuality into an ideal. This portrait has the effect of a self-confession, of a programme. A man of the north has never looked at us like this. There is something Christ-like in it. Without Italy it would have been impossible for Dürer to choose a type as elevated as this.

It might be expected that this attitude would lead to a general elevation of the types found in German art, that celestial and earthly figures would become more imposing, that all scenes of biblical history would

156

be remoulded to fit a new concept of humanity. Germany might be expected to have learnt a feeling for majesty.

And the series of 'great paintings' does indeed begin at this time, but the outcome is disappointing. Dürer took up few subjects; his treatment of them was laborious and hesitant, so that he himself lost the courage to continue these imposing paintings; he probably felt too that his perception was not yet mature enough to achieve a perfect balance of form and content. The best results were achieved only later and in a different field, that of graphic art.

When he was back in Nuremberg he first of all experimented with the nude. The problem posed in the engraving of *Adam and Eve* was to be developed further on a higher level. Dürer craved for life-size scale, an image of man in the totality of his natural appearance, which is to say in colours, and not merely in linear abstraction. As a result he painted the large double panel of *Adam and Eve*, dated 1507 (Madrid, Prado; Plate 61). Again he based his representation on fixed proportions—a mere haphazardly chosen individual case seemed to him worthless—but the proportions are different from those used earlier, they are slimmer and lighter; Dürer's conception of a beautiful figure had changed.[73] He also had a new conception of the harmony of forms in a perfect body, the necessity of all the limbs being in tune with each other. He may have found the Eve of 1504 with her badly assembled limbs insufferable. In Italy he had learnt to sense a body as a unified whole and soon a new, more coherent movement was to be seen to pervade the parts, so that all forms harmonized like music. The rigid frontality has been vanquished, and the figures stir without fear of the measuring compasses; construction and natural movement are no longer in opposition. Dürer also shows a new freedom in the way he does not submit unconditionally any more to a 'classical' formal pattern. Without losing sight of the typical, he has become decidedly more naturalistic in this large picture than he had been in the engraving. And the portrayal of movement leaves no doubt at all: Dürer was more strongly 'classical' *before* his Italian journey than afterwards. Eve moves entirely in accordance with the northern concept of beauty.

The figures stand in front of a black background, a prototype for which can already be found in the Paumgärtner altarpiece. (Dürer liked a black background in his drawings too.) The strong tonal contrast has the advantage of maintaining the unity of the figures, so that even individual areas of complicated modelling (such as that of Adam's left arm) do not 'upset' them. The treatment of the lines and planes is in itself calm and generous. If one wants to assess this new calmness from a particular instance, one should compare the drawing of the branches in engraving and painting.

Adam steps forward lightly and weightlessly, his limbs placed in a *contrapposto* pose for purely compositional reasons, but this calculation to achieve a formal effect is hidden behind a convincingly lifelike

expression. Adam rises on his toes and leans forward in one continuous movement, his glance full of desire, and his hand—though it does not yet reach out—showing the temptation he feels in its finger tips.[74] The only suggestion of delay, the coquettish, delicate holding of the twig over the loins, is comical.

Eve is even more delicate. By setting the feet one behind the other Dürer makes her slim figure rise from an exceedingly narrow base. The long torso is reminiscent of older German models of beauty. The heads are expressive in the manner of the sixteenth century, to whom the art of earlier times seemed to be a mute art. Dürer presumably used studies made in Venice; there is probably even a direct relationship between the head of Eve and the drawing done in Venice.

Another expressive female figure was designed at this time, a *Lucretia* (drawing of 1508, W.436).[75] The theme of the *Adam and Eve* was seduction, here it is despair. It was an invention of the Latin peoples to combine tragic emotion with the nude, and this is one of the themes which was taken up most avidly in the north. This time Dürer did not represent a figure which was demonstrably constructed; it is possible that it was based on a Venetian nude but the individual features have obviously been much worked over. The best parts of the figure are the lower ones; the position of the legs has been subtly conceived. But the general movement is completely inadequate for the pathos of a Lucretia. What magnificent motifs were invented by Baldung in similar cases—when a young woman is touched by Death. Dürer does not deny that basically he is only interested in the organism of the body. This is why the suicide is so half-hearted in this drawing. In the executed painting it is once again watered down and the changed position of the arm with the dagger, although clarifying the situation, destroys the fine rhythm of the original figure. (Added to this is the ugly widening of the top of the loin-cloth made in the seventeenth century.)

At the same time Dürer was working on a picture which showed the violent death of a mass of people: *The martyrdom of the ten thousand Christians under King Sapor* (Plate 62), commissioned by the Elector of Saxony (Vienna). Rather than one thing many things are shown, far too many! In this respect it is a German picture. Isolated figures always have something unfamiliar and bleak for the northerner; he wants a crowd, and moreover a crowd with its surroundings. His painterly instinct opposes the sculptural instinct. In this mass execution in the open air both of these come together. The unnatural result is a large crowd made up of single figures which have interesting sculptural qualities in their own right and are portrayed with great exactitude, and yet are not meant to be seen individually. Michelangelo was thinking of pictures of this kind when he said: 'The Germans represent far too much in their pictures, a mass of figures where one would be sufficient to fill a picture.'

158

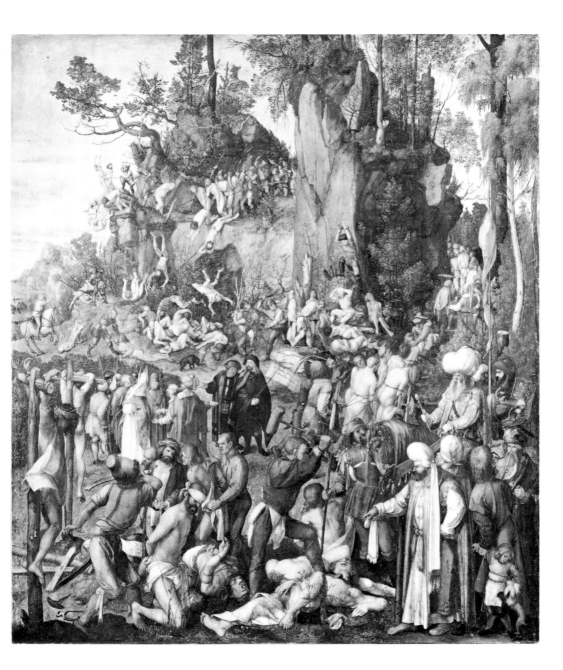

62. *The martyrdom of the ten thousand Christians under King Sapor.* 1508. Oil, 99 × 81cm. Vienna, Kunsthistorisches Museum.

People have pitied Dürer for having had to treat such a subject; I fear they are wrong. He worked on this picture devotedly for a long time and thought it was good. To show his satisfaction he put himself into the picture, as a full length figure, together with his friend Pirckheimer who makes a comical gesture of pity in the middle of this butchery. The inscription on the banner not only gives the signature and date—*Albertus Dürer 1508*, but proudly adds the nationality: *alemanus*—this was painted by a German![76]

Dürer was only concerned with the formal problems of the subject,

159

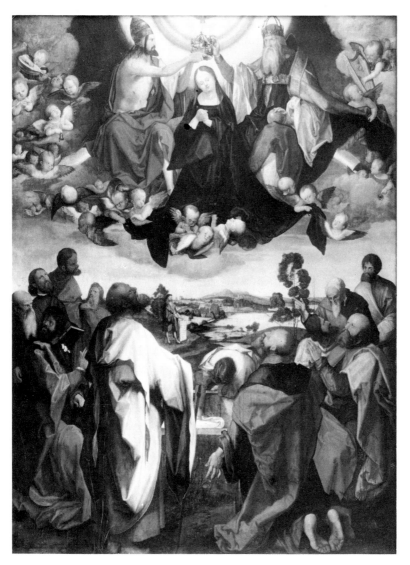

63. *Heller Altarpiece:
The Assumption.*
1509. Oil,
185 × 134.5cm.
Copy, Frankfurt,
Städelsches
Kunstinstitut.

with nudes, movement, foreshortening, abundance without loss of
clarity, the mastery of a large space by the assured use of perspectival
diminution.

This last concept must be further considered. Earlier art was afraid
of scaling down, or jumped straight from large to very small objects.
Dürer exploited the discovery that there was a regular relation between
distance and the size of an object and that the application of this per-
spectival recession in figure compositions could be of good service to
the spatial illusion. The figures in the middle ground stand in a relation
of 1:2 to those of the foreground. How important these rules were at
this time is shown by the similar construction in the pattern book of
the French theorist on perspective, Viator, who has already been men-

160

tioned on p. 84 in connection with the *Life of the Virgin*. The caption for this page reads:

'Les quantitez et les distances
ont concordables différences.'

There is an early woodcut (B.117) of the same subject and it is instructive to compare it with the picture in this respect and see how the recession has not yet been treated with a view to achieving a calculated spatial effect. The painting is immediately preceded by a drawing of 1507 (Albertina, W.438); thus the way Dürer makes things clearer at the last moment, intensifies movements and interweaves motifs can be checked. One has to look hard to distinguish the individual incidents: the beheading of the kneeling man, the killing of the prostrate man with a wooden mallet, etc. No earlier picture in Germany had had such a rich composition; it is a pity that the impression it gives is so disjointed, that Dürer's feeling for rhythm has broken down so entirely.

After this painting Dürer started the great work on which he spared no effort and which he wanted to last for centuries, the *Coronation of the Virgin* with the Apostles at her tomb. This was a subject of the greatest significance whose depiction—with life-size figures—demanded the most monumental form. The time for an understanding of majestic themes had come. People were tired of delicate and sweet subjects and wanted to be moved more deeply. Paintings depicting mere reality had lost their ability to astound—people yearned for a new idealism. Dürer was prepared to provide it.

He was commissioned by the Frankfurt merchant Heller with whom he had been in contact for some time. They exchanged letters frequently while the work was in progress, the picture becoming more substantial and thus also more expensive than the patron had intended. In 1509 Dürer sent his good wishes with the finished panel. But they were of no avail. The picture was sold by the Dominicans in Frankfurt to the Elector Maximilian in Munich in 1615, and it was destroyed there by a palace fire (at the beginning of the eighteenth century). We only know it from a feeble copy by Jobst Harrich (Plate 63) which was substituted for the original in Frankfurt.[77] The side panels are still there, but they are only workshop productions. Not even the small portraits of the donors are by the artist's own hand.[78]

There are two scenes, one in heaven and one on earth. The lower region, with the Apostles, is the one that is emphasized. But there is no indication of the suddenness, of the impression the miracle of the empty tomb must have made on those standing around it. Dürer has avoided the naturalism of earlier art. The figures are all statuesque, incorporated into an orderly structure. Dürer makes use of this device above all to infuse the picture with an ideal atmosphere. The two figures in the foreground, St Peter and St Paul, are like two immense pillars; they are different from each other, one standing and one kneeling, but they are both predominant, and both are shown at the same distance

from the margin. The remaining Apostles who are seen behind them in quick recession are also distributed evenly, five on the right and five on the left. At the spot where St Peter kneels and where the balance is thus threatened, one of the five figures has been drawn towards the middle. A composition of this kind was unknown in Germany. People were familiar with symmetry, that is, the uniformity of two sides around

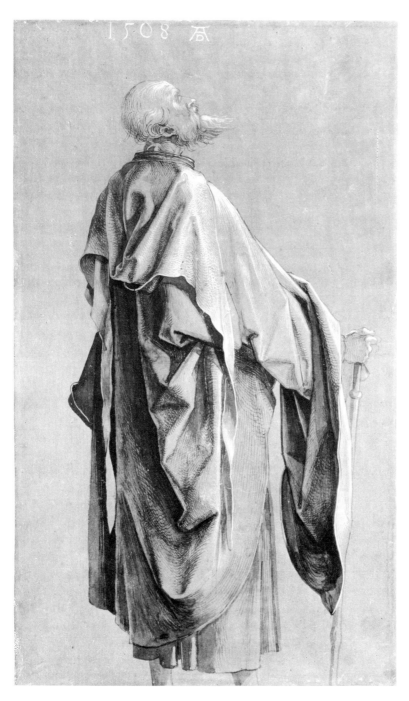

64. *St Paul.* 1508. Drawing for the Heller altarpiece, 400 × 235mm. Berlin, Kupfer-stichkabinett.

a given centre, but not with this regularity without any indication of a centre. And this in a merely narrative picture! This is the concept of a monumental composition which Dürer had gained in Italy. For him majesty was no longer confined to the individual motif, inserted here or there, but to the general composition. Only now did he work with clearly distinguishable levels of importance in the picture, exploit main themes, and take general contrasts into account. The *Rose garland* picture seems unstructured beside the Heller altarpiece. But this very preoccupation with the appearance of the picture has its dangers too. German art is extremely antipathetic to the presentation of mere form. And can it really be said in this case that the formal structure is entirely met by the subject? And there is Dürer's fatal ambition to equal the Italians' abundance of sculptural motifs. Every figure, including those in the very background, is meant to be interesting in its pose and its gestures; this results in a rapid loss of sensitivity.

But if the principal figures are considered, what remarkable attempts Dürer has made to convey noble existences! St Paul is picked out as the most important personality (Plate 64); he does not show Italian verve, nor the commanding freedom of movement of Fra Bartolommeo's figures, but his stance is rocklike. His gown hangs in unyielding folds. There is desperate seriousness, something laborious and clinging in these forms—a slow-moving but inflexible power. This makes it difficult for the head to be effective as well. It is different from the rest of the figure; there is a noticeable lack of coherence. Dürer usually modelled the parts separately and joined them together afterwards. But the degree of idealism is also different. The garment is more splendid than the man. One can feel how Dürer's strength was taxed in order to raise the figure above the characteristics of the ordinary citizen. This does not mean that he was dependent on a model. Figures do have particular expressions, but nevertheless their effect depends on the intensity of the individual rather than on greatness of character. That nobody followed nature's example more tenaciously than Dürer is shown in his humped foreheads, beaked noses and the curves of his cheekbones and jaws. And in his powerful heads of old men Dürer did rise to the sublime here and there, such as in the Apostle looking down (Plate 65), of whom there are still traces in the St Paul. On the other hand Dürer also abandoned himself to mere peculiarities and looked to models where nature had taken pleasure in the distinctive tracing of petty details for the heads of his Apostles. It is strangely inconsistent that the great Italianate composition has to accommodate figures like that old journeyman tailor with a goatee—Robert Vischer described his head as that of a pert madman—the drawing for whom is in the Albertina. Dürer must even have had a special liking for him, for he later repeated the figure in the beautiful sheet of the *Temptation of St Anthony* of 1521, though there it was used in a context which allowed a slightly comical interpretation. With other figures, Dürer observed

a more elevated level, but then they are sometimes spoilt by the artist in him who liked to show their heads from awkward viewpoints. This means that Dürer could present masterful foreshortenings without feeling that in certain positions a head appears undignified. I think St Peter's head is an example of this, and the gesture of St Paul can hardly be considered to make an elevated impression, either. Models for these types would most easily be found by the modern observer among the *petits bourgeois* tourists in the Sistine Chapel doing their duty in front of Michelangelo's ceiling. In the painting the cast of the features has been made somewhat nobler, but the foreshortening has remained.

I feel that the most idealized figures in this work are not the Apostles, nor the heavenly sovereigns, but the youthful figures of the angels. Theirs is the eternally fresh beauty that springs from nature herself.

For no other picture are there so many preliminary drawings as for the Heller altarpiece. There are drawings of heads, hands, feet, draperies,[79] but not a single sheet which tries to establish the whole flow of the composition or to find the most suitable expression for St Paul's upward glance or St Peter's action of casting himself onto his knees. This is not simply chance. Dürer's contemporaries already noticed that he built up his compositions with individual elements. Camerarius says of this that it was miraculous how Dürer drew all the parts singly and how afterwards everything fitted in all the same.[80] But there are no studies for the whole picture in which the relationships of the figures would have been experimented with until the appearance of natural optical cohesion and a perfect flow had been achieved. And is this not noticeable? Are not the juxtapositions and individual movements somewhat unwieldy because of it?

Even in the upper group where there are but few figures the flow is no freer. Other artists have presented the Coronation in Heaven with more animation, with a splendid whirl of lines, but this was simply not what Dürer wanted. Beside a Baldung Grien he will always appear sedate, reserved and sometimes pedantic. His strength lies in his clear delineation of shapes. If one considers the draperies, they alone produce such a powerful polyphony that hardly anything else can be appreciated, just as to some people Bach makes all other music insignificant.

And yet the movement does seem strangely emphatic and significant. At this time there was a general demand for stronger gestures. The Coronations of the fifteenth century, at least of its second half, were now thought much too demure; Christ should reach out more majestically, the crowning gesture should be more sweeping. In this picture strength and restraint are joined. The main figure of Christ is shown with the upper part of his body nude. He grasps the crown with both hands. The dominant element is the vertical which is retained even though the body turns sharply. God the Father accompanies the action with greater composure, and Dürer sees Mary, in the German fashion, only as a shy woman, not to say an embarrassed matron.

65. *Head of an Apostle.*
1508. Drawing for the
Heller altarpiece,
317 × 212mm. Vienna,
Albertina.

Without doubt the Heller Coronation painting is the most brilliant fruit of the Italian journey. But it is astonishing that apart from a historical narrative, no representational picture grew out of it. For this was the true characteristic of Venetian art: to show quiet, representative figures within the impressive solemnity of a simple architectural setting. There would have been no lack of opportunities in Germany either. Madonnas and saints were needed all the time. There are obviously deeper reasons for Dürer not taking up compositions with niches and halls: he was not able to sense the necessary unity of figures and constructed space. Northern imagination as a whole is a painterly, not an architectural one, or rather an imagination concerned with

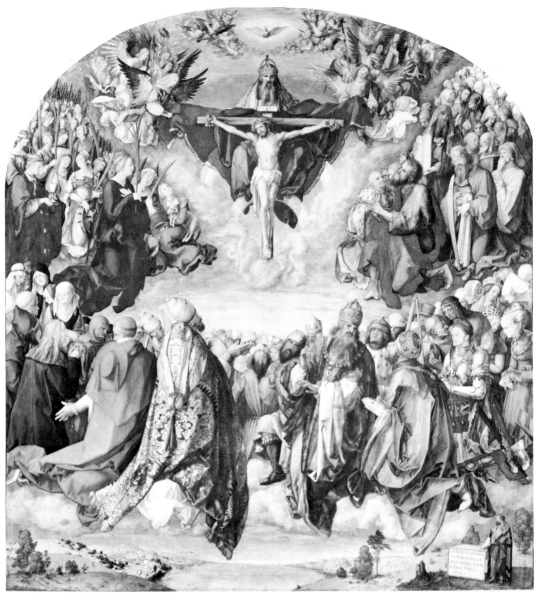

moving, not with static space. In this context, the drawing of a *Madonna with four saints* of 1511 in Vienna (W.509) shows this national difference very clearly.

Neither are we in any way recompensed by the large picture of the *Madonna with the iris*[81] in an open garden setting. The formulation of this artistic problem is rather indifferent. Dürer himself does not seem to have thought highly of this work, if it is correct to identify a Madonna mentioned in the Heller correspondence on 24 August 1508 with this picture.

Dürer's art triumphs in free, not in constructed space. He seems to have won complete artistic freedom only when painting the innumerable hosts of the *All Saints* picture (Plate 66).

66. *All Saints Altarpiece (Adoration of the Holy Trinity)*. 1511. Oil, 144 × 131cm. Vienna, Albertina.

The title of 'All Saints' is used—following Thausing—because the chapel for which the copper-smith Landauer commissioned the picture was dedicated to all the saints. But the old title, *The adoration of the Holy Trinity*, was more explicit. The Christian world, divided into clergy and laity, adores the Godhead revealed. Men of the Old Testament and holy women of the New Testament appear in separate processions, choirs of angels accompany them and all this takes place in the clouds high above the earth.

One would like to think of this picture as a vision which Dürer had had in a magnificent landscape. One would like to believe that he was walking in the evening with the lake far beneath him and the last light fading, and that suddenly he saw the sky filled with figures, saw the incarnation of the great mystery of the Salvation, God the Father with the crucified Christ and the hosts of heavenly saints approaching through the skies to take their place beside the Thrice Blessed. And that far below he saw mankind like an immense, ideal congregation for whom Christ had suffered so horribly.

It is unlikely that this is how it happened in reality, but it remains a peculiarly northern characteristic to imagine the adoration of the Trinity as an apparition in the sky. Raphael's *Disputà* in the Vatican stanze suggests itself as a comparison, for the subject-matter is very similar. But for Raphael it seemed obvious (quite apart from the demands of the particular wall) to begin with the solid ground on which he developed his main scene, and only then to add the circle of calmly enthroned celestial beings. In Dürer's picture the earth is far below, the onlooker himself is put on an ideal plane, so that the miraculous seems close to him and the familiar distant. Thus an element of fantasy comes into the picture. It may be remembered that Altdorfer attained striking effects thanks to this device, and in the seventeenth century the Italians too exploited it thoroughly.

The figures do not appear in close set rows, clearly arranged, countable, but in surging throngs, a pulsating multitude of heads. An immense space is enclosed in the picture. To appreciate it fully one has to think back to similar situations in the *Apocalypse*, such as the second vision (B.63). Just as painters to start with could only portray haloes as upright discs on a plane, and only afterwards dared to represent them resting horizontally, that is in foreshortening, so Dürer did not move his circle of men upward any more, but into the depth of space. The result is a restless flow and yet at the same time a general solemn calm.

Single figures are not important in this composition, but the main centres are bound together into a firm system. The vertical line of the Trinity group dominates the concentric and harmonious curves. It is composed in strict frontality, with the outspread cloak adding much to its importance, and although it does not reach the lower group it remains the central axis of its circular formation. The leaders of the congregation of mankind are the emperor and the pope, on the right

and on the left respectively. The latter is a majestically conceived figure, especially in the long train of his draperies.

The two figures are set diagonally opposite each other and neither can be separated entirely from his neighbour. The motif of the emperor is only completed by the figure of the kneeling king to whom he talks, and the contour of the pope derives its solemnity from the parallel accompaniment of the cardinal. The cardinal in turn glances back, with a gesture to encourage the kneeling donor to approach. In this he is doing the onlooker a service. In earlier art the fact that the eye must be guided in such a case would not have been considered. The old donor is a profile figure of moving simplicity, a poor man who is suddenly summoned to enter the hall of heaven (preliminary study in Frankfurt, w.511).

We have a study for this picture of 1508 (Chantilly, w.445). It is simpler, but also less interesting. The landscape motif was there from the beginning and was originally of even greater importance. When Dürer increased the hosts of men he did so at the cost of the setting. The diagonal position of the figures in the foreground is only found in the painting and the effectively narrow gap between emperor and pope (with its resulting intersections) was also only evolved in the course of the work. Only then was the group of the Trinity set so high and the whole distribution of the masses changed. The flat arch forming the upper termination also belongs to this definitive rearrangement.

But the peculiar charm of the drawing lies in the fact that the composition is shown in an elaborately rendered frame (Plate 67). The frame that was in fact executed still exists (Nuremberg) and it is different from the design, but it is important to possess evidence which proves that Dürer tested on paper the harmony of the two elements, of frame and picture. It is unfair to the picture to reproduce it without its frame. It looks as though it has no head. The panel seems unbalanced in itself—it needs a termination at the upper end. The effectiveness of the frame was still taken into account, though it was something new to the north for the altarpiece to have no side wings.

The design shows a frame on a simple Italian pattern: two smooth columns with an entablature and a semi-circular wall arch above. There are indications here and there that the forms have not yet been fully understood, and the predella which tapers towards the bottom and takes the ground from under the feet of the columns, so to speak, has been designed unhesitatingly in the old style. But to German eyes at the beginning of the sixteenth century the work must have appeared entirely foreign, so much so, that Dürer abandoned it. It is most instructive to observe with him how the architectural forms lose their size and severity, how the planes are given over to ornament, in one word how Dürer tried to assimilate the foreign system to national taste. Already in the early design the predella represented a compromise; now the contraction of the arch on top, whereby the connection

168

67. Design for the All
Saints altarpiece
with frame.
1508. Pen drawing,
391 × 263mm.
Chantilly, Musée
Condé.

with the columns is lost, is another step in this direction.[82] The columns themselves have become more delicate and are encased for two-thirds of their height in 'stockings' of leafy, intertwined branches. The decoration has generally become more detailed, agitated, and flickering. This fits in very well with the mood of the picture.

In addition the strong accents of shade on the frame, combined with shining gold, have a beneficial, soothing effect on the picture and make it look like a glittering tapestry, for the colours in themselves are not at all quiet. It is astonishing how Dürer ignored everything he had ever observed as far as the colours of objects in the sky were concerned. The knight's armour or the pope's pluvial are treated in a completely unpainterly fashion. One coloured plane is set beside another in a purely decorative way, producing a light, multi-coloured, harsh harmony. Thausing may be right though in thinking that this florid colouring was the right way of giving the German people an idea of the magnificence of Paradise.

Finally, the frame is also important for the subject-matter. It shows the Last Judgement, and so earnestly admonishes people to accept the offered salvation. As the preliminary drawing shows, Dürer designed the figures himself.

The new graphic style:
the smaller Passions

Italy had provided Dürer with the impetus to approach subjects in a more objective way, to visualize form on a larger scale. Although there had been boldly executed drawings already before 1505, these had only been cursorily done. Dürer lost his comprehensive vision as soon as he paid closer attention to form. The broadly drawn and yet momentous heads for the Heller altarpiece would have been impossible without his Italian training, and even so small regressions can be noticed here and there, for instance in the hands, when the work is compared with what was done in Venice. There are no clearly consistent developments in Dürer's works.

The new drawing style is simple and clear and confined to essentials. The display of virtuosity is a general characteristic of sixteenth-century graphic art. The onlooker is meant to see where the first and the last strokes are and be convinced that the exact number of strokes is necessary, neither more nor less. Alberti's phrase about necessity being the ultimate determination of beauty, which can be thought of as the motto of High Renaissance art, is relevant even for the pattern of strokes in an individual drawing. It has already been said that the lines must have their own decorative beauty, but compared with the beginnings of this kind of drawing, its development now leads to an increasing reduction of lines and a more rational economy in the use of individual elements.

In the Albertina there is the strange drawing by Raphael which he gave to Dürer as a present, a red chalk study of two male nudes. A note was made on it by Dürer himself to the effect that these nudes had been sent to him by Raphael to 'show his hand' to him; it is dated 1515. It may be presumed that this sheet was not the sole contents of the consignment, as it is probable that there were pen drawings too. In any case, even though the attitude of both artists to nature was very different, their technique is quite similar. Dürer made a series of free drawings from the nude in the years 1514, 1515 and 1516 which can easily be compared with pen drawings by Raphael in their transparent execution, broad strokes and peculiar rhythm of lines and intervals. After all both are artists of the Cinquecento.

The new drawing style had its most obvious effect on woodcuts and engravings. In the engravings the subtle treatment of the plate at the time of the *Large Nemesis* or *Adam and Eve* has been renounced. Any line which is not effective with regard to the whole has been eliminated. The drawing encloses forms with firm, clear lines. The woodcuts go even further. The technique of the *Life of the Virgin*, with its minute undulations and sporadic dots, has been transformed into a broadly

sweeping style, which in its tendency towards simplicity not only avoids any complicated lines and intersections but even tries specifically to confine itself to straight lines as long as possible.

This is now more easily possible than before, because the picture is built up in broad layers of tone following Dürer's new painterly taste. Straight hatching can cross a round form unhesitatingly, as long as the form is not highlighted. Whole complexes of different forms are drawn together uniformly; on the other hand new sources of painterly richness are found in contrasting directions of hatching. The narrowness or width of the intervals is less important than the effect of these changes of direction. One discovers that the same hatching appears lighter or darker according to the orientation of the strokes.

The eye is focused on tonal values, but also on large masses, and the composition is unified and comprehensive, which makes the most homogeneous of the earlier sheets seem to fall apart. When these graphic works are treated in the style of the paintings, with sides which correspond precisely, and strong contrasts, a structural unity usually supplements the painterly one. In any case these sheets share the general clarification of Dürer's style in that the main motif is also the most eye-catching and the principal theme obviously dominates the subordinate ones.

The supplementary sheets to the old sequences of the *Large Passion* and the *Life of the Virgin* were designed in this style in about 1510. The interval in date was a considerable one, and there are violent contrasts. When one opens the *Passion*, the first sheet is the more modern design of the *Last Supper* (Plate 68) and the next is the *Agony in the Garden* (Plate 17), one of the most clumsy of the old sheets. Today one would try to unify the styles, but Dürer always presented the product of his most recent taste with the same *naïveté* as the old architects who followed the changes of taste in their cathedrals without qualms.

A comparison of the *Last Supper* with the *Crucifixion* (Plate 19) or the *Lamentation* (Plate 20; see above, pp. 77 and 78) will show up the differences between the old and the new woodcuts very clearly. In the older examples the main effect is based on lines, in the new ones on tone. The whole field is covered, and what remains white thus appears like a shining light. Not only is the Lord's halo characteristic of this painterly approach, but even more so are the large areas of light and dark in the centre of the picture: the white on the table and the shadow underneath it, and between the two—wonderfully light and atmospheric—the half-tone of the table-cloth in the shadow. Unfortunately it is impossible to retain the charm of the original effect in a smaller reproduction.

If one looks at the drawing of a figure in detail, it will be found that the modelling is done in broad layers. The lines frequently run straight across curved shapes. The sense of a body's volume—which the old style had tried in vain to achieve by rendering each fold of a garment

differently—is conveyed by merely widening or narrowing the intervals and changing the direction of the hatching. Of decisive importance for the general impression of space is that the more distant figures are no longer modelled at all, but appear flat, as they do in nature.

The lines are much simpler than before and the effect is more powerful because it is based entirely on strict economy. Even the impression of shade, lit by reflections, the trembling half-light, could be conveyed by this linear technique.

There is no need to point out the structural arrangement of the figures. In the foreground there are symmetrical 'stage' figures, made interesting by their contrasting movements. The inn-keeper who pours the wine only bends forward towards the spectator because Judas bends

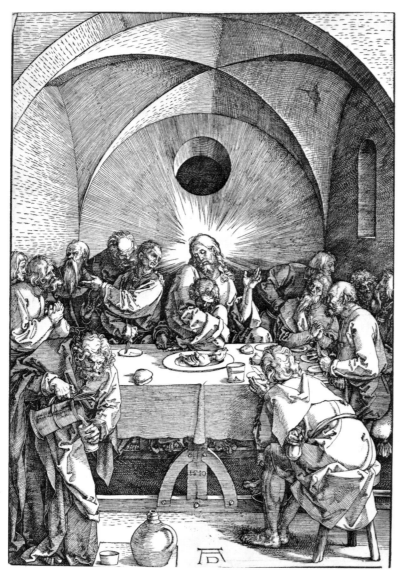

68. *Large Woodcut Passion: The Last Supper*. 1510. 395 × 284mm.

into the picture on the other side. He is the figure in the shade, Judas the one in the light. These devices are taken from Italy. From the same source comes the motif of connecting the main figure with those at the corners while the rest of the company is much less obtrusive. The motif of combining the disciples in groups is directly reminiscent of Leonardo.

Whether a greater emotional impact has been gained by all this is another question. Later on Dürer designed another *Last Supper* (1523; Plate 111) which compares favourably with this one and makes it seem somewhat negligible. But I would also agree with those who sense a growing coldness in Dürer's whole technique and prefer his old wood-cut style, in spite of its plainness, because it was more warmly alive.

The rest of this group of supplementary scenes, the title page, *Christ taken by the Jews*, *Christ in Limbo* and the *Resurrection*, which is especially magnificent in its light effects, will be discussed below when the *Passion* series are compared. As far as the *Life of the Virgin* is concerned, only the *Death* and the *Coronation of the Virgin*—apart from the title page—belong to the year 1510.

The *Coronation* is particularly interesting because it deals with the same subject as the Heller altarpiece. It shows clearly how Dürer distinguished between a monumental and an unmonumental approach. Thausing has observed before this that Christ in the woodcut is treated in a sentimental, prayerbook fashion with his head held coyly and his chest thrust forward. This feature is not yet present in the preliminary drawing, of which only copies exist (Berlin and Milan, Ambrosiana, W.II.XXIII). The simplification in the positioning of the arms—in both cases the furthest away holds the crown—is also a later solution and was felt to be the only suitable one for a woodcut.

There is also a preliminary drawing for the *Death of the Virgin* (Albertina, W.471). It is thought to be very much earlier than the wood-cut, but the tonal hatching as well as the composition of figures shows that it cannot have been done in connection with the earlier sheets of the *Life of the Virgin*. In the final version the only alterations are in the shadows which have been grouped into larger masses and in the lights which have been stressed more strongly. The lower end and canopy of the bed were made smaller. Especially instructive is the revision made in the way the curtains of the bed were hung. Originally they were both tied up evenly but to draw the onlooker's attention to the principal subject of what was happening at the dying woman's bed, one of them was loosened and pulled to the side. The large unifying cross-staff is also a motif of Dürer's mature style.

The works of this time can be directly compared to earlier ones: in the single woodcut of the *Adoration of the Kings* of 1511 (B.3) a subject is treated which already existed in the *Life of the Virgin*. This comparison is probably more suitable than any other for clarifying the change in atmosphere. The new drawing is an impressive design—this is obvious just from the way the figures are connected with the large

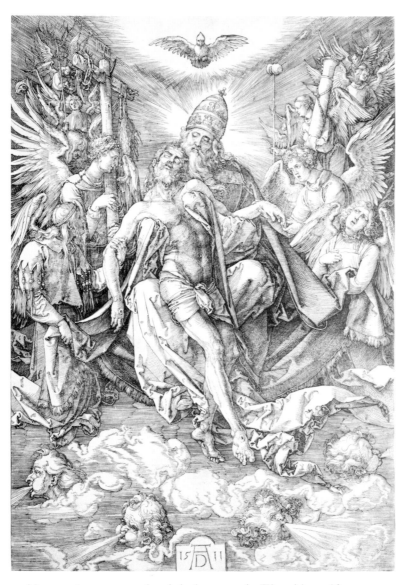

69. *Seat of Mercy (The
Trinity)*. 1511.
Woodcut,
392 × 284mm.

architectural structure—but it lacks warmth. The old motifs are more
heartfelt and so are the old lines, not to mention the wealth of detail.
Dürer has lost the poetry of the diminutive which he had once devel-
oped, now he only writes in capital letters.

 But it is true that he rises higher than he had ever done before when
the subject itself is simple. The *Seat of Mercy in the clouds* of 1511
(B.122; Plate 69) is not only the most beautiful woodcut of this period,
but also shows an unsurpassed power of invention.[83] If the motif is
seen unexpectedly—by coming across it, for example, in the church of
St Mary in Lübeck where there is a large painted version of it—the
imposing and immensely expressive force of Dürer's drawing will not
be forgotten. It is true that someone like Baldung Grien produces a
more captivating effect in his version of the theme where the broken

corpse of the Son is carried to the Father, who only becomes visible high up in Heaven, and where all the angels start to lament at the sight, but the artistic achievement is higher in Dürer's picture.

The old man supports the corpse with his veiled hands under the shoulders, which are thus thrust upward while the head sinks back in pain and exhaustion. This is not the kind of triumphal presentation found in the *All Saints* picture, but a pitiable one which is meant to move the heart. The angels are allowed to approach closely and to support an arm and hand of the corpse. Two of them hold the ends of the cloak, others approach holding the instruments of the Passion. The drawing reaches a climax in the way it sets tone against movement. The flashing aureoles on the dark ground and the light whirling clouds are deliberate contrasts, as are the lively, crackling draperies at God's feet and the mysteriously muffled rustling of the shadowy hollows in his cloak.

The years 1510 and 1511 were prolific as far as the woodcuts are concerned: the *Flagellant* (B.119) dated 1510, the *Beheading of St John the Baptist* (B.125) of the same year and the *Presentation of his head* (B.126) of the following year, also the *Mass of St Gregory* (B.123), *St Christopher* (B.103), *St Jerome in his cell* (B.114; Plate 89) and two *Holy Families* (B.96 and 97). These are all magnificent woodcuts, the only exception being possibly the last mentioned (B.97) which is a super-ficial work. There was no comparable production of engravings. Only a few sheets were done during these years and they are not the best of their kind. The 'deeply cut, regularly hatched' style, which succeeded the old more subtle technique, was not favourable to copper engraving. F. Lippmann has remarked: 'Though the execution is brilliant, and just because the lines are pure and sharp, this technique easily produces a cold, metallic effect.' As a characteristic example he cites the *Madonna with the pear* of 1511 (B.41).[84] The engravings only flourish in the ensuing years.

Meanwhile the two techniques compete with each other in a parallel sequence of scenes of the Passion in small format. The so-called *Small Woodcut Passion* appeared in 1511 with a great number of other works. It was a large collection of woodcuts and the accompanying Latin verses were again provided by the Augustinian Schwalbe. Two sheets are dated 1509, two 1510, the others are not dated but in the main show the same characteristics.[85] Beside this woodcut sequence, an engraved history of the Passion had long been planned but it was only seriously taken up in 1512. All its sheets are dated, one 1507, two 1508, one each 1509 and 1511 and ten 1512. Usually the *Healing of the lame man by St Peter and St John* of 1513 (B.18) is placed with the *Passion*. There was never an edition in book form.

The *Woodcut Passion* (Plates 70, 71, 74, 77, 79, 80, 82), which consists of thirty-seven sheets and is called the *Small Passion* to distinguish it from the large one, is Dürer's most popular Passion. It tells the story

in detail. It starts with the Fall and the Expulsion from Paradise and leads up to the events after the Ascension of Christ. The beginning was designed with enjoyment, almost with humour: Adam and Eve stand in front of the tree in cordial embrace looking at each other, while she already holds the apple. Adam, hesitant, steps out daintily and cautiously; Eve frivolously puts one foot on the other.[86] But after this the tone changes completely and throughout the scenes are intended to move the spectator, with an unmistakable tendency towards a popular appeal. Christ on the Cross, for instance, is again shown with bent knees in the traditional manner which demands pity. But Dürer is not sentimental, the main characteristic of the whole sequence is one of submission, as the title implies. The hero goes through the stages of the story as a quiet, dignified sufferer, and only once, in the scene of Christ carrying the Cross, is the expression intensified to a loud outcry. It is noticeable that all foreign elements have been eliminated as much as possible in the movements and costumes. The angel of the *Annunciation* does not wear a classical garment as he did in the *Life of the Virgin* but appears in his well-known deacon's vestment, as does the angel of the *Expulsion*. No attempt has been made to show what is extraordinary in the spiritual content of the situations; much is even superficial. *Christ taking leave of his Mother* cannot be compared to the corresponding scene in the *Life of the Virgin*. Yet with all their simplicity most sheets have attained a beautiful solemnity.

The execution is intentionally simple. There are no foreshortenings, no complicated postures or arrangements, everything is essential. Utmost clarity has been gained in this way, even though a few additional flourishes and a linear movement with more twists than would be allowed to the more serious, subtle engraving have been conceded on principle to the woodcut with its natural poverty.

The value of these drawings lies in the way the main motifs have been rendered quite distinctly, and this means a lot. Dürer wanted to show how a situation could be explained with a few strokes, and there are a number of motifs to which he generally gave a final and conclusive shape. *Christ washing the feet of his disciples* ('not my feet only') (Plate 70), the *Agony in the Garden*, *Christ carrying the Cross*, the *Deposition*, the *Lamentation* and the *Entombment* are such models of simple and expressive representation.

Only those who demand movement everywhere will criticize these things unfavourably. It is true, a feeling of spontaneity is lacking, much seems obviously 'composed' and becomes effective only through the solemn, ordered composition. One need not necessarily think of Holbein, who was a master in the depiction of events. Even beside Altdorfer Dürer often appears stiff and schoolmasterish, although he surpasses him by far in earnestness of purpose. But here we touch on a limitation found in all Dürer's art, which there is no need to discuss at this particular moment.

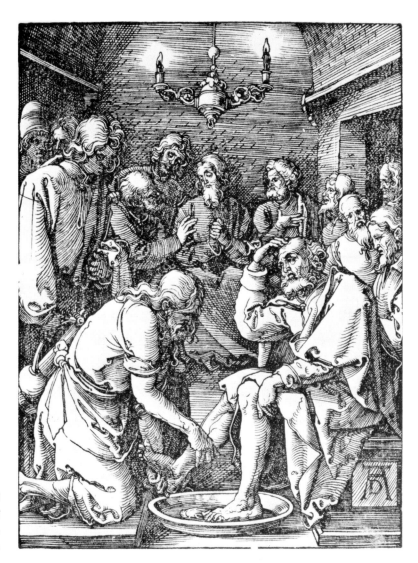

70. *Small Woodcut Passion: Christ washing the feet of his disciples.* 1511. 127×97mm.

The *Engraved Passion* (Plates 72, 76, 81, 83) does not entirely possess the unified character of the woodcut sequence. Its creation took place over a longer period of time. But from the very beginning the engraving was used by Dürer for his more intimate artistic interests; it is the most sensitive gauge of his artistic changes. Thus as early as 1507 we find a *Lamentation* conceived in the manner of a sculpturally modelled Italian composition, while by the late date of 1512 we find sheets conceived in an entirely painterly way. Apart from this the nature of the engraving enabled the most difficult problems to be taken up. In them Dürer shows the foreshortenings he avoids in the woodcuts, he operates with more varied combinations of figures, his drawing of details of heads and bodies is refined, he experiments with costumes. Here he becomes a painter who is also able to convey the subtler relations of light and shade. The engraving, as has been men-

177

tioned already, was meant for a different public—it was done for the connoisseur. It is natural that this sequence of engravings could not have the same freshness as the woodcuts, where Dürer's only concern was to find the simplest and most striking way to express the subject. Sometimes the engravings seem almost affected, and yet here too are scenes with immense impact—the *Ecce Homo* comes to mind.

We shall now try to analyse individual scenes, using the other versions in the *Large Woodcut Passion* and the drawings of the *Green Passion* as references.

THE AGONY IN THE GARDEN (L.W.P.; E.P. 1508; S.W.P.)[87]: in the sequence of the *Small Woodcut Passion* (Plate 71) this scene is probably the most perfect of all. It has the old arrangement with which we are already familiar from the *Large Woodcut Passion* (Plate 17). Christ is

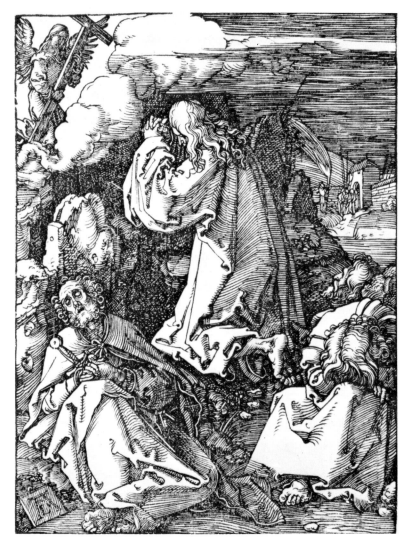

71. *Small Woodcut Passion: The Agony in the Garden.* 1511. 127 × 97mm.

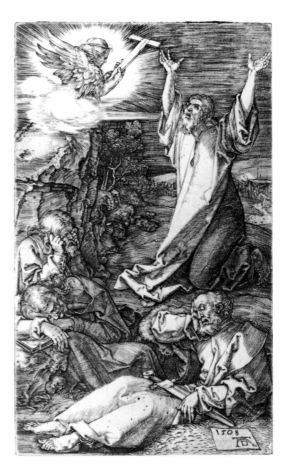

72. *Engraved
Passion: The Agony
in the Garden.* 1508.
115 × 71mm.

in the centre, the rock as the background, the disciples in the fore-
ground, Peter on the left, the two others together on the right. But now
everything is more clearly and strongly expressed. What is most impor-
tant is that Christ now emerges as the principal character. The figures
are no longer scattered, no longer of equal significance so that the chief
protagonist has to be sought out. A definite order of importance has
been established instead. Christ immediately attracts the eye as a light
mass against a black ground, and the disciples seem only to be com-
panions. Only two are really visible and one of these hides his face.
This is John who rests his forehead on his knee. As the youngest he
enjoys the right of deep sleep. But in Peter we find a superb expression
of troubled, restless half-sleep. Formerly they had merely been people
with their eyes closed, now it can be seen that they sleep. In the figure
of Christ the movement of kneeling has first of all been clarified, so that
its significant points can be immediately grasped. The expression too
is so distinct that the essence of the atmosphere can already be felt at a
great distance. The gesture is submissive, it says 'yet not what I will
but what thou wilt'. The face is nearly invisible but the inclination of
the head and the lines of the long simple garment are infinitely moving.

179

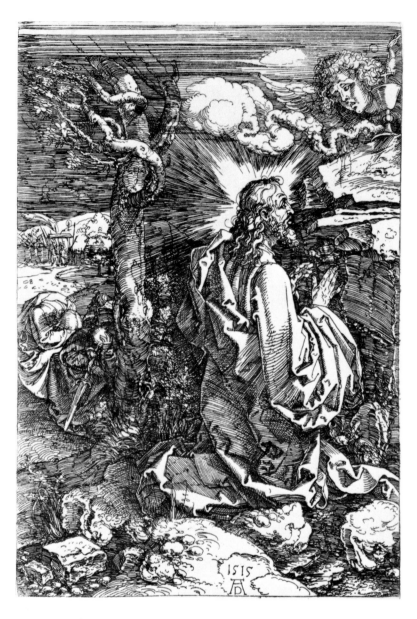

73. *Agony in the Garden*. 1515. Etching on iron, 225 × 160mm.

The engraving (Plate 72), which was done somewhat earlier, in 1508, is not on the same level as the woodcut, but generally the same stylistic characteristics apply to it. With a loud cry Christ throws up his arms before the angel who shows him the Cross. They are white shapes in front of the dark night sky, and a large, broad shaft of light sets off his figure from the surroundings. The disciples are all elaborately rendered with subtle strokes of the burin, but they are not individually obtrusive. Peter is represented somewhat laboriously as a sitting figure with his legs stretched along the lower edge of the engraving.[88]

Dürer was preoccupied with the problem of Gethsemane for a long time to come. It recurs repeatedly in drawings, of which at least one

was used for reproduction, the large etching on iron of 1515 (B.19; preliminary drawing in the Albertina, W.585). Christ's upright head is seen in profile, staring at the cup, and his hands are open in a gesture not of rejection but of readiness to receive (Plate 73). He is deeply agitated but the struggle is over. His draperies are very imposing. The disciples are kept completely in the background.[89]

We may wonder if the type of the recumbent Christ lying flat on the ground, which was inserted in a cut of little worth into the context of the *Small Woodcut Passion* (B.54), was possibly only a thought of the last years. It only appears for certain in a drawing of 1524 (Frankfurt, W.798).[90] The fact that beauty of appearance was disregarded entirely fits in with the solemn, serious attitude of that period. 'He fell on the ground'. For the second decade this motif would have been at least unusual.

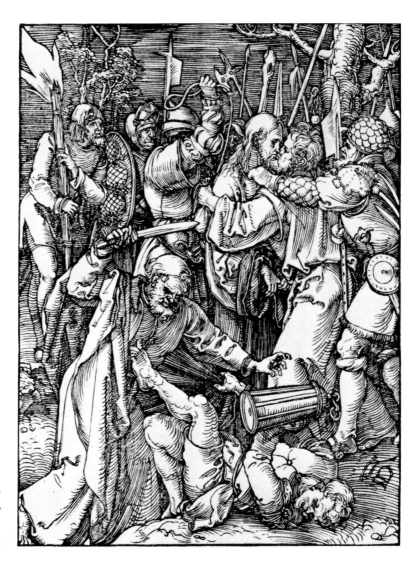

74. *Small Woodcut Passion: Christ taken by the Jews.* 1511
127 × 97mm.

CHRIST TAKEN BY THE JEWS (G.P. 1504, W. 300; preliminary drawing in Turin, W. 299; E.P. 1508; L.W.P. 1510; S.W.P.): the main motif of this scene is the kiss of Judas. Judas and Christ, both standing figures, are hemmed in by a crowd of men who all make the capture at the same time, pushing and tearing with rods and cords (Plate 74). At the same time the episode which took place between Peter and the slave Malchus had to be represented as well. The danger was that the main figure would be lost. Dürer still made this typical mistake in the *Green Passion* (Plate 75). He wanted to show everything: Judas embracing and kissing Christ, a rope being thrown over Christ's head, his hair being torn, being pushed in the back and his cloak being pulled. Christ's figure only emerges slowly and at the same time the feeling grows that, if a noble effect is to be achieved, he must be treated with consideration, that his figure would not be intersected so arbitrarily and he should not be made to look ridiculous by having his cloak pulled.

The best solution for an overall composition is provided by the *Large Woodcut Passion*. Christ, held back by the kiss and pulled forward at the same time, appears as a large white figure dominating the whole picture on the diagonal. He keeps his dignity and yet the onlooker immediately understands that an act of violation is being committed. The diagonal is given the greatest possible effect by the contrary movement of the accompanying lines. The figure of a young axebearer in the left foreground is used to produce this effect. In the right corner the episode with Peter takes place.

In the smaller formats of the *Engraved Passion* and the *Small Woodcut Passion*—and especially in the latter—this episode becomes almost the main theme. It is a useful subject, and no parallel could be more instructive in showing up Dürer's development than a comparison of this scene in the *Green Passion* on the one hand and in the *Small Woodcut Passion* on the other.

In the *Green Passion* the event is shown on a single plane, the figures are widely dispersed, the act of striking itself is archaically distinct as in the *Apocalypse*, yet extravagant and uninteresting because there is no resistance. The servant on the ground shows no strength in his action and his body seems to have no weight. The drawing breaks down at crucial points. In the *Small Woodcut Passion*, on the other hand, we see a rich and tightly interlocked moving throng. The figures are no longer seen two-dimensionally and in profile, but in foreshortening and in turning movements. The servant lying on his back tries to parry the blow with a lantern and thrusts his foot against the chest of his attacker, drawing him nearer with the cloak at the same time so that his kick will have more force. Peter, with his hesitant movement, is the old man he ought to be and not an angel from the Euphrates.

CHRIST BEFORE HIS CAPTORS (G.P. [2] 1504;[91] S.W.P. [3], the fourth confrontation [Christ before Herod] dated 1509; E.P. [2] 1512): while normally we find only a rendering of the more usual scenes of Christ

75. *Green Passi*
Christ taken by the Je
1504. Pen drawi
282 × 180mm. Vien
Alberti

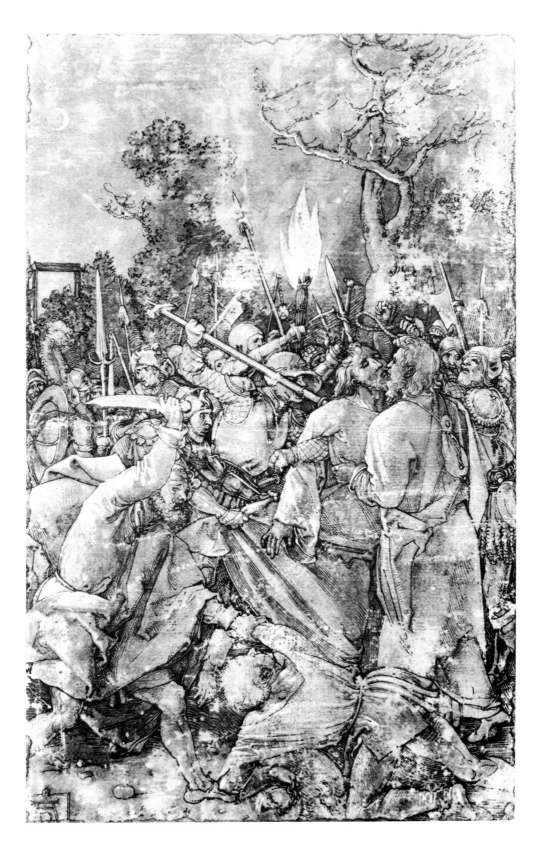

before Caiaphas and Pilate, the *Small Woodcut Passion* with its simple means shows in addition the scenes of Christ before Annas and Herod. The psychological content of these various confrontations is not the same, but if distinctions could be made in the spoken word, the subject, when represented pictorially, was necessarily reduced to one essential problem: the prisoner before authority. Dürer here makes variations on a simple theme which are essentially formal exercises.

He tries out various possibilities in the spatial arrangements. Besides the normal confrontation in a profile view, which is only shown in the *Green Passion*, he presents the confrontation at an angle, on steps at different levels, even with Christ placed low in the middle ground, as in the scene with Pilate in the *Small Woodcut Passion* which has an additional zig-zag movement.

The treatment of the architectural background, which in the *Green Passion* had been used ornamentally and without taking the figures into account, becomes more and more economical. The figure of Christ before Herod in the *Small Woodcut Passion* would not seem to be so tall if it were not for the wall arch above his head.

In the engraving it is painterly motifs which show up new aspects of the subject. *Christ before Caiaphas* has the effect of a night scene. The whole group of Christ and the people around him has been given *one* dark tone: Caiaphas alone is strongly lit. In the second confrontation in the *Engraved Passion* (of Christ before Pilate) Dürer has repeated himself. He has given a painterly, tonal effect to an idea from the *Green Passion* and clarified, strengthened and compressed it at the same time. This is of course consistent with his artistic development.

It can again be observed here that the figure of the hero is treated with consideration. The precedent found in the *Green Passion*, which allowed Christ's cloak to be pulled, and so took away all appearance of dignity, is not now repeated any more.

THE MOCKING OF CHRIST and CHRIST CROWNED WITH THORNS (G.P. 1504;[92] S.W.P.; E.P. 1512): the subject of Christ sitting with men pressing around him lends itself especially to a rendering of exciting movement in individual figures, showing them kneeling, bending forward, etc. It demands a tight throng of people, but utmost artistic reticence as well if distinctness and dignity are to be preserved.

The *Mocking of Christ* is only represented in the *Small Woodcut Passion*. It is a scene full of people and somewhat muddled, yet the immensely expressive figure of Christ, set frontally into the centre, triumphs over the medley. In the scene of Christ crowned with thorns on the other hand, where the same problem is tackled, he is shown in profile and sits at the side. In the *Small Woodcut Passion* the simplest aspects are sought, profile is juxtaposed with profile in the first row of the group and a second row is placed parallel to the first. In the engraving Christ remains in profile, but otherwise, following the nature of its technique, simplicity has been avoided and a richer and more

184

picturesque group has been formed, although full clarity has not everywhere been achieved. The kneeling youth (has he been drawn in imitation of Italian tarot cards?) makes a disjointed gesture, he hands over the reed but his hand is completely separated from his body. Although the strongest light is on a minor figure, Christ's dignified profile figure dominates the picture all the same. A comparison with the shaky abundance of the *Green Passion* shows up the monumentality of these Christ figures most clearly.

THE FLAGELLATION (L.W.P.; G.P. 1504; S.W.P.; E.P. 1512): after the pleasure of presenting the beauty of the body, which is what he was principally concerned with in the two earlier representations, the mature Dürer stresses character and expression. The *Small Woodcut*, however, has turned out somewhat lamely, but the finely drawn engraving is very impressive in the way it shows the projecting profile and wincing movement of the tormented body held up by a strong will. Both representations show Christ in profile. The movements of the tormentors are muted so that they do not overwhelm the principal figure.

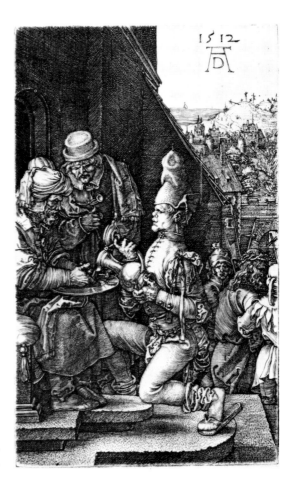

76. *Engraved Passion: Pilate washing his hands.* 1512. 115 × 71mm.

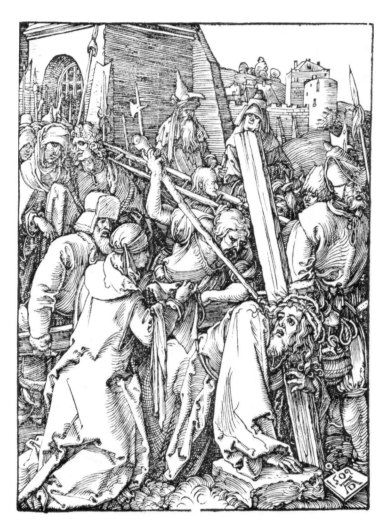

77. *Small Woodcut Passion: Christ carrying the Cross.* 1509. 127 × 97mm.

ECCE HOMO (L.W.P.; G.P. 1504; S.W.P.; E.P. 1512): the engraving outclasses all other versions. With magnificent economy and restraint the two contrasting figures are seen facing each other: the sufferer and the pitiless man. The expression of suffering is restrained yet very eloquent. The unbroken contour of the unmoved onlooker is as individual as it is effective as a contrast. Pilate plays no part. His figure is small and partly hidden from the eye by Christ's raised cloak. There is little more than a hint that there are more people. This is no representation of the insistent demand 'Crucify him!', it is not an event but mere existence. In the *Small Woodcut Passion* the attempt to represent a large crowd fails completely.

PILATE WASHING HIS HANDS (S.W.P.; E.P. 1512): little has been made of the psychology of this interesting situation. Even if the woodcut is disregarded, one might at least expect the engraving (Plate 76) to show some of the life that Holbein conveyed, where Pilate was shown putting his hands over the basin with a hasty gesture, giving in to the pressure

but refusing to take any responsibility. In Dürer's picture Pilate washes his hands with such deliberate care that it does not give the impression of a symbolic gesture any more. He might be a surgeon calmly disinfecting his hands before an operation. And the onlooker's attention is held by the youth with the jug rather than anything else. He has the face of a Moor[93] and wears a very strange costume. He kneels in the centre of the picture, a bright, isolated figure.

CHRIST CARRYING THE CROSS (L.W.P.; G.P. 1504; S.W.P. 1509; E.P. 1512): the scene in the *Small Woodcut* series triumphs (Plate 77; see also Plate 18). The expressive power of the 'fall' has been unsurpassably intensified. The supporting arm, which is the more important one, is now in front. Its supporting function is all the more impressive as the body seems to hang from it, and the head is very low. Christ turns to Veronica and looks up at her with an immense effort. For the onlooker this turning movement has an emphatic and painful meaning. The same scene by Raphael surpasses the significance of Dürer's representation only in so far as Christ's eyes meet those of his Mother.

The engraving does not attempt to vie with the woodcut in its main motif. It shows Christ erect, walking, being pulled forward, turning towards the women.

CHRIST BEING NAILED TO THE CROSS (G.P. 1504; S.W.P.): the composition in the *Green Passion* contained many interesting individual gestures. It needed a new version to make it more concentrated, to stabilize it generally and suppress obtrusive subsidiary motifs. The figure now appears at the side of the picture, erect and seen from the back, producing an effect of balance and concentration. Christ's legs are no longer so obtrusive. Our vision and sympathy are concentrated on the upper parts. And it was a moving idea to represent the body as waiting for the last nails rather than nailed down completely. Only in this way could the touching gesture of Christ's free hand be gained and the calm way he lies on the cross be made expressive.

THE CRUCIFIXION (L.W.P.; G.P. 1504; E.P. 1511; S.W.P.): it has already been mentioned that in the woodcut the crucified Christ was shown in the traditional, moving fashion, hanging pitiably on the cross, while in the engraving these devices were relinquished. But neither is the engraving concerned merely with presenting an example of a perfect body (no more so than the *Flagellation*). Dürer's intention is rather to portray a specific psychological situation. The closeness of Christ and St John leaves hardly any doubt that the moment represented is when Christ entrusts his Mother to the care of his disciple. Both are calm and statuesque—it is not a passionate scene.

But there is another engraving, done in 1508 (Plate 78), which is full of powerful, passionate expression. St John wrings his raised hands, Mary writhes convulsively on the ground and the figure of Christ, though his legs are stretched, conveys his suffering very impressively by having his arms nailed high above his head. In the earlier *Cruci-*

fixions by Dürer the arms are simply extended horizontally. The diagonal movement into the depth of the scene fits in well with the passionate character of this unique sheet. In the figure of St John the connection with Mantegna is unmistakable. Christ's loin-cloth has for once been treated exceptionally quietly.

THE DEPOSITION (G.P. 1504; S.W.P.): this scene is probably the most imposing composition Dürer attempted in the *Green Passion* (Plate 21). The theme of the suspended corpse turning from the hips with arms hanging down is impressive in itself and gains further significance from a complex system of movements which together extend the central motif in all directions. Nevertheless there are still painful confusions in this sheet. That Christ's head does not hang down is a regrettable inconsistency. This is where the reworking plays its part. Hardly anything but the mechanical process of the deposition is shown in the woodcut (Plate 79), but the very logic of the mechanical facts is made clearer.

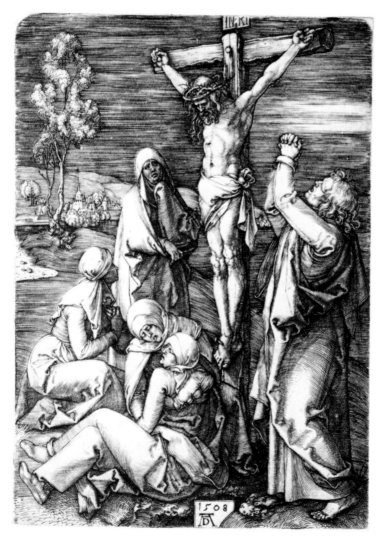

78. *Crucifixion.* 1508.
Engraving,
133 × 98mm.

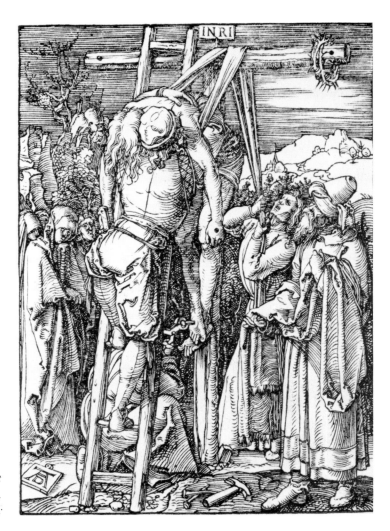

79. *Small Woodcut Passion: The Deposition.* 1511. 127 × 97mm.

Nor has sentiment been neglected. Nothing could be more moving than the way the dead man lies on his supporter's shoulders like a child. THE LAMENTATION (L.W.P.; G.P. 1504; E.P. 1507; S.W.P.): the scenes of the Lamentation develop towards greater intensity of expression as the image of a man who is merely ill and tired changes to that of a dead man who still shows that he died under great suffering. As far as form is concerned the development moves from correct to foreshortened viewpoints and at the same time towards a growing dependence of the subsidiary figures on the principal character or group. The *Small Woodcut Passion*, in its concise and striking manner, is the most imposing (Plate 80). Not only the sorrowful head but the arms and legs as well are made expressive. The earlier engraving (Plate 81) still suffers from the desire to produce interesting sculptural contrasts with the limbs and to differentiate them by means of light as well. It was done immediately after the Italian journey; the legs are similar to those of the Christ-child in the *Rose garland* picture. The earlier representations need not be taken

into consideration at all. As I said before, the corpse lying flat, supported under the arms, hardly seems to be a corpse at all, and a way of expressing great suffering has not yet been found, in the *Green Passion* even less so than in the earlier *Large Woodcut Passion* (Plate 20). In both cases the body is shown whole length, parallel to the lower edge and right in the foreground. The general development which can clearly be followed in these versions is seen in the slanting of the body back into space and the introducing of foreshortened views. Usually these artistic problems of drawing are left to the engraving, but in this woodcut at least a simple use of foreshortening has been attempted in order to suggest the completely broken body. The diagonal of the raised legs and the two angles of the arms help to make the figure of Christ dominate the whole picture as never before.[94]

THE ENTOMBMENT (L.W.P.; S.W.P.; E.P. 1512): the typical stylistic contrast between woodcut (Plate 82) and engraving (Plate 83) is very prominent in this scene. Both were done at about the same time, but

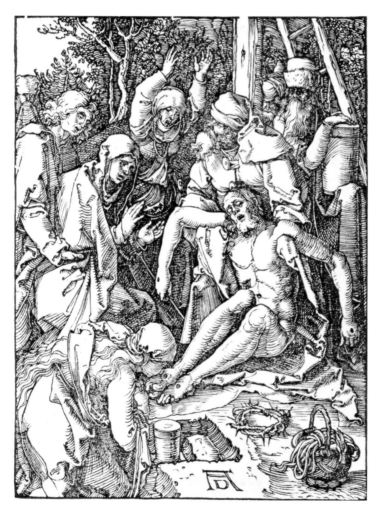

80. *Small Woodcut Passion: The Lamentation.* 1511. 127 × 97mm.

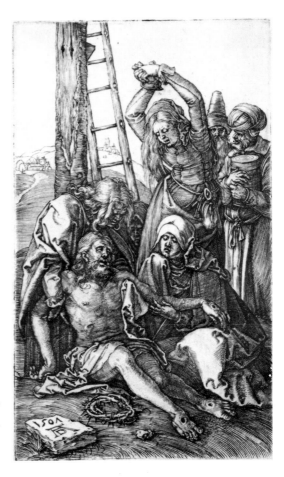

they are entirely different; in one the simplest, in the other the most
complicated image has been sought for. It is quite clear which of them
shows more feeling. The Christ of the woodcut *Entombment*, who is at
peace, is wonderfully impressive, especially coming after the broken
Christ of the *Lamentation*. The engraving works with intersections,
sacrificing the dignity of the body to them.

CHRIST IN LIMBO (L.W.P. 1510; S.W.P.; E.P. 1512): the same contrast
is repeated in the related scenes of the *Descent into Limbo*. The figure
of Christ bending down is shown in profile in one, from the front in the
other, leaning towards the onlooker. The small woodcut is only a repe-
tition of the large one done at the same time. Of course it does not reach
the former's very brilliant effect of light and dark, but it corrects a
number of ugly, unintelligible details (the left hand and right leg, for
example). It is also the only representation in which the motif of
Christ's stooping descent has an unassuming and expressive effect.

THE RESURRECTION (L.W.P. 1510; S.W.P.; E.P. 1512): the main figure is
very similar in all three versions: Christ triumphant, striding forth
in an idealized Italian manner, and contrasted with the figures of the
sleeping guards hunched together. The *Large Woodcut* makes the event

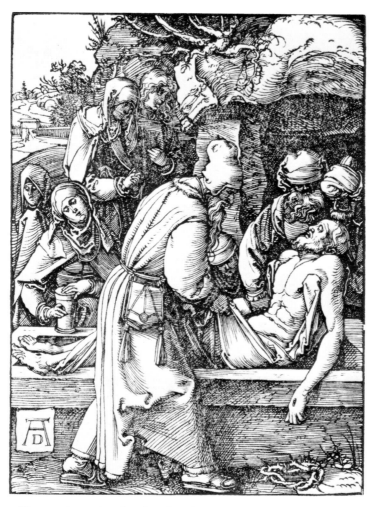

82. *Small Woodcut Passion: The Entombment.* 1511. 127 × 97mm.

still more imposing by showing Christ walking on clouds. The older artists, with their more sober approach, had been content with the mere emergence from the sarcophagus and were not particularly concerned with decorum.

At this moment Dürer attempted a yet more lofty version. There is a carefully executed drawing with white highlights done in 1510 which does not show Christ walking, but flying (Albertina, w.487);[95] he pushes himself upwards sharply, seen slightly from below. A companion work showed Samson among the Philistines with the donkey's jaw-bone—the Old Testament parallel to the Resurrection; it is now in Berlin (w.486).[96] Together they formed a small diptych.

THE MAN OF SORROWS (E.P. 1509; L.W.P.; S.W.P.): Christian sympathy did not rest content with the representation of the *Ecce Homo* or the other episodes of the Passion, it wanted another suffering Christ, independent of the historical scenes, a figure in which all sorrow would be concentrated and presented to the onlooker's devotion. The three printed *Passions* have the *Man of Sorrows* as a frontispiece.

The engraving of 1509, which is the first of the sequence, shows Christ, divested of his garments, standing with trembling knees and arms drawn up as if shivering. He holds the scourge and rod in his hands. The wound in his side is bleeding. At the back stands the pillar of torture. This type had been used by Dürer in an earlier engraving (B.20) which almost certainly belongs to the time of the *Green Passion* but which hardly portrays more than a beautiful body with beautifully posed legs. The actual theme only becomes important now, in 1509. Presently the standing figure disappears as well and Dürer finds that a sitting pose expresses the situation more completely.[97] The Man of Sorrows of the *Large Passion* appears seated, wringing his hands and turning his face to the side imploringly. He is still accompanied by the servant who hands him the reed as a sceptre, but nonetheless the scene is not conceived as realistic history; it takes place in the clouds. But this composition is too brisk and energetic to produce a truly tragic impression. The best representation is that of the *Small Passion* with its huddled figure of the lonely sufferer whose face is hardly visible but whose tired way of supporting his head is infinitely more expressive than the most imploring raising of the eyes.

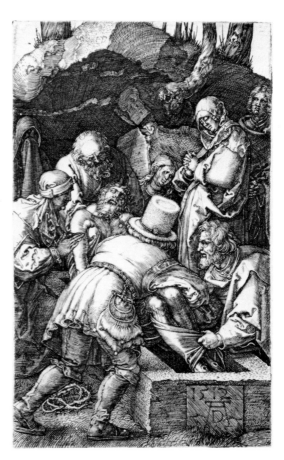

83. *Engraved Passion: The Entombment.* 1512. 115 × 71mm.

It can be said that Dürer introduced a new conception of Christ by adding strength and manliness to the suffering and submission which in previous times were considered to be the essential characteristics of the figure. The sequence of the Passion scenes gives detailed—if not uniformly obvious—evidence of this. Dürer's conception of the character of the Saviour is most clearly seen in the new type of Christ's head, and nowhere does this appear in purer form than in the face of sorrows in the *Sudarium of St Veronica*, an engraving of the year 1513 (B.25; Plate 84). I do not know whether the sudden new profundity and fervour of the representation has to be explained by specific experiences on Dürer's part. Other people too begin to experience things more profoundly in their forties, and to delve more deeply. In any case this *Sudarium* is the crowning glory of all the designs of the Passion, and if ever Dürer produced a popular work, it was this one. The type has a validity even today.

Since Schongauer's great *Christ carrying the Cross* (Plate 4) such moving eyes have not been found in any German graphic work. But the significance of the glance of Dürer's Christ is very different from that of Schongauer's. Schongauer wants to present the head of Christ with as much delicacy and mildness, with as much suffering and pathos, as possible. Dürer represents the suffering too, but also something else: the will to master it. This difference is typical. Even the structure of the head is different—it is broader and stronger. The facial expression is

84. *Sudarium of St Veronica*. 1513. Engraving, 102 × 140mm.

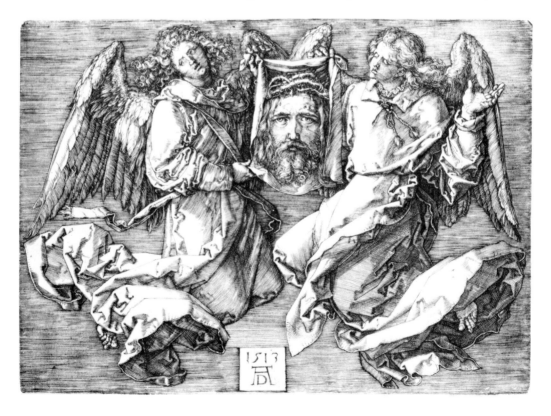

determined above all by the area above the eyes. The contrast provided by the female figures of the plaintively compassionate angels forcefully enhances the character of the head.[98]

The engraving shows a new technique too which raises it to the level of the master engravings. The drawing is simple yet supple without seeming brittle or metallic. How soft the wings are now, and yet how transparent the means, compared with the exertions Dürer thought necessary in the early engraving of the *Large Nemesis*. The garments of the angels gleam and rustle like silk. The whole apparition is seen against a dark ground like night.

It has been said that Dürer gave his own features to this head of Christ and the Munich self-portrait has been referred to as evidence. But because this self-portrait is a somewhat uncertain guide to Dürer's real appearance it will be as well to judge the Düreresque features of his Christ-type in general terms only. Both are heads which have been evolved out of a new concept of man and this has led to a certain harmony between the mood of the portrait and the idealized head.

The colossal woodcut of Christ's head with the crown of thorns appears colder, it is almost Gorgon-like and terrifying, yet of the greatest magnificence. It has been attributed to Dürer and will always remain so, even if it was executed by a different hand. Bartsch mentions it only in the appendix of spurious woodcuts (Appendix, 26). In the seventeenth century there were already connoisseurs who recognized Beham's hand in it, and it was unhesitatingly incorporated by Pauli into his catalogue of that master (Pauli, 829). Geisberg on the other hand attributes it to the Master of the Celtis illustrations (*Einblatt-drucke* No. 772). Passavant's statement in his supplements to Bartsch that no one but Dürer could have given the sheet this splendour must also be considered, for the conception and drawing are conditioned by Dürer.

It is characteristic of German art that its final word should have been said in a single head. If one considers Italian representations of the Passion one remembers them for their figures, and it was only with Guido Reni that the single Head of Sorrows became popular. In the north it had long been so.

The master engravings and related works

The three engravings of the *Knight, Death and the Devil* (B.98), *Melancholia* (B.74) and *St Jerome* (B.60) have always readily been combined into one group. Their size is much the same, they were done in direct succession (1513 and 1514) and they show the same perfection in their execution. It was also thought that their subjects must be related too and that thus they might also be spiritually linked. And if this proved to be impossible with the three sheets a fourth was even being demanded, to complete a sequence of the four temperaments.[99]

But today no one is really willing to believe in such a grouping. Why should the problem be made difficult if it can be understood quite easily? The *Knight, Death and the Devil* has been recognized as the image of the 'Christian Knight', an old subject which does not need to be accompanied or supplemented. The inscription on the *Melancholia*, 'Melencolia I', already shows that it is something out of the ordinary. Neither of the other sheets has such an inscription. Finally one knows from past experience that St Jerome had been represented countless times as a single print and does not need any special interpretation at all. It is true that the *St Jerome* and the *Melancholia* can be contrasted so that they show differences in mood. They are seen as conscious opposites, yet they are not meant to be studied simultaneously, for they are not formal counterparts. But both are pictures of certain moods. Interest is not centred on the sculptural form but on the painterly atmosphere of the whole. This differentiates them sharply from the *Knight* where the clear delineation of figures, especially that of the horse, is most important. Its artistic concerns do not fit in with the group and indeed its roots lie elsewhere.

THE KNIGHT, DEATH AND THE DEVIL (1513; Plate 85): I repeat: in the context of Dürer's art of 1513/14 the knight's horse seems to be archaic.[100] It is shown in such a completely unpainterly fashion, in pure side view, and there has been no playing down of the intention to reveal the actual shape in its utmost distinctness. These are tendencies with which we are familiar from the engraving of Adam and Eve, and our horse is indeed a study of proportions just like those male and female figures. Dürer had at that time already been concerned with the horse's proportions.[101] He continued his constructions in Italy and around 1512 and 1513 his interest revived once more. But his exertions were confined to the theoretic field and it is surprising to see another constructed figure in a picture. Dürer himself seems to have found the motif of just an ordinary animal too insignificant to fill an engraving. So he gave it a new sense by going back to the type of the *eques christianus*, bringing in Death and the Devil and changing the figure into

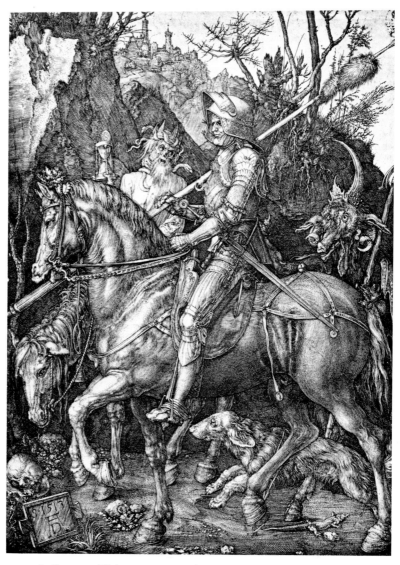

85. *Knight, Death and the Devil.* 1513. Engraving, 250 × 190mm.

a symbolic one. This was not to the advantage of the picture. It cannot be denied for a moment that the accompanying figures are appendages and the whole scene represents a compromise.

Credit must be given to Hermann Grimm who was the first to refer to Erasmus's work on the Christian knight for an explanation of Dürer's engraving. Its title is already found in Sandrart. In the diary of his journey to the Netherlands Dürer himself simply calls the sheet the *Rider*. The interpretation also makes it quite easy to understand another allusion in the diary when Dürer, having heard of Luther's arrest, calls out to Erasmus: 'Ride forth, you knight of Christ'. Weber has further elucidated the subject by proving that the figure of the Christian rider was an old concept familiar in mystic thought, and that it had already found expression in popular woodcuts. It is true that as far as we know today it was always just a single figure, without Death or the Devil. But

there are examples of the appearance of these two in pictures of the pilgrim who marches along the road of Life—which is basically the same subject. These discoveries make it very doubtful whether it was Erasmus's booklet that suggested the subject. Dürer shows us the Christian for whom life is military service and who does not fear the Devil or Death as he is armed with belief. And at that time everyone understood this.[102]

But as I said, Dürer was originally merely concerned with the simple subject of a horse and rider. There is a drawing of this of 1498, done from life and inscribed: 'This was the armour in Germany at the time' (cf. p. 126). The figure of the man is almost repeated in the engraving; it still satisfied Dürer fifteen years afterwards. It is an example of his thriftiness in management. The horse on the other hand has been drawn afresh with a different structure and movement. It gives the impression of being distinctly Italian—not so much in its details, such as the Italian head, but much more in the articulation of the whole form, the way the head and neck are connected and also the neck and body, the way the shoulders can be clearly seen and the legs are separated from the horizontal mass of the body. For the first time the sculptural contrasts of a horse's body have been fully understood. This was not the case in the *St Eustace* or the *Small Horse* of 1505, although the latter already contained Italian elements. Added to this is the wonderfully concise linear balance of the whole. It is not the compellingly unified linear effect, for which Gothic art searched, but the convincing way in which contrasting directions are related. There are stronger formal contrasts than ever before, yet the general appearance shows a coherence rare in classical art. The eye immediately feels the order on which the principal outlines and their rhythm are based, even though the mind is incapable of penetrating the secret.

The structure of the horse is only indirectly copied from nature. The weak shoulders and colossal neck are conspicuous. Their form was obviously largely decided by theories of proportion. Indeed, the pattern has recently been discovered.[103] But where did the decisive impetus come from? Former historians have pointed to Verrocchio's *Colleoni* in Venice. Dürer must have studied this figure closely, as well as the classical horses on San Marco, and these models may have determined a number of details, but on the whole they look different. Their movements are different, one foot is lifted and both legs on the same side move forward. The same is the case with Donatello's *Gattamelata* in Padua. Dürer's horse on the other hand lifts the two diagonally opposite legs. There was only one horse in Italy at the time which had legs in this position, the most modern of all, Leonardo's model for the equestrian monument of Francesco Sforza. It was presumably still standing in Milan, though in a state of decay. Dürer could easily have seen it there, but other points of contact are possibly more likely.

The general appearance of their horses was very similar indeed.

Leonardo himself had a classical model, the so-called *Regisole* in Pavia (destroyed 1796), in which the same simultaneous lifting of the diagonally opposite legs could be seen. Leonardo says somewhere that the movement of this horse was praised especially.[104] It has also long been known that Dürer copied some of Leonardo's studies of horses.[105] He knew that he had come to the right forge and he made the best of it.

The dog which runs beside the rider could be interpreted in a religious sense[106] but it is more likely that it is part of the old profane imagery of the picture, the natural companion of the man and, for formal reasons, desirable beside the horse's legs. It is a beautiful long-haired pointer.

These figures of perfection and strength are approached by ugliness and decay, the images of the Devil and Death. Death, a half-skeleton in a white shirt, rides close up to the man and raises the hourglass in front of his eyes. His bones are partly covered with wispy hair. This frightening phantom has living eyes but no nose. Snakes wind round his neck and crown. His miserable horse hangs its head and sniffs at the skull on the ground. Dürer had drawn King Death once before in this way, even more impressively, as a crowned skeleton with a scythe, bending forward on his nag with a bell tinkling at its neck (W.377; Plate 86). For the Devil too there is much comparative material. Dürer has presented the most complete collection of motifs. The snout is

86. *King Death on a horse*. 1505. Charcoal drawing, 210 × 266mm. London, British Museum.

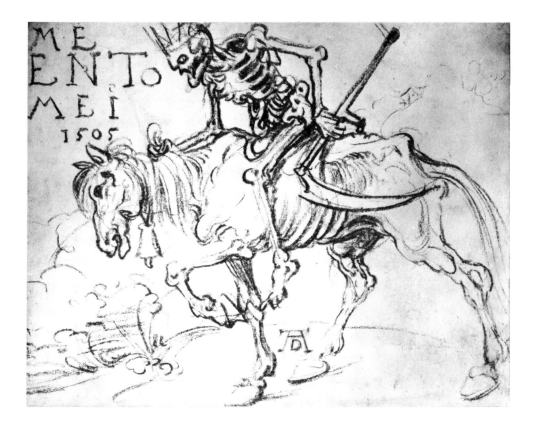

pig-like. The eyes are piercing and circular. He approaches from behind and reaches out for the rider with his claws. But the rider does not see him and rides straight on with a slight smirk, the significance of which we may no longer understand correctly. The same expression is used for Eve in the engraving and in the *Large Nemesis*.

An essential factor for the general impression is that the rider fills the whole breadth of the sheet. Following Dürer's taste for massed effects in these years, the background stretches high up forming a dark wall with a strong light in front.[107]

In this way it was possible to give great emphasis to the white-shirted Death, whose mere size is insignificant. The disastrous muddle of the legs, on the other hand, was irreparable. Nothing could undo the impression of incoherence. But just because the subsidiary figures seem so dismembered, the main figure gains its flat, structurally clear and concise appearance, which goes well with the print's meaning, even if there is little sense of gruesomeness.[108]

MELANCHOLIA (1514; Plate 87): a winged figure of a woman sits very low on the ground on a step by a wall. She sits heavily, like someone who will not get up again soon. Her head rests on her propped-up arm and her hand is clenched. In the other hand she holds a pair of compasses, but she is not thinking about them; she does not do anything with them. The sphere which relates to the compasses rolls on the ground. The book in her lap remains unopened. Her hair falls in dishevelled wisps in spite of the small, dainty wreath. Her eyes look, sombre and fixed, from her darkly shadowed face. What does she look at? At the large block? No, her glance passes beyond it into nothing-ness. Her eyes alone move, but her head does not follow the direction of her glance. Everything seems to emanate ill-humour, numbness and apathy.

But there is animation all around her, a chaos of objects. The geometric block looms bulkily, almost threateningly—it is uncanny because it looks as if it is about to fall. A half-starved dog lies on the ground, together with the sphere and a great many tools: a plane, saw, ruler, nails, pincers, a pot for mixing paints—all untouched, lying around in disorder.

What does it mean? As an explanation the wings of a fabulous bat-like creature at the upper left bear the words MELENCOLIA I.[109]

'Melancholia' is an ambiguous term. We only remain familiar with one of its meanings, that used to describe a mental disorder which paralyses man and everywhere puts obstacles in his path. But melancholy is also one of the four temperaments. A melancholic in this sense need not be a sick man. According to Aristotle melancholics are earnest men with a gift for intellectual work.

Dürer's engraving has thus often been interpreted in this sense, as an allegory of deep, speculative thought. It has been said that he only wanted to represent the searching intellect which has advanced from

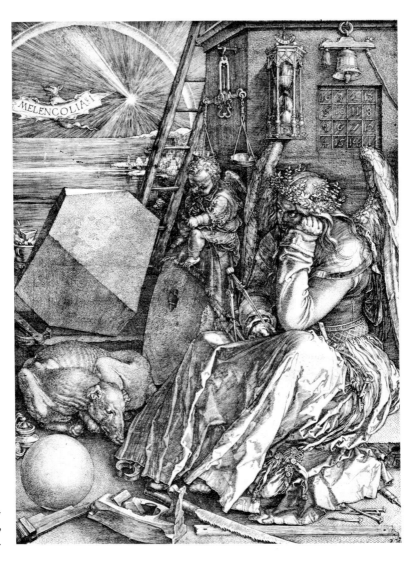

87. *Melancholia*. 1514.
Engraving,
239 × 168mm.

experiment to synthesis and, by extreme mental concentration, is try-
ing to make the vague ideas of inward perception distinct. It has also
been said that the woman is oblivious of the reality around her and only
pursues her vision, that she is the very image of creative scientific
labour.

But in what way? Is this paralysed state really only masking the
most intense productivity? It is obvious that something is alive in this
immobile figure; the tense glance, the tightly clenched fist are signs of
will-power. But do they give one the impression that this woman is
engaged in an activity which suits her? Is she not rather in a state of
acute unease? And the deeply shadowed face, the dishevelled hair—do
they not have a meaning? And if a critic of today finds that the unkempt
hair is fitting for a scholar, and that the disorder on the ground has a
stimulating piquancy, then this is a modern attitude. In the sixteenth

century study was carried out in a painstaking, orderly and quiet way, and one cannot but think that the contemporaries of Dürer's *Melancholia* must have been most upset at first by this unbalanced picture.

Our interpretation can be supported by a further consideration. Predecessors can also be found for the *Melancholia*. As the doctrine of the temperaments was a popular one, they were the subject of verses and pictures in calendars. In one the melancholic is shown as a man with his arms on the table, resting his head on them, while his wife has gone to sleep at her distaff.[110] The most significant characteristic of a melancholic was taken to be an aversion to any activity. Melancholia was anyhow 'the basest complex'. This was the popular judgement, quite the opposite of what Aristotle had said.

But thanks to Giehlow we now know that the classical interpretation had been made current again a short time before. Marsilius Ficinus had written in his work on the threefold life, which had been translated into German, 'All men who have excelled in great art have been melancholics' (after Cicero, Tuscul. I, 33: *omnes ingeniosos melancholicos esse*).[111] This work was known to Dürer and he has followed it in the engraving both in detail and generally. Morose inactivity is not represented at all. Many tokens of the exact sciences and technical skills are heaped up around his nobler type of Melancholia. Nonetheless, these objects are not being used and the figure is entirely apathetic. So Dürer follows the traditional representations as well.

Our interpretation presupposes, however, that Dürer was already aware of the modern ambiguity in the meaning of melancholy, that he distinguished between the normal classification of a temperament where black gall does not go against the other fluids, and that state of imbalance when the soul takes on an aversion to any activity. Is it right for us to presume this? Certainly. In his writings Dürer uses the term melancholia only once, but in a very significant context. He is speaking of the education of young painters and mentions the possibility that a youth when learning might over-exert himself, that he might 'practise too much'. In this case 'melancholia' would get 'out of hand' and he would have to turn to the amusement of stringed instruments 'to enliven his blood'. This is just what we need for an explanation of the engraving. It is true that Dürer does not show a young artist's sinking spirits; he represents intellectual effort generally and singles out as the main motif the activity which was then considered to be at the very centre of learning—mathematics. But there is no doubt that it is not activity which is shown but the inhibition of activity, that is the very state to which the melancholic is especially prone, where the blood has become black and thick, where melancholy has got 'out of hand'. Evening is particularly dangerous. The bat points to this hour.

Marsilius Ficinus describes melancholic depression at length. Extreme preoccupation with intellectual topics ('when instruction is uninterrupted') uses up the clear blood, the brain becomes cold and dry,

reason is blocked. 'Reason is blocked.' This is precisely the woman's state in Dürer's engraving. She gazes into emptiness. The sphere has rolled down from her lap, the pair of compasses is not used. She might be said to be moodily pondering. But if this is so it is the consequence and not the cause of the fit of melancholy.[112]

It is surely wrong to interpret Dürer's *Melancholia* in the sense of a Faustian confession: '. . . and I see that we cannot know anything.' Of course the large block-like object always gives the impression that it signifies a tormenting, unanswerable question. It plays such a conspicuous part in the picture that the eye cannot avoid it. Could it possibly pose a mathematical problem, something like the squaring of the circle? But the experts deny that the object has or had any particular geometric interest. Its mere irregularity is not enough. It cannot be a crystal—which must have been one of nature's formidable secrets —as size and uncrystal-like surface texture do not allow this interpretation. But the block does not even lie in the woman's line of vision. It should be remembered how high the centre of vision is in the picture. The block rests on the same step as that on which she sits, no higher.

In short, I cannot see that there are any allusions to particularly difficult problems. Even less appropriate seems the interpretation which says that thought and research do not make anyone happy as they lead to no conclusions. This negation of scientific scholarship would contradict the whole tendency of Dürer's thought. He took as much pleasure in learning as Leonardo and admired the kind of unabating research and observation which brought man nearer to God. Of course, he was also conscious that human nature had its limits and that it was impossible to reach a clear and conclusive understanding. But should we therefore abandon all research? 'We do not accept this bestial thought,' says Dürer to such a question.

Thanks to Warburg the astrological aspect of the problem and the melancholic's relationship to the planetary deity Saturn, to whom he is subjected, have been investigated.[113] Panofsky and Saxl have carried this research further.[114] It is not without significance to know that already in the Middle Ages measuring was connected with the image of Saturn. And in one place Dürer surely demonstrated astrological wisdom: the panel of numbers on the wall in which any four squares come to the same sum whether they are added up horizontally, vertically or diagonally. These 'magic squares' were thought to possess secret powers. The one shown here is the Jupiter square which provided protection against the depressing power of Saturn because of the joyful nature of its deity. That the square can be explained according to astrological therapeutics is confirmed by the fact that it is made of metal, as Agrippa of Nettesheim once said it should be.[115]

In contrast to the figures in the calendar, Dürer's *Melancholia* has wings. This means that he did not want to represent an individual human being suffering from melancholy, but the very concept of

203

melancholy. In the same way the woman of the *Large Nemesis* (Plate 41), for instance, is characterized as an allegorical figure. The meaning of the compasses and sphere was quite clear to the public of the time.

Mathematics is the basis of all science. This is why it must play a central part in the picture. The large block, even if it does not contain a particular geometric problem, belongs to the same range of ideas. It was already praised by Sandrart as a perspective construction. The Dresden sketchbook contains the preliminary drawing for it.[116] The scales and hourglass are also easy to understand, the latter as a means of measuring time—unless the proximity of the small bell indicates rather that time is running out. The alchemist's pot is also a part of the legitimate household effects, but the inventory is in no way exhausted with it. An attempt has been made to prove that the objects are tokens of the entire *artes liberales* and *artes mechanicae* of the Middle Ages. This is an understandable effort, but it has not led to any results. Various tools of civilization are represented, but it seems that no systematic illustration of traditional categories was attempted. The crucial point is that everything is scattered on the floor, not broken (as are the earthly musical instruments at the feet of Raphael's *St Cecilia*, who hears celestial harmonies) but unused. The pincers are half hidden by the woman's skirt and she puts her foot on the saw.

Dürer himself has given an explanation of two everyday objects, the pouch and the keys hanging from the woman's belt. They symbolize wealth and power.[117] These gifts are said to be available to the saturnine as well. But it seems unlikely that anyone should have suddenly invested these objects, which were among the attributes of every housewife, with a special significance!

But these are all only superficial aspects which have nothing to do with the artistic value of the engraving. The really astonishing thing is how Dürer has used all possible formal means to convey the mood of melancholy. He must have seen a model for the figure in real life, a sight which had fascinated him, someone crouching on the ground in utter despondency. But the way in which he has given expression to this mood is entirely original and creative.

The disturbed mental state is mirrored in the disturbed composition. 'You have made my tools out of order. . . .' There is no predominant line, no pronounced horizontal or vertical. The objects are juxtaposed harshly and chaotically. The large block looks awkward within the composition. The diagonal of the ladder makes an awkward impression, it creates an impure harmony (how calm it seems immediately the ladder is covered up!). The lack of a framework, the chaos of the whole, has an unpleasant effect.

The light is not concentrated but broken up; the main highlights are set very low. The tonal movement shows no decisive contrasts, it goes across the print in chromatic passages. An unsteady light flares in the sky, the comet of Saturn.

However, Dürer has used one type of contrast—a psychological one. This is found in the small cherub who sits on top of the millstone. He is not troubled by sad thoughts and writes busily on his little slate, though this cannot be taken seriously. He is no 'thinker in miniature' but a child doodling with a slate pencil in his small fist.[118]

The way Dürer's *Melancholia* was conceived and characterized survived even the spread of Italianate types. Precisely twenty-five years later Hans Sebald Beham used the motif again in an engraving. Here we still find the woman sitting exhausted with her arms propped up, idly measuring the sphere. But the representation has been 'purified' in the classical sense, i.e. everything that might suggest an individual existence has been eradicated.

ST JEROME IN HIS CELL (1514; Plate 88): St Jerome is the saint in his room. He translated the bible from the original into Latin. He is a scholarly, thoughtful man who needs an enclosed room and quiet. It is

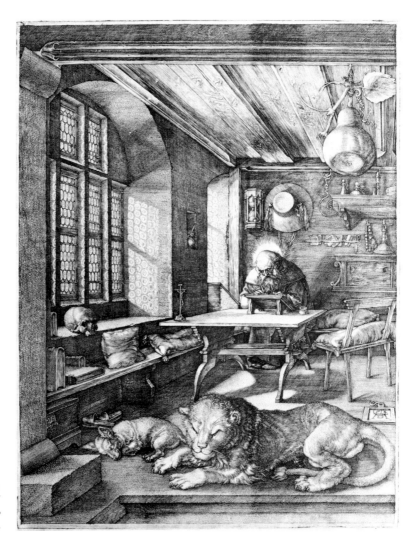

88. *St Jerome in his cell.*
1514. Engraving,
247 × 188mm.

known that at other times he went into the loneliness of the desert to pray, and to do penance by beating his chest with stones. Once a lion came to him and St Jerome extricated a thorn from its paw; after that the lion followed him like a domestic pet.

Dürer represented St Jerome more often than any other saint. In the beginning he showed the episodes with physical activity in the tradition of the fifteenth century: the extrication of the lion's thorn and the asceticism with the stone. But later he represented the more spiritual, prayer, contemplation. Here, with this St Jerome writing, it seems as if Dürer only thought to show the warmth of a homely, well-cared-for room.

It is very much a Late Gothic room with groups of windows, beamed ceiling and panelled wall. A bench running along the sides is covered with cushions. There is a beautiful table with the customary writing-stand on it, and another is set against the window. There is a variety of utensils on the wall and a pumpkin is suspended from the ceiling, as can still be seen in farmhouses today. The lion lies quietly on the floor. A small dog is asleep beside him.

But what is most important is not the furnishing of the room but the distribution of the lines and light. Dürer has taken great care to create the very impression that was avoided in the *Melancholia*; everything is made to seem joyful and calm with an atmosphere of cheerfulness and order.

The room is firmly enclosed on three sides, which in itself produces an effect of calm. A pilaster projects on the left, with dark beams above, then a step, and the barricade of animals. The room is only open at the right and the centre of vision lies on the very edge of this side. In this way breadth is introduced into the confined space. But Dürer takes care in various ways to retain the character of enclosure, to ensure that the room does not 'peter out'. The animals contribute to this as well as the big pumpkin which hangs down from the ceiling and fills the corner, giving coherence to the whole. It has the same functions as a tendril gaily appearing through a window or a branch in the top corner of a landscape, which thus conveys a sense of intimacy. To the onlooker it is hardly noticeable that this intimate feeling arises not from the landscape itself, but from the way the view has been enclosed.

The horizontal is the line of calmness. It pervades the whole picture, though contrasts are not excluded by it. The objects have been arranged in horizontal layers. The large shapes which frame the scene at the top and bottom virtually determine a pattern which is echoed repeatedly in the animals, the wall, the ceiling and the brightly lit table. This makes the diagonals and the bold window arch possible as well as the gaily rounded shapes. The small bench which has been pushed to one side, and the shoes carelessly thrown down, are further harmless caprices which do not destroy the peace of the room. It is not meant to look dead but alive, suffused with that warm life which trembles as

light in the roundels of the window-wall and plays in the lines of the veined beams, murmuring quietly like the water of a little stream running over stones.

The strongest contrasts in line and light are in the centre. There is much movement focused here which becomes more and more gentle the more it moves outward. Although the light fluctuates gaily the overall impression is calm and collected because there is one dominating highlight. It rests on the figure of the saint and on the table. The pure white of the paper is echoed on the pumpkin, but there it does not have quite the same effect of brightness because the dark contrast is lacking.

The brightness of the pumpkin is still considerable, and it adds to the gayness of the picture in the same way as the low spot of light on the sphere added to the depressing effect in the *Melancholia*.

The *Melancholia* had only indeterminate contrasts of tone, what might be described as a low-keyed handling of light. In the *St Jerome* the lights and shadows progress in clear, vigorous intervals.

The way the light is slanting through the round window-panes with the patterns of the sun on the splay, the meeting of the different sources of light and the balance between shade and reflected light have always been admired. The brightly lit interior has become for the first time a problem of graphic art, strangely enough, of the art of black and white only. Dürer would not have considered painting such a subject. And yet there was one artist in Germany at that time who already saw these phenomena in terms of colour: Grünewald, in Colmar.

Have we finished our analysis? The saint himself has not yet been mentioned! The strange thing is that the pious writer may well be over-looked. He is very small in relation to the room. The atmosphere of the picture is determined by the objects in it and not any more by the subject of the figure. It seems as if this might have been the beginning of a period of paintings of interiors such as the Dutch cultivated in the seventeenth century. But the development did not continue along these lines and it was to be almost a century before Rembrandt was born.

The very accomplished linear technique of these sheets may be generally characterized as a break with the technique which used simple, deep, long strokes to make a picture appear strong and bright, in favour of one which sought more nuances and tones and stressed texture without, however, bringing back the subtleties of the earlier engravings. The elements of the drawing are meant to remain distinctive, able especially to withstand the process of printing. Dürer used more and more clusters of small wedge-like strokes which cover the surface in all directions like sprayed water. The technique is not the same in all three engravings. The *Knight, Death and the Devil* still retains some characteristics of the earlier style. The glowing shadows and metallic glitter of the highlights are very forceful indeed in a good

impression. This is in keeping with the theme. The other two sheets are a more even, silvery grey. Thausing's idea that this effect might have come about because the composition was originally etched on the plate is not correct. Strange things happen. The large shaded parts of the skirt in the *Melancholia*, for example, show a combination of diverging, closely packed strokes producing a kind of shapelessness of which one would have thought Dürer incapable—especially in an engraving. The result is a flickering chiaroscuro with isolated flashes of white, ridge-like folds. Who could describe all the different surface textures? I shall only say that we would think such a technique incomprehensible if we did not know that it was nourished by a newly found sensuousness. The drawings above all give a great deal of information about this underlying psychology. There is nothing comparable—neither earlier nor later—with the miniature paintings of 1512 in the Albertina (w.614, 615) which show Dürer's grasp of the character of the plumage of birds' wings and breasts.[119]

Another new feature of the master engravings is their 'coloured' appearance. This means that a spot of darkness now signifies more than merely a shadow, it marks the light value of a colour. The horse of St Eustace is only modelled with shadows; it is uncertain whether it is meant to be brown or black or white, whereas the knight's horse in the engraving of the *Knight, Death and the Devil*, on the other hand, evokes the impression of a very definite colour or at least shade of colour. It must be grey or light brown. A bright object like Death's shirt appears definitely white. It is bright not because the light is focused on it but because this is its local colour. The plate with the 'magic square' in the print of the *Melancholia* gives the impression of being a different colour from the wall, although the light is the same on both. In the engraving of St Jerome the wall has the dark colour of wood and the lion is a convincing tawny yellow.

These are innovations of basic importance. The suggestion of colour had never been entirely absent, but this is now a distinct system. Beside it individual attempts from Dürer's earlier 'painterly' period—such as the attempt to suggest colour in the wings of the *Large Nemesis*—seem to be merely isolated efforts.

But it is interesting that nevertheless Dürer did not think of applying this principle consistently. The gradations of light seen in real life were observed more sharply than before but it did not enter Dürer's head to attempt a precise transposition of colour values in his engravings, to make miniature images of coloured objects. He exaggerated light and shade when he thought it appropriate, a right he claimed for graphic representation. The horse in the *Knight, Death and the Devil* has large white patches which cannot be interpreted as mere highlights. St Jerome's cowl is completely white on the light side, though the colour would surely not appear as bright as this even in full sunlight. Correspondingly the dark side is too black to be natural.

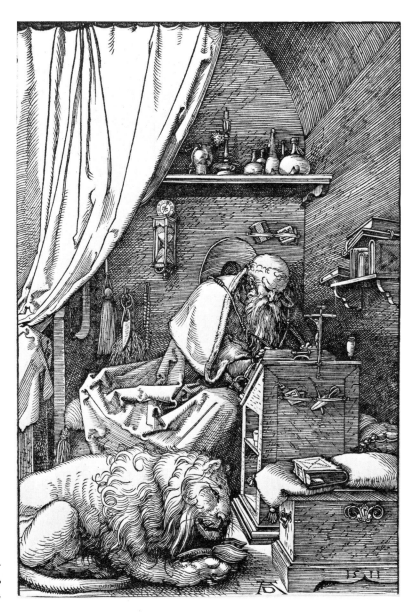

89. *St Jerome in his cell.*
1511. Woodcut,
235 × 160mm.

These calculated effects of colour are not found in the woodcuts at
all. It is most instructive to compare the engraving of St Jerome of 1514
with the woodcut of 1511 (B.114; Plate 89) to see the different tech-
niques used in the different media. A cell is also shown in the woodcut
but it is not portrayed in detail. However many small objects there are
lying about, the woodcut is still selective. Atmosphere is created by the
distribution of broad masses of light and shade, and lines which are
clearly visible. The basic difference in the way the lines are handled is
once again very obvious. Here they have an independent decorative
value and do not just serve modelling and colouring as they do in the
engraving. The more superficial the expression, the more important

209

does the play with lines itself become. And of course there had to be ruffles of draperies in the woodcut. The room is only made cosy by the abundantly heaped draperies of the cloak on the bench. Characterization stops where lines cannot be used to express features. The drawing of the lion's skin is confined to a few indications. The woodcut simply does not compete with the engraving in the rendering of texture. The different ways in which the beams are treated is the most vivid example of this. There had been a strong interest in the graining of wood before, in the fifteenth century. Schongauer, in his large engraving of Christ carrying the Cross, paid detailed attention to the rendering of the wood, although this upset the proportions of his composition because the lines now had a much greater significance than they would have had in reality. Only Dürer, in his engraving of St Jerome, played down the texture of the wood so that it fitted properly into the general composition, without, however, thereby diminishing the abundance of detailed observations. Dürer did this in the engraving; but in the woodcut, in which a naturalistic representation did not seem possible, he remained on the level of the fifteenth century and treated the motif of graining in a purely decorative way (cf. the woodcut of the *Adoration of the Kings*). The woodcut is also conservative as far as colour is concerned, as I have already said. There is no suggestion that the cardinal's cloak of the *St Jerome* is red, and no indication of the colour of the cushion, the curtain or the lion.

During these years Dürer felt the need to try out other possible graphic techniques besides woodcuts and engravings. He experimented with a needle on metal plates, that is, he tried out lines which were merely scratched, as well as etchings, where the biting of the design is left to a corrosive acid. Etching was a new technique in high art but drawing with the needle was already common practice, and through the achievements of the Housebook Master it must have even been renowned as a particularly refined artistic technique. But while the Housebook Master used this technique for lively, impressionistic effects, Dürer tried to exploit it to convey tones. He achieved the most remarkable results already in the *St Jerome by the willow tree* of 1512 (B.59). The sheet shows the praying saint seated; he has a white beard and his body is brightly lit; he appears in front of a dark background of rock and the lower half of his figure remains in the half-light. It has an effect of such painterly subtlety and softness that Lippmann got the impression that Dürer was about to break through the barriers of the sixteenth century. It is all the more strange that Dürer's attempts to feel his way through to a painterly style were immediately broken off.[120] But it must be said that he could hardly have been at ease in this field of indistinct expression. Even the achievements of the painterly interior in the engraving of St Jerome were not followed up.

Etching took over from the delicate work with the needle. Dürer treated it like a woodcut technique and used massive strokes. He did

five sheets, the last in 1518. The thickness of the etched lines (on steel or iron) could only produce coarse effects. Sometimes Dürer almost verged on crudeness. One can hear the wind in the branches in the uncanny, flickering night scene of the *Agony in the Garden* of 1515 (B.19; Plate 73) and the lament of the angel who soars up into dark space with the sudarium in his hands is like the howling of a storm (B.26, 1516). There is also a passionate scene of a *Rape* from the same year (Plate 90). A naked rider gallops off with a woman. It need not be the *Rape of Proserpina*, for similar subjects were known to popular imagination.[121] The way the man grips the animal between his legs, leans back

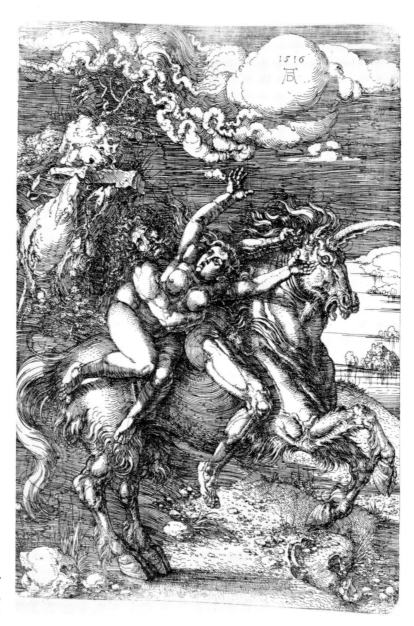

90. *Abduction on the unicorn*. 1516. Etching, 308 × 213mm.

and grasps the struggling body of the woman to himself with an iron grip, while he can hardly keep his hold of the mane of the hellish steed, is all so magnificently conceived, that even the somewhat shallow treatment of the woman cannot spoil the impression. But the animal's movement is not very successfully suggested, for its hind legs stand still. This *Rape* and a contemporary etching of a few nudes with unintelligible gestures (B.70) are the main evidence—as far as the graphic arts are concerned—of Dürer's treatment of the nude in his middle period. It is strange that he now only treats these subjects in his coarsest technique. Even the drawings hardly yield anything more. Dürer contents himself with the rendering of figures in movement which are put on paper with a sure hand, but have little natural atmosphere about them and seem cool when compared with the contemporary works of Swabian and Swiss masters we know.[122]

Only very late, in 1518, is etching used for calm description, as in the *Landscape with the cannon* (B.99). Here Dürer tried, on a large format, to reduce the contents of a wide territory to the simplest expression. We will take this opportunity to make some general comments on the landscape drawings of this period before we go on to other subjects.

Dürer has made it easy for us to judge his progress as a landscape artist by drawing the region around the *Wire-drawing mill* once again in his mature years (W.480, silver-point). We know it already from a watercolour of his youth (Plate 53). The view is nearly identical and the landscape has hardly changed either. The trees have grown—the young plant on the far bank has shot up—and the point of view has been moved a little more to the right, but this does not explain the change in the effect. The fact that the perspective is better is not decisive either. The crucial point is that the eye is no longer attracted by individual objects but to the space as a whole. Our eyes are drawn at once across a few rooftops into the depth of the picture. It starts with an abruptly cut-off effect: we do not see the weight-bearing wall beneath the roof, we are not to loiter in the foreground, the 'picture' is much further back. The small half-timbered house with the hip roof which interested Dürer so much earlier is still there, but it has completely different functions within the composition. Dürer did not think a tidily prepared foreground necessary any more. In its place the trees on the left forming a foil, which in the first version was schematized with a cut-off effect and thus failed as a side scene, have been drawn into the picture as a broader mass. The consequences for the treatment of the background region are obvious. This development is principally the same with other artists and was repeated always and everywhere right up to Rembrandt. Strangely enough Dürer confined his discoveries to drawings; he never painted anything similar.

The same devices are used in a pen drawing of the Herold mountain

near Nuremberg which is dated 1510 (Bayonne, Musée Bonnat, w.481). Again, the real subject lies in the middle ground. The onlooker is immediately drawn into the depth of the scene by a house in the foreground which is cut off to the roof by the lower corner of the picture. The roof runs lengthwise into the picture and thus presents another invitation to move into the space. The unusually marked difference in the sizes of objects of the same kind in the foreground and middle ground also contributes to emphasizing the range of depth. This important sheet is so carefully drawn and has such a coherent composition that it gives the impression of being meant for an engraving. This would have been the first pure landscape engraving.[123]

The advantage of portraying a definite locality is also found in another sheet (formerly Bremen, w.118). The name which is added indicates the village of Kalkreuth, a few hours north of Nuremberg. Dürer's vision is comprehensive. The eye is attracted by groups of houses, not by individual ones—the village has been seen in its context within the whole landscape. The characteristic spatial relations are immediately clear. Watercolour has been added. Beside this sheet the *Landscape with a river* of around 1515 in Cambridge—which has been identified as the valley of the river Wiesent near Ebermannstadt—seems like a quick travel sketch.[124]

There is another interesting coloured landscape of this period (Berlin, w.117) in which Dürer has done away with almost all individual details. It is a flat, summer-yellow landscape, opening out into the far distance with a mountain slope on the right which slowly disappears stage by stage into the distant blue. A magnificently wide view is conveyed in this small drawing. The small village in the middle shows that again the region around Kalkreuth is represented, but the whole picture is so typical that it could well stand for a representation of the Franconian landscape as a whole.

Beside such things the *Landscape with the cannon* can hardly hold its own in spite of all its excellence. The coarse technique of Dürer's etching was not quite sufficient to establish the separate degrees of the background. Nevertheless, the village among the trees makes a strong and typical impression. It has been identified as Kirchehrenbach, near Forchheim, with the mountain range of the Ehrenbürg behind it.[125] In accordance with popular taste Dürer added a lake to heighten the charm of the small native village. It must also not be forgotten that in the etching the cannon was his main concern and the landscape was only an addition.

The pictures of peasants belong in this context of village views. There are two engravings of 1514, the *Dancing couple* and the *Bagpiper* (B.90, 91) and then a late addition of 1519, the *Egg seller and his wife* (B.89). The literature of the time made fun of peasants and Dürer himself also laughed at them, his earlier pictures of peasants being caricatures. Now the tone has become markedly different. The essential

factor is not their comical appearance but all the forcefulness of their characteristic features. I do not mean to say that Dürer remained serious when he showed this dancing couple stamping the ground with an elephant's tread, but what magnificent strength he gave to their bodies! This is not the kind of thin little peasant whom the Housebook Master, and Dürer himself at an earlier stage, had drawn, but an earthbound race which tills the hard soil.

Again Dürer did not proceed from figures to genre scenes. He showed a group of dancers but no fair, a bagpiper but no festivity, a peasant with an egg-basket but no market. And yet these subjects were not unknown to his time. Dürer's natural inclinations made him concentrate on the representation of the individual figure and made it difficult for him to convey the milieu as well. He did not try to repeat the venture of his *St Jerome in his cell* and never even attempted a Holy Family in a workshop or a homely Madonna in an interior.

And why does he only show us peasants and street-musicians? Was Nuremberg not full of characteristic life of all kinds? Here too it has to be admitted that the preceding generation promised a richer harvest and that not all the seeds of Dürer's youth came to life. There was no other possibility. The element of genre became less and less important for him.

To demand from Dürer a comprehensive picture of life in the homes and streets or even a sentimental depiction of trifling bourgeois life in the manner of Ludwig Richter is to misunderstand him completely. He was far too much aware of the misery of the little alley to want to narrate its secret joys, and his mind was too concentrated on typical and permanent subjects to mirror the fleeting apparitions of life with a quick eye. His thoughts became more and more earnest and profound. He conceived subjects like the portrait of his old mother and the majestic heads of the Apostles in Florence. This mood slowly prepared the ground for the high idealism of his last years.

The charcoal drawing of his mother (W.559; Plate 2)[126] was done in 1514, the year of the *Melancholia*. It was also the year in which the old woman died and it has been thought that the engraving must have a definite and pertinent connection with this event. This is wrong, but there is a connection in the unique introspectiveness of both drawing and engraving. In none of his earlier portraits had Dürer been so much concerned with the representation of a definite expression. This is precisely the main difference between the art of the sixteenth-century portrait and that of earlier ages. Up till then portraits had been mere depictions of the exterior appearance of the sitter, mere enumerations of shapes compared to the energy with which art now expressed mental states through form. The psychological sympathy of the artist must have been new and of increased strength, otherwise the characteristic expressive features would not have been discovered. The basic expres-

214

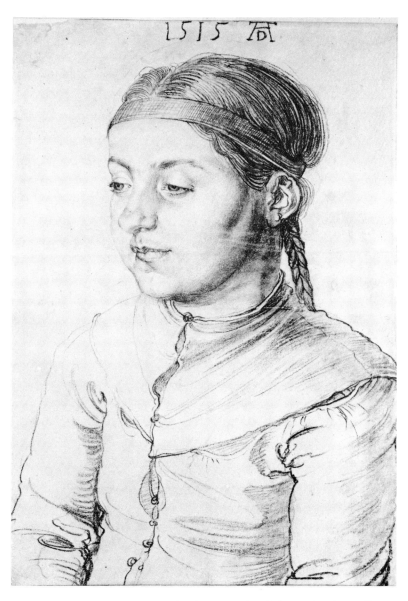

91. *Portrait of a young girl*. 1515. Charcoal drawing, 420 × 290mm. Berlin, Kupferstich-kabinett.

sion Dürer wanted to convey in the portrait of his mother is similar to the subject of the *Melancholia* and he used the same means of representation by partly hiding the upward glance of the eye. The head is life-size. No reproduction can convey the impression of the original. The onlooker literally shivers when he sees those majestic charcoal strokes which Dürer seems to have taken straight from life and set down on paper without the least hesitation, and with the assurance of a sleepwalker. Baldung reflects the impression of this new kind of portraiture in the distinguished head of an old man in London.

The *Young girl* of 1515 (Plate 91; Berlin, charcoal drawing) is a drawing of similar perfection. She is thought to be a young niece of Dürer as there is some likeness between her and Dürer's wife. It is

clear that she will not become beautiful and she does not look at all intelligent, but how well, in spite of the freshness of youth, the dumb and withdrawn character of this child has been conveyed! Here German art learnt to make new psychological distinctions. One thinks of Donatello and his figures of dreamy young boys.

All works of this period have a very strong psychological flavour, which is still clearly noticeable even in spoilt drawings such as the handsome *Young man* of 1515 (Berlin, w.563, charcoal). The lines of the mouth are shown with more feeling and even the most complicated formal shiftings of the perspective seem to be at the service of expression.

At the same time an infiltration of horizontals is noticeable. Often an inscription is added at the top or the bottom of a picture. Of course such an innovation also had its effect on the general conception of shapes. The horizontal elements of a head are now stressed more strongly than the vertical ones. This in turn adds interest to the appearance of the sitter.[127]

The last portraits of this wonderful series were done by Dürer in 1518 during the Diet at Augsburg. The most important one is the portrait of the Emperor in the Albertina (w.567; Plate VII). The drawing gives a true likeness of the Emperor Maximilian, his nobility, charm, imaginativeness, his witty and versatile temperament. And how well the characteristic anomalies of the Habsburg profile are softened and serve to heighten the expressiveness of the head! The typical reaction of the onlooker is not—as it is with a portrait of Maximilian by Bernhard Strigel for instance—'Oh yes, a hooked nose and protruding lower jaw.' These features are there but our first impression is not determined by them. The mental qualities of the sitter have an immediate impact. At that time a pattern for portraits of emperors did not yet exist in the north and Dürer could not have hidden a feeble character behind a majestic gesture.[128]

Are people prejudiced when they find the living line of the drawing lacking in the painting of Maximilian, in the Vienna Gallery, or the—presumably earlier—portrait in watercolours on canvas of the emperor in Nuremberg? I do not think so. But even the woodcut portraits seem lifeless compared with the drawing. This is all the more astonishing, as Dürer must have done all he could to pass on the likeness of the person he esteemed very highly in the purest possible state.[129]

During this entire period there were no painted portraits which were of the same high quality as the drawings. The small male head of 1516 from the Czernin Gallery, now in Washington, seems flat,[130] and though the portrait of Dürer's teacher Wolgemut in the Germanisches Museum (Plate 5) makes a strong impression at first sight, its state is such that one can understand—though one need not agree with—Thausing's and others' belief that it is only a copy. The third figure in the date 1516, near the monogram, has been corrected: originally there was an O there. This is strange. To me the imposing spiritual expres-

siveness of the head, quite apart from the wording of the long inscription at the top,[131] indicates that the picture was really done in 1516 and not by any chance in 1506. Oswald Krell's (1499) rolling eyes are quite different (Plate 51), and even a head like that of the master-builder Hieronymus (cf. p. 150; Plate 57) does not yet show the stylistic magnificence of the Wolgemut head, where the eyes are calm and majestic, and imposing shadows fill the sockets. The picture in its original state must have been of very high quality. Whether Dürer showed Wolgemut in too positive a light is another question.

Dürer did more portraits in his youth and towards the end of his life than during this middle period. There are conspicuously few portraits, and almost all are incidental works, but they possess an intimacy which makes the later portraits appear cool and the earlier ones superficial in their analysis of character. But Dürer's psychological insight advanced beyond portraits to more ideal figures. The Apostles occupied his mind; they were examples of humanity made sublime, majestic souls who could stand up to the strain of even the strongest emotions. Foremost are the heads of *St James* and *St Philip* of 1516 (Florence, Uffizi; Plates 92, 93).

Many will remember the impression these pictures make on the mind after it has been saturated with Italian art. It seems as if the terrifying seriousness of the German Reformation suddenly becomes apparent. Neither Raphael nor Fra Bartolommeo nor even Leonardo ever mixed so much severity with a sense of the sublime. It was left to the Germans to represent the Apostles not as autocratic, perfect men but as men who were consumed by a feeling of painful inadequacy. The mouth of St James the pilgrim is slightly opened, his eyes stare under contracted brows, he leans to the side. But his head remains heroic, without the least trace of weak sentimentality. Dürer did not want to make St James's individual personality stand out. This is borne out by the fact that he used the same type of features for the Apostle Paul (in the engraving of 1514). A mood is expressed here which appeared in a number of places in Germany at the time. The same expression is found in the magnificent St Jerome of the Isenheim altarpiece in Colmar.

The daintiness of the hair makes a strange impression. Why is there this kind of artificiality when the highest concerns of humanity are at stake? It is an archaic feature which is also found for example in a picture of such serious intentions as the *Lamentation* by Giovanni Bellini in the Brera, where St John laments with his locks finely curled. But why should it be so difficult to understand this old attitude? Is it not a sign of the same kind of solemnity which people feel when they go to church on Sunday with well-groomed hair and a starched shirt?

The second head, St Philip's, is hardly less significant. It is more muted, with the hair and coat coloured grey, while the white beard of St James is shown up by the red ground of his pilgrim's cloak. The

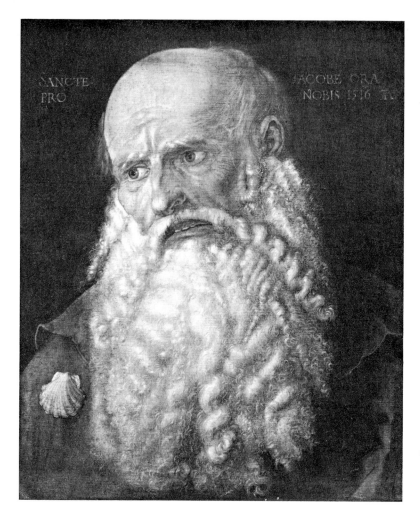

SANCTE PRO

JACOBE ORA NOBIS 1516 T.

92. *St James*. 1516.
Size colour,
46 × 38 cm.
Florence, Uffizi.

technique of both pictures is the kind of linear painting with dull dis-
temper on very fine canvas which was used in the Dresden altarpiece.

Dürer's development as a painter of ideal types is most clearly seen
if one compares the heads in Florence with the figures of the two
emperors of 1512 in Nuremberg. The portrait of the Emperor Sigis-
mund can possibly be excused as being done after a particular model,
but I must admit that I have always been disappointed by the Emperor
Charles too.

Two engravings of 1514 form the preliminary stage to the two pic-
tures. One of them, *St Paul* (B.50), has just been mentioned. His type
and attitude are related to St James's. His gesture is developed psycho-
logically without any dependence on the attribute (the sword is lying
on the ground). He could be a preacher seen in a dream, in rapidly
moving light. A foil and support for the figure is provided by a high
dark wall on one side.[132]

The companion figure of *St Thomas* (B.48) expresses flaming wrath

218

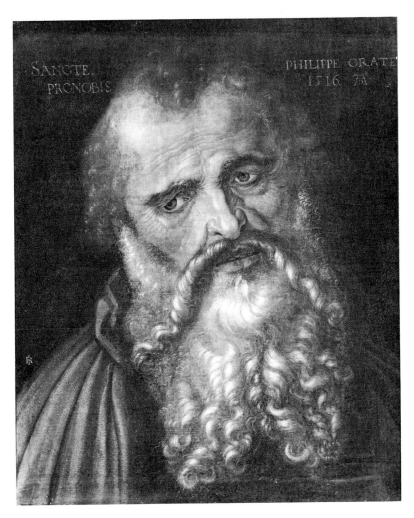

PHILIPPE ORATE
1516. 𝔸

93. *St Philip*.
1516. Size colour,
46×38 cm.
Florence, Uffizi.

and seems to be surrounded by flashing lightning. He is shown striding
out, grasping the top of a spear. His face is shaded. It is figures like
this which enable us to understand how playful the preceding half-
century had been.

A number of drawings show that at this time Dürer was also con-
cerned with idealized, seated figures of men. There is the figure of a
prophet (w.597) with strangely hidden hands, genuinely dated 1517,
and a *St Paul* (w.473), with the wrong date of 1517 added later, which
was done two or three years earlier. There are no architectural features
in this woodcut-like drawing; the forceful expression of the head is
carried on in the billowing masses of drapery alone. 'Numine afflatur'
might be said of this man.

The small *St Anthony* in the engraving of 1519 (B.58; Plate 94) is
only a man reading. He crouches on the ground in the open air, but he
really reads. But who reads in the fifteenth century? Who reads so
voraciously, bending forward and clasping the book as if the rows of

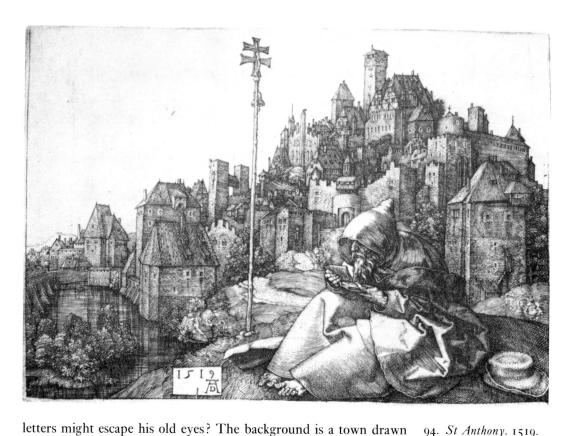

letters might escape his old eyes? The background is a town drawn
with infinite care and showing even the details of individual houses. It
seems like a relapse into the bad old ways to find these things incor-
porated without any cogent reason, merely as an independent feast for
the eyes—all the more so as we already know this view to be an old
property of the Dürer workshop.[133] But this background does have
another function as well. The town follows the monk's contours; this
is its formal justification, just as the rectangle of the small tablet is a
consequence of—or preparation for—the harmonious melting away of
the landscape into horizontal layers. There is also probably a connec-
tion between the mood of the old man intently reading and the archi-
tectural background which demands so much 'devotion to detail' from
the onlooker. I admit that I would find this minute picture of a town
out of place anywhere else, but in this particular case it seems indis-
pensable to me. Finally the cross stuck into the ground, intersecting
the whole scene, is a way of determining space which was well known
in the new century.

Not by chance is the year 1514 also specially significant as far as pic-
tures representing the Madonna are concerned. Dürer reverted to
spiritual values, turned away from the formalism of sculptural com-
positions and developed painterly characteristics to perfection. Among
the works the engravings take the first place. The woodcuts of the *Holy*

94. *St Anthony*. 1519.
Engraving,
96 × 143mm.

Family of 1511, done quickly and in a happy mood, are only followed in 1518 by another woodcut, the *Madonna surrounded by angels*. But more than half a dozen of the most carefully executed engravings of the subject had been done in the meantime.

The *Madonna with the pear* (1511) marks the beginning. It is a new composition. The figure is not central any more but has been pushed towards the side. She leans against a large tree trunk and the picture is full of spirited movement. But the way in which the Mother offers the fruit to the blessing Child is somewhat contrived. Obviously formal considerations were uppermost, considerations of an imagination which demanded a rich arrangement of figures. This characteristic becomes less and less apparent and movements become simpler and more immediately expressive, painterly abundance takes the place of sculptural richness.

The transition is made in a simple Madonna who presses the Child to her cheek, a motif as eloquent and simple as any found in an old Florentine master (1513, B.35). Perfection is reached with the *Madonna at the city wall* of 1514 (B.40; Plate 95). The sculptural qualities of the figures do not invite analysis any more. The way the group is constructed is not intrusive, everything seems self-evident. The Mother, with a serene expression, is about to lift the fretful Child from her lap. This happens without affecting the silhouette. The contour is perfectly contained, and all the expression is concentrated on the inner modelling. There is a great variety of planes. Silken materials in small folds are contrasted with the broader draperies of the skirt. Blunt slabs of stone form the framework. The support at the Madonna's back is no longer a round tree trunk but a heavy wall. A high, detailed background of a town is used as a foil for the heads.[134] The whole picture possesses a tonal harmony of incomparable resonance. A second *Madonna with the pear* (drawing in the Berlin Museum, W.529) was done in the same year. Her impetuous affection seems like a correction of the earlier engraving. Dürer had previously succeeded in representing gay and balanced subjects from time to time, but now everything shows a deeper emotional understanding. How solemn and at the same time how intimate becomes the scene of the *Adoration of the Child* in the stable now—to mention but one more example. In the wonderful drawing of 1514 in the Albertina (W.581), all distracting motifs are left out. The stable is no longer a picturesque ruin but a restful building; there is no complicated perspective, even the angels are excluded, but the movement of the main figures has become one large, coherent surge of adoration. Joseph prays too. The old representation showing the man carrying the lantern and protecting the flame against draughts with one hand would not have fitted in here.

Towards the end of the decade the atmosphere undergoes another subtle change. A new style is foreshadowed which aims even more decisively at a monumental effect working with even more basic motifs.

The views become simpler. The Madonna is again set frontally in the centre of the picture. Important lines are stressed and made effective by contrasts. Light and shade counteract each other in larger planes and simpler intervals. The picture as a whole becomes more important and the space is filled with greater masses. The aim is centred more directly than before on a markedly solemn effect. Large crowning angels appear and unusual light phenomena are used to confirm the impression that this is a sacred subject. The *Madonna crowned by two angels* of 1518 (B.39; Plate 96) is an important example of the growth of this new style. It shows how the folds have been combined into

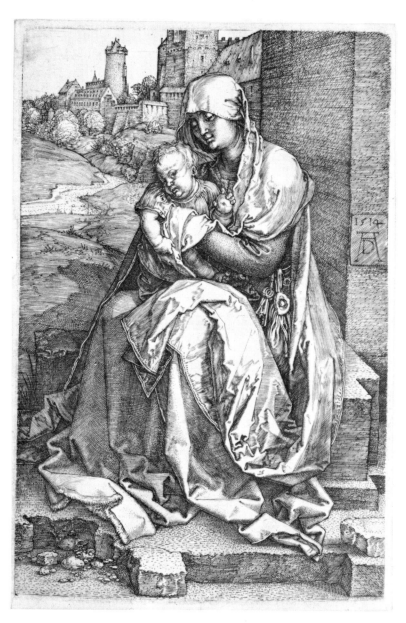

95. *Madonna at the city wall.* 1514. Engraving, 149 × 101mm.

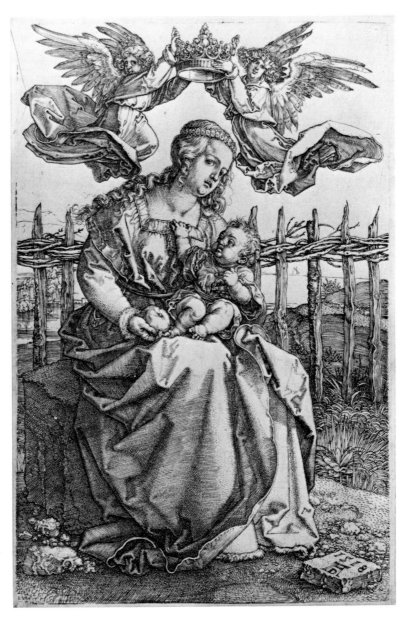

96. *Madonna crowned
by two angels*. 1518.
Engraving,
148 × 100mm.

simpler, larger shapes and the draperies are in harmony with the move-
ment of the figure. There is a coherent upward movement in this figure
which opens out in the angels above, holding the crown. The Madonna
stares in front of her, transported for a moment, as if she had a pre-
monition of the miracle of the coronation. The Child is fretful and
tries to attract her attention but she does not heed it, dreamily holding
an apple in her hand like a holy symbol. Moods of this kind are excep-
tional for Dürer, and there is no doubt that Hans Baldung, for example,
could portray the young mother's forlorn amazement with more imme-
diacy (woodcut of the *Madonna and Child with St Anne by the wall*). In

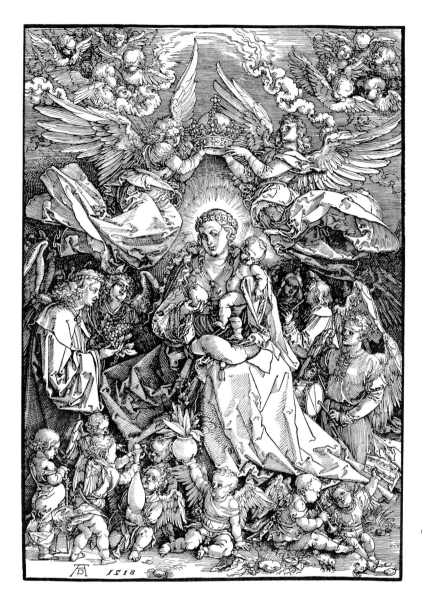

97. *Madonna crowned
 by angels.* 1518.
 Woodcut,
 301 × 212mm.

other respects too, the impression cannot be denied—in spite of all our
admiration for the stylistic magnificence—that the drawing shows less
warmth than former works. A wooden fence closes the stage off at the
back. The setting is no longer the picturesque, dainty corner of a
garden, there are no curling tendrils and no chirping birds; the fence is
straight and the stakes are set at regular intervals. A strong contrast is
consciously introduced by the horizontal line of the connecting twigs
and all the fence's detailed forms obviously only serve as a contrast. In
itself it is hard and drily realistic, and the minuteness with which the
split wood is drawn does not really fit with the conception of the figure.
For the gown Dürer utilized one of the monumental draperies of the
Heller altarpiece, taken from a drawing which he had not used for that

224

painting (Albertina, W.457). It is strange indeed that it is now possible to exchange garments between an engraving and a large painting. But in the original drawing the draperies are not yet handled in the uniform way of the engraving. There is a preliminary drawing in London (W.553), for the angels, in contrast to which the style of the engraving shows a considerable intensification in the strength and clarity of movement. The final preliminary drawing for the whole composition is also in London (W.541).

The theme of the *Madonna crowned by angels* is treated differently in a woodcut of the same time (B.101, 1518; Plate 97). It is simplified in a popular way but shows great pomp. Angels in long gowns approach from the sides bearing fruits and playing music, in front a crowd of small, playful child-angels bustle about, and the two angels holding the crown above the Madonna's head, magnificent in their rushing flight, dominate the picture and hold it together. The essence of the new impression does not lie so much in the effect of black and white or the abundance of figures but rather in the economy with which the main directional lines are laid down. There are no earlier examples of this kind of combination of contrasting verticals and horizontals (the latter seen in the flying angels). But the draperies are broken up in patterns typical of the woodcut; they do not have the large sculptural form of the engravings.

Every year Dürer increased his demand for a large and simple method of representation in his engravings. The *Madonna nursing the Child* of 1519 (B.36; Plate 98)[135] markedly surpasses her predecessor of 1518 in the large planes, and in a simplification of the motifs which almost borders on rigidity. But compared with the *Madonna nursing the Child* of 1503 (Plate 32) the difference is enormous. Straight lines are dominant. Instead of a painterly flickering there are large simple planes. Form is developed to utmost distinctness everywhere. The actual operation of the breast-feeding has also had to be made clear in every detail. It is not surprising that the warmth of the early work has not been wholly preserved.

Finally, in 1520 there are two more engravings of the Madonna: a *Madonna with the sleeping Child* (B.38) in which the Child almost seems to be a mere geometric shape, as it is completely enveloped in swaddling clothes, and the *Madonna crowned by an angel*. In this latter work the new style is less prominent, but the pure frontality of the Madonna's youthful idealized head, held erect, is a new feature. The white head and the large light patch on the skirt below have a strange effect. It is as if the Madonna were sitting in the open air on a stormy night and was suddenly illuminated by a flash of lightning. Fluttering hair, writhing clouds, an angel in a gown which billows upwards—in these surroundings the calmly and solemnly smiling face of the Virgin (somewhat empty, it is true) forms an ideal of mild beauty in the traditional mode. A painting of 1516 in Augsburg shows a preliminary version of this

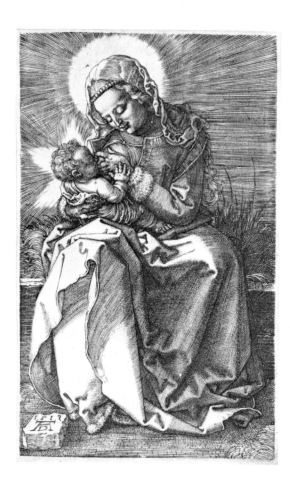

98. *Madonna
nursing the
Child.* 1519.
Engraving,
115 × 73mm.

ideal female head. It is very unpleasant, but the artistic intention is
interesting. The head is constructed, but the scientific-aesthetic
interest cannot have been the only consideration. Dürer must have felt
the need at times to give his Madonnas an appearance of greater
solemnity. The child-like praying Madonna in a *Madonna and Child
with St Anne* is the result of an entirely different mood. This picture
was formerly in Schleissheim and has recently entered the New York
Museum, after being missing for a long time. The overall composition
is entirely different from the graphic works, the heads being really the
only significant part. For St Anne the drawing w.574, a portrait of
Dürer's wife Agnes, was used.

Apart from the seated Madonna, the standing *Virgin of the Immacu-
late Conception* on the crescent moon had always been in great demand.
Dürer treated the theme four times. A shy and deeply felt early en-
graving (B.30), which closely follows Schongauer, was succeeded by a
serene, but somewhat indifferent group in 1508 (B.31). In the Madonna
of 1514 the typical change towards deeper feeling is seen, and this mood
is maintained in the version of 1516. The way in which the Child
nestles against the Mother in the shadow of her cheek is most charming.

226

The Virgin of the Immaculate Conception is unimaginable without an aureole. It was a moment of crucial importance when the traditional representation of this light phenomenon, showing regular spike-like rays which radiated directly from the body, began to change to one which made them more agitated and flickering and moved them away from the figure. Both these characteristics are already there in 1508, the flickering light even earlier as the drawing of Apollo in London shows. Later the dark background was added to intensify the effect.

Late Gothic and Renaissance; the works for the Emperor Maximilian

Dürer was a child of the Late Gothic. His sympathy for Late Gothic forms lasted throughout his life. He admired Italianate forms and tried to imitate them, yet so many features that he did not experience himself or derived from second-hand were taken over that one wonders why this compulsion to meddle with the Italian Renaissance arose. The answer lies in the parallel history of figure drawing. In the field of decoration Dürer's art also undergoes the same process in which natural feeling becomes at first clouded under the spell of foreign models but eventually receives a lasting and valuable training in that school with regard to clarity, regularity and magnificence. Dürer was not ready to substitute the foreign style for native tradition. To the end of his life he used both side by side. In his book on measurements (1525) he showed how Gothic as well as Roman letters were constructed; he only added a modern 'freer' variant. He thought that either could be used, as both were beautiful. He spoke of classical columns but also of Gothic pillars, and with no suggestion that they were out-dated. Nevertheless his fundamental attitude to form underwent a change which in time had to produce a complete change in style. Even subjects like the marginal drawings for the prayerbook of the Emperor Maximilian (Plate 100), which apparently grew entirely naturally and freely, would be unintelligible without his Italian training.

Dürer treated decorative subjects at all periods of his life. The forms of chalices, frames, architectural backgrounds provide enough opportunity to get to know the nature of his attitude to structure and to see how his feeling for form reacted to the foreign stimuli. Dürer is an individual example within a general stylistic development. Before we look at the large decorative commissions of the emperor it may be well to make some general comments on Dürer's taste.

The things he liked in nature were essentially those on which the whole of contemporary Late Gothic art was based. He liked gnarled branches, stags' antlers, the strongly serrated leaves of vines and hops, curling tendrils, intertwined roots, detailed grape clusters and umbels. Dürer tried to show the illusion of free movement in ornament rather than a fixed geometrical pattern, he wanted a painterly effect of tangled, inexhaustible, unlimited movement rather than a clearly arranged display. He did not attempt to abstract natural forms but adopted a dashing naturalism. To him the 'pure' line of the Italians remained an alien element—he needed the flourish. His imagination fed on the lines of wood graining, the shapes made by a leaping flame, eddying water and similar phenomena. But all boisterousness is always counteracted by a structural foil. Natural bridges and small garden huts built art-

lessly of twigs are inconceivable. The naturalism of intertwined roots forming the foot of a chalice is always somehow pointed up by the shape of the chalice, in the same way as the arbours of branches of Late Gothic church portals were only possible when related to rigid walls.

'Late Gothic' is an awkward term. It seems to imply that this taste represented the corruption or dilution of a style. The characteristics which I mentioned are very ancient ones, innate in the Germanic feeling for form. In a certain sense this Late Gothic style is essentially *the* German style.

A German with a grounding in the Late Gothic style must have found classical, Italianate form naked, almost unbearably calm and coldly simple, without any painterly charm. There was as yet no feeling for the beauty of lines in repose; interest was only aroused by the line in movement. Nor was there any feeling for the beauty of a definite, structural plane. It had to be somehow overgrown, corroded, frayed to attract the eye that was used to painterly effects. Italian beauty is inseparable from an appearance of clarity and openness, German art on the other hand made use of concealment and intersection, and the charm of gradual disclosure. It even took refuge in the surprising, played hide-and-seek, so that a close scrutiny would reveal still more innumerable lively, minute details. People could understand Italian columns, arches, portals, if need be, but how little did these forms offer to a taste which had grown up with the mystery of dark shadowy caves, intricately twining branches, winding, knotted, tangled objects. The northern naturalism of ornament was hardly known in Italy.

There were some points of agreement between Late Gothic and Renaissance art, however. The predominance of the vertical had been broken in the north as well, the horizontal had become popular everywhere in architecture. The sense of active tension in forms had been lost. The pointed arch was depressed to a blunt semicircle, and the deeply carved mouldings of a portal were often replaced by flat bands. Artists no longer only made calculations of the distribution of energy but also of planes; they composed in the painterly sense, working with contrasts of planes. The yearning, restless character is replaced more and more by one of permanence and stability. But all this would not have been enough to make acceptance of the Italian style compulsory. Indeed, it was not accepted as a necessity, but as a fashion. The goblet cup in the hands of the *Large Nemesis* is completely convincing, while examples of the new style in the *Life of the Virgin* and the *Green Passion* seem unpleasant, indifferent and derivative. I do not believe that anyone at the time honestly found these cold interiors pleasant, but people thought: 'This may look unbelievably ugly, but we know that it is beautiful as it is the art of the Greeks and Romans.'

The Italianate style took on a new and more significant appearance after Dürer's major Italian journey. The first design for the frame of the *All Saints* picture goes beyond a mere repetition of second-hand

features. It is interesting, however, that this Italianate approach did not last long and that in the executed frame Dürer came to terms with native taste. A coloured drawing of 1509 in Basle, often reproduced, is another example of the same process. Its subject is a Madonna in an open pillared hall. Definite features from Venetian painting are obviously behind it, but Dürer went so far from his point of departure that there was hardly a trace of Venice left. All changes from the Italian original are typical of the German attitude at that time. The overall composition is asymmetrical and individual forms are altered: the 'Corinthian' capital is set diagonally, the entablature is destroyed, the cofferwork of the ceiling has been replaced by a rib vault, etc. The pillars are very elegant but the motif of the hall is not exploited architecturally in the Italian sense, the space itself having no importance for the figure. Dürer tried to make the architecture less severe and produce that illusion of glittering wealth with which Late Gothic art had spoilt the eye. He did this by intersecting the main structural lines with hangings, seemingly accidental shiftings of the furniture and a painterly background.

One would very much like to know how Dürer would have conceived of such an ideal space without imported elements.

99. Design for a candelabrum in the shape of a woman. 1513. Watercolour. Vienna, Kunsthistorisches Museum.

There are a few pieces of decorative art of the time of the *Melancholia* and *St Jerome* which are regarded with special reverence. It was at this time that Dürer's introspection resulted in the most profound insight. The magnificent hourglass in the *Melancholia* is already a valuable piece of evidence, and even if the luscious engraving of the coat-of-arms with the lion surmounted by a cock does not belong to this context, there are drawings of—among other things—the most beautiful chalices which Dürer ever drew. They have a flowerlike, flowing line which was soon to disappear when the severe, structural features of the Renaissance did away with any naturalism.[136]

A candelabrum in the shape of a woman in the Vienna Museum (Plate 99), which was destined for Pirckheimer, was done in 1513 (W.709). In other examples the antlers were suspended horizontally and carried the candles. Dürer here used jagged, upward pointing, wing-like antlers which were balanced by tail fins. The candle was held by the woman on a rose twig.

It fell to Dürer's lot to receive the first large commissions for decorative works at this time. The Emperor Maximilian engaged him in a number of schemes designed to further the fame of his house and his own person. It is interesting to see how Dürer approached decoration at this moment, but unfortunately this is only rarely to be seen clearly. The artist hardly had a free hand.

The emperor wanted a triumphal arch. The desire for a monument was, however, satisfied with an arch on paper, a giant woodcut (Plate 101). The conception lacked a truly artistic character. It was a compound of nearly one hundred blocks. The ingenuity of the combination meant everything, the actual appearance nothing or very little. It represented a pleasure for the mind rather than for the eye. Dürer only participated after the work had begun, and he was one of a number of artists. His scope was limited and the result lacked warmth in spite of all his imaginative efforts.

In the same context the emperor also commissioned a triumphal procession and a special imperial triumphal car, also as woodcuts. This was a better idea and Burgkmair and Altdorfer solved the problem admirably with their supple imaginations. Dürer looks somewhat stiff beside them. The march-like rhythm did not suit him. He only made a few contributions. But the margin drawings for the emperor's prayerbook are high-spirited productions. They were the most popular of these works and made a really free work of art, an unexpected sideshoot of Dürer's linear art at its most accomplished.

THE PRAYERBOOK OF THE EMPEROR MAXIMILIAN (1515; Plate 100): the commission was to adorn the *édition de luxe* of a prayerbook on parchment with ornamental drawings in the margins. Dürer was not the only artist commissioned; Cranach, Baldung and others worked on it too. But Dürer was the principal artist, or in any case he determined

the style. The drawings were not to be miniatures but pen drawings, ornaments which in a certain sense were based on the same stylistic characteristics as the typography. The letters, even though they were printed, still retained something of the flow of the pen; a sentence was a linear pattern just as much as the drawings surrounding it in coloured inks, sometimes reddish, sometimes purple or greenish-yellow (they are much faded now).[137]

To enjoy these drawings one should above all notice their effortlessness, their even flow, the pleasure in the individual stroke. Any reproduction which does not show us this gives a wrong impression, and mere copies are quite incapable of making the high spirit of the drawings felt. They are games with a pen. The draughtsman allows his instrument to frolic about in all sorts of ways on the beautiful parchment. Sometimes the lines trickle slowly, sometimes they flow in a broad stream. The strokes of the pen make bulging flourishes here and ruffled tangles there. This luxurious revelling in free expression would be very strange if Giehlow were right in his contention that the drawings were meant to be transposed onto the wood block. But Leidinger has been able to raise important objections to this view.[138]

Another condition of study must be laid down: text and drawings must be looked at together, not because of the relationship to the subject-matter—that is self-evident—but because the decorations in the margin attain their artistic significance only when contrasted with the panel of letters in the middle, where the bold Gothic types are packed together into a glistening field of black. This rigid spiky field is embraced by the light, swift, coloured drawings which play around it and provide a contrasting freedom and looseness beside the regularity and compactness of the letters. To remove the text and leave the scrolls to themselves is to sever the very link on which the effect is based. They would still have a certain effect, but it would not be the one originally intended, it would be as if a musical accompaniment were played by itself without the main theme. But it is utterly unbearable to separate text and marginal decoration by strong lines. They do contrast, but the playful wave must be able to lap along the side of the panel of text, and a number of letters do fray and develop into overlapping flourishes.

There is also a certain contrast of conception between the drawings and the text. Dignified though the representation of certain subjects is, piety turns into burlesque all the time. It is amusing when the words 'Lead us not into temptation' are illustrated by a fox trying to entice the hens by playing the flute (this is an old theme). But the purely ornamental motifs also show a high-spirited humour, and even when they seem serious at first glance, suppressed giggling may suddenly be heard from any corner.

It is part of the nature of the task that the drawings appear quite flat. Dürer knew very well his reasons for not telling complete stories or treating the space seriously. He was not providing marginal notes

100. Page from the prayerbook of the Emperor Maximilian. 1515. Drawing, 280 × 190mm. Munich, Staatsbibliothek.

such as Holbein's drawings for *In Praise of Folly*, but he wanted to decorate the whole margin. This is why he preserved the basic impression of a strip or band. The onlooker is constantly led from one bit of reality to another: the little tree which grows out of the ground at the bottom of one side and is connected with a group of figures, suddenly leaps miraculously and climbs up the margin as a tendril. There is no uniform scale. All laws of reality are suspended. Forms are thrust against each other in motley succession. One object grows out of another in a fantastic manner—it is impossible to say where a branch ends and a flourish begins. And although volume and density are not lacking, the subject-matter is used more or less as an excuse for a play

with lines only, or rather volumes and lines and planes are inter-
mingled in the most remarkable way. Even Dürer's best collaborators
lack this charming characteristic. Cranach and Baldung too used lines
with virtuosity, but they seem heavy-handed beside Dürer. They are
too serious, too objective.

An attempt to describe the subject-matter of which Dürer made use
would lead to a lengthy exposition. He went from human figures to
animals and plants and down to geometric shapes such as vessels and
columns.

The method he used to fill the plane varies. Sometimes it is purely
painterly: the tendrils somersault and swing about in a seemingly
arbitrary way; sometimes there is a perceptible structure: a vertical
motif is developed symmetrically around a central axis. But the latter
is exceptional. Symmetry seems to exist almost exclusively to be
abandoned again. The main stress shifts continually.

This marks the main difference from Italian decorations, which
were always evenly developed, either by having a distinct central axis
or by stringing the motifs on an imaginary thread. In any case a geo-
metric axis predominated. In Italy a marginal decoration was treated
in the same way as the ornamentation of pilaster. Italian art had pro-
duced a strange beauty in this very art form. It combined heterogeneous
parts which were in themselves more or less coherent and managed to
infuse the sequence with a certain essential rhythm. Nothing similar
was known in Gothic art. But this system of vertical decoration soon
made a strong impression in the north too and Dürer, as I said before,
tried his luck with it on a few sheets at least. But even when his form
was least structured he showed that he had studied Italian art. At least
those characteristics which set him apart from tradition were for the
most part of Italian origin: a composition with contrasting, relatively
independent formal elements, and a rhythmical order which is so
strong even in the completely free drawings, that the structured draw-
ings do not seem conspicuously different from them.

I do not want to be misunderstood: Dürer's marginal drawings are
not a hair's breadth less German because he had learnt these things in
Italy. Sooner or later German artists would have adopted this method
independently. In fact the drawings have such a distinctly German
character that they seem to be a linear extract of German nature. This
is not because Dürer used chiefly native flora; but any German land-
scape reminds us of these detailed forms, this display of linear move-
ment and filled-out planes. It is the life of a summer meadow, the life
of a wood.

THE TRIUMPHAL ARCH (B.135, 1515; Plate 101).[139] The monstrous
woodcut of the triumphal arch has always been hard for Dürer's
admirers to take. It cannot be viewed coherently, because by looking at
the complete structure the details are lost, and yet the details pre-
suppose a knowledge of the complete work. The whole composition

too is awkward and the treatment very stiff in parts. In several print rooms the woodcut can be seen glued together. Most readers will know the one in the Dürer House in Nuremberg, where the triumphal arch scrapes an uncomfortable and unfestive living in a room on the ground floor.[140]

The structure has little in common with a classical triumphal arch, although the accompanying text refers specifically to such monuments. It is a structure of predominantly vertical tendency, with a triangular top, and the contour is roughly comparable with a façade such as that of the church of Our Lady in Nuremberg. There are no horizontal divisions. The four large columns have no entablature, they are conceived as vertical forces in the Gothic sense, meant to melt into the air. Flanked by these four columns are three small openings, which are so narrow that the impression of openings is completely overcome by an overall impression of solidity. The eye actually only sees a combination of three tower-like structures of varying heights which have cupolas that fit into the silhouette of a gable and are flanked by real round

101. The triumphal arch of the Emperor Maximilian: *The betrothal of Maximilian and Mary of Burgundy*. 1515. Woodcut, whole arch 350 × 300cm.

turrets at the corners. The enclosing line above has a fantastic movement; the ground plan too has many recesses and projections. If one looks closely one notices that the gates do not just pierce a wall but form the entrances to an inner space. But this is not important. The main object was to obtain large panels for the family tree of the emperor and for the historical scenes of his life. All the planes are covered in this way.

It has long been known that scholars (Stabius) were largely in control of the project. Dürer was thought of as the executing hand, and because the work lacked warmth people have deplored the fact that he was tied by a programme. Recent research has shown that Dürer was not the only responsible artist by any means. The design is presumably by Jörg Kölderer, the court painter and architect from Innsbruck. His coat-of-arms is set beside that of Stabius and is of the same size, while Dürer only figures on a smaller scale in the third place. It is true that Dürer made alterations, but they were not fundamental. Once we are aware of this, it will not be difficult to trace his hand. The centre gate with the winged woman bearing the crown is his, so are the large columns, the griffins and the tops of the side pieces. The centre cupola already seems strangely feeble in comparison, while the luxuriant proliferation of ornaments on the corner turrets forms a contrast of an entirely different kind and unmistakably reveals the imagination of Albrecht Altdorfer.

The upper part of the central gate, for example, is characteristic of German decoration, rather than a specimen of Dürer's own ornamental art, because Dürer would come off much too badly if he were held responsible for the rigidity of the way the motifs are combined. The perspective is almost certainly not Dürer's either.

The gate is framed by two columns on either side, one behind the other. Their capitals carry niches, a garland hangs over the arches and is intersected in the middle by a female half-figure who holds the imperial crown in her hands. It is a richly ornamented piece. But how strange that the hanging garland should destroy the arch at the very point where it gathers its real strength, at the apex. The motif of hanging garlands of fruit or flowers is Italian but the particular linear movement is not at all so. The north exploited the charm of overlappings and intersections; form itself was less important. The drawing of the Virgin of 1509 in Basle shows similar characteristics.

But there are even more surprising features in store for the spectator: the garland is held by human figures who are sitting half-hidden behind the lunettes. They are only gradually discovered. The artist wanted to surprise the spectator, here and in other places. These are the German counterparts of Michelangelo's slaves on the Sistine ceiling!

The combination of a string-course over a niche with a lunette above is a Venetian motif. The capitals too presumably go back at least in inspiration to a column in San Marco. But the placing of a string-

course directly on top of a capital would have been monstrous to the Italian feeling. This can only be understood with reference to Gothic art, for it is analogous to the way in which a tabernacle develops out of a buttress. Live birds with their wings bound together sit in the nest formed by the capital. The intermediate spaces are stuffed with real twigs, just as the garland above is made of real lilies of the valley. Small wonder that herons and dogs run around freely in this context. Everything moves as though on an ant-hill.

A modern onlooker will of course find an explanation for this spectacle in the fact that the arch was only an imaginary, not a real object. And it is true that artists were not so pedantic as to include subtleties on paper which they left out on an actual building. But an object like the Sebaldus tomb resting on scrolls, with its infinite wealth of forms which cannot be taken in as a single coherent impression, is not so very different from conceptions like this triumphal arch. It is a pity that this painterly search for fantasy should never have been given full rein.

Dürer pounced on Italian motifs in order to be able to make his building richer and gayer, but these foreign suggestions seem rather to have had a cooling and hampering effect on his feeling. Had Dürer ever been commissioned to design such an imaginary building in his own way, who knows if we would not have had a miraculous work from which the spirits of the fields and woods looked out with a hundred eyes.

THE TRIUMPHAL PROCESSION AND THE TRIUMPHAL CAR (1518): one can hardly imagine Dürer as an official orator. He lacks the easy pathos, festive ecstasy, the unhesitating impetuosity. It was probably a great mistake to couple him in tasks like this one with such an emphatic draughtsman as Burgkmair. Here the Augsburg artist was in his element. Without a trace of fatigue he made his groups march by in a long procession, and one can hear the universal rejoicing as his broad scrolls soar in the air and beautiful saddle blankets flutter and surge around the horses' haunches. The parts of the triumphal procession which are attributed to Dürer, such as the 'mechanically driven' cars, look arid in comparison. But one must not base one's judgement of his talent for festival decorations on this. He did better things, so much better that the correctness of these attributions may justifiably be doubted. And we may safely abandon the question of the amount of Dürer's share in the triumphal procession altogether and concentrate on the authenticated drawings.

Around 1515 German taste turned towards broad and weighty subjects. I have already pointed this out in my discussion of the development of the portraits. These often contain an uninterrupted horizontal strip, the head becomes broader and more massive, hats stretch out with enormous brims, broad, short beards are back in fashion.

Dürer designed a number of costumes around 1515 which show

this new attitude: court dresses, it seems, whose wearers could revel in the fullness of a very untrammelled existence. Broad-hemmed fabrics are given the impression of weight, the arms are made to carry immense masses of draperies, materials resting on the shoulders are extended as far as possible in width so that the natural proportions of the human form are distorted in a way which strongly favours the horizontal. The colour combination of green and black with a little gold is felt as a particularly solemn triad (cf. the drawings in the Albertina, w.686–89). In the same manner are treated the figures of six horsemen of 1518 which were intended for the triumphal procession but which were not in the end transferred onto the woodblock (the ordinary pen drawings are in the Albertina, w.690–92, 694, 696, 698; the coloured, but somewhat mechanical versions are in the library of the Vienna Museum, w.693, 695, 697, 699). Their ease of invention and charming appearance far surpass anything that has been connected with Dürer's name in the woodcut triumphal procession. They are horsemen in full festive dress bearing trophies and banners, the horses heavily bridled with broad harnesses. Dürer seems to embrace the new style with the utmost ease, and the way he sees the overall unity of the animals, riders and the pageant, in all their formal abundance, is really surprising. Who would have imagined the painter of the Heller altarpiece, with its faltering composition, capable of these luscious rhythms? The horses are not all drawn equally well, but some move perfectly. The horseman with the French trophy can be considered the best. Dürer's representation of movement is now immediately convincing, something which was still lacking in the engraving of the *Knight, Death and the Devil*. The horse moves in a graceful, springing trot. The theme of a coherent procession is of course not taken up in these drawings, and there is reason to believe that this is all to the good. Even the triumphal car is hard to take.

The work on the triumphal car, on which the emperor and his kin were to be seen moving along, was begun before that on the triumphal procession. The drawing in the Albertina (w.671) which shows the horses speeding along and in which the carriage is still exquisitely delicate, was in all probability done as early as 1512/13. The final version, however, which is packed with all those allegories which give the picture its unmistakable flavour, was only put on paper in 1518. It is the coloured, colossal and somewhat heavy-handed drawing which is kept in a special display-case in the Albertina (w.685). Four years later, in 1522, a woodcut in eight separate sheets was made after it, but the accompanying family of the emperor was left out (B.139).

Everything is modern in this procession: big carriages, big horses, big women. Figures such as these with short dresses and round limbs, whose nipples and navels are neatly marked underneath their garments, are here introduced into German art, and from now on they are encountered in succeeding generations, wherever there are festivities; it

is not at all certain that we shall see their departure in the twentieth century. The garland bearers on the carriages may well have been copied from Mantegna's dancing muses. The horses' shapes and movements are very coarse and the broad straps of the harness fit in well with this. Another motif in the new style is the way the ribbons of the saddlecloths cross at right angles and thus produce a gridwork of firm squares. In the old style the planes had been patterned with lozenge shapes. The most extreme abundance of form is shown in the carriage, where the eye is saturated with the splendour of many different curves. It is a mark of the Renaissance style that every movement is accompanied by a counter-movement. The way the animals on the wheel-guards of the imperial car show up both directions of the curves is quite un-Gothic, for they stress the upward as well as the downward movement. Finally the new style is seen everywhere in the tendency to make the parts independent and to articulate forms by showing the joints.

The triumphal arch designs are generally more important for the history of Dürer's stylistic development than for his art. The problem has not yet been solved entirely satisfactorily. That Dürer was tied to a programme which put forward demands regardless of visually desirable results is very noticeable. Those great decorative artists of the north who mastered every subject, Holbein and Rubens, were artistic personalities of an entirely different kind.

A large scale transfer of the composition of the woodcut of 1522 was put on a wall of the Nuremberg town hall in the same year. Dürer also did a *Calumny of Apelles* to complete the mural decoration.[141] The paintings are not impressive in their present state and they are all the less interesting as Dürer himself had no hand in the affair. But one aspect is interesting: the way the pictures are incorporated into the space—for Dürer must have been partly responsible for the overall arrangement. It will be found (and nobody will be surprised by this) that the effect of the figures within the total space had not been calculated. The hall is a splendid example of Gothic architecture, but the all-embracing grasp characteristic of the high art of the Middle Ages had long since broken down.

Dürer seems to have been commissioned to do further decorations in the great hall at that time. There is also a drawing for the window wall of the hall, dated 1521 (New York, Pierpont Morgan Library, W.921), and it is one of Dürer's most charming drawings. The wall is pierced by high pointed windows reaching almost to the ceiling; they are set so close that the intermediate wall spaces are narrower than the window lights. For a man of the new age these were offensive dimensions. To make them somewhat more bearable Dürer tried to introduce a strong horizontal counter-direction into this system of verticals. He also tried to alter the characteristically Gothic planes by decorating the upward surging strips of wall entirely with hanging ornaments, and by evoking, on the inhospitable planes, the illusion of calm, independent life. He

filled the spandrels between the window arches with large round figurative medallions. The ornaments in the spaces between the windows are literally suspended from them and they in turn end in the circular form of a light garland. By means of the repetition of the same conspicuous motif at the same height along the whole of the wall, Dürer forced the eye into a horizontal movement and overcame the disadvantage of the situation as much as possible. He softened the pointed arch with garlands of leaves resting right on the apex. In short, he produced the quaintest struggle imaginable between the old and the new style. Above all, it was the way in which the planes were covered which made the new style victorious. The motifs are treated in the manner of the Italian Renaissance; they are combined but they retain their individuality and atmosphere and are clearly distinguished from each other. None of these motifs violates the plane, the space and the ornament filling it are apparently made for each other. There is such a light spaciousness and the forms, which were mostly taken from local surroundings, are treated so gracefully that one may think for a moment that one is in the eighteenth century. Unfortunately creations of similar originality were not repeated in later years.

Somewhere in his manual on proportions Dürer comments on the mastery of Nature which has created man as if he were made in two parts. This is a characteristic belief of the new age. Dürer means the division of the body into two halves, in which, according to the classical pattern, the torso is separated horizontally from the lower limbs.[142] But a Gothic artist would never have seen this line in his version of Nature, neither would he have approved of this division of the body into upper and lower parts. Rather he took away any existing horizontals in favour of a uniform vertical arrangement. The modern generation, however, did not want to destroy the opposition; both need free expression.

I say this as a reminder of the fact that all changes in structure go parallel with and find their common denominator in changes in the attitude towards the human figure. The Renaissance style introduced horizontal divisions which the Gothic style had avoided. In the beginning horizontals were interwoven with vertical systems (as in the Late Gothic choir of St Lawrence in Nuremberg, where the line of the encircling gallery intersects the pillars half way up). But the development led to a complete separation of the two directions, as is the case in the divisions between support and entablature in buildings with Italian orders. A Renaissance goblet is an object which can be separated into a number of independent parts by horizontal divisions; a horizontal cut through a Gothic goblet would sever the nerve.

The crucial point is not that there are horizontals at all, but that their function is to articulate the structure. The character of the Renaissance style is above all based on this feature of articulating the joints. The Gothic goblet has a juncture on its stem too, but it is only an outer ring, not an essential joint.

102. (*left*) Gothic goblet (from the Dresden Sketchbook) 1512/15. Drawing 135 × 58mm. Dresden Sächsische Landesbibliothek

103. (*right*) Double goblet in the Renaissance style. 1526 Drawing, 429 × 293mm Vienna, Albertina

240

The new style separated and individualized the parts; in the old style they had been insolubly fused, and their value and beauty had been embedded in the whole form. This is true of individual linear motifs—compare a Renaissance arabesque with a Late Gothic ornamental pattern—and also of individual planes. Only the Renaissance recognized the value of a definite, balanced plane and made ornament convey the atmosphere of such a plane. But the same is true in relation to Gothic pillars or the different treatment of space: in every case parts which were interwoven, bound up with and supporting each other, were made into independent, individual parts capable of a separate existence.

Contrast two examples of goblets (Plates 102, 103), a 'Gothic' one of 1512–1515 (Dresden Sketchbook ed. Bruck, pl. 156) and a 'modern' one, a large stately specimen (w.933) which Dürer drew in the last years of his life (1526). The Dresden sketchbook contains fully developed examples of the Renaissance style on the same sheet from which the Gothic goblet is taken. I must add that the considerably later drawing already shows the characteristic stiffness of Dürer's rendering of form in his last period. The earlier drawings are more supple. The

style of the Munich Apostles, with its somewhat cold magnificence, is already present in our example. The date (1526) is the same. The individual bosses are put neatly side by side as independent units, while the Gothic goblet throws its crowded circular bosses up from the plane, pushing against each other like boiling water bubbles. The foliage which before had been tangled and frizzy becomes similarly simple, distinct and orderly. The naturalism of the stem is reduced to a few motifs of branches enclosing the structure in a geometrical pattern. The idea of the rotation of the goblet around its own axis is excluded on principle. The base already determines the orientation, and it is maintained throughout. In short, individual forms are offered to the eye as tangible objects, not as a glittering ensemble of forms inextricably bound together. The artist's aim is organic beauty, not the beauty of painterly illusion. Added to this is the new importance of profiles. The vessel can be fully understood through its contours. This is not the case with the goblet which shows the bosses treated in a painterly way; its silhouette can hardly be grasped and is rather the accidental result of underlying shapes.

These things are of crucial importance to the whole of pictorial art. They represent the same changes in perception and attitude which painting and sculpture underwent as well.

The Late Gothic style is an intoxicating style—the term 'painterly' describes it insufficiently. Compositions like the Late Gothic aisle of Brunswick cathedral with its alternately spiralling columns fill the spectator with a kind of ecstasy. The Renaissance, on the other hand, represents the power of reason and clarity. It arose in Italy as the expression of a view of life which the Germans could not wholly understand, and any imitation was doomed in this respect. But it also represented an art of clear perception, and as such it had of necessity to be welcome to the rational generation of that time—quite apart from its other advantages.

The journey to the Netherlands
and the last works

Dürer's last and in a sense greatest period began with the journey to the Netherlands. In his fifties he experienced a revitalization of his perception, of which there is only really one other known case, that of Rubens. The journey meant for Dürer what the marriage with a second, beloved young woman meant for the ageing Rubens: new and deeper springs were opened up for him.

He went as a man who was already world-famous. No longer did he struggle with a foreign art as he had done in Italy. What he saw was a kindred art, and even in the Italianate tendencies of the Flemish 'moderns' of that time, he only recognized his own past. Different though the demeanour of these people was, it could not make him swerve from his course. Many germs suddenly stirred in him, as if a mild breeze had touched the hard wintry soil. Old memories came alive. What grew out of all this was not necessarily connected with Netherlandish characteristics, but nevertheless Dürer needed a foreign country to gain the strength to attempt great works once again. I do not say that he became a new man through visual perception alone. I have already given an indication, in the introductory sketch of Dürer's life, of the most deeply felt experiences he underwent among the adherents of the Reformation in Antwerp.

But he was a painter, and thus above all dependent on the concrete appearance of the world. The Netherlands could still claim a pre-eminent position in the West as far as the refined cultivation of the senses was concerned. Intensive artistic production had been uninterrupted since the time of the van Eycks. Neither great talents nor great tasks were lacking. Even a citizen of Nuremberg might well have felt somewhat provincial among the splendour of the Netherlandish cities. Dürer brought with him an immense desire to see things. He observed everything minutely, art and life, pictures and festive processions. He made portraits of people from all walks of life, even without commissions, just for himself. He bought beautiful antlers and curios. He was so interested in a whale which had been washed ashore by the tide that he went to see it on an excursion of several days in the middle of winter, and he was overjoyed to see the first wonderful objects which were sent across from the newly discovered continent. He is talkative in his diary. It is permeated with the pleasure a man feels who has learnt something new every day.

Massys still had the highest reputation among the artists. He was older than Dürer and his main works, the altar of the *Holy Virgin* in Brussels and the altar of *St John with the Lamentation* in Antwerp, had been finished ten years earlier. These paintings have an atmosphere of

solemn magnificence; their colour and tonality are wonderfully soft and delicate and the heads are movingly real and of a spiritual intensity. Dürer made higher demands where the exploitation of sculptural motifs was concerned and he may in fact have found the arrangements of figures in the *Lamentation* boring—they began to be considered so in the Netherlands themselves—but it meant much for him to see real painting once again, subtle colours and a kind of modelling which was sensitive to even the merest trace of shadow. He had to admit to himself that his *Lucretia* of 1518 would appear unbearable beside these pictures because of its harshness and cold colours. And his sensitivity did regain greater warmth and delicacy for a while. Every portrait drawing after 1520 speaks of a new subtlety in the tonal treatment. It may even be asked whether the whole precision of perception, which is most surprisingly apparent in the portraits as well, is not partly dependent on the impression of Massys' portraiture.

Massys had not remained untouched by Italian art, for a reflection of its greatness shines forth from his pictures. But he was not an Italian-trained artist in the sense of his time, i.e. a painter of the nude, of movement and foreshortenings. In this respect Mabuse could be more justifiably compared with Dürer. He was of the same age, had been in Italy at almost the same time (1508), and had come back as a confirmed admirer of Italian art. A picture in the Berlin Museum, *Neptune and Amphitrite*, gives the best indication of his artistic relationship to Dürer. It shows a nude man and a nude woman constructed on the basis of the engraving of Adam and Eve, and not unpleasant in its linear cohesion, but it lacks the severity of Dürer's sense of form. The *Fall of Man* in the same gallery, however, is already distinctly Mannerist. Dürer made a note on Mabuse in his diary in connection with his *Deposition from the Cross* in Middelburg. He said Mabuse was not as good 'in the outlines as in the painting', which presumably means he thought the painterly treatment better than the drawing.

The other artist orientated towards Italy was Bernaert van Orley. We know his features from an engraving by Philipp Galle after a lost portrait drawing by Dürer. He was still a young man and had made his fortune early. He had been court painter to the regent of the Netherlands, Margaret of Austria, since 1518: Italianate art was now favoured by fashionable society. One of his main works, the *Trials of Job* (in the Brussels Museum), was done just at the time of Dürer's journey. It shows very clearly what was in fashion. There is much foreshortening, surprising lighting, complicated entanglements—it was a picture for the connoisseur, in front of which one could stand for a long time and make learned comments. It is painted well but lacks inherent life—art is approaching virtuosity. As I said before Dürer may have recognized a part of his own past in such works, and seen the dangers to which he had once almost succumbed himself.

The diary also shows traces of the old masters here and there. Hugo

van der Goes, Memling, Rogier van der Weyden, Jan van Eyck are mentioned, perhaps accompanied by an admiring epithet. It is not much, and even the most acute attention does not make these short incidental aesthetic remarks more momentous. Nonetheless one has to believe that Dürer was a conscientious observer: much more than on his visit to Italy he wanted to have seen everything. Antwerp remained his headquarters, but he saw much of the country—quite apart from the fact that in the interest of his pension matters, he once went back as far as Aachen and Cologne. His sketchbook (the 'little book' mentioned in the diary) is full of human types, costumes and architecture of the Netherlands.[143] We only know a fragment of the studies but the individual sheets clearly show the mood of an observer continuously interested in the country and the people. In Italy he had only recorded and nurtured individual impressions—how little the drawings reflected the objects of his surroundings at that time! Now he became the objective traveller who has an eye for everything. Man remained his main concern, however. He became attached to characteristic features with renewed interest; the individual had obviously attained a new fundamental significance for him. Is it purely by chance that because of the oblong format of the sketchbook two heads are shown side by side so often? Is it not rather that physiognomic parallels are sought everywhere? At other times the format induced very original spatial combinations, a head sketched first, then the surrounding space

104. Man in a hat, against an architectural background. 1520. Silver-point drawing, 133 × 194mm. Chantilly, Musée Condé.

added (Plate 104). What would people say if Dürer had done a *painting* like this? A head, more broad than high, pushed towards one side and seen against a lower-lying architectural background![144]

Dürer had not gone to the Netherlands to earn money as a painter. He took on works as the occasion presented them to him. They are mainly portrait drawings in charcoal or crayon on big sheets. Painted portraits are rare and only very occasionally does one hear of other paintings. In any case he was not prepared for larger works. The diary talks of 'Veronica Faces' (i.e. *Christ's Head of Sorrows*) and once of a *St Jerome* on which according to him he expended much effort and which he gave to a Portuguese as a present. The picture was found in Lisbon at the beginning of this century.[145] It shows a life-size half figure, the old saint sitting at his study table, his head supported and his fingers on a skull. It is possible that Dürer followed the Nether-landish custom in the formal arrangement, but he surpassed it as far as spiritual concentration was concerned. The drawings for this paint-ing have been preserved in remarkable entirety.[146] The large brush drawing in the Albertina which shows the same head in a slightly different position has an overwhelming effect. This sheet shows so much greatness and simplicity, so much devotion to the details of creation and power of coherent vision that one may well speak of the beginnings of a new style in Dürer.[147]

One might have thought that by the age of fifty he must necessarily have worked out his formulas, and the abbreviations for what interested him in nature. This is true of certain other artists, but to Dürer's eyes the phenomena became richer and richer and if he wanted to remain honest he had to incorporate more and more of them into his drawings. With his senses completely fresh, as if he were just beginning, he made new discoveries in the realm of form. He had never traced features like the slit of a mouth, the puckering of lips more carefully than now.

His linear vision softened again to a more painterly, tonal one. St Jerome's hand is drawn very differently from the hands of the Apostles in the Heller altarpiece—it is seen more in terms of light and dark planes. At the same time a new feeling for the tonal values of a drawing arose. Up to now the charcoal stick or crayon had determined the extent of a shadow's darkness somewhat arbitrarily. Now it is more carefully weighed and a general tendency towards a lighter treatment is unmistakable. The lightening of the shadows has its parallels in the paintings of that time, and not only in Dürer's. Even now the drawings do not show any characterization of colours; it might rather be said that illusions of colours—which arise so easily—were more consistently avoided. The hair, for instance, is kept white throughout.

Beside such growing subtlety of his linear style in the naturalistic sense, Dürer's occasional purely decorative treatment of lines is all the more conspicuous. He did not mind representing a face in naturalistic detail and then adding the hair in completely stylized curls. This

method is not new and I could have mentioned it earlier, but the principle is most distinct in the context of these fully perfected drawings. It was in fact a method of treating objects of secondary importance, such as hair, head-gear, garments, merely decoratively. Even if Dürer probably did not apply this principle in his finest drawings, it cannot be denied that he achieved an imposing effect through these very contrasts in his characterizations.

Added to all this is a decisive turn towards a large scale. This is expressed in the size of the sheets, and even more clearly in the grandiose drawing style. We have applied the term earlier on, and of course it is always used merely as a relative indication. We cannot say: now he is great, but only: he is greater compared with what he was formerly. But the essence of greatness is the same on all levels: it means that an artist recognizes the one feature in the large variety of visible objects which is of essential significance. He need not abandon the other features but only make them subordinate so that the leading voice can be heard distinctly. The subject does not matter; it may be simply a head or a history-piece: this relation of predominant to subordinate parts must always be maintained and the eye must be capable of recognizing the essential feature immediately and without difficulty. I have already said that Dürer's heads are now more detailed than ever before, yet they give an impression of calm and simplicity.

This development was not confined to the formal side of his art. Greater perception went together with greater feeling. Dürer began to feel greatness in very simple things.

It is well known that Dürer's style took a turn towards simplicity even before the journey to the Netherlands and that in the engravings of the Madonna of 1518 and 1520 he tried to achieve an effect of magnificence. But the production of that period remained somewhat tainted. The monumental intention hid in small formats and the sweeping style often succumbed to archaic desires which demanded circumstantial detail. A new monumentality could not arise out of the feeling on which the *St Anthony with a town view* was based; it retained too much of a feeling of confinement. It needed the wide horizons of foreign countries and powerful experiences to fan the smouldering fire to the flames which would burn away all half-measures.[148]

The Netherlands roused Dürer's wish to do large paintings again. In the years 1521–22 he worked on a painting of the *Madonna with saints*. We do not know why he took up this subject. It is a composition with many figures, and would have become his most important painting if he had not abandoned the work—we do not know why—when the composition was completed and all the individual studies had been made.

The visual arts know of no task which unfolds its characteristic effects more perfectly and with a greater suggestive power than a solemn congregation of imposing figures of this kind, in which the

dignity of every individual figure is taken up and developed by the next and the harmony of the whole in turn infuses all parts with radiance. Dürer had seen works of art of the highest rank in Italy which treated subjects like this, but at that time he had not yet been mature enough to understand their beauty fully. Now, after so many years, he was carried away by the intoxicating harmony of the art of Venice. He became supple in his portrayal of movements and sensitive even to soft rhythms, as though he had just learnt to dance. The painters of the Netherlands taught him this, but perhaps it needed the impressions of Antwerp with her refinement and opulent living to release the memory of Venice. Dürer had already shown an inclination towards Italian splendour earlier; already in 1519 the atmosphere of the Triumphal Procession invaded the representation of the Madonna. The drawing in Windsor of an enthroned Madonna accompanied by a high-spirited angel playing a musical instrument (w.57) provides evidence and serves as an example of this.

It needs a trained eye to see the masterly form of the drawing (w.839) in Bayonne (Plate 105): twelve large figures placed comfortably side by side, a living wave swelling and receding, and Mary as the elevated central figure dominating the picture, supporting and being upheld at the same time. There is no geometrical symmetry—only a balance of

105. *Madonna with saints*. About 1521. Drawing, 315 × 444mm. Bayonne, Musée Bonnat.

masses. The number of figures and the line of movement is different on each side. On the left a kneeling figure is drawn close towards the centre, and behind her is the row of standing figures rising towards the centre and growing more dense. On the right is an even, calm, downward movement with a gap half way down where one of the figures has sunk on to the steps of the throne. The small groups of figures playing musical instruments in the front corners serve to balance the asymmetry. Where the large kneeling figure weighs the scales down two children are set at the very border of the picture; on the other side there are three larger angels who are meant to occupy considerable space.

Most of the figures can be identified. The kneeling woman is shown to be St Catherine by the sword and the wheel. The two women behind her who gracefully incline their heads like two flowers on slender stems are St Dorothy and St Barbara. On the other side there are the earnest figures of St Agnes with the Lamb (seen in profile) and St Apollonia who holds up a pair of tongs with one of the teeth that were pulled out of her mouth. There is not sufficient evidence to identify the praying figure beside her as the donor. She carries no attribute, it is true, but neither does her neighbour, and the downward look of the latter is justified by the composition. The man with the harp is King David; the other men are—we can deduce this from an even earlier drawing—St Joachim, St Joseph and the pilgrim-apostle St James, his hat resting on the back of his neck.

For the first time Dürer provided drawings which relate to the whole composition, and which show that the grouping and rhythmical articulation of figures was at the centre of his artistic interest. The drawing in the Louvre (w.838) shows an earlier version of the composition. In order to gain a magnificent effect Dürer worked with a much larger number of figures. Here there are sixteen saints besides the Madonna which are taken together in groups of four, and staggered upwards in a rigidly symmetrical pattern. The throne has large steps which extend towards the corners. An angel with a lute sits near it in the centre.[149]

The main figures are the same in both designs. But Dürer realized that less meant more and that he would gain more significant contrasts by a reduction in the number of figures. Of the sixteen saints only eleven remained, but these eleven are seen in a new and more significant relationship, although the main motifs stayed unchanged. Instead of two staggered groups there is a consistent line of movement, instead of the sides being uniform there is an asymmetrical arrangement which gives a much stronger impression of the same life animating the whole picture. The angel at the feet of the Madonna has disappeared too, and with him the rather obtrusive steps. It was boring to have the central axis stressed once again with a figure below after it had already been indicated by the Madonna. The horizontal element, desirable where

there were so many essentially vertical figures, is represented quite well by the fox (well-known to the spectator from the *Madonna with animals*, Plate 28). The groups of angels in the corners also effectively counteract the uniformity of lines. The accompanying landscape background was disposed differently as a natural consequence. I do not understand how critics can have tried to reverse the order of the two sheets. Even those who do not think that generally a development towards richer contrasts and from rigidity to freedom proves anything with regard to chronology should be convinced by details in the execution. A movement of greater urgency is given to the motifs (the way the so-called donor prays, the inclination of St James's head), and they emerge from their isolation (King David); the handling of the draperies becomes grander (the skirt of the Madonna) and everywhere silhouettes are intersected (St Agnes's lamb).

Yet the drawing is not the final version either: The number of figures was reduced once again and the oblong format was abandoned in favour of an upright one. Dürer constructed a picture with four male and four female figures. The Madonna, on the high-backed throne, flanked by two paladins and accompanied by a pair of angels on the ground playing musical instruments, dominates the picture to such an extent that the other figures merely seem to owe their existence to her. I am speaking of the wonderful sheet in the Bonnat Collection (Bayonne) which bears the date 1522 as though it was a mark of conclusion.

The development is a perfectly consistent one. The aim was to connect perpetually growing masses coherently and to bind contrasting elements closer and closer together. At the same time the flat design was changed into one of greater spatial depth. It would have been a magnificent picture with the encircling choir of saints led by the women sitting on the ground,[150] and in the centre the group around the Madonna. Horizontal lines have become clearly visible in the broad draperies, and the bulging arms of the throne, the stool of the two angels, and the tall figures of St Joseph and St John the Baptist help to produce an unprecedented effect of richness in the group around the throne. These two men are detached from the main group of figures, and according to a note on colour both were to have been 'red', i.e. they should have provided symmetrical accents beside the Madonna.

A number of large studies of heads from nature, which were to be used for the picture in the oblong version, have been preserved. The known sketches clearly refer to the picture, but it should not be thought that the composition was made dependent on a fortuitous collection of good life-studies. Of course a more or less distinct idea of the design already existed. The first definite version of the whole composition known to us may have been preceded by many others, and the way the heads are posed clearly points to a frame of reference which was still to come. But evidently the faces were meant to be incorporated in all

their individuality. Dürer was not afraid of the earthy appearance of these heads. Dull and earthbound features were to be submerged in the solemn harmony of the movements. German art had now reached a stage where—in order to understand the true subject of the picture— the turning and inclining motions of every single figure must be observed as well as the way in which these are met by their neighbours, just as in Raphael's *Disputà* or the *School of Athens*. Dürer showed a new, quiet, simple beauty in the attitudes and costumes, he took over no ready-made prototypes as he had done formerly. Beauty is not there for its own sake, it is always expressive of something.

The head of St Barbara (the drawing for it is in the Louvre, Paris; Plate 106) is particularly interesting, as it approaches Dürer's ideal

106. *Head of St Barbara.* About 1522. Drawing, 417× 286mm. Paris, Louvre.

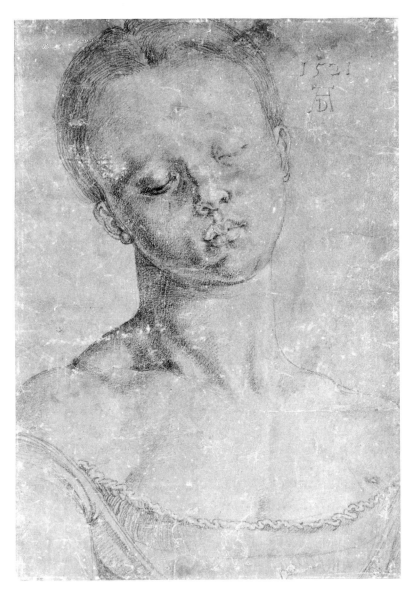

human type very closely. The round lips, pursed as though for a kiss, are a motif which has not been considered unsuitable even for the pure Virgin Mary, as the small picture of the Virgin of 1526 shows.

Besides the heads, studies of draperies are found most frequently at this time. They are all exceedingly meticulous drawings from life. The older Dürer became, the more he tried to make contact with reality.

In the beginning he drew his cascading draperies from his imagination. A few preliminary designs show how his fingers itched, how he could hardly wait to begin. Later on drawings after models became more and more frequent. The garments in the Heller altarpiece were already fairly realistic, but only in his latest works does one get the impression that Dürer is representing nature. There, his forms have an atmosphere of solemn restraint. The gay frills of his youth have been banished, so are the somewhat violent motifs of the Heller draperies. Now there are uncomplicated contours, large planes, simple long folds of draperies, straight if possible, and the accessories are moved to remote spots where they do not impede the main movement. The imposing style of this time can be plainly seen in the drawing for a *Virgin Mary* or *St Anne reading* of 1521 (w.885). The way in which the figure of the woman is realized from within the shadow of the hood of her cloak, pulled over her head, as though she were in a niche, is magnificently conceived, and the forms of the whole figure combine to give an almost architectural effect of simplicity. The gesture of her right hand somewhat resembles that of the Madonna enthroned. In both cases the fingers are inconspicuously placed on top of the plane of the open book. How coarse Dürer's feeling had still been in Venice when he had let his *Madonna with the goldfinch* (Berlin; Plate 58) hold the book, and how incomprehensible it seems that he had been Giorgione's neighbour at the time.

A second group of drawings suggests that there was a picture of the *Crucifixion* which was not executed as a painting either, and whose overall composition is only known through an engraving. Formerly only the outline engraving (P.109) was known, which undoubtedly does not belong to Dürer's work. But in 1923 Dodgson discovered an outline engraving, strikingly similar except for minute differences, but earlier than the first engraving, which, if it was not done by Dürer around 1523, must at least be based on an original sketch.[151] Any attempted reconstruction must take account of the fact that the figure of the crucified Christ is known from the drawings, as are St John and the group of the women. There are also life-studies for Mary Magdalen at the foot of the cross and for some lamenting cherubs. The detailed care of these preparations and the manner of the drawings support the view that Dürer had in mind not merely an engraving but a painting. Unusual, however, is the arrangement of St John remaining on the left and the women approaching from the right. But it is quite likely that the main figures were meant to be joined with a large number of

107. *St John at the Cross*. 1523. Drawing, 419 × 300mm. Vienna, Albertina.

accompanying figures—as is shown in the engraving—even if details of the composition in this are not reliable.

The oldest part of the composition is the group of women dated 1521 (W.858). It already clearly shows the magnificent, restrained pathos which is the distinguishing characteristic of this *Crucifixion*. In order to appreciate the marvellously simple lines of the cloak falling in long, plain folds from the shoulders of the woman, enveloped in her garments like a nun, one has to compare her to the Virgin in the same scene from the *Engraved Passion*, whose movement is similar. Gothic tomb slabs have figures with comparably simple draperies. The accompanying figures repeat the theme to the extent that they surround it with an aura of sublimity without detracting from its unique signifi-

cance. A contemporary drawing of a Crucifixion in the manner of a woodcut (Albertina, w.880) shows vividly how this magnificent, sweeping style is no longer applied in such instances. The most famous contemporary piece of sculpture, the so-called *Nuremberg Madonna* in the Germanisches Museum, originated from a similar approach.

The drawing of St John (w.859; Plate 107) is dated 1523. His gesture is calm but emphatic because everything, garment and movement, are in perfect unison. The leg carrying no weight drags behind. The impression is like the sound of a mournful andante. No one could think, as one could have thought of the Heller altarpiece, that it might be possible to unscrew the heads of the figures; and the formal rendering of movement is always firmly connected with expression. The head leaning back is related to the whole movement, and a spectator would know without looking at the face that those hanging draperies belong to a mourning figure.

But it is remarkable that this magnificent conception was to be compatible with an intimate drawing style which seems just as new in its own way. The figure of Christ (Louvre, w.861, 1523) is a nude which could be put on the same level as the *Large Nemesis* if it were not for its more imposing style.[152] The simplicity of the view is not only the result of a strict frontal pose but also of the simple positioning of the feet, for which Dürer goes back to the very ancient type of the two nails. I do not think that ecclesiastical or antiquarian considerations were the reason for this; it can be understood as a consequence of the new taste for simplicity and straightforwardness. But it is astonishing that this innovation spread so quickly, as though an order had been given. The loin-cloth does not flutter any more either, it hangs down in plain folds.

To this *Crucifixion*, I would like to add a *Lamentation*, a drawing of 1522 formerly in Bremen (w.883; Plate 108). It cannot be claimed with equal certainty to be a design for a painting, but it belongs to the new, magnificent style by virtue of its monumental composition. The picture is broader than it is high: the proportions of its format are determined by the stretched out corpse. The time when Dürer built his pyramid-like Lamentations is gone. What relevance did those forms have for a lamentation of the dead? Here horizontals and low, subdued forms were to be predominant. But it is difficult to manage a broad format because not all figures can sit on the ground. It may do for the women, but the men must stand. Almost contemporaneously, Fra Bartolommeo overcame this difficulty in his classical *Pietà* by using stooping figures. Dürer cut through the knot of the problem by showing the accompanying men as half-figures as well: they stand on a lower level. He attached more importance to the overall pictorial conception than to the scruples of people who approved only of what was probable.

Christ leans against the kneeling Magdalen. His mother crouches on one side near his head, his arm already rests on her lap, she holds it up with her open hand. She bends down and lifts up the face of sorrows

to kiss it, but it is contorted with pain, lifelessly thrown back and meets her kiss with terrifying indifference. The dead body expresses only one thing: pain. All lines have consistently and with apparent naturalness become carriers of expression. The picture possesses great sculptural richness but there is no formal motif which has been introduced merely for its own sake. The bending of one leg produces the same effect of immediacy as the visually surprising positions of head and shoulders. One hand lies flat on the ground, palm downwards, which is rare, completely still; but the fingers seem to touch the earth twitchingly.

It might seem curious that the necessary balance of the picture has been achieved in spite of the uneven filling of the space which puts the whole stress on one side. The two men in themselves would not be sufficient to create this balance. But St John turns away from the main event and searches for a companion to his grief in his neighbour, Joseph of Arimathea. He thus creates a second focus of interest in the picture to which the onlooker will quickly be drawn—and in this way the balance is won.

It seems to me that the ideas which Dürer set down in this drawing were not entirely unused by the new high art, even if he himself did not take them up as a painter. The beautiful, quiet group of a *Pietà* in

108. *Lamentation.* 1522. Silver-point drawing, 245 × 325mm. Formerly Bremen, Kunsthalle.

109. *Annunciation*.
1526. Drawing,
288 × 211mm.
Chantilly,
Musée Condé.

wood in the church of St James in Nuremberg has so many related characteristics that it must be attributed to the same time and possibly directly related to Dürer. The same means of giving the figure of Christ its significance are used. The rare motif of the hand lying on the ground, palm downwards, is repeated too. Only the attitude of the Madonna is different—she prays without great emotion, and shows a coolness which is the hallmark of a derivative classicism.

I have already mentioned in passing an *Annunciation* of 1526 (Chantilly, w.894; Plate 109) in which Dürer searches for an imposing rendering, in accordance with his latest style. The angel approaches the Virgin with erect bearing, his arm outstretched. But what is essentially new in the telling of the story is not present in this feature, but in the earnestness with which the content of the narrative has been felt and repre-

sented free from any purely formal effects. Of course the formal values have been calculated very precisely, but the construction is integrated with the demand for immediate expressiveness. One does not see it unless one looks for it. How mechanical still were even the simple compositions of the *Small Woodcut Passion*! This changes in the period of the *Melancholia*, but in those years Dürer produced very few narrative works. Only now does the new spirit of the story of the Passion make itself felt in a series of large, oblong drawings for a third cycle of the Passion. It is part of the mood of Dürer's last years that they are 'serious songs'.

The *Adoration of the Kings* of 1524 (Albertina, w.892; Plate 110) was presumably meant for the same sequence, providing a strong contrast in mood as an introduction. It is in any case best suited to show the characteristics of this last period, as we have earlier material which is perfect for comparison in the woodcut of 1511 and the woodcut from the *Life of the Virgin*.[153]

The Madonna is no longer the contented mother, neither does the Child reach into the golden casket with playful hands; she is sitting in a formal and solemn pose, holding in front of her the miraculous Child, who is wrapped up completely and looks at the kneeling king with wide eyes. The old king who is the first to kneel has always been considered

110. *Adoration of the Kings*. 1524. Pen drawing, 215 × 294mm. Vienna, Albertina.

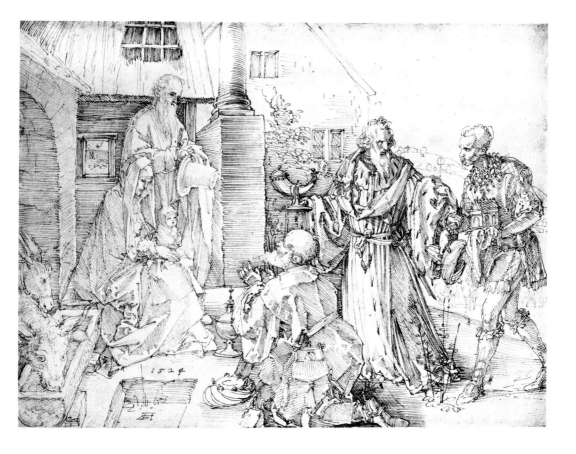

a dignified figure who, it will be found, invests the representation of the adoration from a distance with a particularly high degree of devotion. The more profound conception becomes very clear in the way the second king is related to the Moor. Artists had often made fun of him. Here the noble man leads the negro—who shows his shyness clearly—to the front with real kindness. And the flow which develops from this majestic, sweeping gesture is magnificent. The kings move towards the Madonna like a broad wave and in her they meet a contrast of perfect calm. Joseph is a coherent part of the group, he strengthens it and stresses its importance, and the architectural background aids this with its intersections and narrow framework. The vertical lines have been reserved for this. Everything is simple and most convincing, the gestures as well as the locality. The large gabled house in the middle ground is conspicuously realistic.

Four scenes of the Passion proper are known, but only the first, the *Last Supper*, was cut (Plate 111).

For the *Last Supper*[154] too we possess the composition of 1510 for comparison. The rigorous structuring has gone. It must have seemed too superficial, too purely formal to compose a story with a central figure and symmetrical sides. The twelve figures—Judas has already left—are grouped in a free rhythmical sequence. Christ's figure is

111. *Last Supper.* 1523. Woodcut, 213 × 301mm.

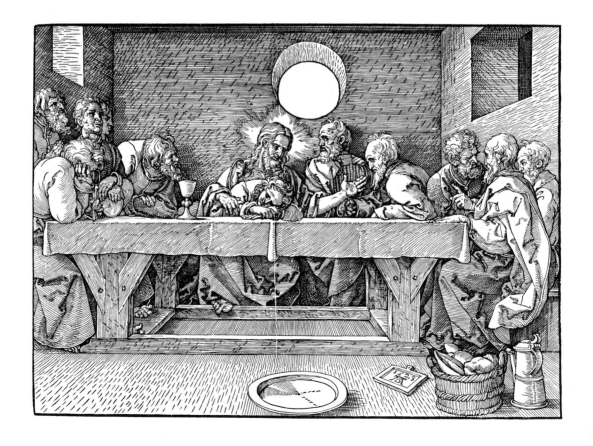

112. *Agony in the Garden.* 1521. Drawing, 208 × 294mm. Frankfurt, Städelsches Kunstinstitut.

adequately stressed on the one hand by a decisive gap and on the other by two figures who are set further to the front and direct the eye towards him. Movement and gestures have been simplified throughout. How complicated the group of 1510 seems: Christ with one knee raised and one arm bent forward, cradling St John. This motif of St John sheltering in Christ's arm does seem somewhat affected, too, and it is not entirely clear—it takes some time before his hands are discovered. The later version may leave anyone who is orientated towards Italian art unsatisfied as regards nobility, but the scene is at least shown simply and impressively. And what a sum there is of fresh and immediately effective expression in the sequence of the Apostles' heads! Peter, next to Christ, sits rigidly, his hands tightly clasped, his head turned as if a strange force had made him suddenly swing round. His neighbour has put his hand on his shoulder and listens to the speech with rapt attention, without lifting his eyes. The old man at the corner of the table sits upright like a tree, his hand lying flat on the table, and on the other side the disciple who supports his head on his hand pierces the tablecloth with his knife in complete forgetfulness of his surroundings. The table is not laid, so as not to disturb its linear calm. Only the chalice is there; bowl, tankard and bread are set on the floor. A large, completely white, circular hole in the wall is the only purely decorative form. Dürer felt the need to make the back wall smaller, and to add an

259

important, dominating feature. It needed conviction and courage to insert this colossal accent asymmetrically into the scene.

The Agony in the Garden (drawing in Frankfurt, 1521, w.798; Plate 112)[155] shows this last *Passion* at its most austere. Christ has thrown himself flat on the ground. It is well known that the same motif was used in the *Small Woodcut Passion* around 1509 but was replaced by a new version, presumably because it was spoilt in the cutting. It is a Franconian motif, as a drawing of around 1490 from the Wolgemut workshop shows (Erlangen, University Library). But Dürer presumably first saw a similar type in Mantegna's predella of the triptych in S. Zeno in Verona. It showed among other stories the scene in Gethsemane (now in the Tours Museum), and there it is one of the disciples —not Christ himself—who lies flat on the ground. As a matter of course linear beauty is absent in this version of the theme. But it is a sign of Dürer's artistic maturity that he has overcome the disadvantages of the motif and infused the scene with an element of necessity. This has been done by gradating the ground in flat layers so that it leads up to the completely prostrate figure. For the same purpose the clouds are shown as long bands of mist stretching out low above the figure. The disciples are nothing but a small group seen far off.

Christ carrying the Cross of 1520 (w.793, Florence, Uffizi; Plate 113)

113. *Christ carrying the Cross*. 1520. Drawing, 210×285mm. Florence, Uffizi.

provides an example of the way Dürer treated a narrative with many figures, showing the way in which he overcame the 'composed' effect and kept the main motif quite distinct in spite of the multitude of figures. The oblong format was particularly advantageous for the depiction of a procession, but the danger was all the greater of losing Christ among the many accompanying figures. He has not fallen to the ground but remains in the *ensemble* as an upright, walking figure, and Veronica holding the cloth up to him brings him only to a momentary halt. The perfection of the sheet lies in this very interweaving of retardatory motifs with the pushing masses whose movement continues on; they are immediately noticeable, perfectly comprehensible, and stress the true significance of the scene although within the overall composition they are being accorded no undue consideration. The artifice is completely hidden. Of course Christ's turning towards Veronica would remain unnoticed if the man behind him (with the high hat) did not also direct the onlooker's glance towards her kneeling figure. On the other hand, pressing forward, the man ensures that the pause is immediately counterbalanced. The cloaked figure of the man in front, seen from the back, who takes a cursory glance backwards, brings about the connection with the front of the procession without attracting interest to himself. The cross is only seen in discreet foreshortening, but ladder and lance are used to help draw the eye towards the central figure and reduce the diffuseness of the surroundings. Such pictures taught the north for the first time what it meant to narrate a story well. The plot is developed perfectly clearly and is yet as abundant as reality and pervaded with the charm of the seemingly arbitrary. A stylistic analysis could uncover a whole theory of narrative technique. The main direction of the movement in the picture is accompanied by an opposing direction for the sake of a richer impression: the procession turns. But the impression of real depth beside the broad spread of figures is created above all by the narrow alley-way and the view through the gate.

A second drawing of *Christ carrying the Cross* (w.794, also in Florence) with the collapsing figure of Christ as its main motif, does not have the same power.[156] In the case of the *Entombment* (1521; Nuremberg, w.796)[157] Dürer goes back to the motif of the funeral procession as he had used it very early on in the *Large Woodcut Passion*. The broad format must virtually have forced him to do this. If the first woodcut demonstrated a relation only in subject-matter to Mantegna's famous engraving, this version shows the dependence quite clearly. Christ's body lies huddled in the shroud; it is carried above and below by a man stepping forward and one stepping backward while a third clasps it in the middle and (corresponding to the Magdalen in Mantegna) reaches across with one arm. When Raphael designed the composition of his *Entombment* he wanted to stress the difference in the movements of the bearers and so he put the steps of the tomb behind the feet of the man going backwards who has to feel for them with his heels. Dürer

had the same idea, only in his picture he made the steps descend.

It is impossible to say if the *Entombment* was meant as a substitute for the scene of the *Lamentation* in this last sequence of the *Passion*. There is an upright composition of this theme in the Albertina (w.587). It is dated 1519 and thus does not belong in this context. But it is valuable to us as evidence that the new style already existed before the journey to the Netherlands. What I call new is the way the bystanders are treated as one mass, in which no figure attracts the eye particularly and the mood of the picture is only indicated here and there by a sudden gesture. That the foreshortened view of a head is reserved for the two main figures is an expression of the new economy. Only in this way was it possible to make them appear as important as was necessary.

A second, later *Lamentation*, again in upright format (1521), has also been treated as a crowd scene. The Madonna sits beside Christ, whose head is shifted in such a way that it seems as if he were trying to look at his mother.

It is true of any picture that the clearer the artist's conception of his subject, the more distinctly it has developed in accordance with the demands of his inner vision, the better it becomes, because this guarantees that the onlooker too can understand it completely and without effort. This is particularly true of the portrait, although here the model seems to be all-important, and the layman does not understand what the creative imagination of the painter himself has to do with it. A good portrait must involve the onlooker immediately in the atmosphere of a particular figure and personality, so that he knows at once, and with certainty, whom he is confronting. But this clarity and precision of effect will only be achieved if an equally clear and precise conception has preceded it in the painter's mind. Dürer's portraits all have this characteristic, more or less, but his perception was never as comprehensive as in this late period. What I mean is that the strong impression of an individual character was always there, but only the last pictures provide an exhaustive clarification and revelation of every form.

Dürer now renounced all external means of making the portrait come to life and confined himself solely to the simple figure. There are no momentary impressions, no glances, no openings of the mouth. He only incorporates hands in exceptional cases and when he does show them, he rarely goes beyond a conventional gesture.[158] Usually only the head is shown, narrowly enclosed. If the portraits are nevertheless strongly eloquent, the reason lies in the thorough examination of form for its essential significance. Nothing has been omitted but the essential forms have been related to the less important ones in a way which makes them decisively predominant, and the onlooker experiences the strange happiness of sudden seemingly visionary powers.

A portrait in Madrid of an energetic and intelligent man, done in 1524 (Plate 114), is justly taken to be the most perfect example of the

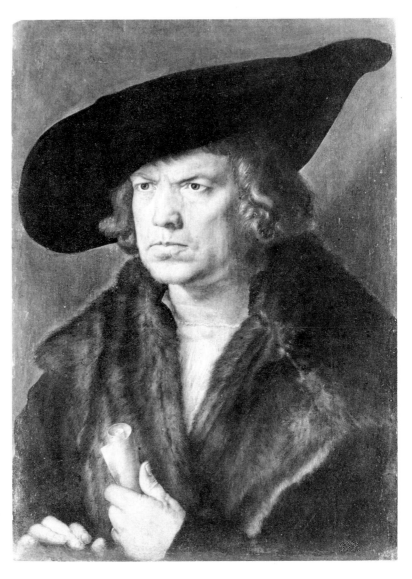

114. *Portrait of a scholar*. 1524. Oil, 50 × 36cm. Madrid, Prado.

later portrait paintings. Many conjectures have been made about the sitter, none of them convincing. A last strong echo is felt of the impression the paintings of the Netherlands had made on Dürer. Throughout his life he had to be reminded from time to time by foreign prototypes of what a painterly picture really was. But the impression never lasted long. When back in Nuremberg he soon moved away from the heads he had painted in Venice. The Madrid portrait had no sequel either. The portraits of 1526 in Berlin, of Holzschuher and Muffel, are again already much more linear.

Both were distinguished Nuremberg citizens, very respectable representatives of a society of which Dürer was a member. One cannot imagine this German town in the period of the Reformation without thinking of these heads, above all that of the councillor *Hieronymus*

Holzschuher (Plate 115) with his white beard, a man in the best of health. He must have been a full-blooded, passionate man with a fiery sanguine temperament, alien to Dürer. Dürer has characterized him in an unusual way. The way the eyes roll and flashes of white locks coil across the forehead is not at all typical for the artist. I need not stress that of course the hair was not like this in reality. Dürer used the language of the linear style of the *Apocalypse*. This is no reflection on the quality of the picture, but as an example of the particular manner of his late style it seems less typical to me than the portrait of the other councillor, *Jakob Muffel* (Plate 116).

The two show strangely contrasting characters. Beside the temperamental man whose fiery blood leads to quick words, Muffel is a reticent

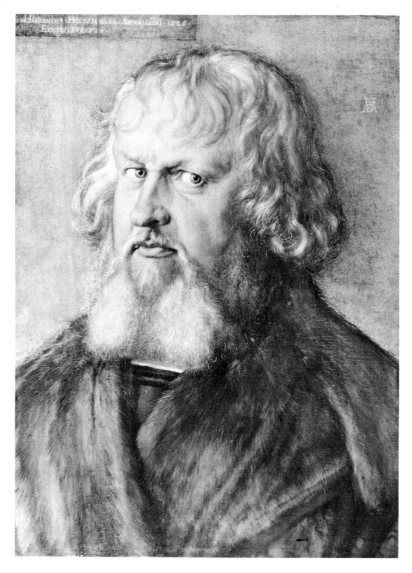

115. *Hieronymus Holzschuher.* 1526. Oil, 48 × 36cm. Berlin, Staatliche Museen.

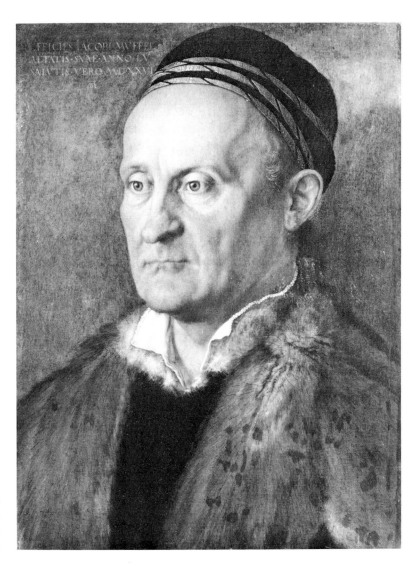

116. *Jakob Muffel.*
1526. Oil on wood,
48 × 36cm.
Berlin, Staatliche
Museen.

man of reason and reflection; he has precise features, narrow lips and small, sharp spots of light in his eyes. The pettiness of the nose could easily give the head an unpleasant effect, if it were not counteracted by the large curve of the exposed forehead. And a trained eye derives the greatest pleasure from following the modelling which is so clear and complete that the observer is able to grasp the whole as well as the individual parts at once. The eye is stimulated immediately. The mere silhouette of the forehead and eye socket is significant; and how well the firmness of the bone structure and the layers of the form are shown up! The head seems to be very simple and yet any comparison will show that the details are worked out more precisely than ever before.[159]

It may seem strange that Dürer did not use strictly frontal views in this period. He had already used them in the portraits of 1503–1505,

265

where he was much more concerned with momentary expression, and in the Munich self-portrait the frontal view had even been combined with the strictly vertical main axis; but he did not want to repeat this solemn pattern. In general he seems to have considered a position between a frontal and profile view as the most significant. As with all portrait painters, he hardly ever used a pure profile view—although he knew quite well that it possessed a certain kind of monumentality.

The most interesting use of the profile is found in the engraving of the Cardinal *Albrecht von Brandenburg* (1524; B.103), which is called the *Large Cardinal* in contrast to the portrait engraving of the same person done five years earlier (1519; B.102). This older version[160] shows the head in three-quarter view, somewhat small for the space; the coat-of-arms and inscription bear down on it rather than embellish it and the horizontal line of a dark tapestry background, which cuts through the picture half way up, has an almost brutal effect. Evidently this noble dignitary wanted something more magnificent the second time, and a very small study in silver-point (Louvre, w.568) became the basis for the large and effective engraving showing the profile against a uniformly dark background. It is a clearer example than the first version of how Dürer raised a portrait above nature. The Cardinal had depraved, protruding eyes, a vulgarly sensual pouting mouth and rank masses of fat around jaw and chin. Dürer's first concern was to overcome the fatal domination of the lower part of the face, so he put a cap on to the head which immediately suggests a more imposing cranium than existed in reality. The monstrous shapes are treated with discretion, but without denying their true character. But the point that was chiefly considered was that a profile view would show up those features of the head which really were imposing. The powerful forms, though somewhat brutal, seem so energetic in this view that they make one forget the sheer mass of the fat deposits. The small forms of the coat-of-arms provide a beneficial contrast. Another portrait of the year 1524 was done with greater sympathy for the sitter. It was of the Elector *Frederick of Saxony*, Dürer's old patron (Plate 117). The head of the model (who is obviously sitting) is shown pressed tightly into an almost square panel; it is heavy and awkward, yet endowed with a strong will-power and sense of perseverance. The preliminary design was a silver-point study from life (w.897), no bigger than the engraving. Dürer must have had an excellent memory, for on examination the engraving —for which the nobleman certainly did not sit again for any length of time—shows greater formal richness than the drawing. Beside the precision of the modelling on the copperplate of the tiny lines around the eyes, lips, etc., the indications in the silver-point make only a very sketchy impression. And only in the engraving have all the details been combined into large units which outline the physiognomy in a simple manner. Compare the treatment of the cheek turned towards the spectator. Dürer also intensified the linear movement in order to pro-

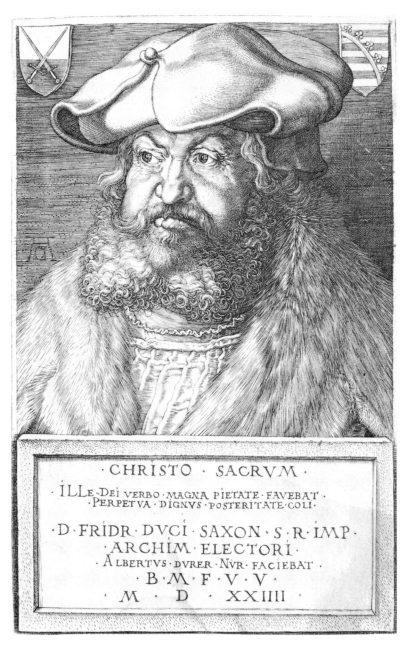

117. Elector Frederick the Wise of Saxony. 1524. Engraving, 193 × 127mm.

duce a more lively effect; not uniformly or everywhere, but very distinctly here, for instance in the brows and the line of the lids. The energetic curve of the brow as it rises above the right eye (in the engraving) is not found in the preliminary drawing, and the line going up from the inner corner of the eye takes a very different course. Finally, this is a good chance to examine in a concrete example what arrangement of free forms the artist found advisable to carry further than in the original study; to see how the line of the buttoned-up flap of the cap has been pressed down deeper on the forehead, how the

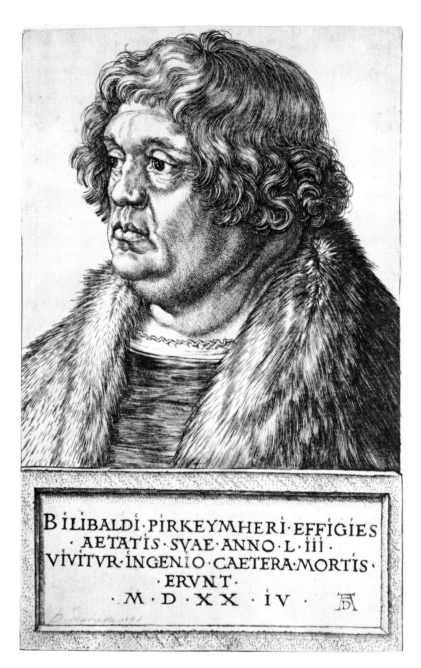

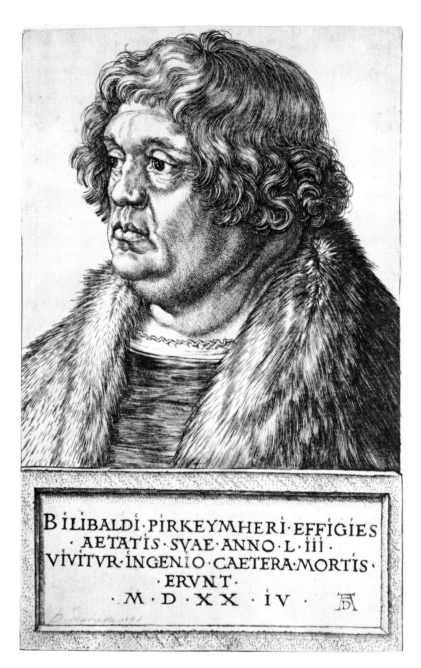

BILIBALDI·PIRKEYMHERI·EFFIGIES
·AETATIS·SVAE·ANNO·L·IĬĬ·
VĬVĬTVR·INGENIO·CAETERA·MORTIS·
·ERVNT·
·M·D·XX·IV· 𝔸

118. *Willibald
Pirckheimer*. 1524.
Engraving,
181 × 115mm.

cap comes down lower on the side of the face (down to eye level), how
the link between beard and hair is broader, the fur cloak reaches higher
up, etc. The wonderful fur is effectively contrasted with the rigid and
brittle treatment of the panel with the inscription.

The Elector would suffice as a sample of top quality portrait en-
graving and a further illustration would be superfluous, but the portrait
of *Willibald Pirckheimer* (Plate 118) should not be left out, and not
just because he was Dürer's best friend. In his case it is instructive to

268

compare the engraving with the drawing of 1503. How immensely more expressive the engraving is! Of course, one is a quick drawing and the other a carefully executed engraving, and the head itself has improved over the twenty years—all this can be taken for granted. But there are differences which are the result of the greater perfection of Dürer's art. The broken nose, distinctly stressed in the early portrait, only served the trivial purpose of recognition; in the engraving it is made completely insignificant through the creation of a more elevated expression. The lips have the suggestive power found in Dürer's most mature drawing style in which all spiritual qualities have come to life. The meaningful eyes also play such a dominant part in the face that one must presume that here too Dürer followed an ideal interpretation and showed their significance rather than their actual size.

Dürer put the art of his engraving at the service of the people he knew well. *Melanchthon* too (1526, B.105) may be included in this circle.

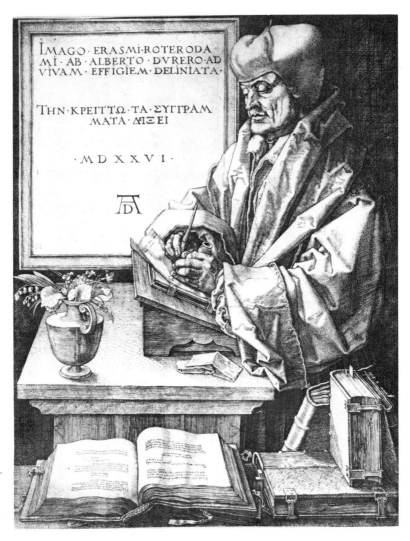

119. *Erasmus of Rotterdam*. 1526. Engraving, 249 × 193mm.

It is true that he had refused an appointment as director of the Nuremberg Gymnasium, but he was in Nuremberg in November 1525 and also in the spring of 1526 when he gave the inaugural lecture at the opening of the Gymnasium on 23 May. Dürer must surely have drawn the somewhat unkempt philologist, with his beautiful forehead and benevolent, shining eyes, with sincere sympathy. All the same it is a cursory work, and the strange background with its restless, uneven, horizontal lines was probably chosen because of this, in order to hide certain irregularities.

The only portraits in which Dürer was notoriously unsuccessful were those of *Erasmus*. He had tried to draw him twice in Antwerp and had not been able to manage it,[161] and now he had the lamentable weakness to yield to the vanity of the sitter and attempt an engraving after so many years had passed. It is Dürer's largest portrait engraving (1526, B.107; Plate 119). It shows the famous scholar half-length, standing and writing. It is probable that Dürer made use of a medal by Quinten Massys, which Erasmus himself had offered for the purpose in a letter to Pirckheimer (14 March 1525), as so much time had passed since he made his drawing.[162] Much care has been taken in the rendering of accessories and the distribution of black and white is remarkably original, yet the picture lacks life and would still do so even if it were not obliterated by the memory of Hans Holbein's masterpiece. It needed Holbein's more detached power of observation to understand the true nature of this quiet face.

Woodcuts as well as engravings were used for portraits. They could never have the pure effect of engravings, as they were only able to provide a stylized reproduction of the original drawing, but they have the advantage of enabling larger dimensions to be used. This advantage was exploited in the life-size portrait of *Ulrich Varnbühler* (1522, B.155; Plate 120).[163] The drawing for it is in Vienna (Albertina, W.908). The face is drawn with hard brown charcoal, the costume with soft black charcoal. The woodcut shows that it was firmly intended to retain the strokes of the original; the block follows the drawing as closely as possible. And it is magnificent to see how the woodcut's technique regains a new freshness from the atmosphere of the drawing on which it is naturally dependent, even if it is in the end considerably coarser.

Those who believe that art should be kept for artists could produce a number of statements by Dürer which at least testify to his opinion that judgements in matters of art should only be made by those who practise the craft themselves—for everyone else art remains a foreign language. And in his early engravings there are certain things which can only be understood under the principle of *l'art pour l'art*. But the older Dürer grew the more he put his art at the service of a definite mission, and the greatest work of his last period, the *Four Apostles*, was meant to have the effect of a sermon.

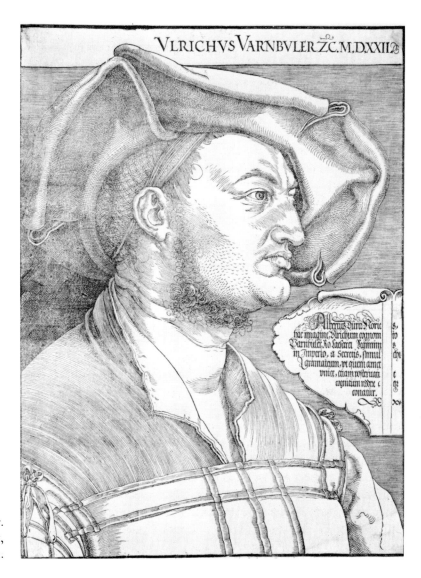

VLRICHVS VARNBVLER ZC.M.D.XXII

120. *Ulrich Varnbühler*.
1522. Woodcut,
430 × 323mm.

Ideal male figures form a special group in this late period. It would have been inconceivable for Dürer to go back to the saints of his youth. A St Sebastian or a young St George would have seemed much too expressionless to him now. He wanted men of great moral significance. Perhaps only the figure of St Christopher, which appears twice in 1521, could be taken as an exception. And yet there is an ethical concept underlying the relation of this man, who is as strong as a giant, to the Child whom he carries across the river and whom he finds inexplicably heavy because he does not know that he is carrying the Christchild and with him the whole world. Luther also liked this story, as can be gathered from his table talk. Dürer drew the figure of St Christopher approximately once every ten years, twice as a woodcut earlier on and now, as was mentioned, as an engraving (B.51, 52). The drawing with the

271

larger figure is without doubt the second version, and is the first to show the motifs of the event with perfect clarity. St Christopher had to be a man who walked heavily and with difficulty, not a hasty young fellow as he was in the early woodcut (B.104). He had to grasp his stick firmly with both hands and it was obviously more significant to make him turn his head back towards the Child rather than look in front of him. Again and again one is surprised to find how little thought was given to the treatment of such types in Schongauer's epoch. In giving back to this figure its true significance Dürer returned to the kind of representation already known to the Middle Ages.

One can make similar observations with regard to the Apostles who develop from the two engravings of 1514. They are completely calm, without any passionate feeling; even the fireworks of their haloes have been abandoned, but they have something of the greatness they had in traditional representations. The attribute of *St Bartholomew* (B.47, 1523) is a knife, as he was flayed with one. It could not be employed directly as a motif as it was not used by the saint himself for anything, but nonetheless it is not hidden: he holds it upright and clasps it tightly, with his arm stretched forward, and this gesture has so much strength that on its own account it encourages the spectator to look for greatness in the head of the figure.[164] The gentle, playfully delicate handling of the attributes, of the kind found in popular devotional art, has had to give way to an entirely different mood. *St Simon* with his saw, also done in 1523 (B.49), outwardly seems to have more in common with popular types, but the similarity is only superficial.[165] Absolutely no doubt about the spirit of the art of Dürer's last period is left by the magnificent, calm *St Philip* (B.46; 1526, corrected from 1523). His garments are of the same solemn, simplified, somewhat cold, straight kind. St Philip's cloak seemed imposing enough for Dürer to use it again—on a colossal scale—for the cloak of St Paul in the painting of the *Four Apostles*.[166]

The graphic technique of these engravings is strong and simple. The tonal gradations are very distinct. While in the earlier engravings the darkest tone had often been in the background, now the strongest shadow (and with it also the impression of the brightest light) is reserved for the figure, and the background, where it has a definite form, has a medium tone.

The subject of the apostles was for Dürer too important for him to content himself with small engravings. Whereas the production of all other large pictures had come to a standstill, Dürer decided to treat at least this theme in a monumental form. He directed his concentrated effort to the more than life-size figures of the *Four Apostles* (1526; Plate VIII). Nobody had commissioned the pictures, nobody bought them and they were not intended for a church. Dürer presented them to the council of his home town and added those portentous captions which show that the work was not simply meant as a work of art but a

religious decree. In times where everything wavered he wanted to set up images of the teachers who alone can serve mankind as guides to righteousness.[167] The strange selection of apostles does not assign the most important role to the principal ones St Peter and St Paul, but to St John and St Paul, who are given precedence, and only then are they followed by St Peter and St Mark who are subordinate to them. We know this method of grouping from Italian pictures, with their lowering of the perspective towards the figure standing at the back. However, here the second pair are so strongly subordinated that it has been thought that they were only incorporated into the picture as an addition. It is well known that the customary title of the *Four Apostles* is incorrect, as St Mark is not one of the twelve Apostles. We do not know whether a centre panel was ever projected, but the composition of the figures is like that of the two wings of a triptych.

The panels are high and narrow, with a dark ground, and are just big enough for one figure. Any spatial beauty in the Italian sense is excluded. There is no pose which stands out for independent attention. Everything serves expressive purposes, for instance St Paul standing broadly and firmly on both feet and St John's supple step leaving one leg slightly free of weight. But the movement is felt rather than seen, for the figures are enveloped in large cloaks. This is where their characters begin to be expressed. The powerful masses of St Paul's long white cloak with its stiff folds are modelled with the whole immense energy of Dürer's feeling for sculptural form. The cloak is straighter than in the engraving of St Philip and its contour is even simpler. St John's cloak with its softer material is in strong contrast to it: its colour is a quite warm red, while the white of St Paul's cloak, cool in itself, is made to appear even colder by the use of greenish-grey shadows. Dürer knew how expressive colours are. He commented on this in some of his writings.[168]

St John bends his head in a relaxed way and looks into an open book; St Paul only stands attentively, his sword resting on the ground, holding a huge bible and looking outwards. He carries the volume on his outstretched lower arm because the high narrow format of the picture urgently demanded a horizontal as a counter-balance. For the same reason St John tucks his cloak under his elbow. As the two horizontals are on the same level, they strengthen each other.

Contrasting expressions have been maintained even in the subsidiary figures. Dürer seems to have reserved the most powerful glance for St Paul; St John, who looks down with lowered lids, does not vie with him. When the second pair was added the adjustment which could have been made was avoided. St Peter's eyes too are hidden, while St Mark's wide-open ones make him look almost frightening.

An old tradition maintains that the four figures represent the four temperaments, and it is easy to understand how such an opinion could have arisen, as their characters are really very different from each

other. Nevertheless, I do not think that this interpretation is justified. To start with it would be difficult to assign a characteristic to each apostle—St Peter would be the phlegmatic one—but above all the mixing of history and theory is incompatible with the spirit of Dürer's later works. Dürer's interest in the apostles was too serious to use them as mere occasions for representing the temperaments. For him they were the historical authors of the message proclaimed in the inscription. But it is true that the figures represent more than mere individuals, as they have been heightened into types. St John's head is that of a youth, probably once without the somewhat saturated appearance it has now,[169] but with full, soft lips and a forehead which is undeniably similar to that of Melanchthon.[170] St Peter is the good old man, but he seems almost unimportant beside the volcanic St Mark, whose eyes roll like a thunderstorm in his yellow head, framed by black frizzy hair and showing his teeth between his lips. He forms the foil and psychological contrast to the calm power of St Paul, whose head—the most important of the four—had probably occupied Dürer for about twenty years. The immense cranium, the deep-set eyes, the nose extending far down and the long beard continuing this line—these are features which appeared already in Venice, and then again in the Heller altarpiece, but only here have they become grandiose.[171] In the picture of the apostles at the tomb of the Virgin Dürer still tried to achieve ideal form by exaggerating individual features; now he finds greatness in simplicity. Looking at this apostle one can understand what Dürer meant when he sadly told Melanchthon that only now did he grasp the magnificent simplicity of nature.[172]

Anyone who has once felt the power of this apostle's eye knows that not only has a new conception of a saint been represented, but a new idea of human greatness as such. The Reformation was brought about by men of this kind. The epoch was a manly one, and Dürer could only present his highest achievements in manly types.

Goethe, on the contrary, thought that women were the only vessel into which we can pour our vision of the ideal.

General remarks on style

Every artist sees the world in predetermined shapes and colours. Dürer had to visualize the world in a linear way. When he is described as primarily a draughtsman, this does not mean that he drew more than he painted but that to him all natural phenomena transposed themselves into linear manifestations. He perceived the plasticity of the body, for which he had a strong—sometimes exaggerated—feeling, in terms of linear currents shooting up and down. And even when these movements became calmer and ebbed away, their occurrence was still suggested by sparse, faint lines. Dürer represented the flashing light as well as the textures of wood and stone and animal fur in a linear style. This is why there is no painting of *St Jerome in his cell*. He thought that the shiny old wood and the charm of the sunlit room was characterized most perfectly by a graphic technique. And the claim that, given analogous tasks, his paintings do not reach the standard of his graphic designs is borne out by his work: Holzschuher's painted beard is worse than beards in engravings, such as that of the Elector of Saxony.

Dürer's line has its peculiar characteristics which make it possible to distinguish the master from all his contemporaries. If it can be said that any drawing style generally shows an inclination to intensify linear movement, Dürer's curves have undergone yet a further process of concentration, and it would probably not be impossible to determine the laws of their formation and also the modifications they underwent at different stages of his development. But I would like to content myself with the suggestions I have made earlier here and there, and only remind my readers that one cannot speak of a line as an abstract concept, but only of concrete lines, pen-lines, chalk-lines, lines traced in copper etc., and that the materials used by the artist for his drawings play a part in his imagination from the very beginning. Artistic sensibility starts with technique. The materials an artist chooses are already an expression of his attitude to form, just as they in turn will have an influence on this attitude and make the specialist a slave of his technique. Dürer was a universal artist and expressed himself in the techniques of woodcut and copper engraving, of drawings done with the pen, with charcoal or crayon, never violating the character of the material. But it may be said that copper engraving was the technique closest to his heart. In it furrows are ploughed into the shining metal by the slowly advancing, tenacious, steady burin, and later appear as lines in the print. The highest precision is demanded of the imagination and each turn of the formative line is felt with double or treble strength according to the energy used. It seems to be the most laborious

graphic technique, and yet Dürer thought engraving was pleasant work compared with the 'tiresomeness' of painting. The result even has something metallic about it. Robert Vischer, who had a specially strong and direct understanding of this side of Dürer's art, said:[173] 'The charm of his engravings consists largely in the fact that one unconsciously senses the material and instrument used and the closely connected characteristics of both. The artistry contained in the prints is itself as terse and sharp as brass and iron, it clamours against their outward appearance like a sword against a shield, it burrows into their essence like the burin into the metal plate. Subject and means, the inner meaning and the outward appearance become equally sharp and tense. It is characteristic that in the copper engravings Dürer obviously prefers to represent objects akin to this technique, armour, weapons, helmets, pewter jugs, glittering, metallic silk, silky hair, flints, expanses of water, haloes, and thin, muscular, sinewy limbs. And sometimes he exaggerates the mild glow of youthful skin, so that it looks like satin.'

The woodcut on the other hand is blunter and less rigid, it feels the way wooden objects feel in contrast to metal objects and takes on a sense of comfortable breadth. It is based immediately on the drawing, while the engraving goes far beyond it in the refinement of its technique. In earlier times it was the other way round. In the fifteenth century it was the engraving which corresponded to the drawing; the woodcut never tried to compete with it. Dürer was the first to introduce the big alteration in the possibilities: he gained the whole charm of free drawing for the wood block, and on the other hand he knew how to wrest a metallic beauty from the copperplate which even the most dexterous pen could never achieve on paper.

But the concept of drawing was also different in the sixteenth century from what it had been in the fifteenth.

The drawing of modern times develops in three stages. It begins with unbroken contours and modelling of many layers of short strokes which produce a shadow and thus the illusion of roundness. Then these opaque masses of shadow dissolve into a few individually visible elements, the strokes become larger and an independent beauty is sought in the direction and position of clear, even layers of strokes. Finally this system is also abandoned and painterly, impressionistic outlines take their place; thick and thin strokes collide abruptly, and in parts there is no coherence at all. Internal modelling consists of a confusion of lines which are neither decorative nor formative in themselves but which are not meant to be taken in individually. They only become effective when they are submerged in the overall impression. The first stage roughly corresponds with the fifteenth century, the second with the sixteenth and the third with the seventeenth century. Just as Rembrandt is the most accomplished representative of the last stage, so Dürer brought the intermediate style—which could be called the decorative style—to perfection. But as a Cinquecento artist he also

links hands across the Alps with artists like Raphael. This development is one which occurs generally in Europe. It should be possible to find a formula for the beauty of lines and intervals in the sixteenth century which would be equally valid for the north and the south.

I repeat, woodcut is part of drawing. But within the sphere of the drawings Dürer made further distinctions according to the materials used. Their peculiar charm rests mainly on his acute understanding of the nature of the tool making the marks: that is, the way the strokes are formed makes us aware of the sensuous abundance of the material. Charcoal, which produces broad strokes, had to be used in luscious sweeps, like the movement of a bow on a sonorous stringed instrument. Pithy crayon called for greater reticence in the strokes, and with the pen the light flow of the lines had to be felt. Dürer retained throughout a peculiarly light spirit in his pen drawings. Carefully detailed drawings in this technique only exist from the earliest stage of his development. The traditional silver-point tended to be rejected. If one had to name a favourite technique of Dürer's it would have to be that of the pen drawing, but to convey the impression fully one would need the old rough paper. Modern reproductions, even if they are perfect in every other respect, falsify the atmosphere of the sheets by using smooth art paper.

Dürer's sculptural sense of form was the main reason for his decisive importance for German art. If the idea of seeing space in a clear geometric way was to gain a footing, it had to come through an artist whose senses were directed with total commitment towards concrete, tangible objects, and who really felt that objects in space displaced the air and who had a strong sensuous awareness of their swellings and curvatures. This was the case with Dürer. He embraced concrete forms with a kind of passion and experienced the ups and downs, the ins and outs of the planes as real movements. It is this sensuousness of perception which made him discover his new lines and which gives his representations their infectious appeal. Whatever it may be, when one has seen an example of Dürer's art, one has a more lively feeling for the movement and straining of forms in space. It may be a mere flowering plant—one will still feel the wondrous will-power in its form more strongly, feel how the stem pushes upwards, how the leaves branch off and seek their own directions, and how they are shaped at their tips, whether they are indented or lobed, if they have edges which are stiff or soft and succulently curled. And one has entered the Düreresque atmosphere completely if one has comprehended a small wood of stems of this kind as a world of its own, full of the strangest spatial relations and secret connections. Dürer's art is richer than that of any other artist of his time in its variety of physical forms and multiple spatial relations. Where his sculptural sense of form is primarily displayed is in the drapery. One has to beware that one does not take abundance for an

effect of painterly dappling. Each form is meant to be seen clearly and understood in its relation to its surroundings, and this not one after another, but all at once. It may be that no modern eye is wholly equal to this demand.

All the studies for the work on proportion would be incomprehensible if Dürer's artistic temperament did not have this sculptural basis. When one sees how he feels his way across the planes of his heads, how he likes especially to turn to old people with distinctive forms, and finds unending pleasure in the modelling of swelling lips or the winding cavities of the ear; one may well be surprised that he never actually made any sculpture proper. His fingers must have itched to do so. Indeed there are a few sculptures which are attributed to him, but with questionable justification. And even if some of the works should happen to be originals they are not what one would expect. They are only small reliefs—there is no free-standing sculpture.[174] But his workshop must have been full of sculptured models, such as occur in the Dresden sketchbook.[175]

Dürer's sensuousness was not only attracted by the sculptural form of the world. He also had a feeling for textures, though not for very many nor evenly at all periods. But this feeling was most powerful for one particular substance. Metallic, shining objects made the strongest impression on him. By this I do not mean real metal alone; silk and feathers and soft hair also have a metallic effect. They are all objects which focus reflected light in highlights. It may be that the memory of the engravings has helped decisively to shape this opinion, but this does not matter, for the engraving is just the place where his elective affinities with the material inspired Dürer to indulge his feeling for textures. His paintings never reach this level. Compared with Grünewald or even Altdorfer, Dürer seems terribly dry and poor. It does become evident that his relationship to colour lacked natural warmth.

His senses reacted to light and shade in a totally different manner. Light phenomena always had strongly evocative overtones for him. The spectacle of the *St Jerome* engraving where the sunlight, broken by round panes, pervades the room with multiple movement and makes it cosy, had been prepared by an early, extremely subtle sensibility to the direction of light. Shining haloes on dark grounds can justifiably be described as one of the most basic experiences of his imagination. He nonetheless remained a sculptural artist in so far as he did not renounce the distinctness of his objects. Hazy, blurred, softly atmospheric effects are well outside the compass of his art. He could never have drawn the same conclusions from his representation of light as Altdorfer drew. Altdorfer represents the whole trembling brightness of an evening sky in his art. The difference is clearly demonstrated in the way he no longer drew the setting sun as a circle, but as an irregular, shifting form, in the same way as the eye, when dazzled, does not see the pure circular form of the sun. But this is already Impressionism,

and Impressionism is at the opposite pole to Dürer's art. Dürer tried to represent objects as they are, according to their sculptural mass, not as they appear. It was Holbein who brought this approach to a conclusion.

Zola's definition of a work of art as a piece of nature seen through a temperament is a bad one, even when applied to his own Naturalism, as it presupposes that perception is a matter of course. But it is exactly in this respect that artistic competence is tested. Not temperament, but power and clarity in perception makes an artist. It may be an arguable point whether or not a work of art without temperament can ever be good, but there is no question that there are a great many works of art full of temperament which are yet pieces of worthless dilettantism.

Dürer is one of the few artists who have an eminent talent for perception, who all at once open up a new relation to the world for their own time and who establish a new conception of pictorial clarity. The fame of his eyesight has become proverbial. A man who knows nothing else about Dürer knows that he saw objects with microscopic precision and worked miracles in his representation of the smallest details of a form. Dürer himself stressed that nothing should be left out and even the smallest wrinkle or vein had to be followed. 'For one should not be superficial and take an object by surprise.' But this conscientious detailing, which impresses the layman most, is not the trait which makes him a great artist. This minute observation only becomes art when the details are made subordinate to the overall impression, when, in spite of all abundance, the whole picture appears simple and the essential characteristics are concentrated in the dominating lines. To achieve this the artist needs to have a clear conception of the object before he starts to draw. Hans von Marées once described this in a most graphic manner: he said that anyone who did not know that a tree consisted of roots, trunk and branches would never be able to draw one properly from nature. I need not use examples to demonstrate once again how Dürer's art concentrated more and more on essential and decisive features. His early desire to take possession of the entire form of any object educated his imagination. He became a reformer by going back to the simplest views, pure profile or frontal views, so that the object was shown in perfect clarity. No one in the north knew what a horse was before Dürer had revealed its figure and its typical contrasting forms in the engraving of the *Knight, Death and the Devil*. The horses of earlier painters had a body, a head and legs too, but only here were these elements seen and contrasted with that clarity which Marées demanded in the depiction of trees, in which the first impression made by the picture had to be that of a primitive relationship of the roots, trunk and branches to each other. Only now does one know what a face, an arm, a foot are. It is true that there is a doctrinaire strain in Dürer which invades his art, but even the most inconspicuous outline drawing

in his book on proportions could not be replaced by the most perfect nude of an artist like Jan van Eyck. His approach is conditioned by the urge to understand a figure completely, and this must be acknowledged as an innovation made by Dürer and the sixteenth century generally.[176]

I call Dürer's art one of representation, in contrast to Grünewald, for example, whose art was above all an art of expression. Dürer's mood was always objective. He never forgot himself, never rose to spontaneous expression, he entirely lacked the necessary intoxication of feeling. A strange discussion would have occurred had he ever met the master of the Isenheim altarpiece, who made everything subservient to expression and who did not hesitate to distort correct representation in favour of a stronger emotional effect. Dürer was modest and always most willing to acknowledge other artists' merits, yet it is very probable that Grünewald would have filled him with horror, just because he would have recognized this 'violent' artist's power. He could have phrased himself in a way similar to that of the old Cornelius when speaking once to Riedel: 'You have achieved what I have tried to avoid all my life.' Only Dürer would have said it without Cornelius's self-assurance.

Every individual figure in Dürer's work is so full of details, so important in itself that one can well understand how it was given an individual place in the artist's imagination and did not easily combine with others. For Dürer it did not seem obvious to start with a concept of the whole composition and develop the details from this. If an overall scheme has been decided on at the beginning, the details usually take on so much independence in the course of the work, that the whole nevertheless looks brittle and laboriously pieced together. This is the strangest aspect of Dürer's art. One cannot say that his imagination did not provide coherent pictures. The pen drawings for the *Life of the Virgin* show how clearly he visualized scenes as *ensembles*, and the sketch was not discarded when transferred to the woodcut. Early paintings like the Paumgärtner altarpiece and the *Adoration of the Kings* also show the same self-evident cohesion between details and overall design. But as soon as Dürer modelled forms more carefully they became separated from their context. It is true that there always is a higher unity, but it does not become properly effective. This is the case with the triangular relationship of the figures in the *Jealousy* and later with the *Rose garland* picture and the Heller altarpiece. Even a single figure becomes separated into head, hands and feet. This is shown clearly in the Heller altarpiece where all Dürer's mastery was not enough to fuse the individual limbs with the figures and create a completely life-like impression. Thus it is particularly to be regretted that Dürer did not paint the late picture of the Madonna with many saints. It would have been the one picture of Dürer's which—through its great rhythmical cohesion—would have possessed that life-giving beauty which is the

necessary result of a confluence of abundant and freely developed individual existences. The late narrative pictures have similar merits but cannot be taken into consideration because of their smallness. But the development is obvious. Only in the last years of Dürer's life can one say that he completely overcame the prejudices of a small workshop and developed his perception so that he could present every detail without becoming narrow.

Critics have tried to explain the often more constricting than liberating effect of Dürer's art through his excessive dependence on the model. They say he could not draw the smallest corner of a garment without a model and so had to rely upon the laborious piecing together of fortuitous studies. Was it surprising that he lacked a comprehensive vision or that his approach retained an element of difficulty?

Expressed in this way the contention is likely to lead to misunderstandings. Was Dürer, the draughtsman of the prayerbook, not able to depend on his own imagination? It is true that the relation between the model and his power of invention sometimes seems unbalanced. It is impossible to tell whether it is a lack of self-assurance or devotion to nature which makes him fall back on old studies from life to use even for minor features—for example, the brushwood in the engraving of the *Knight, Death and the Devil*—rather than invent something to fit the occasion. It is obvious that the freshness of any picture based on imagination suffers from this procedure. But Dürer did have his own vision, the 'secret treasure trove' was full. Much as he clung to nature, he could get on perfectly well without her. I do not think that any similar case is known in art history. It is true that Dürer drew draperies after a model with the most painstaking care, but then again he abandoned himself to the guidance of his imagination, and one cannot tell the difference. At any rate when he drew fluttering draperies he had to rely on his own conceptions. The same man who seemingly constructed his pictures figure by figure, with little help from any imaginative faculty, designed the most complicated scenes without hesitation. It is surely significant that there are so few compositional sketches, that is, so few preliminary versions evolving an idea for a whole picture. Dürer did not need long to grope his way to the picture he had in mind. He could visualize it clearly straight away in all its details. And finally it was his lucid imagination which enabled him to draw from nature with that wonderful assurance which needed no corrections, and possibly even to surpass the preliminary drawing in the design on the copper plate.

We always associate Dürer's style with crisp, curly features. The question is, did he see objects like this or did he intentionally make them curly? There is no such thing as objective perception, and when two people draw the same object the two pictures which result are

different from each other—everyone sees according to his temperament. These are well known facts. But they are not sufficient to explain the phenomenon in Dürer's case. With him we have to get used to an idea of what a picture should be which has become completely alien to us. His style is not the product of an inflexible perception, but of a conscious intensification, trimming and transformation of natural forms. There are drawings by Dürer which prove conclusively that he was capable of seeing nature with an astonishing lack of stylistic prejudice—they have a perfectly naturalistic effect. But naturalism lost its relevance for him as soon as he was dealing with a painting and not a study. He stylized most in the woodcut, whose relative poverty seemed to make a fuller, more decorative treatment of line necessary. Here he made the shapes most curly and incorporated his own adornments and decorative passages into the compositions with the least hesitation. He was more reticent where engravings were concerned, but even there he thought that he had to intensify the lines if he wanted to keep in step to a certain extent with the impression nature made. And the drawings provide further evidence of how his linear treatment varied according to material and degree of finish. The most objective impression is given by the detailed watercolour and gouache studies. One would think that Dürer might at least have acknowledged a kind of obligation to naturalism in his paintings, but again this is not so. Here, too, Dürer varied his treatment according to the subject. Sometimes he gave more, sometimes less, but perhaps he never equalled the perfect colouring of his best drawings. In any case, again and again he fell back unexpectedly on completely unpainterly devices, as if he had never known anything of the way colour behaved in nature.

This must be kept in mind if Dürer's style is to be considered. Only on this basis could one deal with the further question as to whether and how far Dürer stylized facial expressions and gestures.

The problem of beauty

When Dürer died his contemporaries knew that not only had a great artist passed away—they thought that he had been the greatest since classical antiquity—but also that he had given a new meaning to the very concept of an artist. Dürer had thought of himself as a kind of steward of all things visible. He had set his own tasks—independently of the restrictions of craft and the tradition of patronage—and had opened up undreamed-of vistas of the possible ways of representing the world. But his contemporaries were most impressed by his theoretical foundations for painting. This was the main point in all the eulogies. Camerarius, who gave a good and objective appreciation of the master in his Latin edition of the book on proportion of 1532, put forward as the highest praise in his characterization of Dürer that he 'had raised mere practice (*usus*) to the level of a scientific system again (*quod ad artem et rationem usum revocarat*)'. This, he said, was something new for the north; up to then nobody could tell why a work of art was good. Excellence should be won from scientific insight, not by lucky chance (*magis scientia quam casu*).

For Camerarius this surely meant above all the scientific handling of perspective. For us perspective construction is no longer exciting. We have known for a long time that its rules are encased in textbooks. We grew up with perspective vision, and the artist—if he uses construction—uses it merely to check his intuitive feeling. But in Dürer's time it was a problem of the utmost importance. The discovery of the pyramid of recession at once gave drawing a different significance: it became mathematics. Dürer was full of enthusiasm for the science of perspective. His words still convey all the joy in the discovery by a generation which learnt to understand painting as a soluble problem of applied geometry.

People also spoke already of legitimate relations of light and shade, and there was even talk of the theory of colour.

But meanwhile, the most important was that which could be grasped by measurement. Geometry ruled the spirit of that time. To be able to measure things meant to be able to understand them. In painting measurements were needed not only for perspective, in order to understand the law of illusion, but also for the proportions of the objects to be represented. 'All created things are determined by number, weight and measurement.'[177] Dürer was a natural geometrician. No history of mathematics can pass him by.[178] He approaches even the complicated organism of the human body with the eyes of a geometrician. He is only content when he has enclosed form in lines which can be defined with precise mathematical calculation. It is not surprising that he even-

tually proceeds like an architect and draws the body following Italian models in superimposed cross-sections, like an architectural survey of a tower. He thought that making measurements kept its high educative value, even if it was not applied in the practice of painting. The main point for him was obviously that one was forced to give a perfectly clear account of one's conception of the human body. But he would hardly have occupied himself with this problem at such great length if he had not had a second aim in mind: to discover the proportions of the beautiful human body. This is the other side of his theoretical researches and for Dürer it was the more important one. His main literary work was dedicated to it.

Leonardo was the first to say that painting was a science and he indeed possessed a knowledge of the nature of form and its appearance which was unequalled by any of his contemporaries—including the scholars. But it is characteristic of the whole of the Italian Renaissance that from the very beginning art was accompanied by theory. This started with an investigation of the geometric solids and perspective and above all tried to set down a theory of the principles of optics. It then advanced to a comprehensive synopsis of the possible forms of structure and movement of the human figure and went as far as the problem of the ideal figure, that is, it tried to establish the measurements for the normal human proportions (at first only for the male figure). The well-known names connected with this are Leon Battista Alberti and Leonardo.

Dürer must have learnt about these researches in Italy, although Alberti's treatise on painting and 'de statua', which deals with proportions, only existed in manuscript, and nothing at all by Leonardo had been printed. It is thought that Leonardo's friend Pacioli was the intermediary. In any case, when Dürer returned from his great journey, one of his favourite schemes was to produce something similar to the Italians and to provide a comprehensive exposition of everything that belonged to painting under the title of *The Teaching of Painting* or *The Apprentice-Painter's Fare*. There are notes which at least indicate the chapters: on the proportions of the human figure; on the proportions of horses; on the proportions of buildings; on perspective; on light and shade; on colour. Another chapter on composition (on arrangement in paintings) was added elsewhere and in a very comprehensive plan it was intended to include the whole natural history of an artist, how he originated and was educated, how and where he worked best,[179] what art meant to him and to the world.

But Dürer did not seriously adhere to this extensive plan for any length of time; his interest soon became concentrated on the questions which concerned proportions, and after 1513 it was clear that first of all a work on proportions was to be published. But it is not until 1523 that we hear of a manuscript that was ready to be printed, and even then, when everything seemed to be in order, the publication was post-

poned and Dürer published first his book on making measurements (1525). He called this *The Teaching of Measurements with Compasses and Ruler*. It was meant to prepare the ground methodically for the main work. Dürer said it would be superfluous for anyone who knew Euclid. Besides a selection of problems of applied geometry it contains his theory of beauty in letters, designs for monuments, etc. It took yet another three years before the promised main work was published. Previously, in 1527, the treatise on fortifications had been completed, and when the printing had at last started Dürer died during the process. His general aesthetic ideas, which he had once planned as an introduction to the general manual on painting, were now included at the end of the third book.

The concluding passage of the work shows that his plan had not been entirely abandoned. A postscript confirms that Dürer still wanted to write a great deal which would have been 'useful for the art of painting, of landscape, of colour, etc.' Above all, it had been his intention to deal extensively with perspective.

Besides the published works we have fairly extensive manuscript material from his preliminary researches. It shows how extremely difficult it was for Dürer to make himself articulate and order his thoughts. He calls himself an amateur. But in spite of all his awkwardness there are individual phrases of the most astonishing power. Unfortunately the freshness of his first notes has not always been maintained in the book's text.

'When we ask how to make a beautiful picture, some will say: by following the judgement of men. Others will not give in and neither shall I. Without definite knowledge who can tell us with any certainty?' These words from the theory of perspective show what tormented Dürer. He searched for a beauty which would be independent of men's 'opinion'. Mere delight meant nothing, beauty was something which one ought to be able to 'prove'. Human judgement varies, one man likes this, another man that, but true beauty convinces everyone, like a mathematical theorem from which one cannot escape.

This Platonic idea of beauty had cast a spell over Dürer. It was a great, happy revelation to him when Jacopo de' Barbari first hinted that there was a formula according to which the perfect human figure could be constructed. He was seized by such passionate desire to take possession of this beauty, that it may well be believed that he had longed for it in his heart for some time, but only now became conscious of it. However, Barbari's information was fragmentary. Dürer turned to Vitruvius for advice, he tried out various possibilities himself, and at times he may have thought he had discovered the secret, but the idea of beauty changed under his hands. The Adam and Eve of 1507 are different from the Adam and Eve of 1504. Dürer became doubtful and uncertain and eventually grew resigned: he accepted that it is

impossible to attain the whole truth—the highest point we can reach is to recognize the harmony of forms in the individual shapes of an infinitely abundant nature. Our concept of beauty must lie within the sphere of reality, and any speculation on the ideal form will lead to bottomless depths. As early as 1508 there is a drawing of a heavy, fat woman in the Dresden sketchbook (edition by Bruck, pl. 79) constructed according to arithmetical relations. Obviously Dürer could not decide to deny types like these their aesthetic right.

His manner of determining proportions changed. At the beginning Dürer used geometric constructions with circles and rectangles which in parts even coincided with the contour lines of the figure. Then— after the great journey—he began more and more to make only measurements of lengths on the body, horizontally and vertically, and to leave the formative lines between the fixed points to be filled in at will. But the power of conviction suggested by simple numerical relations disappeared proportionally as Dürer became more precise and tried to come into closer contact with reality. In the work on proportion he operated with a double method, with various fractions of the overall length and also with the unit of one-sixth of this length, according to the method Alberti had adopted. On the basis of these two methods five different types of figures are set up in the first book. They are very different from each other and include the extremes of the very fat and the very thin. The second book has another eight men and ten women (constructed according to the second system of measuring) which are only partly identical with those of the first sequence. Anyone was allowed to choose according to his taste. Dürer did not present even the extreme cases as caricatures, but assumed that even they would find their fanciers, although he personally found the fat extreme rather more sympathetic than the thin one. And again he did not think that the types he had selected exhausted the sum of possibilities; intermediate versions were easily conceivable aesthetically, apart from those 'individual variations' which led to merely characteristic images.

But all his constructions are based on the same principle: harmony of the parts. Dürer called it 'matching'. It was of prime importance that the limbs 'matched well' or 'rhymed well together' in their various combinations. With this Dürer took up the great Renaissance pre-occupation with the uniformity of organisms which Alberti had already envisaged. When it is said that Dürer was not concerned with aesthetics but with natural science, with a morphology of natural organisms, in his work on proportion, this does not imply contrast: art and nature coincide. And after all his statement, 'Art is truly in nature—he who is able to extract it, possesses it', is nothing but an expression of the common Renaissance belief that nature was *the* exemplary artist. 'Art' in this context means regular beauty. The Italians found it easy to perceive it in nature and represent it in art; for the northerners it meant a hard struggle.

286

'Different objects can be seen to possess great similarities.' A common law of form holds together even widely different types of one species. Dürer occasionally used the example of the dog. There is an infinite number of different dogs, but all remain within one species and are always different from a fox or a wolf. Men and women too are fundamentally different and yet are of the same genus. Dürer thought that he could point up the differences by varying his examples methodically. But for him the main task of the modern, scientific artist was to show the way things 'matched', the regularity pervading all forms.

But Dürer did not go as far as to claim that beauty only rested in this similarity, whereby no figure could be said to be more beautiful than any other and that essential beauty could only be shown in a group of figures, not in an individual one. Neither his words nor his works allow of such an interpretation.

It is true that Dürer renounced any attempt to arrive at absolute beauty and was content to show that there were common proportions in different forms. But this does not mean that he abandoned the permanent demand for a model of ultimate beauty. This was constantly effective as an invisible centre of gravitation. 'I shall hold him to be the greatest master who can truly show me how to make the nicest picture' (= the most beautiful figure) (LF.253). What we want to know is 'what is the right proportion and no other' (LF.222), but this 'is not given to man to understand, there is darkness deep within us, as God alone knows . . .'

When Dürer demonstrates possible variations in the drawing of a figure, he sets out from a standard type and in the same way he asserts, also in his writings, that neither a pointed nor a flat head is beautiful, but only a round one. Thus a 'peasant' body can show a consistent form but it is obvious that an 'aristocratic' body is aesthetically superior to it. The problem of beauty remains the central problem, even if it can only be solved in an approximate fashion by man.

Dürer suffered immensely from the fact that aesthetic judgement varied so much. Others did not like what he liked. Why was there no unity in judgement? He comforted himself with psychology: not all men see equally clearly, the artist must have the right to determine what is beautiful. But he immediately warned against self-conceit and against arbitrary judgement: 'Many people can see more than one man alone.' There are moments when Dürer declares, directly contradicting himself: 'We want to make what the majority of people think beautiful.'[180]

The fallibility of judgement is a general human predicament. Dürer had experienced it himself—he was not even sure of his own judgement. His appreciation of beauty had varied in different periods of his life. God alone could perceive things clearly. Dürer presumably adopted this Platonic statement from Pacioli. 'And he to whom He would reveal it, would know it too', he added with a biblical turn of

phrase. But our judgement is so confused that we do not even know how to distinguish between what is beautiful and what is more beautiful, let alone imagine the ultimate degree of beauty. There is no human figure of which it could be said that no higher perfection could be imagined.[181] The ideal cannot even be conceived in the case of the lower species, let alone mankind.

'Beauty—I do not know what it is' is thus Dürer's ultimate confession.[182] We have to rely on an approximate knowledge only. But should we 'abandon our desire to learn' because we cannot achieve the very best? No. A man can follow either a good or a bad example, but a man of reason will choose the best possible.

But Dürer was also now certain that beauty could only be developed on the basis of existing nature. All invented constructions are worthless. Nobody can produce a beautiful figure out of his own imagination. This is why Dürer urgently insists: 'Do not swerve arbitrarily from nature's path, thinking you can do better yourself; you will only be led astray.' And further on he says the same again: 'Never consider that you could and will improve on the living force with which God has endowed His own creations. For your powers are helpless before His.'

Beauty, such as God wanted it, has become dispersed in nature, but it is contained in it. The good features have to be gathered together; seldom or never do we find a man who is perfect in all his limbs. The beautiful features of many well-shaped figures should be taken and a praiseworthy work will result. But all the parts of the body have to fit together evenly. Dürer calls this process of choice the 'extraction' (occasionally even the 'pulling out') of beauty from nature. So he again comes back to the fundamental statement: 'Art is truly in nature—he who is able to extract it, possesses it.' In any case, to understand Dürer fully one has to distinguish constantly between that part of beauty which can be grasped in terms of geometry and that which 'cannot be proved by geometry' (LF.226). The diagrammatic figures demonstrating proportions are in no way beautiful. They only contain the structure which has to be filled in with 'beautiful nature'. 'The human body has a great number of lines which cannot be drawn according to any rule' (LF.223). 'What strange curves are found in the head alone. They have to be observed with the utmost diligence.' Here the artist has to rely on mere intuition. Practice is important. He must have seen and drawn a great deal to be able to master the more beautiful forms. In the case of the kind of beauty which cannot be grasped with the help of geometry it is especially important to follow reality, but discerningly, by following 'what is attractive', i.e. beautiful nature.

Ultimate beauty is inaccessible to us, but even the beauty which is materially present is so great that man can hardly comprehend it. 'Although we cannot speak of a living creature of perfect beauty, yet we find so much beauty in the visible world that we cannot grasp it all and not one of us can express it fully in his work.'

Dürer does not maintain that there are figures in nature which correspond exactly to those in his work on proportions. His construction may also be faulty and deviate from what is feasibly truthful and beautiful: another man may improve on it. But he thinks he may rightly claim the fame of being the first in Germany to deal with such topics and of having achieved this without a model or master.

Modern artists will dismiss this concern with proportions. They will object that there can be no fixed system of measurements for the making of beautiful figures, as these measurements have different effects according to different surroundings, and they are certainly not effective throughout the varying positions of the model. They will further say that Dürer's natural feeling must have been defective, otherwise he could not have spent years constructing such phantoms on paper. Had he really been moved by the beauty of the living body he would have left us a few real pictures instead of this collection of puppets. And to the uninitiated Dürer's theoretical endeavours will generally be seen merely as the expression of senile impotence.

This final reproach can easily be proved wrong. Dürer battles with the problem of proportion just during his periods of highest productivity. Apart from the high tide of creative endeavour which set the book afloat after the journey to the Netherlands, most of the studies on proportion centre round the years 1503–4 and 1512–13.

The big difference between the work at the beginning and the continuation is that in the beginning the constructions are immediately transposed into artistic images, while after the Madrid panels of *Adam and Eve* of 1507 theory and art remain definitely separate.

But it would be to misunderstand Dürer entirely to think that in later years he found this question to be merely of theoretical or, let us say, anthropological interest. For him the problem of beauty always remained the central problem of art. We admire exclusively his talent for rendering individual features, the power of description he brought to reality, and we have been conditioned to make no other demands on art at all. But for Dürer this was only one side of art, in fact only the preparation for the other, higher task: to represent perfection. He saw this perfection above all in the beautiful human being, but he also worked on the proportions of the beautiful horse and there were in principle no limits to his researches: he would even have had to recognize the proportions of plants. The longing for ideal types of men and women pervaded his youth. Later this concept became less exclusively important, but the fire continued to smoulder and Dürer was not content until he had formulated his researches into beauty in the *Four Books of Human Proportion*. But he never regarded this theory as more than a manual for artists. He himself no longer had any need for it, but he wanted to publish his results so that a greater artist, coming after him, would find the path prepared.

Surely there is an inconsistency between art and learning here. No one familiar with the history of art will concede that the search for definite proportions is in itself an inartistic undertaking, as modern antipathy would have us believe, but anyone with a more vivid feeling for the human body would not have been content with the stiff figures of a text-book. Presumably they were done in contact with nature: Dürer talks of a considerable amount of measuring from the living body. Here and there the model's forms seem to survive in the drawing, as in the woman with the coif, or a margin sketch might have been drawn during a break from modelling, but Dürer never took so much pleasure in the human body as Mantegna or Signorelli did, showing it in all the glory of full and strong movement. He did not follow up the experiments of his youth. Why did he not paint another Hercules in movement, instead of only an Adam with a concealing twig and a *contrapposto* pose? His concern with movement disappears behind his interest in the structure of the body. Dürer's knowledge of form was great enough to enable him to sketch all kinds of nude figures without difficulty, freely following his imagination. There were figures in movement too; one need only think of the pen drawings of 1514–1516; yet no limb is drawn in such a way that a joint's tension electrifies the onlooker. Here the limits of Dürer's talent are clearly felt—it always was somewhat constrained.[183]

But one does not do justice to Dürer's work on proportion with mere studio argument. Its historical importance lies in the fact that it searches for regular relationships in natural organisms and looks for beauty in this regularity. The Middle Ages had not acknowledged any beauty in nature. All natural forms were considered senseless or imperfect. It was the Renaissance which introduced the concept of the *ratio naturae* and applied it straight away to aesthetics by believing that all beauty had its model in nature. The artist had to create forms in the way nature created them if he wanted to attain harmony. The natural perfection of creation was the most profound conception of this epoch. And by learning to understand the necessity of the overall coherence of single parts, artists arrived at the concept of harmony which Alberti revered as the ultimate level of beauty in which no detail could be changed without destroying the whole. Today we would call this the necessity of organic structure. This was the basis on which Italy developed her wonderful art, and the same idea came to life in Dürer's mind.

He gave German art new eyes and a new heart. But I think that, if he had been asked what he considered to be his true legacy, he would have seen it in his discovery of the idea of a creative art which 'tears' the hidden harmonies from nature and, without abandoning the foundations of reality, and yet going beyond it, reveals the image of beauty.

Notes

1 H. von Stein, *Entstehung der neueren Asthetik*, 1886, p. 70: 'ces choses—(the many remarkable new insights) ces choses sont hors de l'homme, le style est l'homme même.'

2 Letter to Pirckheimer of 7 February 1506. He praises Giovanni Bellini and continues: '... and I do not like that thing any more which I liked so much eleven years ago. And I would not have believed it if anyone had told me, if I had not seen it for myself.' This can hardly concern anything but some matter of art ('that thing' being used without any pejorative overtones). Dürer states a change of taste concerning something which was obviously in Venice.

3 The expression 'to yearn for the hot sun' which sounds remarkable to us, living in an epoch of people longing for Italy and the sun, is no individual phrase of Dürer's. It was used like an adage and had a very general meaning.

4 cf. Heidrich, *Dürer und die Reformation*, 1909.

5 Dürer, *Schriftlicher Nachlass*, ed. Hans Rupprich, Berlin, 1956. *Gedenkbuch*, pp. 36 and 37.

6 cf. Waetzoldt, *Dürer's Befestigungslehre*, 1917.

7 The calm, solemn portrait in the Munich Pinakothek, which belongs within the context of the Venetian works and is obviously later than 1500, which has been suggested as a date, determines our conception more than is fair. It is such a solemn, festive portrait that it is difficult to recognize the ordinary man working in his workshop, to say nothing of the fiery creator of the *Apocalypse* or the boisterous correspondent in Italy.

8 The inscription says: 'I painted this after my own appearance when I was twenty-six years of age. Albrecht Dürer 1498.' Thus the picture must have been done towards the beginning of the year 1498.

9 The back of the picture carries a double coat-of-arms: the open door, recalling Dürer's father's home in Hungary (Ajtos=Tür, i.e. door) and a jumping buck, the coat-of-arms of the Holper family. This implies that the preserved portrait was one half of a double panel, the other half portraying Dürer's mother.

10 cf. Warburg, *Dürer und die italienische Antike* (*Gesammelte Schriften*, 1932, I, p. 443ff.). He specifically points out that the intensified expression of pathos belonged essentially to the concept Dürer's time had of 'classical antiquity'. Cf. Panofsky, *Dürer's Stellung zur Antike* (*Kunstgeschichtliche Einzeldarstellungen*, 1922).

11 cf. the candelabrum in Schongauer's *Death of the Virgin*. In particular the baluster-like swellings and strong joints along the stem are modern (i.e. for that time). Compared with Gothic art they show a basically new conception of form.

12 v. Oechelhäuser, *Dürer's apokalyptische Reiter*, 1885.

13 Anyone who has seen the illustrations in Schedel's *Weltchronik* (1493) knows what an important part fire, blood and similar phenomena play, and how well prepared the public was to judge such representations according to their graphic quality.

14 A drawing of 1497 in Berlin shows a closely related type of a sombre, magnificent figure of a lute-playing man with mighty wings.

15 For the subject and its meaning cf. Franz von Juraschek, *Der Todsündendrache in Dürer's Apokalypse* (*Jahrbuch der preussischen Kunstsammlungen*, 1937).

16 There are seven between 1495 and 1500: the *Martyrdom of the ten thousand Christians, Hercules* ('Ercules'), the *Rider and the mercenary*, the *Men's bath-house*, the *Holy Family with the hares*, the *Beheading of St Catherine*, and *Samson and the lion*.

17 E. Panofsky, 'Herkules am Scheidewege', *Studien der Bibl. Warburg*, vol. XVIII, Leipzig, 1930, p. 181ff. Panofsky also thinks that Cacus, whom medieval mythology called *duplex*, has been boldly represented by Dürer as a double figure, back to back.

18 In the notes for the introduction to the great book on art. Rupprich, op. cit.

19 At first the new perspective was justifiably taken as one possibility among others, not as the only correct one.

20 I wonder whether this head is not a self-portrait of Dürer?

21 This is at least how Zeitblom conceived it, in his painting in Nuremberg, which Dürer copied, leaving out John and Mary Magdalen. The woodcut is not altogether clear.

22 The family of the donor, which was uncovered in 1925, shows the kneeling figures of the goldsmith Albrecht Glimm with two sons, opposite him his first wife Margareth Holtzmann, who died in 1500, and one daughter. Other members of the family who were added later have been removed during the restoration of the original version.—The related picture of the *Lamentation* in Nuremberg strangely enough already shows in the movement of the figure of Christ a definitely classical type, which did not yet exist in the *Green Passion* of 1504. At the same time traditional motifs are used (Magdalen). The grouping is loose and the way in which the figures are set in the landscape is very strange.

23 The collections of the Veste Coburg and the Berlin Kabinett possess contemporary drawings (W.315 and 316). Both may be considered preliminary studies to the *Calvary* grisaille in the Uffizi in Florence. They were also used in the preliminary work for the altarpiece of Ober-St-Veit, as Winkler has established. *Jahrbuch der preussischen Kunstsammlungen*, 1929, pp. 155 and 159.

24 cf. for example the *Venus on a Dolphin*, dated 1503, Albertina, W.330.

25 One can also see the central point of the construction in the upper part of the arm of the standing woman.

26 Heidrich carefully examined the chronology of the *Life of the Virgin* in *Repertorium*, vol. XXIX, p. 227ff. He even thought that the sheet could only have been designed after the Italian journey, around 1507. The *Adoration of the Virgin* at the end, however, must be one of the early, not the late sheets.

27 Single sheets were of course independently available long before the edition in book form—just as the finished parts of the *Passion* were already in circulation.

28 Dürer's conception still shows a strange lack of feeling for architecture: at a later stage he would have thought the narrowing sides of the arch indefensible. The same applies—in the case of the *Lying-in Room*—to the traditional arch which has no (visible) support at all.

29 Joseph even repeats (with characteristic corrections) the figure of the Jew seen from the back in the *Ecce Homo*.

30 In the coloured preliminary drawing in Berlin (W.291) these things are still treated in a simpler fashion. The boards are a subsequent addition in order to break down the overbearing verticalism of the picture.

31 The landscape drawing in Erlangen is a free copy after the woodcut by a draughtsman of Schongauer's circle. But Dürer surely utilized certain memories from his journeys. The study for the whole composition in Vienna (W.293) shows a specifically Bavarian-Tyrolean mountain house, which was left out in the woodcut.

32 In the foreground the second support is missing; it is not visible—probably because Dürer followed the belief that intersections enhance the illusion of space.

33 The man near the pillar in the foreground was obviously taken over from Mantegna, who had shown one of the Apostles clasping a pillar at the side like this in his fresco of the *Assumption of the Virgin* in the Eremitani chapel. Illustrated in Kristeller, *Mantegna*, p. 91.

34 This title is based on the original text of Chelidonius.

35 A second version in the Louvre (W.297) was first published by H. A. Schmid, *Jahrbuch der K. K. Zentralkommission*, 1909.

36 The head is similar to the head of the woman in the middle in *Jealousy* which—according to its technique—must be contemporary. And it is remarkable that both incorporate Leonardesque motifs.

37 The study from nature for this landscape still exists. It is a coloured drawing in London (W.115). The engraving is valuable in that it makes it possible for once to determine the date of one of these watercolours with greater exactness. It is true that the use of the same motif alone would not prove that the engraving must

have been done after this particular study from nature, but there are so many accidental features, such as the cloud formations, which clearly correspond, that it is impossible to deny that one is directly dependent on the other.

38 The figure of Cima's *St Sebastian* is taken from the large altarpiece in the Accademia in Venice which was commissioned by a certain Dragan, as Rudolf Burckhardt has shown. According to Burckhardt's chronology Dürer may well have seen it in Venice. The motif at least could with certainty be dated 1495, because of a corresponding figure of St Sebastian shown by moonlight in the picture in London, which belongs to the centre panel of the *Annunciation* in Leningrad which is dated 1495 (Burckhardt, *Cima da Conegliano*, p. 143). The figure is obviously related to a typical movement found in Perugino, but Cima must be considered as the artist who received, not the one who influenced. Perugino had been in Venice in 1494.

39 Only a dilettante could interpret Schongauer's bare trees otherwise than as a decorative play with lines, inspired by the same feeling that rendered angular bodies and brittle draperies. A leafless tree was considered more beautiful than a tree in full leaf. It is a serene addition to the scene showing the Madonna in the open air, and in the case of the Crucifixion the simultaneous use of globes of leafy trees in the background proves that the artist did not want to indicate a particular time of year. Cf. Fritz Zink, *Die Passionslandschaft in der oberdeutschen Malerei und Graphik des 15. und 16. Jahrhunderts*, 1941 (*Würzburger Studien zur Kunstgeschichte*, I, p. 118).

40 It is possible that they are the Graces after all, which appear in Pirckheimer's couplets and are there equated with the Horae in their number.

The letters O.G.H. have been explained in a number of very different ways. Sandrart (*Teutsche Akademie*, II, 222) says that some people think they stood for '*O Gott Hüte*' ('O God, guard', i.e. guard us against witchcraft).

41 The *Women's bath-house* was presumably meant to be transferred to the wood block, but only an inferior copy of one section exists. It cannot be considered as the formal counterpart to the *Men's bath-house*.

42 G. Pencz, who revised the motif in accordance with the ideas of the younger generation (B.93), took into account those aspects to which classicistic taste could object.

43 cf. Panofsky, 'Herkules am Scheidewege', *Studien der Bibliothek Warburg*, vol. XVIII, Leipzig, 1930, p. 166ff.

44 It is interesting in this respect that the coiffure and headdress of the standing woman show north Italian and specifically Lombard motifs which were not there in the study.

45 The heavily damaged picture is dated 1500 and thus provides a *terminus ante quem* for the last-mentioned engravings. Further evidence for dating the *Hercules* engraving before 1500 is provided by a drawn copy by Fra Bartolommeo. Cf. Knapp, *Fra Bartolommeo*, p. 318.

46 Wackenroder, who did not overlook this connection, touchingly expressed his admiration for this simplicity. (*Herzensergiessungen eines kunstliebenden Klosterbruders*.)

47 The legend of St Hubert tells the same story. The name St Eustace is authenticated for this engraving by a reference in the diary of the journey to the Netherlands.

48 Dürer did not do any more engravings as circumstantial as the St Eustace. He felt himself that format and execution clashed. It is typical for the generation of old Heller (why is he always called old Heller?) that he considered the St Eustace to be the most beautiful of Dürer's engravings.

49 (Nemesis) *Est dea, quae vacuo sublimis in aëre pendens*
It nimbo succincta latus, sed candida pallam,
Sed radiata comam, ac stridentibus insonat alis
—Frena manu pateramque gerit semperque verendum
Ridet—atque huc atque illuc ventorum turbine fertur.
Politian, *Silva in Bucolicon Virgilii pronuntiata, cui titulus Manto* (1498 and elsewhere). Giehlow discovered this passage (*Graphische Künste*, Mitteil. 1902, p. 25f). The general tendency of Dürer's art explains perfectly why he did not base his representation on the idea of being blown about by the wind.

50 Handke, *Die Chronologie der Landschaften Dürers*, 1899, p. 12.

51 A detailed preliminary drawing of the whole is in the Pierpont Morgan Collection (w.333). An immediately preceding drawing of the figure of Eve only in London is identical (w.335). The drawing of Adam (w.422) only followed around 1506, after the engraving. It was used for new researches into proportions.

52 L. Justi, *Konstruierte Figuren und Köpfe unter den Werken A. Dürers*, 1902, p. 7ff. He proves that Eve is based on the same scheme as Adam. Only afterwards do the constructions of male and female figure diverge. Justi was the first to take up this question and find a clear solution to it. After him the material was dealt with successfully once more by Panofsky in *Dürers Kunsttheorie*, 1915.

53 Panofsky has not fully and profoundly tackled this problem. (*Dürer's Stellung zur Antike*, 1922.)

54 Flechsig, II, 167ff. clearly disproved the claim that Dürer's drawing of Apollo in London goes back to the Apollo of Belvedere. Winkler, I, notes on No. 261, has shown that the London drawing originally was a study of proportions after the man with the cornucopia in the *Bacchanal with the vat*.

55 The technique of the engraving seems more traditional than in the case of the Adam. Cranach made use of the figure in the large woodcut of the *Beheading of St John the Baptist*.

56 The peacefully seated woman (Diana) keeps a stag at bay with a negligent gesture. It presses forward, trying to reach the green leaves in her lap. This is obviously an idea Dürer had at the last moment, otherwise the animal would not lie in the picture in such a crushed fashion. The contrast between the plump body of a woman and the arid figure of a man is even more stressed in the *Family of satyrs* of 1505 (B.69), where the mother lies on the ground and the old man pipes a tune to the child between her legs.

57 There is no doubt that the acquaintance with Jacopo de' Barbari was an important experience for Dürer. And even if in his letters from Venice he mocked at the way the Italian was overestimated in Nuremberg, he praised him at other times as a 'good, charming painter'. The evidence of the pictures suggests that Dürer did not consider constructing figures before 1500, that is the year Barbari came to Nuremberg. It is only natural that other cross-currents are looked for only from this time onwards, unless definite features pointing to Barbari will be found in the engravings before 1500. There are points of contact, but even now scholars are not agreed on how significant these are.

58 Allihn, *Dürerstudien*, p. 79ff. This does not of course mean that Dürer did not derive pleasure from a deft peasant face. Cf. the gnarled head of a peasant of around 1505 in the British Museum, w.288.

59 The studies from nature are the pen and brush drawings with watercolours of the *Quarries* (formerly Bremen, w.108, 109). H. Börger kindly drew my attention to this.

60 H. Kauffmann (in *Westdeutsches Jahrbuch für Kunstgeschichte, Wallraf-Richartz Jahrbuch*, vol.X, 1938, p. 166ff.) has recognized and clarified that the wings of the Jabach altarpiece belonged to the *Adoration of the Kings* in Florence. He has also examined the concepts of popular religious feeling on which they were based.

61 The composition of Hans von Kulmbach's *Adoration* of 1511 (Berlin) represents a step forward. The richness of the figure-combinations is very much greater—though clarity does not suffer from this. The imposing architectural motif is another device which makes this early work appear hesitant, constrained and flat in comparison.

62 The place has been definitely identified by Fritz Zink, *Pantheon*, 1942, p. 249ff.

63 Letter to Pirckheimer, 7 February 1506: 'He is very old but still the best painter.' Cf. H. Rupprich, *Dürer's Schriftlicher Nachlass*, vol. I, 1956, p. 44.

64 The *Rose garland* picture was bought in 1606, a century after its discovery, by the Emperor Rudolf II for his gallery in Prague. According to Sandrart (1675) the emperor had the painting —wrapped in carpets and covered with wax cloth—carried across the Alps on the shoulders of a number of strong men, to protect it from being shaken and tossed in a carriage. Later it mysteriously left the possession of the emperor and came into private hands. It ended up—in a much damaged state—in the canonical monastery of Strahow, near Prague. During 1836/7 the

Berlin galleries negotiated with the Abbot Seidler, with a view to buying it. But this plan was abandoned because of a report by the eminent scholar Waagen, who justly stressed the much damaged state of the painting, though he did not take the historical importance of the work into consideration. (Cf. 'Dürers Rosenkranzfest und die Berliner Museen 1836/37.' Ein Briefwechsel, eingeleitet von P. O. Rave, Jahrbuch der preuss. Kunstsammlungen, vol. LVIII, 1937, p. 267ff.) Only in 1935 did the Czechoslovakian state buy the painting for the State Gallery in Prague.

The most reliable information on colours, additions and alterations of the *Rose garland* picture is given by O. Benesch, *Belvedere*, vol. IX, 1930, p. 81ff.

65 This was found by Winkler, *Jahrbuch der preuss. Kunstsammlungen*, 1935. There is a coloured drawing for the Pope's cloak in Vienna (w.401), but it is an isolated instance of a pure watercolour.

66 The slightly different study for the child is in the Bibliothèque Nationale in Paris (w.388). Perhaps there is some influence here after all by earlier Italian painters. Cosimo Tura, for example, drew children's bodies showing similarly exaggerated punctuations.

67 There is a considerable number of drawings, in the Louvre, in the Bibliothèque Nationale, Paris and in Lemberg (w.393–400).

68 cf. the charcoal drawing formerly in Bremen (w.386). Neuwirth, in *Dürers Rosenkranzfest*, 1885, was the first to try and identify the individual heads. Gümbel's attempt, in *Dürers Rosenkranzfest und die Fugger* (*Studien zur deutschen Kunstgeschichte* 234, Strasbourg, 1926), to identify the altarpiece as a donation of the Augsburg merchant family, is unacceptable.

69 The master-builder whose name Hieronymus goes back to an old tradition (w.11). The remaining portrait drawings are of St Dominic (w.381), the praying figure behind the pope (w.383) and the man with the rosary behind the emperor in the Pierpont Morgan Library, New York (w.384).

70 Letter to Pirckheimer, 8 September 1506.

71 Sansovino, *Venezia nobilissima*, 1581, p. 48 V.

72 If the *Adoration of the Kings* of 1504 could be placed side by side with such a Venetian picture, it would presumably be found that the older Dürer had been more 'harmonious'.

73 L. Justi, *Konstruierte Figuren und Köpfe unter den Werken A. Dürers*, 1902, pp. 13, 19. The construction itself is lost and only in parts is there a similarity with other known systems of proportion. The proportions already changed in Italy; this is proved by the studies of proportion for the figure of Eve in London (w.425, 426) dated 1506. It can be clearly traced how Eve's bosom was at first constructed on the basis of a square (*Dresden Sketchbook*, ed. Bruck, pl. 70), then, in the drawings of the nude in Berlin (w.413) and London (w.411), on the basis of an upright rectangle. Cf. also Flechsig, II, p. 144ff.

74 How Dürer came to represent this gesture is shown by the related drawing of a man in the Bonnat Collection (w.332), done already around 1504. The position of the limbs is basically the same; the raised hand holds a club, the lowered one grasps the edge of a shield.

75 As a painting it was only finished in 1518 (Munich). The drawing for the changed position of the arm (w.435) may already be dated 1508.

76 The same signature (*germanus*) is on the Heller altarpiece and earlier on the painting of Eve and the *Rose garland* picture. It is significant that the *All Saints* painting is the first where he signs as Noricus again.

77 The colours of the copy must be questioned. The Paumgärtner *Adoration of the Christ-Child* at least (in the same collection) shows a wholly arbitrary use of colour. The reproduction fails to show up the importance of colour. St Paul should stand out in glowing white.

78 For an extensive description of the whole cf. Weizäcker, *Die Kunstschätze des ehemaligen Dominikanerklosters in Frankfurt a.M.*, 1922; H. A. Schmidt, *Matthias Grünewald*, Strasbourg, 1911, p. 75ff. He was the first to recognize that the Frankfurt panels by Grünewald, representing St Cyriacus and St Lawrence, were the two side wings of the altarpiece.

79 There are eighteen drawings. The whole group is assembled in w.448–465.

80 In the introduction to the Latin edition of the book on proportion.

81 cf. N. G. Catalogue, German School, 1959, p. 32ff.

82 Or is it possible that he should have remembered a form such as is found on the windows of the Loggia del Consiglio in Verona?

83 There is a pen drawing of 1515 in Boston (w.583) which has even simpler motifs of head pose and draperies and an even greater spiritual expressiveness.

84 F. Lippmann, *Der Kupferstich*, 3rd ed., p. 53.

85 But it must be admitted that the *Adoration of the Shepherds* (B.20) does not quite fit into this style.

86 An earlier, large drawing of the same subject, done in 1510, is in the Albertina (w.470).

87 The abbreviations stand for the following: L.W.P. = Large Woodcut Passion; S.W.P. = Small Woodcut Passion; E.P. = Engraved Passion; G.P. = Green Passion. They are used in chronological order.

88 A drawing in the Ambrosiana of the *Agony in the Garden* (w.298) shows the same principal motif, except that the disciples are all on one side. It must be a copy of an unexecuted design for the sequence of the *Green Passion*.

89 A drawing in the Louvre (w.584) shows a preliminary stage of this composition. Another in the Albertina (w.598) was done at about the same time (cf. the imploring upward glance). A drawing of 1518 in the Louvre (w.586) already has more affinities with the last *Passion*. It shows the disciples at the edge of the picture.

90 A less accomplished version is an undated drawing in Berlin (w.803), presumably a preliminary study.

91 Preliminary drawings in the Berlin Kabinett (w.301, *Christ before Caiaphas*) and in the Albertina (w.303, *Christ before Pilate*). The study in the Dresden sketchbook only belongs to around 1510 and should not be taken as a first idea.

92 Preliminary drawing in the Albertina (w.305).

93 It has its origins in the Leonardesque studies of profiles, of which the Dresden sketchbook contains important examples (Bruck, pl. 122ff.).

94 There was formerly a large charcoal drawing of a *Lamentation* in Bremen (w.578) bearing a date which can possibly be taken as 1513. It is impressive, but there is no distinction yet between dignified and undignified effects of foreshortening. But Dürer's mastery is already shown in the way the lines of the steps prepare the onlooker for the foreshortening of Christ's legs. The drawing has been largely gone over and might almost be by Baldung.

95 The preliminary drawing for the Resurrection in Brunswick (Blasius Collection, w.485) still has the calm, traditional type of figure showing one leg bearing the main weight, the other free of weight, instead of rendering flying motion. At the bottom there is a recumbent figure on a tomb which Robert Vischer has explained (*Studien zur Kunstgeschichte*, p. 583ff.). The tombs of the Fugger family in the church of St Anne in Augsburg were done after designs by Dürer.

96 Preliminary design in the Ambrosiana in Milan (w.488). Flechsig II, 273 proves that the designs were first of all intended for the ornaments on the tomb of the two Fuggers. The second version of the designs changes everything which could have recalled their original function.

97 Dürer represents the standing figure of Christ only once more, in an insignificant etching of 1512 (B.21). The etching of the seated Christ, of 1515, is also conspicuously slight, like a mere exercise.

98 Even the pen drawing in the Albertina (w.608) —which is usually quoted as the preliminary study for this engraving—is so much less expressive that it hardly deserves being called thus. The small *Head of Sorrows* (w.609) in the Uffizi is more passionate and (if it is genuine) in any case later than the drawing in the Albertina.

99 Weber, *Beiträge zu Dürers Weltanschauung*, 1900, p. 3ff., compiles the older explanations. Lippmann was the latest to put forward the most impressive explanation by pointing to the traditional division of the human virtues into three: the *virtutes morales, intellectuales* and *theologicales*. In Dürer's time these were discussed in Gregor Reisch's *Margarita Philosophica* which went into several editions (Lippmann, *Der Kupferstich*, 3rd ed., 1905, p. 56).

100 The inscription reads: *S. 1513*—S. standing for Salus.

101 cf. i.a. the engraving of the *Small Horse* of 1505 (B.96). As far as formal characteristics are concerned it stands in the same relation to the *Large Horse* of the same year (B.91) as the *Eve* of the engraving to the woman of the *Large Nemesis*. A drawing of a horse in Cologne is even earlier; it was done in 1503.

102 Weber, op. cit., p. 13ff. Cf. E. Schmidt, *Charakteristiken* II, p. 1ff. Wilhelm Waetzoldt ('Dürer's Ritter, Tod und Teufel', *Schriftenreihe der preuss. Jahrbücher*, vol.XXXIII, 1936) gives a vivid description of the spiritual background from which this appropriate picture arose.

103 J. Kurthen ('Zum Problem der Dürerschen Pferde-Konstruktion', *Repert. für Kunstwissenschaft*, vol. XLIV, 1922) demonstrates that the double-sided drawing for the horseman in the Ambrosiana (recto and verso) is genuine.

104 'Di quel di Pavia si lauda più il movimento che nessun altra cosa . . . il trotto è quasi di qualità di cavallo libero' (Codex atlanticus, fol. 147r). The first to interpret this passage correctly was Müller-Walde. Cf. his essay on 'Lionardos Reiterdenkmäler', *Jahrbuch der preuss. Kunstsammlungen*, 1899, p. 81ff.

105 Ephrussi, p. 132f. Dresden Sketchbook (ed. Bruck), pl. 128, dated 1517. The lower as well as the upper figures go back to Leonardo. The tracing technique can be held responsible for the conspicuously unsteady strokes, though it is true that the whole drawing seems somewhat thoughtless. There are corresponding studies for legs and arms (pls. 107, 108, 109) which are partly anatomical; they also are based on Leonardo. (Weixlgärtner in *Graphische Künste*, 1906, gives a more exact account of the original sources.) Cf. Pauli's publication on a horse (of 1503) in Cologne after Leonardo, *Zeitschrift für bildende Kunst*, vol. XXV, p. 105.

106 Weber, op. cit., p. 35. In popular mystical literature a dog usually accompanies the pilgrim. It represents divine fervour and earnestness which should accompany man on his journey through life.

107 A study from nature of 1510 (W.111) was used for the brushwood. Flechsig II, 75 dates the brush drawing 1498; Winkler I, 84, agrees with the early date. But there is no valid reason to reject the inscribed date of 1510, even though it is not in Dürer's own hand.

108 Anyone who looks for gruesome effects will be satisfied by a drawing in Frankfurt (W.161), where a skeleton swoops down from the sky, the horse rears and the rider, who is thrown out of the saddle, clasps the animal's neck. If only one could prove that the drawing is by Dürer! It belongs—together with other related sheets —to around 1500.

109 'I' must of course be taken to be a number. Passavant's curious translation (III, 153): Melancholia i, go away Melancholia! need not be considered. I have published a short history of the various explanations given to Dürer's *Melancholia* in *Jahrbuch für Kunstwissenschaft*, vol. I, 1923. There have basically been three answers to the fundamental question of what is the woman's state of mind, and why she sits heavily and rigidly like this. Some say that all activity has ceased because the woman is depressed and melancholic, others that it has ceased because the woman despairs of the success of her work, yet others say that the woman is not at all dejected and her activity has not ceased either, but that a state of inward concentration, a kind of prophetic vision, is represented. In this view the concept of melancholia disappears completely and the figure is seen as an image of the speculative mind, even of Geometry or Architecture.

It seems impossible to me to regard the woman as anything other than what the inscription declares her to be, namely Melancholia, and I have no doubt that what is represented is not activity but on the contrary the interruption of activity. And if one is to say why activity is interrupted the natural answer is this: melancholic depression prevents the woman from continuing her work. To talk of an insolubly difficult task and resulting despair is to go beyond what is there in the picture for everyone to see. The term melancholia is sufficiently expressive, and this very simple interpretation corresponds exactly to the written passage which must be taken as the picture's source: reason becomes blocked when 'black gall' thickens. Of course Dürer too associated the concept of melancholia

with temperament—he did not merely see it as a mood which could befall anyone. The state of mind shown in the picture is typical of a melancholic, even though it is not his permanent state. The woman is strong and the attack will pass.

110 From an Augsburg calendar of the fifteenth century (Muther, *Buchillustration der Gotik und Frührenaissance*, pl. 34). It has already been quoted by Allihn, *Dürerstudien*, 1871, p. 102, who refers back to Scheible (*Leap-year* I).

111 cf. Giehlow's fundamental comments on Dürer's *Melancholia* in *Mitteilungen der Gesellschaft für vervielfältigende Kunst*, 1903/4. Marsilius Ficinus's work of 1489 was published in German by Grüninger in Strasbourg in 1505, and quickly went through several editions.

112 Marsilius Ficinus distinguishes between two forms of melancholic illness: a benevolent one which passes without doing any harm and a malevolent one which makes the sufferer grow thin and evidently lose his senses. Dürer obviously represents the first, his woman is strong and will overcome her depression. But it is most probable that the number I in the inscription means that Dürer planned to represent the second kind of melancholia as well. One cannot really think of any continuation other than 'Melencolia II', if only because there are no equivalent terms referring to the remaining temperaments. There are only adjectives, such as *sanguineus* which is used in an analogous fashion to *melancholicus*, etc.

113 Warburg, *Heidnisch-antike Weissagung zu Luthers Zeit* (*Gesammelte Schriften*, 1932, I, p. 487ff.).

114 Panofsky-Saxl, *Dürers Melencolia I*, 1923.

115 Agrippa von Nettesheim, *De occulta philosophia*. The quotation is given by Giehlow, op. cit., p. 76.

116 Dresden Sketchbook, ed. Bruck, pl. 131, with the eye above which marks the central point of the construction. Other drawings in the same book also show that particularly at that time Dürer was much concerned with the problems of descriptive geometry. Cf. pl. 134, the first fixed eye piece, dated 1514.

117 The explanation is given on a sheet in London (LF. p. 394). The sketch of a *putto* with plumb-line and sextant on the same sheet also belongs to this context. Giehlow was the first to relate the passage to the *Melancholia* (op. cit.).

118 Drawing for the head in the British Museum (w.619).

119 The birds' wings are directly reflected in the angels of the *Sudarium* (Plate 84). The helmets in the Bonnat Collection in the Louvre (w.177), one of which reappears in the coat-of-arms with lion and cock (B.100), are wrongly dated 1514; they presumably belong to around 1500.

120 The *Holy Family* (B.43) was presumably done somewhat earlier.

121 cf. Schedel's *Weltchronik*, fol. CXXXIX: the evil one carrying off a sorceress on a horse.

122 They are the pen drawings w.668, 667, 666, 622.

123 For the identification of the place cf. Mitius, 'Dürers "Kirchdorf"', *Monatshefte für Kunstwissenschaft*, 1913, p. 245, and Mitius, 'Mit Albrecht Dürer in Heroldsberg und Kalchreuth', *Erlanger Heimatbuch*, 1924.

124 cf. Fr. Zink, 'Die Passionslandschaft in der oberdeutschen Malerei und Graphik des 15. und 16. Jahrhunderts', *Würzburger Studien zur Kunstgeschichte*, ed. K. Gerstenberg, vol. I, 1941, p. 80.

125 Mitius, 'Die Landschaft auf Dürer's "grosser Kanone"', *Mitteilungen des Germanischen Museums*, 1911, p. 141. Only recently the exactly corresponding drawing has come to light which came into possession of the Boymans-van Beuningen Museum, Rotterdam, from the Koenig Collection (w.479).

126 The inscription reads: '*1514 an oculi* (= 19 March). *Dz ist Albrecht Dürer's muter, di was alt 63 Jor*' (this is Albrecht Dürer's mother who was 63 years old), and an addition says: '*und ist verschiden im 1514 Jor am erchtag vor der Crewtzwochen um zwei genacht*' (and she died on Tuesday, 16 May 1514, two hours before nightfall).

127 The horizontal strip seems to be first used in the drawing mentioned (w.563). There are a few precedents for the black background of the same drawing, but only now does it become dominant. Cf. w.564 (1516); w.573, the so-called Hofheimer; w.566 (1517); w.569; and

w.570, Count Philipp of Solms (1518). Cf. Graf zu Solms-Laubach, *Jahrbuch der preussischen Kunstsammlungen*, 1937, p. 184ff. All drawings mentioned are done in charcoal. An exception is a portrait of the brother Andreas of 1514 (Albertina, w.558), which is done in silver-point. Dürer later developed the motif of the flat horizontal strip into a barrier in space behind which the figure, with both arms showing, appears free and powerful: *Henry Parker, Lord Morley*, 1523 (w.912).

128 Among the other Augsburg portraits the head (w.561, Oxford) should be mentioned which was identified by Dörnhöffer as the painter Burgkmair, also the cardinals '*Lang von Wellenburg*' (w.911, Albertina) and *Albrecht von Brandenburg* (w.568, Albertina). Of the last-mentioned drawing Dürer also made an engraved version, his first portrait engraving (B.102). I shall discuss it later on.

129 According to Stegmann (*Mitteilungen des Germanischen Museums*, 1901, p. 132ff.) it is probable that the Nuremberg version preceded the Vienna one. Geisberg ('Holzschnittbildnisse des Kaisers Maximilian', *Jahrbuch der preuss. Kunstsammlungen*, 1911, p. 236) has shown that only one of the four woodcuts goes back to Nuremberg and Dürer's workshop, and even in this case a name like Springinklee as author cannot be immediately dismissed, as the design is so superficial.

130 This portrait of a cleric has gained greater plasticity now the layers of dirt and varnish have been taken off. Cf. Tietze, *Pantheon*, 1934.

131 The inscription repeats the date and gives the name of the person represented and—in an additional note—says that he died in 1519.

132 Originally there was no wall on the plate (Passavant III, 489, cf. Jaro Springer, 'Dürers Probedrucke', *Festschrift für Friedr. Schneider*, 1906); the preliminary design from the Lanna Collection (w.592, Collection Winter, Vienna) does not show it either. There is an earlier design for the figure in the von Nostiz Collection in Dresden, but it is substantially different. Winkler III, 591 and 592, agrees with this view on the relationship of the drawings.

133 The town view incorporates elements taken from Trent, Innsbruck and Nuremberg.

134 Nuremberg castle is represented, as seen from Dürer's house. Cf. Wilh. Funk, 'Die Landschaft auf A. Dürers Kupferstich "Die Madonna an der Stadtmauer"', *Festschrift der internationalen Dürerforschung*, 1928, p. 107ff.

135 The design for the final version is in the Albertina (w.542). Here too a drawing for the Heller altarpiece—for Christ's gown (w.455)—was used for the draperies.

136 I include in this context an undated drawing of a chalice in the British Museum (w.234) which I consider to be the best of these drawings.

137 Dürer's sheets of the prayerbook (1–56), together with Cranach's contributions, are in the State Library in Munich; the remaining sheets, as far as they are known, are in Besançon. The date 1515 on Dürer's drawings was added after his death (as well as the monogram), but it is correct. The Munich fragments have been published repeatedly, most recently by Leidinger, 1923 (together with Cranach's drawings). Giehlow published a comprehensive edition in 1908.

138 cf. Giehlow, 'Beiträge zur Entstehungsgeschichte des Gebetbuches', *Jahrbuch der kunsthistor. Sammlungen des Allerh. Kaiserhauses*, 1899. Leidinger (op. cit.) stresses that the straight lines between the lines of lettering and around the whole text of a sheet merely seem to have served to make the printed page look like a manuscript page. This fact alone makes it improbable that the drawings were meant to be cut. Also they are coloured. And why use precious parchment? According to Leidinger there would only have been an edition of ten copies.

139 The date marks the finish of the drawing, not the cutting.

140 Published in *Jahrbuch der Sammlungen des Allerh. Kaiserhauses*, 1885/6; there also the Triumphal Procession 1883/4. Joseph Meder, *Dürer-Katalog*, Vienna, 1932, pp. 205–223, published the results of an exhaustive examination of the Triumphal Arch for the Emperor Maximilian. He points out Dürer's contributions to the 192 woodblocks of the gigantic work and also establishes the exact characteristics and differences between the five complete editions and the four editions of the historical scenes.

141 The drawing dated 1522 in the Albertina (w.922).

142 The *Four Books on Human Proportion*, 1528, fol. 5v.

143 An edition of the silver-point sketchbook in the original size and the probable sequence was edited by E. Schilling: *A. Dürers niederländisches Reiseskizzenbuch*, with introduction by Heinrich Wölfflin, Frankfurt a.M., 1928.

144 Dated 1520. The number XXIIII presumably states the age of the sitter. Another note identifies the church as St Michael in Antwerp.

145 Karl Justi was the first to draw attention to the picture (*Jahrbuch der preuss. Kunstsammlungen*, 1888, p. 149). The painting had a remarkable influence on the artists of the Netherlands. Julius Held, *Dürers Wirkung auf die niederländische Kunst seiner Zeit*, The Hague, 1930, p. 139, quotes 24 copies.

146 The head is in Berlin (w.789), the studies for the hand, book and skull are in the Albertina (w.790-2). The skull, a splendid example of Dürer's late style, still retains the lower jaw—which makes it particularly expressive. It has to be compared with the skull of the Coat-of-Arms to get any real idea of the new greatness of Dürer's style.

147 There is an inscription at the top margin: '*Der Man was alt 93 Jor und noch gesunt und fermuglich zu antorff*' (this man was 93 years old and still healthy, and probably from Antwerp). Cf. LF., p. 119.

148 For this whole question, cf. Müller and Veth, *Dürers niederländische Reise*, 1918, 2 vols.

149 A drawing of 1521 in Chantilly (w.837) may be mentioned here. It is an earlier design and has only very few figures. It is startlingly asymmetrical.

150 The left figure is St Margaret with the dragon. Is it possible that this figure echoes the impression of an Antwerp procession on Ascension Day where such a figure of a saint leading the animal with a belt pleased Dürer very much? Cf. LF., p. 119.

151 Meder included the engraving in his *Dürer-Katalog* of 1932 (No. 25) among the authenticated sheets.

152 The nude half-figure of the *Man of Sorrows* of 1522, formerly in Bremen (w.886), is related; it too was a preliminary drawing for a (lost) painting. A mezzotint engraving of 1659 by Kaspar Dooms is a copy of it. Cf. F. Schneider, 'Alb. Dürers Tafelgemälde "Barmherzigkeit", 1523, ehemals im Dom zu Mainz'. *Mainzer Zeitschrift*, vol. II, 1907. H. Swarzenski, *Zeitschrift für Kunstgeschichte*, vol. I, 1933, considers as the original a painting of *Charity* in the gallery of Count Schönborn in the palace of Weiszenstein near Pommersfelden, formerly thought to be a copy. H. Tietze and E. Tietze-Conrat II, 2, 1938, No. 895, have agreed with this view. But the feeble drawing, incompetent foreshortening and the stunted arm underneath are sure signs of the hand of a weak copyist.

153 The relationship of the drawing of the Mass (Berlin, w.921) to the woodcut of St Gregory celebrating Mass of 1511 (B.123) is also instructive.

154 A differing preliminary drawing is in the Albertina (w.889).

155 There too is a second, very splendid drawing of 1524 (w.891) where Christ kneels before the angel and throws up his arms. The foreground with a path is vast and empty. The disciples are seen one behind the other along the border of the path and lead up in a solid curve to the principal figure. Cf. a preliminary design for this, a drawing of 1520 in Basle, von Hirsch Collection. Published by Swarzenski, *Handzeichnungen alter Meister aus deutschem Privatbesitz*, 1924, pl. 8 (w.797 following this).

156 The second drawing also appears in a number of grisaille versions (in Dresden, Bergamo, and the best in Doughty House, Richmond). To this can be added a group of women (preliminary study in Berlin, w.893). Cf. *Dürer Society*, vol. VII, 1904 and H. Tietze and E. Tietze-Conrat II, 2, p. 51.

157 The drawing in Frankfurt (w.799), also dated 1521, has a looser structure and less pronounced contrasts and thus must be the earlier composition.

158 This is the case in the drawing of a young woman with a lap-dog (w.914) in the Fogg Museum.

159 It has been conjectured that the picture was only painted after the death of the sitter, which occurred in the same year, 1526. But the inscription '*aetatis suae anno 54*' runs contrary to this.

160 The large chalk drawing from life in the Albertina (w.568).

161 We only know one of the drawings, the one that shows Erasmus from the front, smiling (Paris, w.805).

162 cf. Haarhaus, 'Die Bildnisse des Erasmus von Rotterdam', *Zeitschrift für bildende Kunst*, 1899, p. 44ff. Erasmus was little pleased with the likeness.

163 The tinted prints of this woodcut belong to a later period.

164 Drawing in the Albertina (w.876). Here the model clasps a rod—which does not mean that a figure of St Philip was originally intended.

165 Drawing in the Albertina (w.875): the hands are tightly clasped and the eyes glance upwards, which seems to indicate a figure of St John at the foot of the Cross. Also the treatment does not have the geometrical, stylized drapery folds of those drawings that have been established as the models for the engravings (w.878, w.786). This is why I believe that, like w.859, it was originally a study for the large picture of the Crucifixion, and that it was only incorporated into the Apostle sequence when it was no longer of any use in the other context. Lately, Flechsig II, 378, and Winkler, note to IV, 875, have agreed with this opinion.

166 Drawing in the Albertina, 1523 (w.878). Also w.874, w.877, w.879.

167 The contemporary significance of the pictures has been finally established by Heidrich, as a testimony against the 'fanatics'. *Dürer und die Reformation*, 1909.

168 LF.247.

169 Thausing already noticed the altered silhouette.

170 Drawing for the whole figure with the date 1525 in Bayonne, Musée Bonnat (w.873).

171 Drawings for St Paul and St Mark in Berlin (w.872), for St Peter in Bayonne (w.871). Cf. E. Bock, 'Dürers Zeichnungen zu den Münchner Aposteln', *Kunstchronik*, 1922/3, p. 378ff.

172 Letter from Melanchthon to Georg von Anhalt, 17 December 1547. He talks of Dürer's confession that earlier on in life he had liked best many-coloured pictures with many figures in them and that only in his old age did he start to look at Nature and imitate her true appearance, realizing now that this simplicity was the highest glory of art (*postea se senem coepisse intueri naturam et illius nativam faciem imitari conatum esse eamque simplicitatem tunc intellexisse summum artis decus esse*). There is a similar statement in a letter to Hardenberg, saying that Dürer regretted having been fond of representing monstrous and strange figures so much in his youth (*monstrosae et inusitatae figurae*).

173 Robert Vischer, *Studien zur Kunstgeschichte*, p. 234ff.

174 There are three pieces which could seriously be attributed to Dürer: a small relief of a nude woman seen from the back; a medallion showing an old man who looks like Dürer's father; and another medallion with a head of Lucretia similar to a drawing of 1508.

175 On Dürer's use of lay figures which he took over from the Italians, cf. Arpad Weixlgärtner's essay in *Festschrift für Wickhoff*, 1903.

176 Erasmus mentioned Dürer in his 'De recta latini graecique pronuntiatione'; among other things he stressed the following characteristic of the artist: *ex situ rei unius non unam speciem sese oculis intuentium offerentem (exprimit)*. The meaning of this obscure statement is probably similar to what I said above. As far as I know this passage from Erasmus was first brought to light by Hermann Grimm, after which it was quoted a number of times, and Robert Vischer published the full quotation as the motto of his Dürer essay. Although what is said in the passage is perfectly correct, it loses some of its significance if one knows that it is made up entirely of statements taken from Pliny. F. Studniczka has shown me the relevant passages which were imitated, starting from the amazement at the expressive power of mere black and white painting (*monochromata*) up to the praise of Dürer as a painter of light phenomena: *quin ille pingit et quae pingi non possunt, ignem, radios, tonitrua, fulgetra, fulgura*, etc., which merely repeats what Pliny says of Apelles: *pinxit et quae pingi non possunt, tonitrua, fulgetra, fulgura*. But there does not seem to be an analogous passage in Pliny to the difficult *ex situ rei unius non unam speciem sese oculis offerentem (exprimit)*. The

difficulty lies in the fact that we do not know what Erasmus considered to be the opposite of *una species. Species* in any case is the painterly appearance, and the statement presumably means that Dürer did not content himself with a chance view of an object but presented a comprehensive image of it. This would be saying something very significant about Dürer's art and it is possible that the words are a reminiscence of what the painter himself may have told the Humanist about his artistic principles.

177 LF. p. 285. A quotation from Aristotle in Pacioli, *Divina Proportione*, c. II.

178 Steigmüller (*Dürer als Mathematiker*, 1891) gives an account of Dürer's accomplishments as a mathematician which can be understood by the layman too. Cf. also Leo Olschki, *Geschichte der neusprachlichen Literatur*, vol. I, p. 414ff., where Dürer's relationship to mathematics and theories of construction in Germany is dealt with.

179 For this too Italian sources have been established, i.e. the work of Marsilius Ficinus on the healthy life. Cf. Giehlow's discussion of the *Melancholia* mentioned above (*Mitteilungen der Gesellschaft für graphische Kunst*, 1903/4).

180 Alberti based his proportions of the beautiful human figure on an average taken from the measurements of human figures which were declared beautiful by connoisseurs (*periti*).

181 cf. Cicero, *Orator*, c. 2. Müller, *Geschichte der Theorie der Kunst bei den Alten*, II, p. 199, discusses this passage.

182 The meaning of this frequently quoted statement (which occurs twice, but only in the manuscripts) is rather ambiguous. On the one hand—taken in its context—it can really only mean that Dürer talks of the incomprehensibility of the highest beauty (God alone knows it). But the statement 'beauty—I do not know what it is, although it is in many things' on the other hand could be taken to mean that Dürer thought beauty was essentially unfathomable.

I may add that other terms must be interpreted in an ambiguous way too if one wants to do the text justice. Thus 'matching' means proportional, but also indicates the mean between two extremes; 'seemly' can mean suitable, appropriate within a given context, but also beautiful in an absolute sense—the opposite being 'ugly and unseemly' and 'unseemliness and deformity'.

183 This statement will seem exaggerated if one thinks of the magnificent drawing of five men rising from the dead which came to Berlin from the Lanna Collection in 1910 (w.890). But basically this reaction is right, especially as this drawing is ultimately based—as has been pointed out frequently—on Paolo Uccello's *Deluge* in S. Maria Novella in Florence (the intervening links are not known).

Bibliography

A. BARTSCH: *Le peintre-graveur*, 1803–21, vol. VII.

J. D. PASSAVANT: *Le peintre-graveur*, 1860–4, vol. III.

CAMPBELL DODGSON: *Catalogue of early German woodcuts in the British Museum*, vol. I, 1903, vol. II, 1911.

CAMPBELL DODGSON: *Albrecht Dürer (The Masters of Engraving and Etching)*, London and Boston, 1926. Catalogue raisonné of all engravings and etchings by Dürer in chronological order.

WILLI KURTH: *Albrecht Dürer, Complete Woodcuts*, London, 1963.

JOSEPH MEDER: *Dürer-Katalog. Ein Handbuch über Albrecht Dürers Stiche, Radierungen, Holzschnitte, deren Zustände, Ausgaben und Wasserzeichen*, Vienna, 1932.

F. LIPPMANN: *Zeichnungen von Albrecht Dürer*, Berlin, 1883–1929. Seven volumes with 913 items. The last two volumes were edited by F. Winkler.

F. WINKLER: *Die Zeichnungen Albrecht Dürers*, Berlin, 1936–9, Deutscher Verein für Kunstwissenschaft. 4 vols.

WÖLFFLIN: *Drawings of Albrecht Dürer*, London, 1970. A selection of 81 drawings.

EDUARD FLECHSIG: *Albrecht Dürer (Kritische Einzeluntersuchungen über Reihenfolge und Entstehungszeit von Dürers Werken)*, vol. I, Berlin, 1928; vol. II, 1931.

HANS TIETZE and E. TIETZE-CONRAT: *Kritisches Verzeichnis der Werke Albrecht Dürers*. Vol. I: *Der junge Dürer*, Augsburg, 1928; vol. II, 1 and 2: *Der reife Dürer*, Basle and Leipzig, 1937 and 1938.

WILHELM WAETZOLDT: *Dürer and his Times*, London, 1950.

LANGE UND FUHSE: *Dürers schriftlicher Nachlass, hrsg. auf Grund der Originalhandschriften und teilweise neuentdeckter alter Abschriften*, Halle, 1893. It contains Dürer's family chronicle and other personal notes, the letters, rhymes, the diary of the journey to the Netherlands and excerpts from the printed books as well as manuscript plans for them. The most important passages are collected together by HEIDRICH, *Dürers schriftlicher Nachlass*, Berlin, 1908. The *Teaching of Measurements* has been published as a single volume by Pelker, Munich, 1908. A revised and updated critical edition is HANS RUPPRICH (ed.), *Dürers schriftlicher Nachlass*, Deutscher Verein für Kunstwissenschaft, Berlin, 1956–69, 3 vols.

ERWIN PANOFSKY: *Albrecht Dürer*, Oxford, 1945.

CHRISTOPHER WHITE: *Dürer: The Artist and his Drawings*, London, 1971.